iPhoto '09 THE MISSING MANUAL

The book that should have been in the box®

iPhoto'09

David Pogue & J.D. Biersdorfer

iPhoto '09: The Missing Manual

by David Pogue & J.D. Biersdorfer

Copyright © 2009 David Pogue. All rights reserved. Printed in Canada.

Published by O'Reilly Media, Inc., 1005 Gravenstein Highway North, Sebastopol, CA 95472.

O'Reilly Media books may be purchased for educational, business, or sales promotional use. Online editions are also available for most titles: *safari.oreilly. com.* For more information, contact our corporate/institutional sales department: 800-998-9938 or *corporate@oreilly.com.*

April 2009:

First Edition.

December 2009: Second Printing.

The Missing Manual is a registered trademark of O'Reilly Media, Inc. The Missing Manual logo, and "The book that should have been in the box" are trademarks of O'Reilly Media, Inc. Many of the designations used by manufacturers and sellers to distinguish their products are claimed as trademarks. Where those designations appear in this book, and O'Reilly Media is aware of a trademark claim, the designations are capitalized.

While every precaution has been taken in the preparation of this book, the publisher assumes no responsibility for errors or omissions, or for damages resulting from the use of the information contained in it.

This book uses Otabind, a durable and flexible lay-flat binding.

Table of Contents

Introduction	- 1
About This Book	. 4
The Very Basics	. !
Part One: iPhoto Basics	
Chanter 1: Camera Meets Mac	ç
Chapter 1: Camera Meets MaciPhoto: The Application	
Getting Your Pictures into iPhoto	
The Post-Import Inspection	
Where iPhoto Keeps Your Files	28
There is not neeps four files	20
Chapter 2: The Digital Shoebox	33
The Source List	33
All About Events	37
Photos View	41
Selecting Photos	48
Hiding Photos	50
Three Ways to Open a Photo	52
Albums	55
Smart Albums	
Folders	
The Info Panel	
Extended Photo Info	69
Deleting Photos	70
Customizing the Shoebox	72
Chapter 3: Five Ways to Flag and Find Photos	77
Flagging Photos	
Searching for Photos by Text	77 79
The Calendar	
Keywords	80
Ratings	83 88
	88
Chapter 4: Faces and Places	89
Faces	89
Places	101

Chapter 5: Editing Your Shots	113
Editing in iPhoto	113
The Toolbar and Thumbnails Browser	116
Notes on Full-Screen Mode	117
Notes on Zooming and Scrolling	118
The Rotate Button	120
Cropping	121
Straightening	125
The Enhance Button	125
Red-Eye	127
Retouching Freckles, Scratches, and Hairs	128
The Effects Palette	129
The Adjust Panel	131
Introduction to the Histogram	132
Exposure	134
Contrast	135
Saturation	136
Highlights and Shadows	137
Definition	138
Sharpness	138
De-noise	139
Color Balance	139
Copy and Paste	142
Beyond iPhoto	142
Reverting to the Original	143
Editing RAW Files	144
Part Two: Meet Your Public	
Chapter 6: The iPhoto Slideshow	151
About Slideshows	151
Instant Slideshows	154
Slideshow Settings	158
Saved Slideshows	162
Slideshow Tips	171
Slideshows and iDVD	173
	.,5
Chapter 7: Making Prints	175
Making Your Own Prints	175
Ordering Prints Online	184

Chapter 8: Email, Web Galleries, and Network Sharing	
Emailing Photos	189
Publishing Photos on the Web	193
Flickr	194
Facebook	198
The MobileMe Gallery	20
iPhoto to iWeb	21
Exporting iPhoto Web Pages	214
Photo Sharing on the Network	
Photo Sharing Across Accounts	222
Chapter 9: Books, Calendars, and Cards	225
Phase 1: Pick the Pix	226
Phase 2: Publishing Options	226
Phase 3: Design the Pages	
Phase 4: Edit the Titles and Captions	243
Phase 5: Preview the Masterpiece	248
Phase 6: Send the Book to the Bindery	251
Photo Calendars	253
Greeting Cards and Postcards	259
Chapter 10: iPhoto Goes to the Movies	263
Before You Export the Slideshow	263
Two Ways to Make Movies	264
Exporting a QuickTime Movie	267
Fun with QuickTime	271
Managing Movies Imported from Your Camera	275
Editing Digital-Camera Movies	275
Burning a Slideshow Movie CD or DVD	276
Slideshow Movies on the Web	278
Chapter 11: iDVD Slideshows	283
The iDVD Slideshow	283
Extra Credit: Self-Playing Slideshows	291
Dead There is the control of	
Part Three: iPhoto Stunts	
Chapter 12: Screen Savers, AppleScript, and Automator	
Building a Custom Screen Saver	
One-Click Desktop Backdrop	
Exporting and Converting Pictures	
Plug-Ins and Add-Ons	
AppleScript Tricks	
Automator Tricks	304

Chapter 13: iPhoto File Management	309
About iPhoto Discs	309
iPhoto Backups	313
Managing Photo Libraries	314
Merging Photo Libraries	318
Beyond iPhoto	319
Part Four: Appendixes	
Appendix A: Troubleshooting	323
The Most Important Advice in This Chapter	323
Importing, Upgrading, and Opening	323
Exporting	325
Printing	327
Editing and Sharing	327
General Questions	328
Appendix B: iPhoto '09, Menu by Menu	333
iPhoto Menu	333
File Menu	338
Edit Menu	341
Photos Menu	343
Events Menu	345
Share Menu	346
View Menu	346
Window Menu	348
Help Menu	349
Appendix C: Where to Go From Here	351
Index	353

The Missing Credits

About the Authors

David Pogue (original author, editor) is the weekly tech columnist for the *New York Times*, an Emmy-winning correspondent for *CBS News Sunday Morning*, weekly CNBC contributor, and the creator of the Missing Manual series. He's the author or co-author of 49 books, including 24 in this series and six in the "For Dummies" line (including *Macs, Magic, Opera*, and *Classical Music*). In

his other life, David is a former Broadway show conductor, a piano player, and a magician. He lives in Connecticut with his wife and three awesome children.

Links to his columns and weekly videos await at www.davidpogue.com. He welcomes feedback about his books by email at david@pogueman.com.

J.D Biersdorfer (author, '09 update) is the author of *iPod: The Missing Manual* and *The iPod Shuffle Fan Book*, and co-author of *The Internet: The Missing Manual* and *Google: The Missing Manual*, *Second Edition*. She has been writing the weekly computer Q&A column for the *The New York Times* since 1998. When not slaving over a hot Mac, she plays the banjo and watches the BBC. E-mail: *jd.biersdorfer@gmail.com*.

About the Creative Team

Phil Simpson (design and layout) works out of his office in Southbury, Connecticut, where he has had his graphic design business since 1982. He is experienced in many facets of graphic design, including corporate identity, publication design, and corporate and medical communications. Email: pmsimpson@earthlink.net.

Dawn Frausto (wrangler of files, copy editors, and indexers) is assistant editor for the Missing Manual series. When not working, she plays soccer, beads, and causes trouble. Email: *dawn@oreilly.com*.

Nellie McKesson (production helper) lives in Jamaica Plain, Mass., where she makes t-shirts for her friends (http://mattsaundersbynellie.etsy.com) and plays music with her band Dr. & Mrs. Van Der Trampp. Email: nellie@oreilly.com.

Julie Van Keuren (copy editor) is a freelance editor, writer, and desktop publisher who runs her "little media empire" from her home in Billings, Montana. Before starting her own business in 2006, Julie edited for The Virginian-Pilot of Norfolk, Va.; The Olympian of Olympia, Wash.; and The Seattle Times. She and her husband, M.H., live in Billings, Montana, with their two sons, Dexter and Michael. Email: <code>little_media@yahoo.com</code>.

THE MISSING CREDITS ix

Julie Hawks (indexer) is an indexer for the Missing Manual series. Her other life includes testing software, tinkering with databases, reading Vedanta texts, and enjoying nature. Email: <code>juliehawks@gmail.com</code>.

Derrick Story (contributor) focuses on digital photography, podcasting, and Mac computing in his teaching and writing. You can keep up with his online articles, blogs, and books at *www.thedigitalstory.com*. His video tutorials (including for iPhoto '09) are available at www.lynda.com. Derrick's also a regular contributor to Macworld magazine and speaker at the Macworld Expo.

Lesa Snider (graphics and index production, previous edition) is the author of *Photoshop CS4: The Missing Manual*, and creator of several training videos at KelbyTraining.com and Lynda.com. She's the chief evangelist for iStockphoto.com, a regular instructor at Photoshopworld, and author of the "Graphic Secrets" column for Photoshop User magazine. You can watch her graphics tip each Wednesday night on YourMacLifeshow.com. Web site: *www.GraphicReporter.com*.

Acknowledgements

The Missing Manual series is a joint venture between Pogue Press (the dream team introduced on these pages) and O'Reilly Media (a dream publishing partner). I'm indebted, as always, to Tim O'Reilly, Laurie Petrycki, Peter Meyers, and the rest of the gang.

I also owe a debt of gratitude to my old Yale roommate Joe Schorr, who co-authored the first two editions of this book and wound up, years later, working at Apple, where he eventually became the product manager for Aperture and—how's this for irony?—iPhoto. Some of his prose and his humor live on in this edition.

Professional photographer/writer Derrick Story's mark is on this book, too. His writeups of the Adjustments Palette live on in Chapter 5.

The photos featured in this book's examples were taken by Lesa Snider King (balloon festival shots), Derrick Story (Chapter 5 shots), and me (most of the rest).

Thanks to Zach Brass, who created a number of the screenshots in this book; to Dennis Cohen, who tech-edited this book's early editions; and to David Rogelberg.

Even more special thanks to Jude Biersdorfer, who cheerfully undertook the challenge of updating this book to reflect the changes in iPhoto '09 without making it sound like two different authors were at work. She did a seamless, witty, professional job.

Above all, thanks to Jennifer, Kelly, Tia, and Jeffrey, whose patience and sacrifices make these books—and everything else—possible.

—David Pogue

I'd like to thank my grandfather, Tom Elliott, for getting me my very first 35mm camera (a Pentax K1000) for my 13th birthday, and for always encouraging my interest in photography when I was growing up. Deepest thanks as well to my family and especially Betsy Book, for putting up with me during those crazy days of deadline.

—J.D. Biersdorfer

The Missing Manual Series

Missing Manuals are witty, superbly written guides to computer products that don't come with printed manuals (which is just about all of them). Each book features a handcrafted index; cross-references to specific page numbers (not just "see Chapter 14"); and RepKover, a detached-spine binding that lets the book lie perfectly flat without the assistance of weights or cinder blocks.

Recent and upcoming titles include:

- · Access 2007: The Missing Manual by Matthew MacDonald
- · AppleScript: The Missing Manual by Adam Goldstein
- AppleWorks 6: The Missing Manual by Jim Elferdink and David Reynolds
- CSS: The Missing Manual by David Sawyer McFarland
- · Creating Web Sites: The Missing Manual by Matthew MacDonald
- · David Pogue's Digital Photography: The Missing Manual by David Pogue
- · Dreamweaver 8: The Missing Manual by David Sawyer McFarland
- · Dreamweaver CS3: The Missing Manual by David Sawyer McFarland
- Dreamweaver CS4: The Missing Manual by David Sawyer McFarland
- · eBay: The Missing Manual by Nancy Conner
- Excel 2003: The Missing Manual by Matthew MacDonald
- Excel 2007: The Missing Manual by Matthew MacDonald
- Facebook: The Missing Manual by E.A. Vander Veer
- FileMaker Pro 8: The Missing Manual by Geoff Coffey and Susan Prosser
- FileMaker Pro 9: The Missing Manual by Geoff Coffey and Susan Prosser
- Flash 8: The Missing Manual by E.A. Vander Veer
- Flash CS3: The Missing Manual by E.A. Vander Veer and Chris Grover
- Flash CS4: The Missing Manual by Chris Grover with E.A. Vander Veer
- FrontPage 2003: The Missing Manual by Jessica Mantaro
- · Google Apps: The Missing Manual by Nancy Conner

THE MISSING CREDITS XI

- · Google SketchUp: The Missing Manual by Chris Grover
- The Internet: The Missing Manual by David Pogue and J.D. Biersdorfer
- iMovie 6 & iDVD: The Missing Manual by David Pogue
- iMovie '08 & iDVD: The Missing Manual by David Pogue
- iPhone: The Missing Manual by David Pogue
- · iPhoto '08: The Missing Manual by David Pogue
- iPhoto '09: The Missing Manual by David Pogue and J.D. Biersdorfer
- iPod: The Missing Manual, 6th Edition by J.D. Biersdorfer
- · iWork '09: The Missing Manual by Josh Clark
- · JavaScript: The Missing Manual by David Sawyer McFarland
- · Living Green: The Missing Manual by Nancy Conner
- Mac OS X: The Missing Manual, Tiger Edition by David Pogue
- Mac OS X: The Missing Manual, Leopard Edition by David Pogue
- Microsoft Project 2007: The Missing Manual by Bonnie Biafore
- · Netbooks: The Missing Manual by J.D. Biersdorfer
- Office 2004 for Macintosh: The Missing Manual by Mark H. Walker and Franklin Tessler
- Office 2007: The Missing Manual by Chris Grover, Matthew MacDonald, and E.A. Vander Veer
- Office 2008 for Macintosh: The Missing Manual by Jim Elferdink
- PCs: The Missing Manual by Andy Rathbone
- · Photoshop CS4: The Missing Manual by Lesa Snider
- Photoshop Elements 7: The Missing Manual by Barbara Brundage
- Photoshop Elements 6 for Mac: The Missing Manual by Barbara Brundage
- PowerPoint 2007: The Missing Manual by E.A. Vander Veer
- QuickBase: The Missing Manual by Nancy Conner
- QuickBooks 2008: The Missing Manual by Bonnie Biafore
- Quicken 2008: The Missing Manual by Bonnie Biafore
- Quicken 2009: The Missing Manual by Bonnie Biafore
- QuickBooks 2009: The Missing Manual by Bonnie Biafore

- Switching to the Mac: The Missing Manual, Tiger Edition by David Pogue and Adam Goldstein
- · Switching to the Mac: The Missing Manual, Leopard Edition by David Pogue
- Wikipedia: The Missing Manual by John Broughton
- · Windows XP Home Edition: The Missing Manual, 2nd Edition by David Pogue
- Windows XP Pro: The Missing Manual, 2nd Edition by David Pogue, Craig Zacker, and Linda Zacker
- · Windows Vista: The Missing Manual by David Pogue
- Windows Vista for Starters: The Missing Manual by David Pogue
- · Word 2007: The Missing Manual by Chris Grover
- Your Brain: The Missing Manual by Matthew MacDonald

Introduction

In case you haven't heard, the digital camera market is exploding. At this point, a staggering 98 percent of cameras sold are digital cameras. It's taken a few decades—the underlying technology used in most digital cameras was invented in 1969—but film photography has been reduced to a niche activity.

And why not? The appeal of digital photography is huge. When you shoot digitally, you don't pay a cent for film or photo processing. You get instant results, viewing your photos just moments after shooting them, making even Polaroids seem painfully slow by comparison. As a digital photographer, you can even be your own darkroom technician—without the darkroom. You can retouch and enhance photos, make enlargements, and print out greeting cards using your home computer. Sharing your pictures with others is far easier, too, since you can burn them to CD, email them to friends, or post them on the Web. As one fan puts it, "There are no 'negatives' in digital photography."

But there is one problem. When most people try to *do* all this cool stuff, they find themselves drowning in a sea of technical details: JPEG compression, EXIF tags, file format compatibility, image resolutions, FTP clients, and so on. It isn't pretty.

The cold reality is that while digital photography is full of promise, it's also been full of headaches. During the early years of digital cameras, just making the camera-to-computer connection was a nightmare. You had to mess with serial or USB cables; install device drivers; and use proprietary software to transfer, open, and convert camera images into a standard file format. If you handled all these tasks perfectly—and sacrificed a young male goat during the spring equinox—you ended up with good digital pictures.

INTRODUCTION

1

iPhoto Arrives

Apple recognized this mess and finally decided to do something about it. When Steve Jobs gave his keynote address at Macworld Expo in January 2002, he referred to the "chain of pain" that ordinary people experienced when attempting to download, store, edit, and share their digital photos.

He also focused on another growing problem among digital photographers: Once you start shooting free, filmless photos, they pile up quickly. Before you know it, you have 6,000 pictures of your kid playing soccer. Just organizing and keeping track of all these photos is enough to drive you insane.

Apple's answer to all these problems was iPhoto, a simple and uncluttered program designed to organize, edit, and distribute digital photos without the nightmarish hassles. Successive versions added features and better speed. (There was no iPhoto 3, oddly enough. Keep that in mind if someone tries to sell you a copy on eBay.)

To be sure, iPhoto isn't the most powerful image management software in the world. Like Apple's other iProducts (iMovie, iTunes, iDVD, and so on), its design subscribes to its own little 80/20 rule: 80 percent of us really don't need more than about 20 percent of the features you'd find in a full-blown, \$300 digital asset management program like, say, Apple's own Aperture.

Today, millions of Mac fans use iPhoto. Evidently, there were a lot of digital camera buffs out there, feeling the pain and hoping that iPhoto would provide some much-needed relief.

What's New in iPhoto '09

On the surface, iPhoto '09 doesn't look much different from iPhoto '08. It does, however, harbor some new features, many of them designed to personalize your photos and to make it easier to share them with the world:

- Faces. The most talked-about feature in iPhoto '09 is *Faces*, a new component of the program that analyzes your photos and groups your collections based on the *people* who are in them.
 - When you turn Faces loose on your photos, iPhoto sweeps through your photo library, methodically examining any clump of pixels that looks like it might be a human face. Once iPhoto has detected faces in the photos, it singles them out and invites you to put names to those mugs: Mom, Sweetie, Chris, and so on. Once you do, the program recognizes these same people in other photos. From now on, you have one-click shopping for pictures of a specific person.
- Places. Plotting photos on an electronic map is all the rage these days. With its *Places* feature, iPhoto '09 offers you the power of Google Maps and a whole box of little virtual map pins to show off your travels. Even if you don't have a camera that automatically slaps GPS coordinates onto every photo you snap, you can still use the tools within Places to mark your spot on the map.

Once you get some photos tagged to geographical locations, Places lets you look them up based on where they were taken—either on your own personalized map ("Grandma's house," for example) or neatly sorted by country, state, town, or landmark.

- Travel maps. Apple has given iPhoto '09 a set of stylish new map pages that you can incorporate into *printed* photo books. These maps can be fully customized to show every city you visited, say, on that tour of French Canada, complete with little red arrows showing your route to Québec City and back. Maps give context to the photos, and they look really cool. It's like Rand McNally went along for the ride.
- New slideshow themes. The beloved slideshow feature from the iPhotos of Yore has gotten a major makeover in this latest version of the program. *Themes*—animated visual slideshow styles—debut in iPhoto '09. The traditional slideshow option, with its lengthy choice of Hollywood-esque transitions between photos, is still here, now called Classic. That beloved documentary-style pan-and-zoom effect to bring still photos to life has remained as, of course, the Ken Burns theme.
- Slideshow Export. The new slideshow themes may make you even more determined to show off your pictures-in-motion, and Apple makes it easier than ever to do in iPhoto '09. The new Slideshow Export feature lets you pop out a traveling copy of your iPhoto opus as a QuickTime movie, perfectly sized for a variety of different screens. With just a couple of clicks, you can export the slideshow for an iPhone, iPod, Apple TV, Web page, or even a big screen—and not worry about the video looking grainy or blotchy. Your pal iPhoto finds the resolution solution automatically.
- Online sharing. iPhoto '09 brings online sharing to the masses—including the bazillions of people using Flickr (the largest photo Web site) and Facebook (the most popular "all about me" Web site). Choose some photos and then hit the Facebook or Flickr buttons: You've just published them online. Make changes to the photos on either the Web or in iPhoto, and the updates sync up to the other location.

Flickr and Facebook members can take advantage of iPhoto' other new features as well. Spent all afternoon naming your friends in Faces? Those name tags you apply in iPhoto follow the photos over to Facebook, saving you the trouble of tagging them again online. And those locations you linked to your Places photos take their geographical information with them—so you don't have to fiddle around pinpointing them all over again on your Flickr map.

• Goosed-up editing. The editing tools in iPhoto have been supercharged, thanks to underlying technology swiped from Aperture (Apple's professional photo program). For example, you can now intensify the saturation of the colors in a photo without affecting skin tones. When you eliminate scratches or zits with the Retouch tool, iPhoto no longer blurs things (like clothing borders) that shouldn't be blurred. And the Red-Eye tool now exploits face recognition, so it knows what's an eye and what's not.

INTRODUCTION 3

In short, there are so many changes, you'd practically need a book to keep track—and you're holding it.

About This Book

Don't let the rumors fool you. iPhoto may be simple, but it isn't simplistic. It offers a wide range of tools, shortcuts, and database-like features; a complete arsenal of photo-presentation features; and sophisticated multimedia and Internet hooks. Unfortunately, many of the best techniques aren't covered in the only "manual" you get with iPhoto—its slow, sparse electronic help screens and videos.

This book was born to serve as the iPhoto manual—the book that should have been in the box. It explores each iPhoto feature in depth, offers shortcuts and workarounds, and unearths features that the online help doesn't even mention.

And to make it all go down easier, this book has been printed in full color. Kind of makes sense for a book about photography, doesn't it?

About the Outline

This book is divided into four parts, each containing several chapters:

- Part 1, iPhoto Basics, covers the fundamentals of getting your photos into iPhoto. This includes organizing and filing them, tagging them with a face or a place, searching them, and editing them to compensate for weak lighting (or weak photography).
- Part 2, Meet Your Public, is all about the payoff, the moment you've been waiting for since you snapped the shots—showing them off. It covers the many ways iPhoto can present those photos to other people: as a slideshow; as prints you order from the Internet or make yourself; as a professionally published gift book; on a Web page; by email; or as a QuickTime slideshow that you post on the Web, send to your iPhone, or distribute on DVD. It also covers sharing your iPhoto collection across an office network with other Macs, with other account holders on the same Mac, and with other iPhoto fans across the Internet.
- Part 3, iPhoto Stunts, takes you way beyond the basics. It covers a miscellaneous potpourri of additional iPhoto features, including turning photos into screen savers or desktop pictures on your Mac, exporting the photos in various formats, using iPhoto plug-ins and accessory programs, managing (or even switching) iPhoto libraries, backing up your photos using iPhoto's Burn to CD command, and even getting photos to and from cameraphones and Palm organizers.
- Part 4, **Appendixes**, brings up the rear, but gives you a chance to move forward. Appendix A offers troubleshooting guidance, Appendix B goes through iPhoto's menus one by one to make sure that every last feature has been covered, and Appendix C lists some Web sites that will help fuel your growing addiction to digital photography.

5

About→**These**→**Arrows**

Throughout this book, and throughout the Missing Manual series, you'll find sentences like this one: "Open the System folder—Libraries—Fonts folder." That's shorthand for a much longer instruction that directs you to open three nested folders in sequence. That instruction might read: "On your hard drive, you'll find a folder called System. Open it. Inside the System folder window is a folder called Libraries. Open that. Inside that folder is yet another one called Fonts. Double-click to open it, too."

Similarly, this kind of arrow shorthand helps to simplify the business of choosing commands in menus. The instruction "Choose Photos—Duplicate" means, "Open the Photos menu, and then choose the Duplicate command."

About MissingManuals.com

At www.missingmanuals.com, you'll find news, articles, and updates to the books in this series.

But if you click the name of this book and then the Errata link, you'll find a unique resource: a list of corrections and updates that have been made in successive printings of this book. You can mark important corrections right into your own copy of the book, if you like.

In fact, the same page offers an invitation for you to submit such corrections and updates yourself. In an effort to keep the book as up-to-date and accurate as possible, each time we print more copies of this book, we'll make any confirmed corrections you've suggested. Thanks in advance for reporting any glitches you find!

In the meantime, we'd love to hear your suggestions for new books in the Missing Manual line. There's a place for that on the Web site, too, as well as a place to sign up for free email notification of new titles in the series.

The Very Basics

You'll find very little jargon or nerd terminology in this book. You will, however, encounter a few terms and concepts that you'll see frequently in your Macintosh life. Here are the essentials:

 Clicking. To *click* means to point the arrow cursor at something onscreen and then—without moving the cursor at all—press and release the clicker button on the mouse (or laptop trackpad). To *double-click*, of course, means to click twice in rapid succession, again without moving the cursor at all. And to *drag* means to move the cursor while keeping the button continuously pressed.

When you're told to **%**-click something, you click while pressing the **%** key (next to the space bar). Shift-clicking, Option-clicking, and Control-clicking work the same way—just click while pressing the corresponding key on your keyboard. (On non-U.S. Mac keyboards, the Option key may be labeled "Alt" instead.)

INTRODUCTION

The Very Basics

Note: On Windows PCs, the mouse has two buttons. The left one is for clicking normally; the right one produces a tiny shortcut menu of useful commands (see the note below). But new Macs come with Apple's Mighty Mouse, a mouse that looks like it has only one button but can actually detect which side of its rounded front you're pressing. If you've turned on the feature in System Preferences, then you too can right-click things on the screen.

That's why, all through this book, you'll see the phrase, "Control-click the photo (or right-click it)." That's telling you that Control-clicking will do the job—but if you've got a two-button mouse or you've turned on the two-button feature of the Mighty Mouse, right-clicking might be more efficient.

• Keyboard shortcuts. Every time you take your hand off the keyboard to move the mouse, you lose time and potentially disrupt your creative flow. That's why many experienced Mac fans use keystroke combinations instead of menu commands wherever possible. **%**-P opens the Print dialog box, for example, and **%**-M minimizes the current window to the Dock.

When you see a shortcut like \Re -Q (which closes the current program), it's telling you to hold down the \Re key, and, while it's down, type the letter Q, and then release both keys.

Note: Apple has officially changed what it calls the little menu that pops up when you Control-click (or right-click) something on the screen. It's still a *contextual* menu, in that the menu choices depend on the context of what you click—but it's now called a *shortcut* menu. That term not only matches what it's called in Windows, but it's slightly more descriptive about its function. "Shortcut menu" is the term you'll find in this book.

If you've mastered this much information, you have all the technical background you need to enjoy *iPhoto '09: The Missing Manual*.

Safari® Books Online

When you see a Safari® Books Online icon on the cover of your favorite technology book, that means the book is available online through the O'Reilly Network Safari Bookshelf.

Safari offers a solution that's better than e-Books. It's a virtual library that lets you easily search thousands of top tech books, cut and paste code samples, download chapters, and find quick answers when you need the most accurate, current information. Try it free at http://safari.oreilly.com.

Part One: iPhoto Basics

Chapter 1: Camera Meets Mac

Chapter 2: The Digital Shoebox

Chapter 3: Five Ways to Flag and Find Photos

Chapter 4: Faces and Places

Chapter 5: Editing Your Shots

Camera Meets Mac

he Ansel Adams part of your job is over. Your digital camera is brimming with photos. You've snapped the perfect graduation portrait, captured that jaw-dropping sunset over the Pacific, or compiled an unforgettable photo essay of your 2-year-old attempting to eat a bowl of spaghetti. It's time to use your Mac to gather, organize, and tweak all these photos so you can share them with the rest of the world.

That's the core of this book—compiling, organizing, and adjusting your pictures using iPhoto, and then transforming this collection of digital photos into a professional-looking slideshow, set of prints, movie, Web page, poster, email, desktop picture set, or bound book.

But before you start organizing and publishing these pictures using iPhoto, they have to find their way from your camera to the Mac. This chapter explains how to get pictures from camera to computer and introduces you to iPhoto.

iPhoto: The Application

iPhoto approaches digital photo management as a four-step process:

- Import. Working with iPhoto begins with feeding your digital pictures into the program, either from a camera or from somewhere else on your Mac.
 - In general, importing is literally a one-click process. This is the part of iPhoto covered in this chapter.
- Organize. This step is about sorting and categorizing your chaotic jumble of pictures so you can easily find them and arrange them into logical groups. You

iPhoto: The Application can add searchable keywords like Vacation or Kids to make pictures easier to find. You can change the order of images, and group them into folders called albums. You can group your pictures based on *who's* in them, and have iPhoto help match names to faces. You can pin your photos to a virtual map that shows your travels around the globe. Chapters 2 and 3 cover all of iPhoto's organization tools, and Chapter 4 explains iPhoto '09's two coolest features: Faces and Places.

- Edit. This is where you fine-tune your photos to make them look as good as possible. iPhoto provides everything you need for rotating, retouching, resizing, cropping, color-balancing, straightening, and brightening your pictures. (More significant image adjustments—like editing out an ex-spouse—require a different program, like Photoshop.) Editing your photos is the focus of Chapter 5.
- Share. iPhoto's best features have to do with sharing your photos, either onscreen or on paper. In fact, iPhoto offers nine different ways of publishing your pictures. In addition to printing pictures on your own printer (in a variety of interesting layouts and book styles), you can display images as an onscreen slideshow, turn the slideshow into a QuickTime movie, order professional-quality prints or a professionally bound book, email them, apply one to your desktop as a desktop backdrop, select a batch to become your Mac OS X screen saver, post them online as a Web page, and so on.

Chapters 8 through 13 explain how to undertake these self-publishing tasks.

Note: Although much of this book is focused on using digital cameras, remember this: You don't have to shoot digital photos to use iPhoto. You can just as easily use it to organize and publish pictures you've shot with a traditional film camera and then digitized using a scanner (or had Kodak convert into a photo CD). Importing scanned photos is covered later in this chapter.

iPhoto Requirements

To run iPhoto '09, Apple recommends a Mac that has a G4, G5, or Intel chip, Mac OS X 10.5.6 or later, and 1 gigabyte of memory or more.

The truth is, iPhoto may be among the most memory-dependent programs on your Mac. It *loves* memory. Memory is even more important to iPhoto than your Mac's processor speed. It makes the difference between tolerable speed and sluggishness. So the more memory and horsepower your Mac has, the happier you'll be.

Finally, of course, you'll need a lot of hard drive space—not just several gigabytes for iPhoto and the other iLife programs, but also lots of gigabytes for all the photos you'll be transferring to your Mac.

Getting iPhoto

A free version of iPhoto has been included on every Mac sold since January 2002. If your Mac falls into that category, then you'll find iPhoto in your Applications folder. (You can tell which version you have by single-clicking its icon and then choosing File—Get Info. In the resulting info window, you'll see the version number as clear as day.)

If you bought your Mac after January 2009, you probably have iPhoto '09 installed. Otherwise, it's available only as part of Apple's iLife '09 software suite—an \$80 DVD that includes GarageBand, iMovie, iPhoto, iDVD, and iWeb. You can get the iLife box from *www.apple.com/store*, mail-order Web sites, or local computer stores.

When you run the iLife installer, you're offered a choice of programs to install. Install all five programs, if you like, or just iPhoto.

When the installation process is over, you'll find the iPhoto icon in your Applications folder. (In the Finder, choose Go→Applications, or press Shift-ૠ-A, to open this folder.) You'll also find the iPhoto icon—the little camera superimposed on the palm tree—preinstalled in your Dock, so you'll be able to open it more conveniently from now on.

Upgrading from earlier versions

If you've used an earlier version of iPhoto, then you'd be wise to make a backup of your *iPhoto library*—your database of photos—before running iPhoto '09. That's because iPhoto '09's first bit of business is converting that library into a new, more efficient format that's incompatible with earlier iPhotos (see Figure 1-1, bottom).

Figure 1-1: Top: This message pops up to get you all excited about your voyage into the not-so-unknown.

Bottom: If vou're upgrading from an earlier version of iPhoto, this warning is the first thing you see when you launch iPhoto. Once you click Upgrade, there's no going back-your photo library will no longer be readable with iPhoto 1, 2, 4, 5, 6 or '08. (There was no iPhoto 3. And even though iPhoto '09 comes with iLife '09, its official version number is 8.)

iPhoto: The Application Ordinarily, the upgrade process is seamless: iPhoto smoothly converts and displays your existing photos, comments, titles, and albums. But lightning does strike, fuses do blow, and the technology gods have a cruel sense of humor—so making a backup copy before iPhoto converts your old library is very, very smart.

To perform this safety measure, open your Home—Pictures folder, and then copy or duplicate the iPhoto Library icon. (This folder may be huge, since it contains copies of all the photos you've imported into iPhoto. This is a solid argument for copying it onto a second hard drive, an iPod, or a bunch of burnable DVDs; see page 313.) Now, if anything should go wrong with the conversion process, you'll still have a clean, uncorrupted copy of your iPhoto library files.

Running iPhoto for the First Time

Double-click the iPhoto icon to open the program. After you dismiss the "Welcome to iPhoto" dialog box (Figure 1-1, top), iPhoto checks to see if you have an older version and, if so, offers to convert its photo library (Figure 1-1, bottom).

Finally, you arrive at the program's main window, the basic elements of which are shown in Figure 1-2.

Figure 1-2:
Here's what iPhoto
looks like when you
first open it. The
large photo-viewing
area is where
thumbnails of your
imported photos
will appear. The
icons at the bottom
of the window
represent all the
stuff you can do
with your photos.

When you first run iPhoto '09, the program also asks if you'd like it to look up photo locations on Apple servers so your photos can be placed on a map. This is part of the new Places feature, explained in Chapter 4.

With iPhoto installed and ready to run, it's time for you to import your own pictures into the program—a process that's remarkably easy, especially if your photos are going directly from your camera into iPhoto.

Of course, if you've been taking digital photos for some time, you probably have a lot of photo files already crammed into folders on your hard drive or on flash drives or CDs. If you shoot pictures with a traditional film camera and use a scanner to digitize them, you've probably got piles of JPEG or TIFF images stashed away on disk already, waiting to be cataloged using iPhoto.

This section explains how to transfer files into iPhoto from each of these sources.

Connecting with a USB Camera

Every modern digital camera can connect to a Mac's USB port. If your Mac has more than one USB jack, then any of them will do.

Plugging a USB-compatible camera into your Mac is the easiest way to transfer pictures from your camera into iPhoto.

Note: A few cameras require a pre-step right about here: turning the Mode dial on the top to whatever tiny symbol means "computer connection." If yours does, do that.

The whole process practically happens by itself:

1. Connect the camera to one of your Mac's USB jacks. Turn the camera on.

To make this camera-to-Mac USB connection, you need what is usually called an *A-to-B* USB cable; your camera probably came with one. The "A" end—the part you plug into your camera—has a small, flat-bottomed plug whose shape varies by manufacturer. The Mac end of the cable has a larger, flatter, rectangular, standard USB plug. Make sure both ends of the cable are plugged in firmly.

If iPhoto isn't already running when you make this connection, the program opens and springs into action as soon as you switch on the camera.

Note: If this is the first time you've ever run iPhoto, it asks if you always want it to run when you plug in the camera. If you value your time, say yes. (Why is it even asking? Because, believe it or not, your Mac came with another program that can import photos from a camera. It's called Image Capture, it's in your Applications folder, and you can use its Preferences command to specify which program you want to open automatically when you connect your camera.)

In iPhoto '09, a wonderful thing happens when you connect the camera: After a pause, you get to see thumbnails (miniature images) of all the photos on your camera's memory card, as shown in Figure 1-3.

Tip: If, for some reason, iPhoto doesn't "see" your camera after you connect it, try turning the camera off, then on again.

How is this wonderful? Let us count the ways. First, it means that you can see right away what's on the card. You don't have to sit through the time-consuming importing process just to discover, when it's all over, that you grabbed the wrong card or the wrong camera.

Second, you can choose to import only *some* of the pictures. (To choose the photos you want to import, use any of the photo-selection techniques described on page 48.)

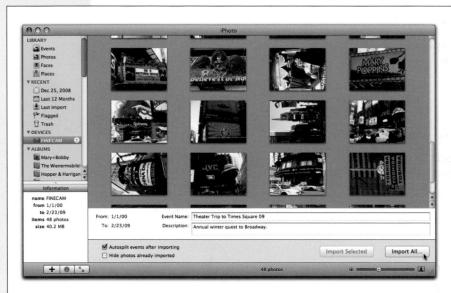

Figure 1-3: iPhoto is ready to import, Captain! If you have to wait a long time for this screen to appear, it's because you've got a lot of pictures on your camera, and it takes iPhoto a while to count them up and prepare for the task at hand. (The number may be somewhat larger than you expect if you didn't erase vour last batch of photos.)

The option to import only some of the photos opens up a whole new workflow possibility: You can *leave all the photos on your memory card*, all the time. You can take new photos each day, and import only those onto your Mac each night. If your memory card is big enough, this routine means that you always have a backup of your photos.

Tip: If you've decided to work this way, then you can save yourself some time and worry by turning on "Hide photos already imported," a checkbox at the bottom of the screen. Now, each time you connect the camera, you'll be shown only the new photos, the ones you haven't imported yet. One quick click on the Import All button (step 3) brings in only the latest shots, without your having to pick through the whole collection on the card, trying to remember which pictures you've already downloaded to your Mac.

Something else happens when you connect the camera, too: Its name and icon appear in the Source list. That's handy, because it means that you can switch back and forth between the importing mode (click the camera's icon) and the regular working-in-iPhoto mode (click any other icon in the Source list), even while the time-consuming importing is under way.

(Here's an idea for Apple: As long as the camera's appearing in the Source list, wouldn't it be cool if you could drag photos *onto* the camera, too? Maybe next year.)

2. If you like, type in an *Event name* and description for the pictures you're about to import.

An Event, in iPhoto's little head, is "something you photographed within a certain time period" (for example, on a certain day or during a certain week). This was a new photo-organization concept in iPhoto '08 (it replaced the old *film rolls* concept), but it makes a lot of sense.

See, in the old days, iPhoto just imported everything on your memory card and displayed all of those pictures in one gigantic clump—even if they included photos from several different events, shot weeks apart.

Now, during the importing, iPhoto automatically analyzes the time stamps on the incoming photos and puts them into individually named groups according to when you took them.

You can read much more about Events on page 37. In the meantime, your job here is to type a name for the event whose photos you're about to import. It could be *Disney Trip, Casey's Birthday*, or *Baby Meets Lasagna*, for example—anything that will help you organize and find your pictures later. (Use the Description box for more elaborate textual blurbs, if you like. You could specify who was on the trip, the circumstances of the shoot, and so on.)

Tip: See the checkbox called "Autosplit events after importing"? If you turn on this box, then iPhoto will automatically group the imported pictures into Events, as described above; you will not, however, be offered the chance to *name* the Events (except for the first one) until after the importing is over.

If this option is turned off, then all the photos will end up in one giant Event. (You can always split up this one giant batch into several Events later.)

3. Click the appropriate button: Import Selected or Import All.

If you selected just *some* of the photos in step 1, then the Import Selected button springs to life. Clicking it brings only the highlighted photos onto your Mac, and ignores the rest of the camera's photos.

If you click Import All, well, you'll get all of the photos on the card, even if only some are selected.

Note: At this point, you might see a special message appear if you're about to import photos you've already imported (Figure 1-4, top).

In any case, iPhoto swings into action, copying each photo from your camera to your hard drive. You get to see them as they parade by (Figure 1-4, bottom).

When the process is complete, and the photos are safe on your hard drive, iPhoto has another question for you: Do you want to delete the transferred pictures from the memory card?

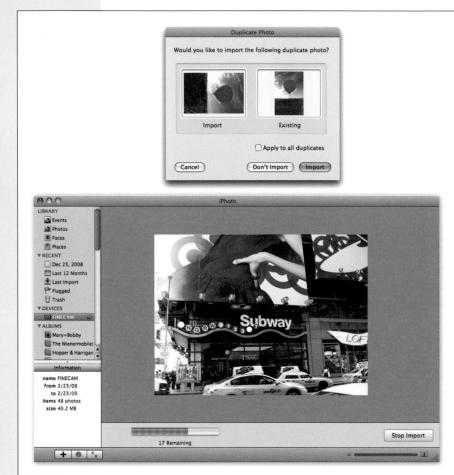

Figure 1-4: Top: You may sometimes see the "Duplicate Photo" message. iPhoto notices the arrival of duplicates (even if you've edited or rotated the first copy) and offers you the option of downloading them again, resulting in duplicates on your Mac, or ignoring them and importing only the new photos from your camera.

Bottom: As the pictures get slurped into your Mac, iPhoto shows them to you, nice and big, as a sort of slide-show. You can see right away which ones were your hits, which were your misses, and which you'll want to delete the instant the importing process is complete.

If you click Delete Originals, iPhoto deletes the transferred photos from the memory card (either all the photos or just the selected ones, depending on the button you clicked at the beginning of step 3). The memory card will have that much more free space for another exciting photo safari.

If you click Keep Originals, then iPhoto leaves the memory card untouched. You might opt for this approach if you've adopted the "use the card as a backup" lifestyle described on page 14. (You can always use the camera's own menus to erase its memory card.)

4. "Eject" the camera by clicking the • button next to its name in the Source list.

Or, if the **\(\theta\)** button doesn't appear, just drag the camera's icon directly onto the Trash icon in the Source list. You're not actually throwing the camera away, of course, or even the photos on it—you're just saying, "Eject this." Even if the camera's still attached to your Mac, its icon disappears from the Source list.

Tip: Alternatively, you can Control-click or right-click the camera's icon and then choose Eject from the shortcut menu.

At last, your freshly imported photos appear in the main iPhoto window, awaiting your organizational talents.

5. Turn off the camera, and then unplug it from the USB cable.

You're ready to start having fun with your new pictures (page 26).

USB Card Readers

A USB *memory card reader* offers another convenient way to transfer photos into iPhoto. Most of these card readers, which look like tiny disk drives, are under \$20, and some can read more than one kind of memory card.

GEM IN THE ROUGH

The Memory Card's Back Door

When you connect most camera models to the Mac, the memory card shows up as a disk icon at the upper-right

corner of your desktop, as shown here.

You get the same effect when you insert a memory card into a card reader attached to your Mac.

In the disk window, you'll usually find several folders, each cryptically named by the camera's software. One contains your photos; another may contain movies.

In the iPhotos of years gone by, you could perform a sneaky trick with this icon.

By opening this "disk" icon, you could selectively delete or copy photos from the card. But since iPhoto '09 offers

that feature right within the program, there's no need to muck around with the desktop card icon.

Except in one situation.

Finding the folder that contains the memory card's photos is still the only way to copy photos *from* your hard drive *to* your camera. Just drag photos to the "disk" icon in the Finder, either from another Finder window or even right out of the iPhoto window.

If you have a reader, then instead of connecting the camera to the Mac, simply remove the camera's memory card and insert it into the reader (which you can leave permanently connected to the Mac). iPhoto recognizes the reader as though it's a camera and offers to import the photos, all of them or some of them, just as described on the previous pages.

This method offers several advantages over the camera-connection method. First, it eliminates the battery drain involved in pumping the photos straight off the camera. Second, it's less hassle to pull a memory card out of your camera and slip it into your card reader (which is always plugged in) than it is to constantly plug and unplug camera cables. Finally, this method lets you use almost *any* digital camera with iPhoto, even those too old to include a USB cable connector.

Tip: iPhoto doesn't recognize most camcorders, even though most models can take still pictures. Many camcorders store their stills on a memory card just as digital cameras do, so a memory card reader is exactly what you need to get those pictures into iPhoto.

Connecting with a USB card reader is almost identical to connecting a camera. Here's how:

1. Pop the memory card out of your camera, and then insert it into the reader.

Of course, the card reader should already be plugged into the Mac's USB jack.

As when you connect a camera, iPhoto displays the thumbnails of all the photos on the card, and you're offered a chance to type in an Event name and description.

2. Click Import All (or Import Selected).

iPhoto swings into action, copying the photos off the card. When you're asked how you want iPhoto to deal with the originals on the memory card, click either Delete Originals or Keep Originals.

3. Click the Eject button (**a**) next to the card's name in the Source list, and then remove the card from the reader.

Put the card back into the camera, so it's ready for more action.

Importing Photos from Really Old Cameras

If your camera doesn't have a USB connection *and* you don't have a memory card reader, you're still not out of luck.

First, copy the photos from your camera/memory card onto your hard drive (or other disk) using whatever software or hardware came with your camera. Then bring them into iPhoto as you would any other graphics files, as described next.

Tip: If your camera or memory card appears on the Mac desktop like any other removable disk, you can also drag its photo icons, folder icons, or even the "disk" icon itself directly into iPhoto.

Importing Existing Graphics Files

iPhoto is also delighted to help you organize digital photos—or any other kinds of graphics files—that are already on your computer, like in a folder somewhere.

Now, for years, Mac fans complained about the way iPhoto handled photos that were already on the hard drive: When you imported them into iPhoto, the program *duplicated* them. You wound up with one set inside iPhoto's proprietary library package (page 28) in *addition* to the original folder full of photos. Disk space got eaten up rather quickly as a result. This system also meant that iPhoto couldn't simultaneously track photos that resided on more than one hard drive.

But today's iPhoto can track, organize, edit, and process photos on your hard drive(s) right in place, *right in the folders that contain them*. The program doesn't have to copy them into the iPhoto library, doesn't have to double their disk-space consumption.

This is a blessing if you already have folders filled with photos. You can drag them directly into iPhoto's Source list (or the main viewing area). iPhoto acts like it's importing them, but doesn't really. Yet you can work with them exactly like the ones that iPhoto has actually socked away in its own library.

If you choose to go this route, here are a few tips and notes:

- Very ugly things will happen in iPhoto if you delete a photo "behind its back," in the Finder. When, in iPhoto, you try to open or edit one of the deleted photos, an error message will appear, offering you the chance to locate the photo manually. And if you can't find it, then the photo opens up as a huge, empty, gray rectangle filled with an exclamation point. (You kind of know what the program means.)
- On the other hand, iPhoto is pretty smart if you *rename* a photo in the Finder, or even drag it to a different folder.

Apple doesn't really want this feature publicized, hopes you won't try it, and won't say how iPhoto manages to track pictures that you move around even when the program isn't running.

But it works. Moved or renamed photos still appear in iPhoto, and you can still open, edit, and export them.

- If you delete a photo within iPhoto, you're not actually deleting it from your Mac. It's still sitting there in the Finder, in the folder where it's always been. You've just told iPhoto not to track that photo any more.
- Using this feature, you can use iPhoto to catalog and edit photos that reside on multiple hard drives—even *other computers on the network*. Just make sure those other disks are "mounted" (visible on your screen) before you attempt to work with them in iPhoto.
- On the other hand, iPhoto's new offline smarts don't make it a good choice for managing photos on CDs, DVDs, or other disks that aren't actually connected to, or inserted in, the Mac.

Internal or External?

Now, it's nice that iPhoto can track external photos without having to make its own private copies. But the old way had some advantages, too. When iPhoto copies photos into its own library, they're safer. For example, you can back up your iPhoto library, content in the knowledge that you've really backed up all your photos (instead of leaving some behind because they're not *actually* in the library).

Fortunately, how iPhoto behaves when you import graphics files is entirely up to you. It can *either* copy them into its own library *or* it can track photos in whatever Finder folders they're already in. You make this choice in the iPhoto—Preferences dialog box (Figure 1-5, top).

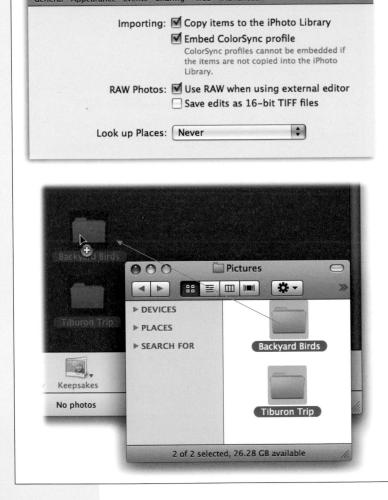

Advanced

Figure 1-5:

Top: In the Preferences dialog box, click the Advanced button. Here's where you specify whether or not you want iPhoto to duplicate imported photos from your hard drive so that it has its own library copy. (If you turn off this checkbox, iPhoto simply tracks the photos in their current Finder folders.)

Bottom: When you drop a folder into iPhoto, the program automatically scans all the folders inside it, looking for pictures to catalog. Depending on your settings in Preferences, it may create a new Event (Chapter 5) for each folder it finds. iPhoto ignores irrelevant files and stores only the pictures that are in a format it can read.

Dragging into iPhoto

No matter what choice you make in the Preferences dialog box, the easiest way to import photos from your hard drive is to drag them into the main iPhoto window. You can choose from two methods:

• Drag the files directly into the main iPhoto window, which automatically starts the import process. You can also drop an entire *folder* of images into iPhoto to import the contents of the whole folder, as shown at the bottom of Figure 1-5. You can even drag a bunch of folders at once.

Tip: Take the time to name your folders intelligently before dragging them into iPhoto, because the program retains their names. If you drag a folder directly into the main photo area, then you get a new Event named for the folder; if you drag the folder into the Source list on the left side of the screen, then you get a new *album* named for the folder. And if there are folders inside folders, then they too become new Events and albums. Details on all this reside in Chapter 2.

• Choose File→Import to Library (or press Shift-ૠ-I) in iPhoto and select a file or folder in the Open dialog box, shown in Figure 1-6.

These techniques also let you select and import files from other hard drives, CDs, DVDs, iPods, flash drives, or other disks on the network.

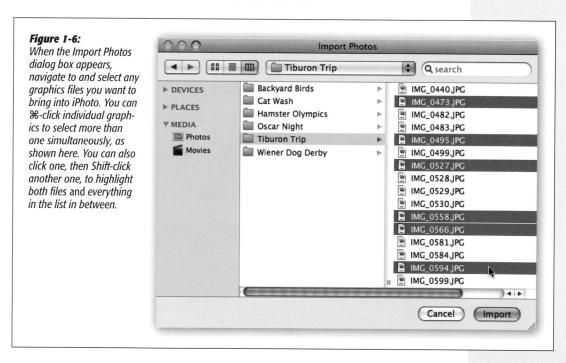

Side Doors into iPhoto

Don't look now, but Apple has been quietly creating new ways to get photos into iPhoto, directly from other programs on your Mac.

For example, if you use the Mail program of Mac OS X 10.5 (Leopard) and someone sends you a photo, you can pop it directly into iPhoto from within the email message. Just click the little Save button that appears above the body of the message. From the pop-up menu, choose Add to iPhoto.

In Mac OS X 10.5, you can begin a slideshow right from the Finder. Highlight some icons, and then just press the space bar to open the Quick Look preview.

Once the slideshow is under way, wiggle the mouse to produce the slideshow control bar. See that? Second button from the end: the Add to iPhoto button.

(The same toolbar, and the same button, appear anywhere else fine slideshows are found in Mac OS X, including Preview and Mail.)

GEM IN THE ROUGH

Saving Everyday Documents into iPhoto

Most people think of iPhoto as a photo-management program. But thanks to a sneaky new command that Apple has added to every program, iPhoto can now serve as a document management program.

Thanks to this command, iPhoto has become a convenient,

centralized, well-organized database of documents. You can keep drafts or final copies of all your work, ready to be searched, sorted, emailed, printed, cropped, even laid out and custom published as a hardcover book. (Are you listening, authors, lawyers, and real estate agents?)

The key to all this magic is the Save PDF to iPhoto command. It's sitting there even now, in almost every program on earth. So why haven't you seen it? Because it's hidden.

Start in the program where you've done the work: word processor, database, layout program, sheet-music program, Web design program, whatever. Choose File—Print. In the Print dialog box, click the PDF button. From the pop-up menu, choose Save PDF to iPhoto.

In a moment, a funny little dialog box appears, asking which iPhoto album you want this PDF document stored in. Choose an existing album or create a new one, and then click OK.

Now you arrive in iPhoto, where your newly hatched

PDF document is ready to inspect. Open it for editing just as you would any photo (Chapter 2). Now you can page through it using the Previous and Next controls; print or send it using the toolbar controls; edit it like a graphic; apply searchable keywords, description text, or ratings to it; and so on. The only limit is your imagination.

Both of those handy buttons deposit a copy of the photo directly into your iPhoto collection, even if iPhoto isn't open at the time.

The File Format Factor

iPhoto can't import digital pictures unless it understands their file formats, but that rarely poses a problem. Every digital camera on earth can save its photos as JPEG files—and iPhoto handles this format beautifully. (JPEG is the world's most popular file format for photos, because even though it's compressed to occupy a lot less disk space, the visual quality is still very high.)

Note: The terms JPEG, JFIF, JPEG JFIF, and JPEG 2000 all mean the same thing.

But iPhoto '09 imports and recognizes some very useful additional formats.

RAW

Most digital cameras work like this: When you squeeze the shutter button, the camera studies the data picked up by its sensors. The circuitry then makes decisions pertaining to sharpening level, contrast and saturation settings, color "temperature," white balance, and so on—and then saves the resulting processed image as a compressed JPEG file on your memory card.

For millions of people, the resulting picture quality is just fine, even terrific. But all that in-camera processing drives professional photographers nuts. They'd much rather preserve *every last iota* of original picture information, no matter how huge the resulting file on the memory card—and then process the file *by hand* once it's been safely transferred to the Mac, using a program like Photoshop.

That's the idea behind RAW, which is an option in many pricier digital cameras. (RAW stands for nothing in particular, and it's usually written in all capital letters like that just to denote how imposing and important serious photographers think it is.)

A RAW image isn't processed at all; it's a complete record of all the data passed along by the camera's sensors. As a result, each RAW photo takes up much more space on your memory card. For example, on a 6-megapixel camera, a JPEG photo is around 2 MB, but the same picture is over 8 MB when saved as a RAW file. Most cameras take longer to store RAW photos on the card, too.

But for image-manipulation nerds, the beauty of RAW files is that once you open them up on the Mac, you can perform astounding acts of editing on them. You can actually change the lighting of the scene—retroactively! And you don't lose a single speck of image quality along the way.

Until recently, most people used a program like Photoshop or Photoshop Elements to do this kind of editing. But amazingly enough, humble, cheap little iPhoto '09 can edit RAW files, too. For details on editing RAW images, see Chapter 5.

Getting Your Pictures into iPhoto

Note: Not every camera offers an option to save your files in RAW. And among those that do, not all are iPhoto compatible. Apple maintains a partial list of compatible cameras at http://support.apple.com/kb/HT1475. (Why are only some cameras compatible? Because RAW is a concept, not a file format. Each camera company stores its photo data in a different way, so in fact, there are dozens of different file formats in the RAW world. Programs like iPhoto must be upgraded periodically to accommodate new camera models' emerging flavors of RAW.)

Movies

In addition to still photos, today's digital cameras can also capture digital movies. These are no longer jittery, silent affairs the size of a Wheat Thin; modern cameras capture full-blown, 30-frames-per-second, fill-your-screen movies—even high-definition movies!

Movies eat up a memory card fast, but you can't beat the convenience, and the quality comes breathtakingly close to camcorder quality. (Recent camera models can even zoom and change focus while "filming," just like a camcorder.)

The first frame of each video clip shows up as though it's a photo in your library; only a little camera icon and the total running time let you know that it's a movie and not a photo. iPhoto is no iMovie, though; it can't even play these video clips. If you double-click

one, it actually opens up in QuickTime Player, a different program that's dedicated to playing

Figure 1-7:

digital movies.

See Chapter 10 for details on editing these movies, either in iMovie or in OuickTime Pro.

Fortunately, iPhoto can import and organize them. The program recognizes .mov files, .avi files, and many other movie formats. In fact, it can import any format that QuickTime Player (the program on your Mac that actually *plays* these movies) recognizes, which is a very long list indeed.

You don't have to do anything special to import movies; they get slurped in automatically. To play one of these movies once it's in iPhoto, see Figure 1-7.

Other graphics formats

Of course, iPhoto also lets you load pictures that have been saved in a number of other file formats, too—including a few unusual ones. Here's what it can handle:

• TIFF. Most digital cameras capture photos in a graphics file format called JPEG. Some cameras, though, offer you the chance to leave your photos *uncompressed* on the camera, in what's called TIFF format. These files are huge—in fact, you'll be lucky if you can fit one TIFF file on the memory card that came with the camera. Fortunately, they retain 100 percent of the picture's original quality.

Note, however, that the instant you *edit* a TIFF-format photo (Chapter 5), iPhoto converts it into JPEG.

That's fine if you plan to order prints or a photo book (Chapter 9) from iPhoto, since JPEG files are required for those purposes. But if you took that once-in-alifetime, priceless shot as a TIFF file, then don't do any editing in iPhoto—don't even rotate it—if you hope to maintain its perfect, pristine quality.

- GIF is the most common format used for non-photographic images on Web pages. The borders, backgrounds, and logos you typically encounter on Web sites are usually GIF files—as well as 98 percent of those blinking, flashing banner ads that drive you insane.
- PNG and FlashPix are also used in Web design, though not nearly as often as JPEG and GIF. They often display more complex graphic elements.
- BMP is a popular graphics file format in Windows.
- PICT was the original graphics file format of the Macintosh before Mac OS X. When you take a screenshot from Mac OS 9, paste a picture from the Clipboard, or copy an image from the Scrapbook, you're using a PICT file.
- Photoshop refers to Adobe Photoshop, the world's most popular image-editing
 and photo-retouching program. iPhoto can even recognize and import *layered*Photoshop files—those in which different image adjustments or graphic elements
 are stored in sandwiched-together layers.
- MacPaint is the ancient file format of Apple's very first graphics program from the mid-1980s. No, you probably won't be working with any MacPaint files in iPhoto, but isn't it nice to know that if one of these old, black-and-white, 8 × 10 pictures, generated on a vintage Mac SE, happens to slip through a wormhole in the fabric of time and land on your desk, you'll be ready?

Getting Your Pictures into iPhoto

- SGI and Targa are specialized graphics formats used on high-end Silicon Graphics workstations and Truevision video-editing systems.
- PDF files are Portable Document Format files that open up in Preview. They might be user's manuals, brochures, or Read Me files that you downloaded or received on a CD.

In version '09, iPhoto is a better PDF reader than ever. You can open a PDF document at full-screen size, page through it, even crop or edit it as though it were a photo. In fact, Mac OS X makes it extra easy to create PDFs and stash them in iPhoto all in one step, as described in the box on page 22.

If you try to import a file that iPhoto doesn't understand, you see the message shown in Figure 1-8.

The Post-Import Inspection

Once you've imported a batch of pictures into iPhoto, what's the first thing you want to do? If you're like most people, this is the first opportunity you have to see, at full-screen size, the masterpieces you and your camera created. After all, until this moment, the only sight you've had of your photos was on the little screen on the back of the camera.

In iPhoto '09, there's a great way to go about inspecting your pictures after you've imported them: the "double-click to magnify" feature.

Once you've imported some pictures, click the Last Import icon in the Source list. In the main iPhoto window, you're now treated to a soon-to-be-familiar display: a grid of thumbnails. In this case, they represent the pictures you just imported.

Double-click the first one. If all goes well, it now swells to fill the main part of the iPhoto window, as shown in Figure 1-9.

Note: If you don't see something like Figure 1-9, then it's likely that you or somebody else has changed the iPhoto preferences so that double-clicking a thumbnail does not magnify a photo for inspection. Choose iPhoto—Preferences, click General, and where it says "Double-clicking a photo," select "Magnifies photo." Close the Preferences window.

Figure 1-9:
As you walk
through your new
photos, you can
go backward or
forward,
rotate a photo,
delete a bad shot,
or add a star rating
to a picture.

There are many ways to add ratings, including by swiping across the dots in the Source list Information panel, or in the photo's own Info box (page 88).

After the shock of seeing the giant-sized version of your photo has worn off, press the → key on your keyboard to bring the second one into view. Press it again to continue walking through your imported photos, checking them out.

This is the perfect opportunity to throw away lousy shots, fix the rotation, and linger on certain photos for more study. You can even apply a rating with a keyboard shortcut; later, you can use these ratings to sort your pictures or create *smart albums*. See Chapters 2, 3, and 4 for full details on smart albums and ratings.

Here's the full list of things you can do as you walk through the magnified pictures:

- Click inside the photo to demagnify it. You return to the window full of thumbnails. (Double-click another one to magnify *it* and return to the inspection process.)
- Press the ← or→ keys on your keyboard to browse back and forth through your photos.
- Click the Rotate button to flip a photo, 90 degrees at a time. (Option-click to rotate the photo in the opposite direction.)

The Post-Import Inspection

• Give each photo a rating in stars, from 1 (terrible) to 5 (terrific). To do that, press **%**-1 through **%**-5 (or press **%**-0 to remove the rating). Chapter 4, which explains how to add name and place tags to pictures, also tells you how add star ratings when editing each photo's Info box (page 88).

Tip: You won't actually see the stars appear unless you open the Info panel at the lower-left corner of the window by clicking the tiny **1** button, or by clicking the **1** button on the photo itself.

- Press Delete on your keyboard to delete a photo.
- Click the Hide button to *hide* a photo. You return to the thumbnails view, the photo you were looking at fades away, and the remaining thumbnails slide over to close the gap.

Hiding a photo isn't the same as deleting it; the photo's out of your way, but it's still in your library, and you can always bring it back. More on hiding photos appears on page 50.

- Click the Flag button to *flag* a photo. Flagging means whatever you want it to mean. It could mean "This one's a winner," "Send this one to Uncle Morty," "Edit me," or whatever you decide. Page 77 has the details.
- Click Edit to open the editing mode described in Chapter 5, where you can take care of jobs like cropping, color-correcting, or adjusting the exposure of a picture.

The other buttons on the bottom-edge toolbar offer ways to share photos or add names to them, and you can customize the assortment here; see page 347.

When you're finished walking through your pictures, click anywhere on the photo to return to your thumbnails.

Where iPhoto Keeps Your Files

Having entrusted your vast collection of digital photos to iPhoto, you may find yourself wondering, "Where's iPhoto putting all those files, anyway?"

Most people slog through life, eyes to the road, without ever knowing the answer. After all, you can preview, open, edit, rotate, copy, export, and print all your photos right in iPhoto, without actually opening a folder or double-clicking a single JPEG file.

Even so, it's worthwhile to know where iPhoto keeps your pictures on the hard drive. Armed with this information, you can keep those valuable files backed up and avoid the chance of accidentally throwing them away six months from now when you're cleaning up your hard drive.

A Trip to the Library

As you now know, when you import pictures into iPhoto, the program generally makes *copies* of your photos, always leaving your original files untouched. (Of course, if you tell iPhoto to erase your camera's memory card after importing, then the originals aren't untouched—they're obliterated. But you get the point.)

The question is: Where do they all go?

iPhoto stores its copies of your pictures in a special folder called iPhoto Library, which you can find in your Home→Pictures folder. If the short name you use to log into Mac OS X is *mozart*, then the full path to your iPhoto Library folder from the main hard drive window would be Macintosh HD→Users→mozart→Pictures→iPhoto Library.

Tip: You should back up the iPhoto Library regularly—using the Burn command to save it onto a CD or DVD, for example. After all, it contains all the photos you import into iPhoto, which, essentially, is your entire photography collection. Chapter 13 offers much more on this file-management topic.

Now, if you're following along in the comfort of your own living room, you might be objecting to the description of the iPhoto Library. "Hey," you might be saying, "that's not a folder! In old versions of iPhoto, it *was* a folder. But I can't open this one to see what's inside. So it's *not* a folder."

OK, you're right—it's not an ordinary folder. It's a package.

In Mac OS X, *packages* or *bundles* are folders that behave like single files. For example, every properly written Mac OS X *program* looks like a single, double-clickable application icon. Yet to the Mac, it's actually a folder that contains both the actual application icon and all of its hidden support files. (Even *documents* can be packages, including iDVD project files, iMovie 6 files, and some TextEdit documents.)

As it turns out, iPhoto '09's library is a package, too. It may look like a single icon called iPhoto Library, sitting in your Home→Pictures folder. But it's actually a folder, and it's absolutely teeming with the individual JPEG files that represent your photos.

If you'd like to prove this to yourself, try this experiment. Choose Go→Home. Doubleclick the Pictures folder. See the iPhoto Library icon?

Control-click it or right-click it. From the shortcut menu, choose Show Package Contents. You're asking Mac OS X to show you what's inside the iPhoto Library.

The iPhoto Library package window opens.

What all those numbers mean

Within the iPhoto Library, you'll find a set of mysteriously numbered files and folders. At first glance, this setup may look bizarre, but there's a method to iPhoto's madness. It turns out that iPhoto meticulously arranges your photos within these numbered folders according to the *creation dates* of the originals, as explained in Figure 1-10.

Where iPhoto Keeps Your Files

Other folders in the iPhoto Library

In addition to the numbered folders, you'll find several other items nested in the iPhoto Library window, most of which you can ignore:

- AlbumData.xml. Here's where iPhoto stores access permissions for the various *photo albums* you've created within iPhoto. (Albums, which are like folders for organizing photos, are described in Chapter 2.) For example, it's where iPhoto keeps information on which albums are available for sharing across the network (or among accounts on a single machine). Details on sharing are in Chapter 8.
- Dir.data, iPhoto.db, Library.data, Library6.iPhoto. These are iPhoto's forinternal-use-only documents. They store information about your iPhoto Library, such as which keywords you've used, along with the image dimensions, file size, rating, and modification date for each photo.

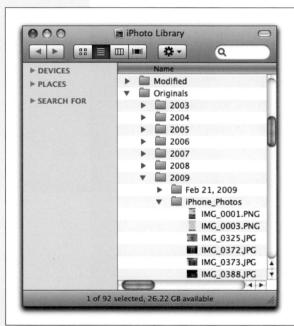

Figure 1-10:

Behold the mysteries of the iPhoto Library. Once you know the secret, this seemingly cryptic folder structure actually makes sense, with all the photos in the library organized by their creation dates.

FREQUENTLY ASKED QUESTION

Moving the iPhoto Library

Do I have to keep my iPhoto Library in my Pictures folder? What if I want it stored somewhere else?

No problemo! iPhoto has come a long way since the days when it had to keep its library in your Pictures folder.

Just quit iPhoto. Then move the *whole* iPhoto Library (currently in your Home—Pictures folder) to another location—even onto another hard drive.

Now open iPhoto again. It proclaims that it can't find your iPhoto Library. Click the Choose Library button to show the program where you put it. Done deal!

- Data. This folder contains index card-sized previews of your pictures—jumbo thumbnails, in effect—organized in the year/month/day structure shown in Figure 1-10.
- Originals. This folder is the real deal: It's the folder that stores your entire photo collection. Inside, you'll find nested folders organized in the year/month/day structure illustrated in Figure 1-10.

This folder is also the key to one of iPhoto's most remarkable features: the Revert to Original command.

Whenever it applies any potentially destructive operations to your photos—like cropping, red-eye removal, brightening, or black-and-white conversion—iPhoto *duplicates* the files and stuffs the edited copies in the Modified folder. The pristine, unedited versions remain safely in the Originals folder. If you later decide to scrap your changes to a photo using the Revert to Original command (page 143)—even months or years later—then iPhoto ditches the duplicate. What you see in iPhoto is the original version, preserved in its originally imported state.

• Modified. Here are the latest versions of your pictures, as edited. (Remember, behind the scenes, iPhoto actually duplicates a photo when you edit it.)

Look, but don't touch

While it's enlightening to wander through the iPhoto Library window to see how iPhoto keeps itself organized, *don't rename or move any of the folders or files in it.*

You should do all of your photo organizing within the iPhoto program, not behind its back in the library. Making changes in the Finder will confuse iPhoto to the point where it will either be unable to display some of your photos or it'll just crash.

And that, by the way, is precisely why the iPhoto Library is now a package (which takes some effort and knowledge to open) instead of a regular folder. Apple Tech Support evidently got one too many phone calls from clueless Mac users who'd opened the iPhoto Library manually and wound up deleting or damaging their photo collections.

The Digital Shoebox

Then you get right down to it, working in iPhoto takes place at three different zoom levels. You begin fully zoomed out, looking at *piles* of photos—your *Events* (called Spring Break, Robin's Graduation, and so on). Then you drill down into one of the piles; in the main Photos view, every picture appears as an individual thumbnail. Finally, you can zoom in even more, filling the screen with just one photo.

If you've imported photos into iPhoto, as described in the previous chapter, your journey out of chaos has begun. You're not really organized yet, but at least all your photos are in one place. From here, you can sort your photos, give them titles, group them into smaller subcollections (called *albums*), and tag them with keywords so you can find them quickly. This chapter helps you tackle each of those organizing tasks as painlessly as possible.

The Source List

Even before you start naming your photos, assigning them keywords, or organizing them into albums, iPhoto imposes an order of its own upon your digital shoebox.

The key to understanding it is the *Source list* at the left side of the iPhoto window. This list grows as you import more pictures and organize them—but right off the bat, you'll find icons like Library, Last 12 Months, and Last Import.

Library

The first four icons in the Source list are under a heading called Library. This is a very reassuring little heading, because no matter how confused you may get in working with subsets of photos later in your iPhoto life, clicking one of the first two Library

The Source List

icons (Events or Photos) returns you to your entire picture collection. It makes *all* of your photos appear in the viewing area. Clicking the Faces or Places icons (Chapter 4) shows the photos you've tagged based on who's in them or where they were taken.

Events

When you click Events in the Source list, each thumbnail represents one pile (or shoebox, or envelope) of pictures. (Figure 2-1 shows the effect.) Each pile is one *Event*, a clump of pictures that were all taken at about the same time—all on someone's birthday or wedding weekend, for example.

You can open up one of these "shoeboxes" by double-clicking, or you can flick through the thumbnails within an Event by passing your cursor slowly across its thumbnail, left to right. Details on Events begin on page 37.

Figure 2-1:
Top: Each Event is a clump of photos all taken at about the same time. Events are iPhoto '09's primary organizing structure, like it or not. (The Library heading doesn't even list your

photos by year

anymore.)

Bottom: You can also view your entire collection as Photos, meaning that every single photo has its own thumbnail in a huge scrolling list. They're still grouped by Event, though, as indicated by the collapsible headings.

Photos

Click Photos, on the other hand, to see *all* the photos' thumbnails displayed. Not just summary Event thumbnails, but one thumbnail per photo, all on a massive, scrolling display (Figure 2-1, bottom).

The Source List

You can still see which photos were taken at which Event, thanks to the headings that separate the batches.

Faces

If you've taken the time to introduce iPhoto to your friends and family, as described on page 89, click Faces to see everyone grouped into neat little albums on a virtual corkboard.

Places

iPhoto '09 can link your photos to specific places on a map. Click Places in the Source list to see your world in your own pictures. You do need to tag your photos in a special way to get them on the map, however; page 102 tells you how.

Recent

This new major heading in the Source list turns out to be very useful indeed. Since an iPhoto library can grow to 250,000 pictures, it's a smart assumption that very often, what you want to see most are the photos you've worked with *recently*. So the items in this list change over time, to reflect what you've been using lately. For example:

Figure 2-2:

Top: You can specify how far back the "Last ____ Months" album goes on the General panel of iPhoto Preferences (bottom).

Don't forget, by the way, that iPhoto isn't limited to grouping your pictures by year. It can also show you the photos you took on a certain day, in a certain week, or during a certain month. See page 80 for details.

Bottom: While you're in Preferences, don't miss the "Show item counts" option. It places a number in parentheses after each album name in the Source panel, representing how many pictures are inside.

The Source List

- [Most recent Event]. The first icon here identifies the Event you most recently opened in the Events list. It's a shortcut, provided for those times when the Event you want to work with this morning is the same one you were editing last night.
- Last 12 Months. The Last 12 Months icon puts the most recent photos at your fingertips. The idea, of course, is that the freshest photos are often the most interesting to you.

Actually, it doesn't even have to say "Last 12 Months." You can specify how *many* months' worth of photos appear in this heap—anywhere from one month to a year and a half—by choosing iPhoto—Preferences and going to the General panel (Figure 2-2).

• Last Import. Another group of photos you'll probably want to access quickly is whatever photos you just downloaded from your camera.

That's the purpose of this icon. With one click, iPhoto displays only your most recently downloaded photos, hiding all the others. This feature can save you a lot of time, especially as your library grows.

- Flagged. As noted on page 77, *flagging* a photo marks it for your attention later. You can flag all the good ones, or all the ones that need editing, or all the ones you want to round up to use in a custom-published book. Click this icon to see all the photos you've flagged, no matter what albums or Events they're in.
- Trash. Click this icon to see all the photos, albums, folders, books, and other items you've targeted for deletion. They're not really gone until you *empty* the Trash. See page 72 for details.

Shares

Under this heading, you'll see the names of all the other iPhoto libraries that people on your home or office network have *shared*, so that you can view them (or copy them) from the comfort of your own desk. See Chapter 8 for details on sharing. (If you don't see a Shares heading, then there aren't any other Macs on your network with iPhoto running and sharing.)

Later in this book, you'll find out how to dump photos onto CDs or DVDs—and then load them back into iPhoto whenever you darned well feel like it. CD icons and DVD icons show up under Shares, too.

FREQUENTLY ASKED QUESTION

Your Own Personal Sorting Order

I want to put my photos in my own order. I tried using View→Sort Photos→Manually, but the command is dimmed out! Did Apple accidentally forget to turn this on?

No, the command works—but only in an album, not in Events or Photos. If you create a new photo album (as explained later in this chapter) and fill it with photos, you can then drag them into any order you want.

Subscriptions

It's one of iPhoto's coolest features: Once somebody has published a set of photos on the Web (say, on a Flickr page, described in Chapter 8), you can *subscribe* to it. You wind up with a special kind of album, listed as a Subscription, that's automatically kept updated and synchronized with the online album as it changes. (Think grandparents and grandkids, and you'll see the possibilities.)

Albums

Later in this chapter, you'll find out how to create your own arbitrary subsets of pictures, called *albums*, and even how to stick a bunch of related albums into an enclosing entity called a *folder*.

Any folders and albums you've created are listed here.

MobileMe Gallery, Facebook, Flickr

Once you've published a set of photos as a Web-based picture gallery in MobileMe, Flickr, or even Facebook (Chapter 8), its icon appears here. Click it to remind yourself of what's in that gallery—and, if you've permitted your fans to upload photos of their own to MobileMe, to download *their* pictures into *your* copy of iPhoto.

Keepsakes

Under this heading, you'll find the icons for any of Apple's custom-publishing goodies that you've assembled: photo books, photo calendars, or photo greeting cards. Open the iPhoto window wide to see separate icons for Book, Calendar, and Cards. Chapter 9 has details.

Slideshows

Saved slideshows (Chapter 6) get their own icons in the Source list, too.

Tip: Saved slideshows and custom-publishing projects can be filed in folders, too, right alongside albums. (You might not expect that, since slideshows and projects begin life under separate headings in the Source list.)

As you go, though, remember this key point: Photos listed under the Library and Recent headings are the *real* photos. Delete a picture from one of these collections, and it's gone forever. (That's *not* true of albums, which store only aliases—phantom duplicates—of the real photos.)

All About Events

The primary photo-organizing concept in iPhoto '09 is the Event: a group of photos that were all taken at about the same time. It certainly makes a lot more sense than the *film roll*, the organizing construct of previous versions. A film roll consisted of all the photos you imported at once, no matter how many months apart you took them.

Note: If you upgraded to iPhoto '09 from an earlier version, then your old film rolls were automatically converted into Events.

iPhoto does this autosplitting whenever you bring new pictures in, *if* you've told it to do so. Here's how:

- When you import from a camera. At the moment of importing, turn on the "Autosplit events after importing" checkbox (shown in Figure 1-3 on page 14).
- When you import from your hard drive. Choose iPhoto→Preferences. Click Events. Turn on "Imported items from Finder."

(If you don't turn on these options, then all the pictures you import from the camera or the desktop in a single batch get clumped into a single Event, regardless of when they were taken.)

The Events List

When you click Events at the top of the Source list, you see an array of big, rounded thumbnails, as shown in Figure 2-1. They represent your Events. To save space, iPhoto shows only *one* picture from each Event; you can think of it as the top photo on the pile. Using that sample photo, along with the Event's name and date, you should be able to figure out which pile of photos each Event contains.

UP TO SPEED

Defining an Event

When you import photos, either from a camera or from the hard drive, you're given the opportunity to have them autosplit into Events. When the importing is over, you might wind up with two, five, or 10 "piles" of photos on the Events screen shown in Figure 2-1, depending on how long it's been since the last time you downloaded pictures.

Right out of the box, iPhoto defines an Event as one day. If you took pictures on June 1, 2, and 3, then you wind up with three Events.

You might consider that breakdown too rigid, though. It's not an especially logical grouping if, for example, you were away for a wedding weekend, a three-day trip to a theme park, or a weeklong cruise. In all of those cases, you'd probably consider all the photos from that trip to be one Event.

In other, less common situations, you might consider one day to be too long a window. If you're a school photographer

who conducts two shooting sessions a day—morning and afternoon, for example—you might want iPhoto to split up the incoming photos into smaller time chunks, like a new Event every four hours.

In any case, iPhoto can accommodate you. Choose iPhoto →Preferences. Click the Events button. From the "Autosplit into Events" pop-up menu, take your pick: "One event per day," "One event per week," "Two-hour gaps," or "Eight-hour gaps." (Those "gap" options are iPhoto's way of saying, "If more than that many hours have elapsed since the last batch you took, then I'll call it a new Event.")

Of course, it's extremely easy to split, merge, slice, and dice Events, move photos around between Events, and so on; details appear later in this chapter. But you may as well let iPhoto do the bulk of the grunt work the moment you import the pictures. **Tip:** You can make the Event thumbnails bigger or smaller. Drag the Size slider in the lower-right corner of the window.

The Events page is a zoomed-out, big-picture view of your entire photo collection. Thanks to that "piles" concept, a single screenful of thumbnails might represent thousands of individual photos.

Here's what you can do when you're looking at the Events thumbnails:

- Scan through a pile. Here's a tricky move that's relatively new to the Macintosh skill set: Move your cursor sideways across the face of an Event thumbnail without clicking. As you go, the photo on the face of the thumbnail changes, as all the pictures within flicker by. It's a good, quick way to get a look at the other pictures in the virtual heap.
- (If there are lots of photos in the Event, then every fraction of a millimeter of mouse movement triggers the appearance of the next photo, which makes it very hard to have much control. Making the thumbnails bigger may help. Remembering that this technique is just supposed to give you an *idea* of what's in the Event—that this isn't supposed to be a real slideshow—may also help.)
- Sort the Events. Ordinarily, iPhoto presents the Event thumbnails in chronological order; in effect, it chooses View—Sort Events—By Date for you. But you can also sort them alphabetically by choosing View—Sort Events—By Title. In either case, you can also reverse the sorting by choosing View—Sort Events—Descending (or Ascending).
- Rearrange the Event thumbnails. You can drag one thumbnail in between two others to rearrange them. When you do that, iPhoto chooses View—Sort Events—Manually for you, because your thumbnails are no longer sorted alphabetically or chronologically.
- Change the key photo. The *key* photo is the one on top of the pile, the one that represents the Event itself. As it turns out, iPhoto suggests one, but only at random. Usually, you'll want to rummage through the pictures and choose a better one to represent the whole batch. For a birthday party, for example, you might choose the candle-blowing-out shot to be the one on top of the pile.

To change the key photo, scan through the pile using the cursor as described above. When you see the picture you want to be the new key photo, tap the space bar. You can also Control-click (or right-click) the thumbnail—and from the shortcut menu, choose Make Key Photo. Not enough key-photo selection methods for you? Here's another one: Click the \odot icon that appears when you pass the mouse over an Event's lower-right corner. The tile spins around to reveal fields for location and other info (page 106) and offers the opportunity to pick a new key photo, too.

Note: You can designate a key photo while you're surveying the photos within an Event, too. See the Tip on page 40.

- Rename an Event. To rename an Event, just click its existing name and then type away. Press Return, or click somewhere else, when you're finished.
- Merge Events. You can combine two Events into one simply by dragging one Event thumbnail onto another. iPhoto instantly combines the two sets of photos. (The one you dragged vanishes; the combined pile assumes the name and key photo of the one you dragged *onto*.)
- Delete an Event. If you're quite sure you want to ditch an entire batch of pictures, then click its icon and then press **%**-Delete. (Or drag the Event thumbnail onto the Trash icon in the Source list.) Later, you can empty the Trash as described on page 72.

Note: There are other ways to merge, split, create, delete, rename, and move photos between Events—but you do all that in Photos view, described later in this chapter.

Opening an Event

And then there's the one thing you'll do most often on the Events page: *Open* an Event.

Open to Photos view

Ordinarily, double-clicking an Event thumbnail opens the Photos view (shown in Figure 2-1, bottom), where the main part of the iPhoto window is filled with the *individual* thumbnails of all the pictures in that Event. From here, you can search, sort, edit, and otherwise work with your photos.

You can always return to the Events screen, either by clicking Events in the Source list or by clicking the All Events arrow button at the top of the screen.

Tip: Once you've opened an Event into Photos view, you have another, even better chance to choose a key photo for it (the one that appears "on top of the pile" in Events view). Just click the photo thumbnail that you want to exalt to that special position, and then choose Events—Make Key Photo.

Open a photo directly

If you choose iPhoto→Preferences and click Events, you'll see that you have another option, which is kind of cool in its own way. Where it says, "Double-click Event," select "Magnifies photo."

Now double-clicking an Event thumbnail opens directly to whatever photo is visible on that thumbnail for closer inspection; click that enlarged photo again to return to the Event thumbnails. In other words, you can now work like this when you're looking for a certain picture:

1. Move your cursor slowly across the face of an Event thumbnail.

The photo miniatures flicker by.

2. When you see a photo that's worth a closer look, double-click.

It opens, in all its full-window magnificence.

3. When you're finished looking, click the photo.

It shrinks back to the original thumbnail size. You're right back on the Events page.

In other words, using this system, you can duck into the heap of photos represented by the Event, pull one out for a better look, and then toss it back into the pile and continue perusing. You've bypassed the intermediate step of looking at a page full of photo thumbnails.

This is a very handy way to work. But what if you *want* to get to the page full of photo thumbnails?

Whenever you've turned on the "Magnifies photo" setting, a new Show Photos button appears on any Event thumbnail when you point to it (Figure 2-3). Clicking that button opens the Event into a full window full of photo thumbnails.

Tip: If you point to the Show Photos button without clicking, the thumbnail itself changes to a miniature grid showing *nine* ultra-miniatures of the photos within. You can use that momentary display change to your advantage; even if you don't wind up clicking Show Photos, at least you now have a quick, albeit microscopic, overview of nine representative pictures inside.

Figure 2-3:

When you've told iPhoto that double-clicking an Events thumbnail opens a single photo, the Show Photos button appears on any thumbnail you point to (as shown in this super-magnified view).

Click it to open the Event in Photos view.

Photos View

When you click Photos in the Source list, or when you double-click an Event (or click the Show Photos button on an Event thumbnail), you arrive at the main iPhoto display. It's called, for want of a better term, Photos view.

Photos View

This is your lightbox, your slide sorter. Here, every photo has its own thumbnail. You can scroll through this list, looking over your pictures or marking them with keywords, ratings, and descriptions. Here's where you choose photos for inclusion in slideshows, prints, books, and calendars.

In short, this is the view where you'll be spending most of your organizational time.

Size Control

You can make the thumbnails in iPhoto grow or shrink using the Size Control slider (on the right side of the iPhoto window, just under the photo-viewing area). Drag the slider all the way to the left, and you get micro-thumbnails so small that you can fit hundreds of them in the iPhoto window. If you drag it all the way to the right, you end up with such large thumbnails that you can see only one picture at a time.

Tip: You don't have to drag the Size slider; just click anywhere along the slider to make it jump to a new setting. You can also scale all of the thumbnails to their minimum or maximum size by clicking the tiny icons at either end of the slider.

By the way, you might notice that this Size slider performs different functions, depending on which mode iPhoto is in. When you're editing a photo, it zooms in and out of an individual image; when you're designing a photo-book layout (Chapter 9), it magnifies or shrinks a single page.

Tip: You may want to adopt a conservative dragging approach when using the Size slider, since iPhoto may respond slowly in enlarging or shrinking the photos. Just drag in small movements so the program can keep pace with you.

Sorting Photos

iPhoto starts out sorting your photos chronologically, with the oldest photos at the top of the window. Your main iPhoto window may look like a broad, featureless expanse of pictures, but they're actually in a logical order.

Tip: If you'd prefer that the most recent items appear at the top of the iPhoto window instead of the bottom, then choose View—Sort Photos—Descending.

Using the View→Sort Photos submenu, you can make iPhoto sort all the thumbnails in the main window in a number of useful ways:

- By date. This sort order reflects the dates the photos were taken.
- By keyword. This option sorts your photos alphabetically by the *keywords* you've assigned to them (page 83).
- By title. This arrangement is alphabetical by the photos' *names*. (To name your photos, see page 43.)

- By rating. If you'd like your masterpieces at the top of the window, with the losers way down below, choose this option. (To rate your photos, see page 88.)
- Manually. If you choose this option, you can drag the thumbnails around freely within the window, placing them in any order that suits your fancy. To conserve your Advil supply, however, make no attempt to choose this option when you're viewing an *Event's* contents—do so only in an *album*. See the box on page 36 for details.

Renaming Photos

If you choose View→Titles, then every photo's name appears beneath its thumbnail. Which is just great, as long as you don't mind referring to your pictures as IMG_09231. JPG or DSC_0082.JPG.

On page 65, you can read about a way to rename a whole batch of photos at once (Yellowstone 1, Yellowstone 2, and so on).

But if you're inclined to rename each photo *individually*, you'll find that task a lot easier in iPhoto '09. In this version, you can rename just about anything by double-clicking its existing name and typing over it: Events, albums, slideshows, projects—and photos. See Figure 2-4.

Figure 2-4: Choose View→ Titles to see your photos' names. Double-click a thumbnail's name to open its nameediting box. Type a new name-and then press Tab to highlight the next photo's name. Type a new name for that one, and proceed through the whole batch. You never even have to lift your hands from the keyboard.

You can make a photo's title as long as you want, but it's smart to keep it short (about 10 characters or so). This way, you can see all or most of the title in the Title field (or under the thumbnails).

You can find yet another method for renaming photos on page 65. It's handy if you're plowing through an album sticking photos on the map with the Places feature.

Displaying Event Names

When you enter Photos view by opening an Event, you see *only* the photos associated with that Event. All the others are hidden.

If, however, you click Photos in the Source list, then you're seeing *all* your photos. And it would be nice to have some way to manage them all, especially when your collection heads up into the 250,000-pictures realm.

So here's a proposal: Choose View—Event Titles so that a checkmark appears. (Just make sure View—Event Titles is not set to Manually.) Now iPhoto sorts your photos by Event *and* adds a labeled, dated divider line above each one (Figure 2-5).

Tip: Better yet, use the keyboard shortcut Shift-**%**-F to hide or show the divider lines.

Figure 2-5: This tidy arrangement is the fastest way to use iPhoto. Display the photos grouped by Event, and then hide the photo batches you're not working with. Click the flippy triangle beside each header to expand or collapse the Event, just like a folder in the Finder's list view.

You'll probably find this arrangement so convenient that you'll leave it on permanently. As your collection grows, these groupings become excellent visual aids to help you locate a certain photo—even months or years after the fact.

Furthermore, as your library becomes increasingly massive, you can use these Event groupings to preserve your sanity. By collapsing the flippy triangles next to the groups you're *not* looking at right now (Figure 2-5), you speed up iPhoto considerably. Otherwise, iPhoto may grind almost to a halt as it tries to scroll through ever more photos. (About 250,000 pictures is its realistic limit for a single library on everyday Macs. Of course, you can always start new libraries, as described in Chapter 13.)

Collapsing Events En Masse

On a related note, here's one of the best tips in this entire chapter: *Option-click* an Event's flippy triangle to hide or show all of the Event's contents. When all your photos are visible, scrolling is slowish, but at least you can see everything. By contrast,

when all your Events are collapsed, you see nothing but their names, and scrolling is almost instantaneous.

Tip: Click anywhere on the Event divider line—on the Event's name, for example—to simultaneously select all the photos in that Event.

Creating Events Manually

Events are such a convenient way of organizing your pictures that Apple even lets you create Events manually, out of any pictures you choose.

This feature violates the sanctity of the original Event concept: that all the photos taken in a certain time period are one Event. Still, in this case, usefulness trumps concept—and that's a good thing.

You just select any bunch of pictures in your library (using any of the techniques described on page 48) and then choose Events→Create Event. iPhoto creates and highlights the new Event, like any normal Event. It then gives the newborn Event a generic name, "untitled event." You can always rename it, as described on page 47.

Tip: If you've *flagged* photos in your collection, as described on page 77, you can also choose Events—Create Event from Flagged Photos. That's a great way to round up pictures that currently sit in different Events—but nonetheless belong together.

Alternatively, you can gather up all those flagged photos and add them to an *existing* Event. To do that, click Events in the Source list. Click the desired Event's thumbnail, and then choose Events—Add Flagged Photos To Selected Event.

Splitting Events

Here's yet another way to create a new Event: Split off a bunch of photos from another one. You can either ask iPhoto to do that automatically, based on when the pictures were taken, or you can do it manually.

• The automatic way. Suppose you didn't turn on the "Autosplit events after importing" checkbox (page 38) when you imported some photos, and now you're having second thoughts. You wound up importing hundreds of pictures taken over the course of several weeks, and now you decide that it *would* be sort of handy if they were broken up by day or by week.

First, make sure you've told iPhoto what time period you want to serve as the cutoff point for Event groups (a day, a week, eight hours, or two hours; see the box on page 38).

Then click Events in the Source list. Highlight the Event or Events that you want to split, using any of the selection techniques on page 48. Finally, choose Events—Autosplit Selected Events.

iPhoto automatically breaks up the selected Events into more Events, as necessary, to put photos into the desired groupings.

Photos View

• The manual way. You can also chop an Event in two, subdividing it at any point that feels right. For example, iPhoto may have grouped 24 hours' worth of photos into a single Event, even though you actually got five hours' sleep in the middle and would prefer the subsequent photos to appear in their own Event. Figure 2-6 has the details.

Figure 2-6:

To split an existing Event in two, click Events in the Source list, and then open the Event you want to split. Scan through the photo thumbnails.

Top: Click the photo that marks the beginning of what you'd like to become the new, split-apart Event. Click the Split button on the toolbar.

Bottom: iPhoto creates a second Event out of the photo you clicked and all the ones after it. You can now name the new Event. Don't forget to specify its key photo as described on page 39.

Moving Photos Between Events

The fact that iPhoto offers to group photos into Events by time period is a handy starting point. But it's *only* a starting point. You can, and should, freely drag photos among your Events according to any logic that suits you.

▼ ALBUMS

■ Mary+Bobby
■ Tom or Zach
■ Zach
■ The Wienermobile

In Photos view, select the photo(s) you want to move (page 48). Then just drag them directly onto another Event's name or key photo. The deed is done.

Merging Events

You can *merge* Events in Photos view with one quick swipe—a great technique when your collections start to get enormous. Figure 2-7 shows the details.

Figure 2-7:
You can combine two
existing Events just
by dragging the key
photo of one Event on
top of another Event's
key photo, as shown
here. The Event you
moved disappears
entirely.

Renaming and Dating Events

As you know from Chapter 1, iPhoto gives you the opportunity to name each Event as it's created—that is, at the joyous moment when a new set of photos becomes one with your iPhoto library.

If you don't type anything into the Event Name box that appears at that time, though, iPhoto just labels each Event with a date. Fortunately, you can easily change any Event's name at any time. To rename an Event, double-click its existing name and then start typing.

Scrolling Through Your Photos

All right, you've gotten the hang of the Source list, Events, and the Photos view. Enough learning about iPhoto already—now it's time to start *using* it.

Browsing, selecting, and opening photos is straightforward. Here's everything you need to know:

• Use the vertical scroll bar to navigate through your thumbnails.

Pressing your Page Up and Page Down keys works, too. (They scroll one screenful at a time.) If your mouse has a scroll wheel on top (or a scroll pea, like Apple's Mighty Mouse), you can also use that to scroll.

Tip: iPhoto '09 can display a large, translucent "heads-up display" that shows, chronologically or alphabetically, where you are as you scroll. See page 73 to turn it on.

• Scrolling can take awhile if you have a full library, especially if you haven't collapsed the Events you're not using. But you can use this standard Mac OS X trick for faster navigation: Instead of dragging the scroll box or clicking the scroll bar arrows, *Option-click* the spot on the scroll bar that corresponds to the location you want in your library. If you want to jump to the bottom of the library, Option-click near the bottom of the scroll bar. To find photos in the middle of your collection, Option-click the middle portion of the scroll bar, and so on.

Note: By turning on "Jump to here" in the Appearance pane of your System Preferences, you can make this the standard behavior for all Mac OS X scroll bars—that is, you won't need the Option key.

- Press Home to jump to the very top of the photo collection, or End to leap to the bottom. (Hold down the Function key plus Home or End on some MacBooks.)
- You can't hide the Source list at the left side of the window. You can adjust its width, though. To do so, drag the thin, black divider bar (between the Source list and the main photo-viewing area) sideways. When your cursor's in the right place for dragging, it turns into a double-headed arrow.

Selecting Photos

To highlight a single picture in preparation for printing, opening, duplicating, or deleting, click its thumbnail once with the mouse.

That much may seem obvious. But many Mac novices have no idea how to manipulate *more* than one icon at a time—an essential survival skill.

To highlight multiple photo (or Event) thumbnails in preparation for deleting, moving, duplicating, printing, and so on, use one of these techniques:

• To select all the photos in the window. Select all the pictures in the set you're viewing by pressing \(\mathbb{H}\)-A. (That's the equivalent of the Edit→Select All command.)

Tip: In Photos view, you can select all the photos *in one Event* by clicking its name or its key photo.

• To select several photos by dragging. You can drag diagonally to highlight a group of nearby photos. You don't even have to enclose the thumbnails completely; your cursor can touch any part of any icon to highlight it. In fact, if you keep dragging past the edge of the window, iPhoto scrolls the window automatically.

Tip: If you include a particular thumbnail in your dragged group by mistake, **署**-click it to remove it from the selected cluster.

Selecting Photos

• To select consecutive photos. Click the first thumbnail you want to highlight, and then Shift-click the last one. All the files in between are automatically selected, along with the two photos you clicked (Figure 2-8, top). This trick mirrors the way Shift-clicking works in a word processor, the Finder, and many other kinds of programs.

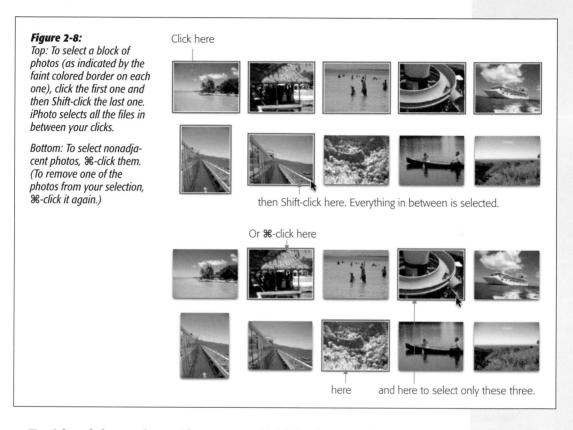

- To pick and choose photos. If you want to highlight, for example, only the first, third, and seventh photos in a window, start by clicking the first photo's thumbnail. Then \(\mathbb{H}\)-click each of the others. Each thumbnail sprouts a colored border to indicate that you've selected it (Figure 2-8, bottom).
- To deselect a photo. If you're highlighting a long string of photos and then click one by mistake, you don't have to start over. Instead, just **\mathbb{H}**-click it again, and the colored border disappears. (If you do want to start over from the beginning, then just deselect all the photos by clicking in any empty part of the window.)

The **\mathbb{H}**-click trick is especially handy if you want to select *almost* all the photos in a window. Press **\mathbb{H}**-A to select everything in the folder, and then **\mathbb{H}**-click any unwanted photos to deselect them. You'll save a lot of time and clicking.

Selecting Photos

Tip: You can also combine the **%**-clicking business with the Shift-clicking trick. For instance, you could click the first photo, then Shift-click the tenth, to highlight the first 10. Next, you could **%**-click photos 2, 5, and 9 to remove them from the selection.

Once you've highlighted multiple photos, you can manipulate them all at once. For example, you can drag them en masse out of the window and onto your desktop—a quick way to export them. (Actually, you may want to drag them into a *folder* in the Finder to avoid spraying their icons all over your desktop.) Or you can drag them into an album at the left side of the iPhoto window. Just drag any *one* of the highlighted photos; all the other highlighted thumbnails go along for the ride.

In addition, when multiple photos are selected, the commands in the File, Edit, Photos, and Share menus—including Duplicate, Print, Revert to Original, and Email—apply to all of them simultaneously.

Hiding Photos

For years, you've had only two choices when confronting a so-so photo in iPhoto: Keep it or delete it.

Keeping it isn't a satisfying solution, because it's not one of your best, but you're still stuck with it. You have to look at it every time you open iPhoto, you have to skip over it every time you're making a photo book or slideshow, and so on.

But deleting it isn't such a great solution, either. You just never know when you might need *exactly* that photo again, years later.

FREQUENTLY ASKED QUESTION

The Blurry-Photo Effect

Hey, what's the deal? When I double-click a photo to open it for editing, it appears momentarily in a coarse, lowresolution version. It takes a couple of seconds to fill the window so I can get to work. Do I need to send my copy of iPhoto in for servicing?

No, not exactly.

Today's digital photos are pretty big, especially if you've got one of those cameras that takes giant-sized photos (12 megapixels, for example).

Now, as it turns out, that's a lot more pixels than even the biggest computer screen has. So the Mac must not only "read" all the photo information off your hard drive, but

it also must then compute a scaled-down version that's exactly the size of your iPhoto window. Naturally, all this computation takes time.

Apple has tried to disguise this moment of computation by first displaying a full-sized but blurry, low-resolution photo, filling in the sharpened details a moment later. You can't begin editing until the full-window computation is complete. On the other hand, you do get to see, clearly enough, which photo you've opened. And if you've opened the wrong one, you don't have to wait any longer; you can click over to a different photo, having wasted no more time than necessary.

Hiding Photos

In iPhoto '09, you have a happy solution to this quandary: You can *hide* a photo. It's there behind the scenes, and you can always bring it back into view should the need arise. In the meantime, you can pare your *visible* collection down to the really good shots, without being burdened every day by the ghosts of your less impressive work.

To hide some photos, select them (page 48). Then take one of these steps:

- Press **%**-L, or choose Photos→Hide Photos.
- Click Hide on the toolbar at the bottom of the window.
- Control-click (or right-click) one of the selected photos; from the shortcut menu, choose Hide Photos.

The selected photos sprout little Xs in their upper-right corners—and then they vanish. Of course, they're still taking up disk space. But they no longer bog down iPhoto when you're scrolling, and they no longer depress you when they stare out at you every day.

But don't worry: iPhoto doesn't let you forget that they're there. Whenever you open an Event, the words "Show 7 hidden photos" (or whatever the number is) appear in the title bar. You can see it in Figure 2-9. (This notation also appears in Photos view if you've chosen to display Event headings, as described on page 44.)

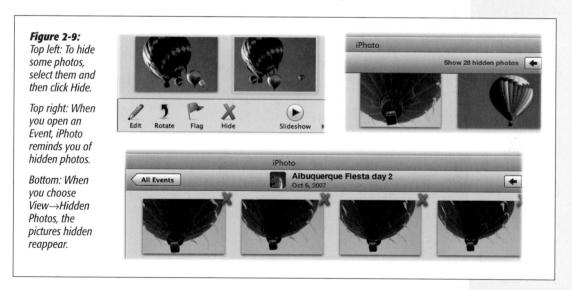

Seeing Hidden Photos

To bring all your hidden photos back into view for a moment, do one of these things:

- · Choose View→Hidden Photos.
- · Press Shift-\H-H.

• Click that "Show 7 hidden photos" phrase, if you see it (Figure 2-9, top right).

All the hidden photos now reappear, bearing those little Xs on their corners (Figure 2-9, bottom). This is your chance to reconsider—either to delete them for good, or to welcome them back into society.

Unhiding Photos

Just marking a photo as hidden doesn't mean you can't change your mind. At any time, you can unhide it, turning it back into a full-fledged photographic citizen.

To do that, first make your hidden photos visible, as described above. Then select the photo(s) you want to unhide, and repeat whatever step you took to hide it in the first place. For example:

- Press **%**-L, or choose Photos→Unhide Photos.
- Click Unhide on the toolbar at the bottom of the window.
- Control-click (or right-click) one of the selected photos; from the shortcut menu, choose Unhide Photo.

Three Ways to Open a Photo

iPhoto wouldn't be a terribly useful program if it let you view only postage-stamp versions of your photos (unless, of course, you like to take pictures of postage stamps). Fortunately, iPhoto offers three ways to view your pictures at something much closer to actual size.

You'll use these methods frequently when you start editing your photos, as described in Chapter 5. For the moment, though, it's useful to know about these techniques simply for the more common act of viewing the pictures at larger sizes.

Method 1: Right in the Window

The easiest way to open a photo is simply to double-click a thumbnail. Unless you've changed iPhoto's settings, the photo opens in the main iPhoto window, scaled to fit into the viewing area (Figure 2-10).

Tip: You can open up more than one photo simultaneously in the Edit window. Just highlight two or more photos, and then double-click any one of them (or click the Edit button). The upper limit ranges from six to 12 photos, depending on the size of your screen. (If you choose more than iPhoto is prepared to handle, it opens only *one* of the selected photos.)

This feature is a great way to compare similar shots to choose the best one.

Whenever you've opened a photo this way, the top of the window displays a parade of all the *other* photos' thumbnails. Feel free to switch to any other photo by clicking its little postage-stamp icon up there (or by clicking the big Previous/Next arrows at

the bottom of the window). In fact, you can **%**-click or Shift-click these thumbnails to display additional photos simultaneously, using the same techniques described on page 48.

Figure 2-10: This is the wav most people open pictures, at least at first. It's comforting to see landmarks like the Source list and toolbar. The downside is that those other screen elements limit the size of the enlarged photo; that's why you might want to consider one of the other photo-opening methods described later in the chapter.

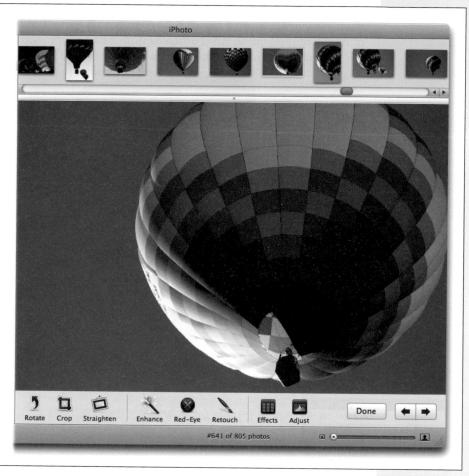

Or, if you'd rather hide the thumbnail browser to reclaim the space it's using, choose View→Thumbnails→Hide (Option-緩-T).

To return to your thumbnail-filled photo-organizing world, click Done (at the bottom-right corner of the screen). Or double-click the photo you're viewing; the picture itself is a much bigger target than the little Done button.

Method 2: Full-Screen Mode

Here's another way to take a gander at a photo. Sure, all of these options make the program more complicated, but you'll really like this new feature; it's often the most effective of all. In full-screen mode (Figure 2-11), a selected photo fills your *entire*

Three Ways to Open a Photo

monitor, edge to edge. No window frame, no Source list stacked with icons down the left side—just your big, glorious photo, blown up as big as it can go.

This mode is much more interesting when you're *editing* photos, which is why it's described and illustrated at greater length in Chapter 7.

Tip: You can also open several photos in full-screen mode simultaneously. If you highlight several thumbnails before entering full-screen mode, then iPhoto displays them side by side.

Figure 2-11: There's no more option to open a photo into a floating window of its own, as in previous iPhoto versions. Using the shortcut menu (lower right), however, you can jump directly to full-screen view, which is pretty wonderful.

Once again, you can either tell iPhoto you always want your photos to open this way, or you can invoke full-screen mode manually:

- Go to iPhoto—Preferences. On the General pane, from the "Edit photo" pop-up menu, choose "Using full screen." (Then close Preferences.) Now double-clicking a photo opens it into full-screen mode.
- To open a photo this way only once, Control-click or right-click it. From the shortcut menu, choose "Edit using full screen" (Figure 2-11).

Or, if you're in a real hurry, just click the little Full Screen icon (►) beneath the Source list.

To exit full-screen mode, double-click anywhere on the photo, or click the Close Full Screen icon (♠), or tap the Esc key on your keyboard.

Method 3: In Another Program

The iPhoto Preferences box knows there's other software out there, big, burly photo-editing programs like Adobe Photoshop or Apple's Aperture. By choosing Preferences General —Edit Photo —In Application and picking another program installed on the Mac, you tell iPhoto that you'd rather use different software for manipulating the finer points of your photos. Chapter 5 has more information.

Albums

In the olden days of film cameras and drugstore prints, most people kept their pictures in the paper envelopes they were in when they came from the drugstore. You might have put a photo in an album or mailed it to somebody—but then the photo was no longer in the envelope and couldn't be used for anything else.

But you're digital now, baby. You can use a single photo in a million different ways, without ever removing it from its original "envelope" (that is, Event).

In iPhoto terminology, an *album* is a subset of your pictures—drawn from a single Event or many different ones—that you group together for easy access and viewing. Represented by a little album-book icon in the Source list at the left side of the screen, an album can consist of any photos that you select. It can even be a *smart album* that iPhoto assembles automatically by matching certain criteria that you set up—all pictures that you took in 2008, for example, or all photos that you've rated four stars or higher.

While your iPhoto library as a whole might contain thousands of photos from a hodgepodge of unrelated family events, trips, and time periods, a photo album has a focus: Steve & Sarah's Wedding, Herb's Knee Surgery, and so on.

As you probably know, mounting snapshots in a *real* photo album is a pain—that's why so many people still have stacks of Kodak prints stuffed in envelopes and shoeboxes. But with iPhoto, you don't need mounting corners, double-sided tape, or scissors to create an album. In the digital world, there's no excuse for leaving your photos in hopeless disarray.

Of course, you're not *required* to group your digital photos in albums with iPhoto, but consider the advantages of doing so:

- You can find specific photos faster. By opening only the relevant album, you can avoid scrolling through thousands of thumbnails in the library to find a picture you want—a factor that takes on added importance as your collection expands.
- Only in a photo album can you drag your photos into a different order. To change the order of photos displayed in a slideshow or iPhoto hardbound book, for example, you need to start with a photo album (see Chapters 6 and 9).

Creating an Empty Album

Here are a few ways to create a new, empty photo album:

- Choose File→New Album.
- · Press #-N.
- Control-click (or right-click) in a blank area of the Source list, and then choose New Album from the shortcut menu.
- Click the + button below the Source list.

In each case, a dialog box appears, prompting you to name the new album. Type in a descriptive name (Summer in Aruba, Yellowstone 2009, Edna in Paris, or whatever), click OK, and watch as a new photo album icon appears in the Source list. (Several are on display in Figure 2-12.)

Now you can add photos to your newly spawned album by dragging in thumbnails from your library, also as shown in Figure 2-12. There's no limit to the number of albums you can add, so make as many as you need to satisfactorily organize all the photos in your library.

always added to the

Figure 2-12:

bottom of the list, but vou can change the order in which they appear by simply dragging them up or down. When you draa multiple photos into an album, a little red numeric badge appears next to the pointer, telling you exactly how many items vou've got selected. In this example, five pictures are being dragged en masse into a photo album.

Creating an Album by Dragging

Creating a new, empty album isn't always the best way to start. It's often easier to create an album and fill it with pictures in one fell swoop.

For example, you can drag a thumbnail (or a batch of them) from the Photos area directly into an empty portion of the Source list. In a flash—well, in about 2 seconds iPhoto creates a new album for you, named "untitled album." The photos you dragged are automatically dumped inside.

Similarly, you can drag a bunch of graphics files from the *Finder* (the desktop behind iPhoto) directly into the Source list. In one step, iPhoto imports the photos, creates a new photo album, names it after the folder you dragged in, and puts the newly imported photos into that album.

Tip: In the same way, you can drag photos directly from the Finder onto an *existing* album icon in the Source list, forcing iPhoto to file them there in the process of importing.

Creating an Album by Selecting

Here's a handy, quick album-creation command: File→New Album From Selection. Scroll through your library and select any pictures you like, using the methods described on page 48. (They don't have to be from the same Event, or even the same year.) When you're done, choose New Album From Selection, type a name for the new album, and then click OK.

Tip: To rename an existing photo album, double-click its name or icon in the Source list. A renaming rectangle appears around the album's name, with text highlighted and ready to be edited.

Adding More Photos

To add photos to an existing album, just drag them onto its icon. Figure 2-12 illustrates how you can select multiple photos and drop them into an album in one batch.

The single most important point about adding photos to an album is this: Putting photos in an album doesn't really *move* or *copy* them. It makes no difference where the thumbnails start out—whether it's the library or another album. You're just creating *references*, or pointers, back to the photos in your master photo library.

This feature works a lot like Macintosh aliases; in fact, behind the scenes, iPhoto actually creates aliases of the photos you're dragging. (It stashes them in the appropriate album folders within the iPhoto library.)

What this means is that you don't have to commit a picture to just one album when organizing. One photo can appear in as many different albums as you want. So, if you've got a killer shot of Grandma surfing in Hawaii and you can't decide whether to drop the photo into the Hawaiian Vacation album or the Grandma & Grandpa album, the answer is easy: Put it in both. iPhoto just creates two references to the same original photo in your library.

Viewing an Album

To view the contents of an album, click its name or icon in the Source list. All the photos included in the selected album appear in the photo-viewing area, while the ones in your library are hidden.

You can even browse more than one album at a time by highlighting their icons simultaneously:

- To view the contents of several adjacent albums in the list, click the first one, then Shift-click the last.
- To view the contents of albums that aren't consecutive in the list, ℜ-click each of them.

Tip: Viewing multiple albums at once can be extremely useful when it's time to share your photos. For example, you can make prints or burn an iPhoto CD archive (as explained in Chapters 7 and 13) containing the contents of multiple albums at the same time.

Remember, adding photos to albums doesn't remove them from the original Events where they started out. So if you lose track of which album contains a particular photo, just click the Events icon in the Source list to return to the overview of your *entire* photo collection.

Tip: You can put your albums into any order. Just drag them up or down in the Source list.

Moving Photos Between Albums

There are two ways to transfer photos from one album to another:

- To *move* a photo between albums, select it and then choose Edit→Cut (or press **%**-X), removing the photo from the album. Click the destination photo album's name or icon, and then choose Edit→Paste (or press **%**-V). The photo is now a part of the second album.
- To *copy* a photo into another album, drag it onto the icon of the destination album in the Source list. That photo is now a part of both albums.

Removing Photos from an Album

If you change your mind about the way you've organized your photos and want to remove a photo from an album, then open the album and select the photo. (Caution: Be sure that you're viewing the contents of a blue photo *album* and not the main Library, the Last 12 Months collection, or the Last Import collection. Deleting a photo from those sources really does move it to the Trash.)

Now do one of the following:

- Choose Edit \rightarrow Cut (or press **%**-X).
- Drag the photo's thumbnail onto the little Trash icon.
- Press the Delete key.
- Press the Del (forward delete) key.
- Control-click (or right-click) the photo, and then, from the shortcut menu, choose Cut.

The thumbnail disappears from the album, but of course it's not really gone from iPhoto. Remember, it's still in your library.

Duplicating a Photo

You can't drag the same photo into an album twice. When you try, the thumbnail simply leaps stubbornly back into its original location, as though to say, "Nyah, nyah, you can't drag the same photo into an album twice."

It's often useful to have two copies of a picture, though. As you'll discover in Chapter 7, a photo whose dimensions are appropriate for a slideshow or photo book (that is, a 4:3 proportion) is inappropriate for ordering prints $(4 \times 6, 8 \times 10, \text{ or whatever})$. To use the same photo for both purposes, you really need to crop two copies independently.

In this case, the old adding-to-album trick isn't going to help you. This time, you truly must duplicate the file, consuming more hard drive space behind the scenes. To do this, highlight the photo, and then choose Photos→Duplicate (ℜ-D). iPhoto switches briefly into Import mode, copies the file, and then returns to your previous mode. The copy appears next to the original, bearing the same name plus the word "copy."

Note: If you duplicate a photo in an album, you'll see the duplicate both there and in the library, but not in any other albums. If you duplicate it only in the library, that's the only place you'll see the duplicate.

Putting Photos in Order

If you plan to turn your photo album into an onscreen slideshow, a series of Web pages, or a printed book, then you'll have to tinker with the order of the pictures, arranging them in the most logical and compelling sequence. Sure, photos in an Event

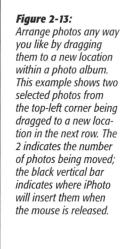

Albums

or a smart album (page 61) are locked into a strict sort order—either by creation date, rating, or name—but once they're dragged into a photo album, you can shuffle them manually into a new sequence.

To custom-sort photos in an album, just drag and drop, as shown in Figure 2-13.

Duplicating an Album

It stands to reason that if you have several favorite photos, you might want to use them in more than one iPhoto presentation (in a slideshow and a book, for example). That's why it's often convenient to *duplicate* an album, so that you can create two different sequences for the photos inside.

Just highlight an album, and then choose Photos→Duplicate. iPhoto does the duplicating in a flash—after all, it's just duplicating a bunch of tiny aliases. Now you're free to rearrange the order of the photos inside, to add or delete photos, and so on, independently of the original album.

Tip: For quick duplicating, you can also Control-click (or right-click) an album in the list and choose Duplicate from the shortcut menu. Duplicating an album creates an identical album, which you can then edit as described on the preceding pages.

Merging Albums

Suppose you have three photo albums that contain photos from different trips to the beach, called Spring Break at the Beach, Summer Beach Party, and October Coast Trip. You'd like to merge them into a single album called Beach Trips 2008. No problem.

Select all three albums in the Source list (**%**-click each, for example); the photos from each appear in the photo-viewing area. Now create a new, fourth album, using any of the usual methods. Finally, select all of the visible thumbnails, and then drag them into the new album.

You now have one big album containing the photos from all three of the original albums. You can delete the three source albums, if you like, or keep all four around. Remember, albums contain only references to your photos—not the photos themselves—so you're not wasting space by keeping the extra albums. The only penalty you pay is that you have a longer list of albums to scroll through.

Deleting an Album

To delete an album, select its icon in the Source list, and then press the Delete key. You can also Control-click (right-click) an album and then choose Delete Album from the shortcut menu. iPhoto asks you to confirm your intention.

Deleting an album doesn't delete any photos—just the references to those photos. Again, even if you delete *all* your photo albums, your library remains intact.

Smart Albums

Albums, as you now know, are a primary organizational tool in iPhoto. Since the dawn of iPhoto, you've had to create them yourself, one at a time—by clicking the + button beneath the Source list, for example, and then filling up the album by dragging photo thumbnails.

iPhoto, though, can now fill up albums *for* you, thanks to *smart albums*. These are self-updating folders that always display pictures according to certain criteria that you set up—all pictures with "Aunt Edna" in the comments, for example, or all the photos that you've rated four stars or higher. (If you've ever used smart playlists in iTunes, you'll recognize the idea immediately.)

To create a smart album, choose File→New Smart Album (Option-ૠ-N), or Option-click the + button below the Source list. Either way, the Smart Album sheet slides down from the top of the window (Figure 2-14).

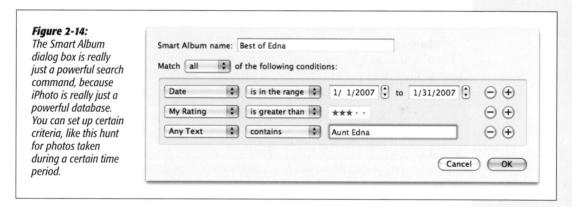

The controls here are designed to set up a search of your photo library. Figure 2-14 illustrates how to find pictures that you took in the first month of 2008—but only those that have four- or five-star ratings and mention your Aunt Edna in the title or comments.

Click the button to add a new criterion row and be even more specific about which photos you want iPhoto to include in the smart album. Use the first pop-up menu to choose a type of photo feature (keyword or date, for example) and the second pop-up menu to tell iPhoto whether you want to match it ("is"), eliminate it ("is not"), and so on. The third part of the criterion row is another pop-up menu or a search field where you finally tell iPhoto what to look for.

- You can limit the smart album's reach by limiting it to a certain Album. Or, by choosing "is not" from the second pop-up menu, you can *eliminate* an album from consideration. All your albums are listed in the third pop-up menu.
- Any Text searches your library for words or letters that appear in the title, comments, or keywords that you've assigned to your photos.

Tip: If you can't remember how you spelled a word or whether you put it in the Description or Title field, choose "Any Text," choose "contains" from the second pop-up menu, and in the search field type just the first few letters of the word ("am" for Amsterdam, for example). You're bound to find some windmills now!

- Description, Filename, Keyword, and Title work the same way, except that they search *only* that part of the photo's information. Search for "Keyword" is "Family" (choose "Family" from the third pop-up menu), for example, to find only those pictures to which you specifically assigned the keyword Family, and not just any old photos where you've typed the word *family* somewhere in the comments.
- Event lets you make iPhoto look only in, for example, the last five Events (choose "is in the last" from the second pop-up menu and type 5 in the box). Or, if you're creating an album of old shots, you can eliminate the latest few Events from consideration by choosing "is not in the last."
- Photo lets you include (or exclude) photos according to whether they're hidden, flagged, or edited. Its pop-up menu also lets you pinpoint RAW photos or digital movies. These are fantastically useful options; everyone should have a smart album just for movies, at the very least.
- Date was once one of iPhoto's most powerful search criteria. By choosing "is in the range" from the second pop-up menu, you can use it to create an album containing, for example, only the pictures you took on December 24 and 25 of last year, or for that five-day stretch two summers ago when your best friends were in town. In iPhoto '09, the calendar serves this function much more conveniently.
- The My Rating option on the first pop-up menu really puts the fun into smart albums. Let's suppose you've been dutifully giving your pictures star ratings from 1 to 5, as described on page 88. It's payoff time! You can now use this smart album feature to collect, say, only those with five stars to create a quick slideshow of just the highlights. Another option is to choose "is greater than" two stars for a more inclusive slideshow that leaves out only the real duds.
- If you've tagged photos in Faces or Places (Chapter 4), then Face and Place let you make smart albums based on who's in the photos or where they were taken.
- Aperture, Camera Model, Flash, Focal Length, ISO, and Shutter Speed are behindthe-scenes data bits that your camera automatically records with each shot, even embedding the information inside the resulting photo file. Thanks to these options, you can use a smart album to round up all your flash photos, all photos taken with an ISO (light sensitivity) setting of 800 or higher, all pictures with a certain shutter speed, all the ones you shot with your Canon ELPH, and so on. (If you choose Camera Model from the first pop-up menu, the third pop-up menu conveniently lists every camera you've ever used to take photos.)
- Click the button next to a criterion to take it out of the running. For example, if you decide that date shouldn't be a factor, delete any criterion row that tells iPhoto to look for certain dates.

When you click OK, your smart album is ready to show off. When you click its name in the Source list (it has a little * icon), the main window displays the thumbnails of the photos that match your criteria. The best part is that iPhoto keeps this album updated whenever your collection changes—as you change your ratings, take new photos, and so on.

Tip: To change or review the parameters for a smart album, click its icon in the Source list and then choose File→Edit Smart album or press **第**-I. The Smart Album sheet reappears.

Folders

Obviously, Apple hit a home run when it invented the album concept. Let's face it: If there were a Billboard Top Software-Features Hits chart, the iPhoto albums feature would have been number one for months on end.

Albums may have become *too* popular, however. It wasn't long before iPhoto fans discovered that their long list of albums had outgrown the height of the Source list. As a result, people grew desperate for some way to organize albums *within* albums.

Apple's response consisted of one word: folders.

If you choose File—New Folder, iPhoto promptly creates a new, folder-shaped icon in the Source list called "untitled folder." (Type a name for it, and then press Return.) Its sole purpose in life is to contain *other* Source list icons—albums, smart albums, saved slideshows, book layouts, and so on.

What's really nice about folders is that they can contain *other* folders. That is, iPhoto is capable of more than a two-level hierarchy; you can actually create folders within folders within folders, as shown in Figure 2-15.

Figure 2-15:

A folder is a convenient container for other kinds of Source list icons. Once you've created a folder, you can drag related albums, saved slideshows, and other icons into it, grouped any way you like. Thereafter, you can make your Source list tidier by collapsing the folder, thereby hiding its contents. Just click the flippy triangle to its left.

Folders

Otherwise, folders work exactly like albums. You rename them the same way, drag them up and down the Source list the same way, delete them the same way, and duplicate them the same way.

Clearly, the people have spoken.

Tip: If you've put something into a folder by accident, no problem. You can easily drag it back out again. Just drag it upward directly onto the Albums heading in the Source list, and then release the mouse.

The Info Panel

Just below the Source list, you'll find three tiny buttons. The second one, the blue **1** button, hides or shows the *Information panel*, which shows you general data about a photo, album, Event, or whatever else you've selected. (There's also an Information box on the "back" of an Event or photo that you can edit; click the **6** icon on the thumbnail to get there. Page 104 has more about editing map locations.)

When the Information panel is visible, you may see any number of different displays (Figure 2-16):

- When a single photo is selected, iPhoto displays that picture's name, rating, creation time and date, dimensions (in pixels), file size, and any comments you've typed.
- When multiple photos are selected, you see the *range* of their creation dates, plus how many photos are selected and how much disk space they occupy.

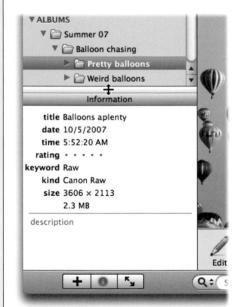

Figure 2-16:

As shown here by the arrows, you can adjust the size of the Information panel either horizontally or vertically, just by dragging the gray "metallic" divider bars.

• When no photos are selected, the Info area displays information about whatever *container* is selected in the Source list—the current album or Event, for example. You get to see the name of the container, the range of dates of its photos, the number of photos, and their total file size on the hard drive.

Tip: When you click Events or Photos at the very top of the Source list, the date-range statistic is pretty cool. It amounts to a stopwatch measuring the span of your interest in digital photography (in the iPhoto era, anyway).

Similarly, the file size info can be extremely useful when creating backups, copying photos to another disk, or burning CDs. One glance at the Info panel—with no photos selected—tells you exactly how much disk space you'll need to fit the current album, folder, or Event.

 When a book, calendar, or card icon is selected (Chapter 9), you get to see its name, theme, dimensions, number of photos, and number of pages, plus any comments you added.

Titles (Renaming Photos)

Just about everything in iPhoto has its own title: every photo, album, folder, Event, photo book, slideshow, and so on. You can rename most of them very easily—just by double-clicking the existing name.

In early versions of iPhoto, though, the only way to edit a photo's name was in the "title" box in the Information panel, shown in Figure 2-16.

Tip: A great keystroke makes life a lot easier when naming a whole bunch of photos in a row (like a batch you've just imported). Edit the title box for the first photo, and then press 第-] (right bracket) to select the next one. Each time you press 第-], iPhoto not only highlights the next picture, but also highlights all the text in its title box so you don't need to click anything before typing a new name for it. (Pressing 第-[takes you back one photo, of course.)

This simple keystroke is your ticket to quickly naming a multitude of unique photos, without ever taking your hands off the keyboard. Page 98 has a similar tip for editing the "backs" of the photos.

Changing Titles, Dates, or Comments En Masse

The trouble with naming photos is that hardly anybody takes the time. Yes, the keystroke described in the Tip above certainly makes it easier to assign every photo its own name with reasonable speed—but are you really going to sit there and make up individual names for 25,000 photos?

Mercifully, iPhoto lets you change the names of your photos all at once, thanks to a "batch processing" command. No, each photo won't have a unique, descriptive name, but at least they can have titles like *Spring Vacation 2* and *Spring Vacation 3* instead of *IMG*_1345 and *IMG*_1346.

To use it, choose Photos→Batch Change, or press Shift-**第**-B, or Control-click (right-click) some selected photos, and then choose Batch Change from the shortcut menu.

The Info Panel

The Batch Change sheet drops down from the top of the window (see Figure 2-17). Make sure that the first pop-up menu says Title.

Tip: Don't be fooled by the command name Batch Change. iPhoto still can't edit a batch of photos. You can't, for example, scale them all down to 640 × 480 pixels, or apply the Enhance filter to all of them at once.

Figure 2-17:

iPhoto's batch-processing feature lets you specify titles, dates, and description for any number of photos you select.

Top: When you assign a date and time to a batch of pictures, turn on "Add 1 Minute between each photo" to give each a unique time stamp, which could come in handy later when you're sorting them. Besides, you didn't take them all at the exact same moment, did you? (iPhoto changes only its internal time stamps. It doesn't actually modify the photo files on your hard drive unless you also turn on "Modify original files."

Bottom: When you title a batch of pictures, turn on "Append a number to each photo" to number them in sequence as well.

Your options, in the second Batch Change pop-up menu, are as follows:

- Empty. Set the titles to Empty if you want to unname the selected photos, so they're all blank. You might appreciate this option when, for example, you're working on a photo book (Chapter 9) and you've opted for titles to appear with each photo, but you really want only a few pictures to appear with names under them.
- Text. This option produces an empty text box into which you can type, for example, *Ski Trip.* When you click OK, iPhoto names all of the selected pictures to match.
 - If you turn on "Append a number to each photo," then iPhoto adds digits after whatever base name you choose—for example, *Ski Trip 1*, *Ski Trip 2*, and so on.
- Event Name. Choose this command to name all the selected photos after the Event's name—"Grand Canyon 2008," for example. iPhoto automatically adds the photo number after this base name.

- Filename. If you've been fooling around with naming your photos and now decide that you want their original, camera-blessed file names to return (IMG_1345 and so on), then use this command.
- Date/Time. Here's another approach: Name each photo for the exact time it was taken. The dialog box gives you a wide variety of formatting options: long date, short date, time of day, and so on.

Tip: Once you've gone to the trouble of naming your photos, remember that you can make these names appear right beneath the thumbnails for convenient reference. Choose View—Titles to make it so.

Photo Dates

When you select a single photo, you can actually *change* its creation date by editing the Info pane's Date field. For example, you can switch the date from the day the digital file was created to the day the photo was actually taken.

In fact, you can also use the Batch Change command to rewrite history, resetting the dates of a group of photos all at once, as shown in Figure 2-17.

(We trust you won't use this feature for nefarious ends, such as "proving" to the jury that you were actually in Disney World on the day of the office robbery.)

Note: Actually, if you just want to fix the date and time stamps on some photos, the new Photos—Adjust Date & Time command is more direct. It opens the "Adjust date and time of selected photos" dialog box, where you can choose a new date and time of the *first* selected photo. Any other selected photos are adjusted, too, by proportional amounts. For example, if you change the first photo's time stamp to make it 10 minutes later, then all other selected photos are shifted by 10 minutes.

Description

Sometimes you need more than a one- or two-word title to describe the contents of a photo, album, folder, book, slideshow, or Event. If you want to add a lengthier description, you can type it in the Description field in the Photo Info pane, as shown in Figure 2-18.

Even if you don't write full-blown captions for your pictures, you can use the Description field to store little details such as the names, places, dates, and events associated with your photos.

The best thing about adding comments is that they're searchable. After you've entered all this free-form data, you can use it to quickly locate a photo using iPhoto's Search command.

Tip: If you speak a non-English language, iPhoto makes your life easier. As you're typing comments, you can choose Edit \rightarrow Special Characters. Mac OS X's Character Palette opens, where you can add international letters like É, Ø, and B. Of course, it's also ideal for classic phrases like "I \checkmark my cat."

The Info Panel

Keep the following in mind as you squirrel away all those bits and scraps of photo information:

• You don't have to manually *type* to enter data into the Description field. You can paste information in using the standard Paste command, or even drag selected text from another program (like Microsoft Word) right into the Description box.

Figure 2-18: Got a picture that's worth a thousand words? Well, the Description field can handle it. But vou'll have to make iPhoto's Info pane pretty larae to see the whole thousand words. By dragging the bars dividing the Info pane, Source list, and photoviewing area, you can adjust the amount of space each takes up in the iPhoto window. In this example, the Info pane dominates the view, with the Source list and viewing area squished to the edges.

- If you feel the need to be verbose, go for it; the Description box holds thousands of words. Careful, though: The field has no scroll bars, so there's a limit as to how much of what you paste or type will actually be visible. (You can, however, scroll the text by pressing the Page Up and Page Down keys, or by pressing the up or down arrow keys, or by dragging the cursor until the insertion point bumps the top or bottom edge of the box. If you've got a lot to say, your best bet is to make the box taller and the Source list wider, as shown in Figure 2-18.)
- If no photos, or several photos, are selected, then the notes you type into the Description box get attached to the current *album*, rather than to the pictures.
- You can add the same comment to a group of photos using iPhoto's Batch Change command. For example, \(\mathbb{H}\)-click all the pictures of your soccer team. Next, choose Photos\(\rightarrow \mathbb{B}\) atch Change, choose Description from the first pop-up menu, and then type a list of your teammates' names in the Description field. Years later, you'll have a quick reminder of everyone's name.

You can just as easily add comments for an album, folder, slideshow icon, book, or Event whose name you've highlighted.

Description as captions

While the Description field is useful for storing little scraps of background information about your photos, you can also use it to store the *captions* that you want to appear with your photos. In fact, some of the book layouts included with iPhoto's book-creation tools (Chapter 9) automatically use the text in the Description field to generate a caption for each photo.

(On the other hand, you don't *have* to use the Description box text for captions. You can always add different captions when you're editing the book.)

Extended Photo Info

The small Information pane below the Source list displays only the most basic information about your photos: title, date, time, rating, format, and size. For more detailed information, you need the Show Extended Photo Info command. It opens the Extended Photo Info window, where iPhoto displays a complete dossier of details about your photo: the make and model of the digital camera used to take it, for example.

To open the Extended Photo Info window, select a thumbnail and then choose Photos→Show Extended Photo Info (or press Option-ૠ-I). (If more than one photo is selected, you'll get only a bunch of dashes in the Info window.)

As you can see in Figure 2-19, the Extended Photo Info panel is expandable. Click enough flippy triangles, and you'll wind up with these five sections of details:

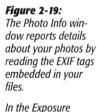

In the Exposure section, you can tell that this photo was shot without a flash, at a shutter speed of 1/250, and with an f-stop of 4.0. Tracking this info can be useful in teaching yourself photography.

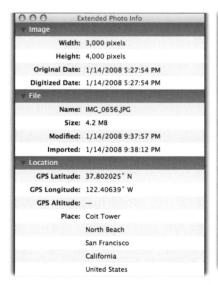

- Images. This panel contains information about the image file itself—its pixel dimensions and when it was shot.
- File. Here are the details of the photo as it sits on your hard drive: its name, size, when it was first imported, and when it was last modified.
- Location. If the photo was geotagged (page 101), you see GPS coordinates and the name of the place where the picture was snapped.
- Camera. If the image was shot with a digital camera, (as opposed to being scanned or imported) the make and model of the camera appear here. You even get to see which version of that camera's software was in use at the time, which can occasionally be important when you're trying to troubleshoot color-shift issues.
- Exposure. Here's a massive list of details about the camera's settings at the instant the photo was taken: shutter speed, aperture size, exposure settings, zoom amount, whether the flash went off, ISO setting, and more.

How on earth does iPhoto know so much about how your photos were taken? Most digital cameras embed a wealth of image, camera, lens, and exposure information in the photo files they create, using a standard data format called *EXIF* (Exchangeable Image Format). With that in mind, iPhoto automatically scans photos for EXIF data as it imports them.

Note: Some cameras do a better job than others at embedding EXIF data in photo files. iPhoto can extract this information only if it's been properly stored by the camera when the digital photo is created. Of course, most (if not all) of this information is missing altogether if your photos didn't come from a digital camera (if they were scanned in, for example).

Deleting Photos

As every photographer knows—well, every *good* photographer—not every photo is a keeper. So at some point, you'll probably want to delete some of your photos.

The iPhoto Trash

iPhoto has a private Trash can that works just like the Finder's Trash. It's sitting there in the Source list (under the Recent heading, for some reason). When you delete a picture, iPhoto puts it into the Trash "album," awaiting permanent disposal via the Empty Trash command. This feature gives you one more layer of protection against accidentally deleting a precious picture.

In the main Photos view, you can relegate items to the Trash by selecting one or more thumbnails under Library (not in an album), and then performing one of the following:

- Drag the thumbnails into the Trash.
- Control-click (or right-click) a photo, and then choose Move to Trash from the shortcut menu.

• Press the Delete key, or choose Photos→Move to Trash.

Tip: Pressing the Delete key also works when you've opened a photo for editing. But to delete a photo from a smart album, press Option-**%**-Delete.

To view the photos that you have sentenced to the great shredder in the sky, click the Trash icon, as shown in Figure 2-20. However, if you suddenly decide you don't really want to get rid of some of these trashed photos, it's easy to resurrect them, using one of these techniques:

Figure 2-20:

When you dump a photo into iPhoto's Trash, it's not really gone—it's just relocated to the Trash folder. Clicking the Trash icon in the Source list displays all the photos in the Trash and makes the Info panel show the total number of trashed photos, their date range, and their sizes.

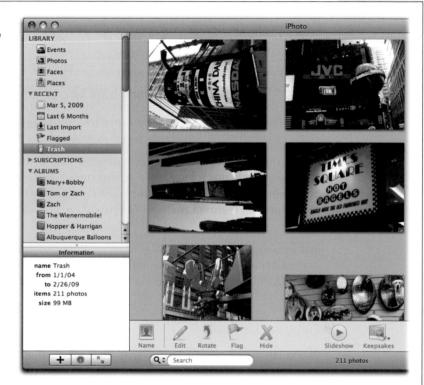

- Highlight them and then press **\mathbb{H}**-Delete (or choose Photos→Restore to Photo Library). Think of it as the un-Trash command.
- Drag the thumbnails out of the Trash and onto the Photos icon in the Source list.
- Control-click (or right-click) the photo or photos and, from the shortcut menu, choose Restore to Photo Library.

You've just rescued them from photo-reject limbo and put them back into your main photo collection.

To permanently delete what's in the Trash, choose iPhoto→Empty Trash, or Control-click (right-click) the Trash icon to access the Empty Trash command via a shortcut menu. iPhoto then displays an alert message, warning you that emptying the Trash removes these photos permanently and irreversibly. Only when you empty the Trash does the iPhoto library actually shrink in size.

(Of course, if you imported the photos from files on disk or haven't deleted them from your camera, you can still recover the original files and reimport them.)

Whatever pictures you throw out by emptying the Trash also disappear from any albums you've created.

Note: If you use iPhoto to track photos that are not actually in iPhoto (they remain "out there" in folders on your hard drive), deleting them in iPhoto doesn't do much. They no longer show up in iPhoto, but they're still out there on the hard drive, right where they always were. See page 20 for more on this external phototracking feature.

Customizing the Shoebox

iPhoto's Photos view starts out looking just the way you probably see it now, with each picture displayed as a small thumbnail against a plain white background. This view makes it easy to browse through photos and work with iPhoto's various tools.

But, hey, this is *your* digital shoebox. With a little tweaking and fine-tuning, you can completely customize the way iPhoto displays your photos.

Start with a visit to iPhoto→Preferences, and then click the Appearance button.

Tip: You can open the iPhoto Preferences window at any time by pressing **%**-comma. This keystroke is blissfully consistent across all the iLife programs.

Changing the View

The controls in the Appearance panel of the Preferences window let you make some pretty significant changes to the overall look of your Library. See Figure 2-21 for an example.

Here are your options:

• Add or remove an outline or a shadow. The factory setting, Drop Shadow, puts a soft black shadow behind each thumbnail in the photo-viewing pane, a subtle touch that gives your library an elegant 3-D look.

As pretty as this effect is, however, there are those who say that on slow Macs, it can bog iPhoto down slightly, as the program has to continually redraw or resize those fancy shadows behind each thumbnail whenever you scroll or zoom. In that case, turning off the drop shadow might grant you slightly faster scrolling.

The Outline setting puts a thin black or white frame around each picture—whichever contrasts best with the screen background.

• Change the background color. A slider here lets you adjust the background color of the photo-viewing pane. Actually, the term "color" is a bit of an overstatement, since your choices include only white, black, or any shade of gray in between.

Figure 2-21: Here's a typical library with a very different look. Instead of the usual white background with drop-shadowed thumbnails, this view presents large thumbnails, with borders. against dark gray. The font for the Source list is enlarged, and the titles for each photo are displayed.

- Adjust the alignment. Turn on the "Align photos to grid" checkbox if you want the thumbnails in your library to snap into evenly spaced rows and columns, even if your collection includes thumbnails of varying sizes and orientations, as shown in Figure 2-22.
- Show scrolling information. This option is well worth turning on. It makes a big, see-through "heads-up display" appear whenever you're scrolling through your Photos display. Apple calls it the Scroll Guide, and it shows where you are, chronologically or alphabetically, as you scroll. Figure 2-23 should make this idea clearer.

Note: The heads-up display does not appear when you've chosen the Manual sorting mode for an album.

• Use smooth scrolling. This option affects only one tiny situation: when you click (or hold the mouse button down) inside the empty area of the scroll bar (not on the handle, and not on the arrow buttons). And it makes only one tiny change: Instead of jumping abruptly from screen to screen, the window lurches with slight accelerations and decelerations so that the photos you're eyeing never jump suddenly out of view.

Customizing the Shoebox

Showing/Hiding Keywords, Titles, and Event Info

If you want your thumbnails to appear with their titles, keywords, or both, then choose View→Titles (Shift-ૠ-T) or View→Keywords (Shift-ૠ-K). Titles and keywords appear under each thumbnail. (See Chapter 3 for more on keywords.)

Figure 2-22:
The "Align to grid" option does nothing if all photos have the same orientation. But with mixed horizontal and vertical images, photos stay in strict rows and columns (right) despite their shape differences. At left: an "unaligned" version of the same thumbnails.

Figure 2-23: As you drag the vertical scroll bar, this headsup display shows where vou are in the collection. What you see here depends on the current sortina method. For example, if vou've sorted by name, you see letters of the alphabet as you scroll. If you've sorted by rating, you see stars, showing you where you are in your scroll through the ratings. And so on.

Customizing the Shoebox

As with most of iPhoto, your formatting options are limited. You can't control the font, style, color, or size of this text. Your only choice is to either display the title and keywords or to keep them hidden.

Five Ways to Flag and Find Photos

The more you get into digital photography, the more pictures you'll probably store in iPhoto. And the more pictures you store in iPhoto, the more urgently you'll need ways to *find* them again—to pluck certain pictures out of this gigantic, seething haystack of digital files.

Fortunately, iPhoto '09 is equally seething with search mechanisms. You can find pictures by the text inside them (name, location, description, Event, and so on); by the date you took them; by the keywords you've tagged them with; or by the ratings you've given them. You can also use iPhoto '09's *flagging* feature to find, and later round up, any arbitrary photos you like.

This chapter covers all five methods.

Flagging Photos

Here's a simple, sweet feature in iPhoto '09: You can flag, or mark, a photo.

So what does the flag mean? Anything you want it to mean; it's open to a multitude of personal interpretations. The bottom line, though, is that you'll find this marker extremely useful for temporary organizational tasks.

For example, you might want to cull only the most appropriate images from a photo album for use in a printed book or slideshow. As you browse through the images, use the Flag button to flag each shot you want. Later, you can round up all of the images you flagged so that you can drag them all into a new album en masse.

How to Flag a Photo

Here are two ways to flag a selected photo, or a bunch of selected photos:

- Press **\(\mathbb{H}**-period, or choose Photos→Flag Photo.
- · Click the Flag button on the toolbar.

A tiny waving-pennant logo appears on the upper-left corner of the photo's thumbnail (Figure 3-1).

Figure 3-1:
When you flag a photo, you're adding a temporary pennant badge to its thumbnail. You're setting this photo aside so that you can later make it part of a grouping of likeminded pictures.

How to Unflag Photos

You can remove flags selectively by highlighting their thumbnails and then choosing Photos→Unflag Photos (or pressing **ૠ**-period again).

Tip: You can also remove the flags from *all your photos at once,* everywhere in your library, by using a secret command. Open the Photos menu, hold down the Option key, and marvel as the new Clear All Flags command appears like magic. Choose that command.

How to Use Flagged Photos

Now, suppose you've worked through all your photos for some purpose, carefully flagging them as you go. Here's the payoff: rounding them up so that you can delete them all, hide them all, incorporate them into a slideshow, finally sit down and geotag them (page 101), use them in a book, export them as a batch, and so on.

See them all at once

If you click the Flagged icon in the Source list, then iPhoto shows you all flagged photos in your entire library. You can select them all and drag them into a *regular* album, if

you like, in readiness for making a slideshow, a book, or anything else where you'd like the freedom to rearrange their sequence.

Put them into an Event

iPhoto can generate a new Event that contains only the photos you've flagged in all your *other* Events. This method isolates the flagged photos instantly into a single, handy subset.

All you have to do is choose Events—Create Event From Flagged Photos. A box appears to warn you that you're about to remove the photos from their *original* Events; nod understandingly and click Create. In a flash, your new Event appears, filled with flagged photos and ready to rename.

Tip: You don't have to create a *new* Event to hold your flagged photos, either. If you click Events in the Source list and then click an Event, you can then choose Events—Add Flagged Photos to Selected Event. That way, you add the flagged photos to an *existing* Event—a handy option when you've put all the flagged photos into an Event and later added flags to *more* photos that really belong with their brethren.

Create a smart album

You can easily set up a *smart album* (page 61) to round up all of the flagged photos in your entire collection. Choose New—Smart Album, and in the dialog box, set up the pop-up menus to say "Photo" "is" "flagged." (Since a Flagged icon is already in the Source list, you'll generally want to do this only if you want a smart album that incorporates some *additional* criteria, like "Rating is greater than 4 stars.")

Hide them all at once

Here's another sneaky hidden iPhoto command. Open the Photos menu and then hold down your Control key. The new Hide Flagged Photos command appears. When you choose it (or just press Control-\mathbb{H}-L), iPhoto designates all of your flagged photos as hidden (page 50).

Move them all to the Trash

The parade of sneaky hidden iPhoto commands never stops. If you open the Photos menu and hold down the Control key, you also get the new Move Flagged to Trash command, which does just what it says.

Searching for Photos by Text

The flagging mechanism described above is an adequate way to tag photos, but there are other ways. The name you give a picture might be significant; its original file name on the hard drive might be important; and maybe you've typed some important clues into its Description box or given its Event an important name.

Anyway, that's the purpose of the Search box below the window. Start by selecting the container you want to search—the Event, album, folder, or whatever—and then proceed as shown in Figure 3-2.

Searching for Photos by Text

Tip: iPhoto '09 is capable of searching your photos' *metadata*, too—the photographic details like camera manufacturer, f-stop, flash status, exposure settings, and so on. But you don't use the Search box for that; you must create a smart album, as described on page 61.

Figure 3-2:

As you type into the Search box, iPhoto hides all pictures except the ones that have your typed phrase somewhere in their titles, keywords, descriptions, faces, places, file names, or Event titles. In this case, the characters "sup" appear somewhere in every photo title.

(To cancel your search and reveal all the pictures again, click the ❸ at the right end of the Search box.)

The Calendar

iPhoto offers a long list of ways to find certain photos: visually, by Event, by album, by searching for text in their names or comments, and so on. But it also offers what seems like an obvious and very natural method of finding specific pictures: by consulting a calendar.

After all, you might not know the file names of the pictures you took during your August 2006 trip to Canada. You might not have filed them away into an album. But one thing's for sure: You know you took that trip in August of 2006, and the iPhoto calendar will help you find those pictures fast.

The Calendar

To use the calendar, start by indicating what container you want the calendar to search: an album or folder, for example, or one of the Library or Recent icons.

Now make the calendar appear by clicking the tiny \circ button at the left edge of the Search box. From the pop-up menu, choose Date (Figure 3-3).

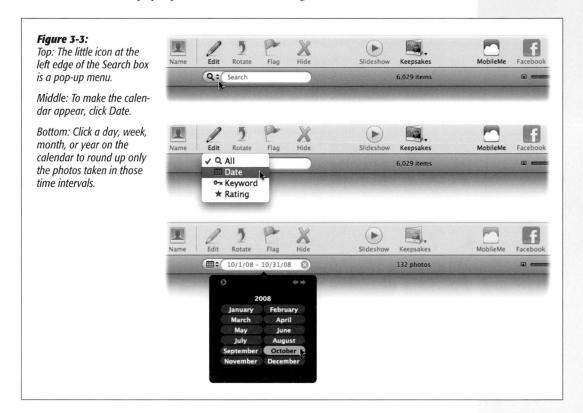

The little calendar may look small and simple, but it contains a lot of power—and, if you look closely, a lot of different places to click the mouse.

For example, the calendar offers both a Year view (showing 12 month buttons) and a Month view (showing 28 to 31 date squares). Click the tiny ◀ or ▶ button in the upper-left corner to switch between these two views. You can also double-click a month's name (in Year view) to open the month, or double-click the month title in Month view ("March 2008") to return to Year view.

Here's how you can use the calendar to pinpoint photos taken in a certain time period:

• Photos in a certain month. See the names of the months in the Year view? The names in bold white type are the months when you took some photos. Click a boldfaced month to see the thumbnails of those photos; they appear in the main viewing area. (To scroll to a different year, click the left/right arrow buttons at the top of the display, as shown in Figure 3-3.)

The Calendar

- Photos on a certain date. In Year view, start by double-clicking the appropriate month name. The calendar now changes to show you the individual dates within that month. Here, bold black type lets you know that photos are waiting. Click a date square to see the photos you took that day. (Here again, the arrows above the calendar let you scroll to different months.)
- Photos in a certain week. Once you've drilled down into the Month view, as described above, you can round up the photos taken during an entire week: Just double-click the week in question. The horizontal week bar of the calendar is now highlighted, and the photos taken during any of those seven days appear in the main viewing area.

It's possible to develop some fancy footwork when you work with this calendar, since, as it turns out, you can select more than one week, month, or day at a time. In fact, you do that using exactly the same keyboard shortcuts that you would use to select individual photo thumbnails. For example:

• You can select multiple adjacent time units by clicking the first and then Shiftclicking the last. For example, in Year view, you can select all the photos from June through August by first clicking June, and then Shift-clicking August. (You can use the same trick to select a series of days or weeks in the Month view.)

Tip: Alternatively, you can just drag the mouse across the dates on the Month view or the months on the Year view to select consecutive time periods.

- You can select multiple time units that *aren't* adjacent by **%**-clicking them. For example, in Month view, you can select November 1, 5, 12, 20, and 30 by **%**-clicking those days. In the photo-viewing area, you see all the photos taken on all of those days combined.
- Here's an offbeat shortcut that might actually be useful someday: You can round up all the photos taken during a specific month, week, or day *from every year in your collection* by holding down the Option key as you select.

For example, you can round up six years' worth of Christmas shots by Option-clicking the December button in the Year view. Or you can find the pictures taken every year on your birthday (from all years combined) by Option-clicking that date in the Month view.

Apple really went the extra mile on behalf of shortcut freaks when it designed the calendar. Here are a few more techniques that you probably wouldn't stumble upon by accident:

- In Year view, select all the days in a month by double-clicking the month's name. In Month view, you can do the same by triple-clicking any date number.
- Return to Year view by quadruple-clicking any date, or by clicking the month's name.

- Skip ahead to the next month or year (or the previous month or year) by turning the scroll wheel on your mouse, if you have one.
- Deselect anything that's selected in the calendar by clicking any empty spot in the calendar.

Once you've made a date selection, faint gray type in the Search box reminds you of the date range you've selected.

Tip: You can reopen the calendar by clicking inside the Search box; you don't have to fuss with the little pop-up menu beside it.

In any case, you can close the calendar and return to seeing *all* your pictures by clicking the **3** at the right end of the Search box.

Keywords

Keywords are descriptive words—like Family, Vacation, or Kids—that you can use to label and categorize your photos, regardless of which album or Event they're in.

The beauty of keywords in iPhoto is that they're searchable. Want to comb through all the photos in your library to find every closeup taken of your children during summer vacation? Instead of browsing through multiple photo albums, just perform an iPhoto search for photos containing the keywords Kids, Vacation, Closeup, and Summer. You'll have the results in seconds.

Note: The next chapter explains how to tag your photos with the names of the people in them or the locations the photos were taken. Needless to say, you can also search for names and places in iPhoto '09.

Editing Keywords

Apple offers you a few sample entries in the Keywords list to get you rolling: Favorite, Family, Kids, and so on. But these are intended only as a starting point. You can add as many new keywords as you want—or delete any of Apple's—to create a meaningful, customized list.

Start by choosing Window→Show Keywords, or just press **第**-K. The weird and wonderful new Keywords window appears, as shown in Figure 3-4.

Then, to add, delete, or rename keywords, click Edit Keywords. Proceed as shown in Figure 3-4.

Tip: As usual in iPhoto, you can select multiple keywords for deletion by Shift-clicking or (for noncontiguous selections) **%**-clicking them in the list before clicking Remove. (When you remove a keyword from the list, iPhoto also removes that keyword from any pictures to which it had been applied.)

Keywords

Be careful about renaming keywords after you've started using them; the results can be messy. If you've already applied the keyword Fishing to a batch of photos but later decide to replace it with Romantic in your keyword list, all the Fishing photos automatically inherit the keyword Romantic. Depending on you and your interests, this may not be what you intended.

It may take some time to develop a really good master set of keywords. The idea is to assign labels that are general enough to apply across your entire photo collection—but specific enough to be meaningful when you conduct searches.

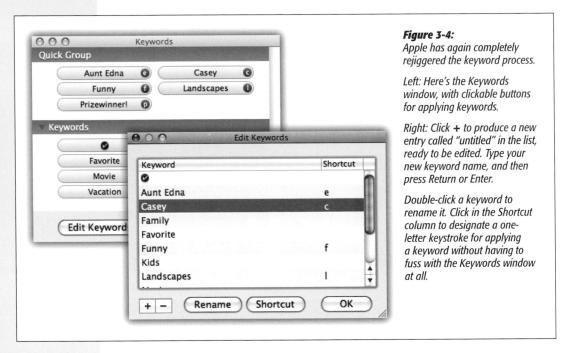

Here's a general rule of thumb: Use *albums* to group pictures for specific projects—a book, a slideshow, or a Web page, for example. Use *Events* for grouping pictures by time or event. And use *keywords* to focus on general characteristics that are likely to appear through your entire photo collection—words like Mom, Dad, Casey, Robin, Family, Friends, Travel, and Vacation.

Suppose your photo collection includes a bunch of photos that you shot during a once-in-a-lifetime trip to Rome last summer. You might be tempted to assign *Rome* as a keyword. Don't...because you probably won't use it on anything other than that one set of photos. It would be smarter to create an Event called "Trip to Rome" to hold all those Rome pictures. Use your keywords to tag the same pictures with descriptors like Travel or Family.

It also might be useful to apply keywords that describe attributes of the photos themselves, such as Closeup, Landscape, Portrait, or Scenic—or even the names of the people *in* the photos, like Harold, Chris, and Uncle Bert.

Note: iPhoto automatically creates the checkmark keyword. It's just a little checkmark that, when applied to your thumbnails, can mean anything you want. In fact, it works *exactly* like the flag feature described earlier in this chapter.

The only reason the checkmark keyword still exists, in fact, is to provide compatibility with previous iPhoto libraries, to accommodate people who used to use the checkmark keyword for purposes now much better served by the flag.

Assigning and Unassigning Keywords

You can apply as many keywords to an individual photo as you like. A picture of your cousin Rachel at a hot-dog-eating contest in London might bear all these keywords: Relatives, Travel, Food, Humor, and Medical Crises. Later, you'll be able to find that photo no matter which of these categories you're hunting for.

iPhoto '09 offers three ways to apply keywords: the mouse way, the keyboard way, and the *other* keyboard way.

• Mouse method. Open the Keywords window by pressing **%**-K. Highlight the photo(s) you want to bless with a keyword. Then click the appropriate button on the Keywords window.

Figure 3-5:

Top: If you point to a thumbnail without clicking, the words "add keywords" appear beneath it.

Bottom: Click there to open this keyword box. Begin typing the keyword you want to assign; iPhoto completes the typing for you. Press Return to accept the suggestion; at this point, you can type the beginning of another keyword to assign more than one.

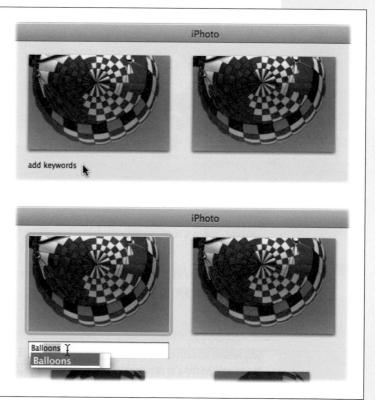

- Keyboard method, with Keywords window. Open the Keywords window by pressing **%**-K. Highlight the photo(s) you want to bless with a keyword. Then press the keyboard shortcut letter for the keyword you want to apply (V for Vacation, for example).
- Keyboard method, without Keywords window. Choose View→Keywords. Now you can see the keyword assignments for every single thumbnail in your collection. Proceed as shown in Figure 3-5.

Keyboard Shortcuts

The business of applying keywords using keyboard shortcuts makes the whole keyword business a lot faster and easier.

You can let iPhoto choose one-letter keystrokes for your keywords automatically, or you can make them up yourself:

- To have iPhoto assign shortcuts. In the Keywords window, drag your most frequently used keywords upward into the Quick Group. As you can see at left in Figure 3-4, iPhoto automatically assigns each one to a letter key. (It uses the first letter of the keyword. If that's already assigned to another keyword, it uses the *second* letter. And so on.)
- To assign shortcuts yourself. For more control, open the Keywords window, and then click Edit Keywords. Click in the Shortcut column and then press the letter key you want to assign. (iPhoto lets you know if you press a letter key that's already in use.)

Viewing Keyword Assignments

Once you've tagged a few pictures with keywords, you can see those keywords in either of two ways:

- Open the Keywords window. When you select a photo, its assigned keyword checkboxes light up in the Keywords list.
- Choose View—Keywords, or press Shift-\(\mathbb{H}\)-K. Now iPhoto shows the actual text of the keywords right in the main photo-viewing area. (You can see the effect in Figure 3-5.)

Using Keywords

After you've tagged photos with keywords, the big payoff for your diligence arrives when you need to get your hands on a specific set of photos, because iPhoto lets you *isolate* them with one quick click.

Start by clicking the tiny icon next to the Search box at the bottom of the window. (This icon usually looks like this: \(\cdot \).)

A little palette of all your keywords appears, and here's where the fun begins. When you click one of the keyword buttons, iPhoto immediately rounds up all the photos labeled with that keyword, displays them in the photo-viewing area, and hides all others.

Tip: If you point to one of these buttons without clicking, a pop-up balloon tells you how many photos have been assigned that keyword.

Here are the important points to remember when using iPhoto's keyword searches:

• To find photos that match multiple keywords, click additional keyword buttons. For example, if you click Travel and then click Holidays, iPhoto reveals all the pictures that have *both* of those keywords.

Every button stays "clicked" until you click it a second time; you can see several of the keyword buttons "lit up" in Figure 3-6.

• Suppose you've rounded up all your family pictures by clicking the Family keyword. The trouble is, your ex-spouse is in half of them, and you'd really rather keep your collection pure.

No problem: *Option*-click the Ex-Spouse keyword button. iPhoto obliges by removing all photos with that keyword from whatever is currently displayed. In other words, Option-clicking a keyword button means "Find photos that don't contain

Figure 3-6: As you click keyword buttons, iPhoto hides all photos except the ones that match. The gray lettering in the Search box identifies, in words, what you're seeing.

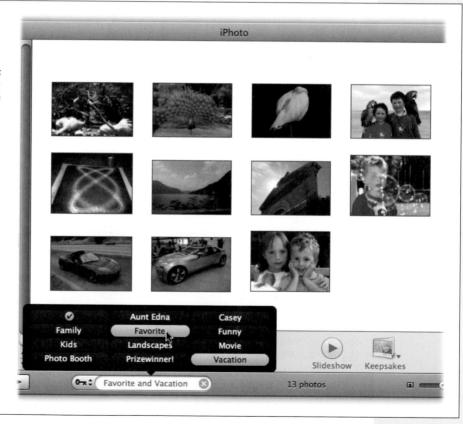

- this keyword." (In that case, the Search box says, in faint gray lettering, "Vacation and *not* Casey," or whatever.)
- You can confine your search to a single album by selecting it before searching. Similarly, clicking the Event (or Recent) icon in the list before searching means you want to search that photo collection. You can even select multiple albums and search only in those.
- Click to restore the view to whatever you had visible before you performed the search.

Ratings

iPhoto offers a great way to categorize your pictures: by how great they are! You can assign each picture a rating of one to five stars and then use the ratings to sort your library, or gather only the cream of the crop into a slideshow, a smart album, or a photo book. Here's how you can rate your digital masterpieces:

Select a photo (or several) and choose Photos

My Rating; from the submenu, choose from one through five stars. You can even do this while you're editing a single photo.

Tip: If the top of the screen is just too far away, you can also Control-click (or right-click) any one of the selected thumbnails (or, in Edit mode, anywhere on the photo) and then choose the My Rating command from the shortcut menu. Its submenu is exactly the same as what you'd find in the Photos—My Rating command.

- If you're not a mousy sort of person, you can perform the same stunt entirely from the keyboard. Press \mathbb{H}-1 for one star, \mathbb{H}-2 for two stars, and so on. Press \mathbb{H}-0 to strip away any existing ratings.
- Click the **1** in the lower-right corner of any photo to spin it around to its Info box on the back. Under the title and date of the photo, swipe the mouse along the dots to add the corresponding number of stars. Page 106 has more on what else you can do in this box.
- To remove a rating, select the photo and choose Photos→My Ratings→None. You're saying, in effect, "This photo has not yet been rated." Keyboard shortcut: \$\mathbb{H}\$-0.

Tip: Once you've applied your star ratings, you can view the actual little stars right under the corresponding thumbnails by choosing View→Ratings (or pressing Shift-**%**-R).

Faces and Places

A syou can see from the previous chapter, iPhoto gives you plenty of ways to organize your pictures into neat little collections. But until the '09 version came along, the only way to organize everything was manually. Manually apply keywords. Manually drag things into albums. Drag, drag, drag.

It's all different now. iPhoto '09 comes equipped with two new features that organize your photos *automatically*. You'd call it artificial intelligence if it didn't seem so much like *real* intelligence.

One of them uses face recognition to group your photos based on who is in them. It can be extremely handy when, say, you need to round up a bunch of pictures of Chris fast for that last-minute, surprise-party slideshow. This isn't the crude sort of face recognition that you find in lesser photo programs or even in digital cameras, which can tell you only *if* there's a face in the picture. iPhoto attempts to go a step further—and tell you *whose* face it is.

You can also round up photos based on *where* they were taken. You can compare various trips to Paris, for example, or show friends what else you did in Chicago besides go to a White Sox game.

Meet Faces and Places, two new features in iPhoto '09 that are sure to become favorites of people who really want to get to the who and the where of their photos.

Faces

Here's the new Faces feature in a nutshell: By analyzing the unique properties of each face in each photo—eyes, nose, mouth, hair color, lack of hair, and so on—iPhoto attempts to distinguish among the people in the photos of your library and group

Faces

them into piles. (Once the setup process is complete, you'll see these piles when you click the new Faces icon in the Source list.)

iPhoto makes a first pass at this automatically, which is pretty amazing.

It's not a perfect process, however; after its initial pass, iPhoto requires you to review each photo and confirm its subject's identity. (It's easy and fun!)

Thereafter, you can click the new Faces icon in the Source list to see that iPhoto has grouped your photos by *the people in them*.

Step 1: Analysis

When you upgrade from an earlier version, iPhoto '09 doesn't waste any time. The first time you run it, the program upgrades your photo library (page 11)—and gets to work searching all your images for human faces (Figure 4-1).

This part of the Faces setup doesn't require any effort from you.

Note: Depending on the size of your photo library, iPhoto may take half an hour or more to burrow through your collection on its initial face hunt. This does not mean you have to sit there waiting for it, putting off the ritual Poking Around in a Brand New Program. Feel free to click away and do other stuff; iPhoto is perfectly content to scan for faces in the background.

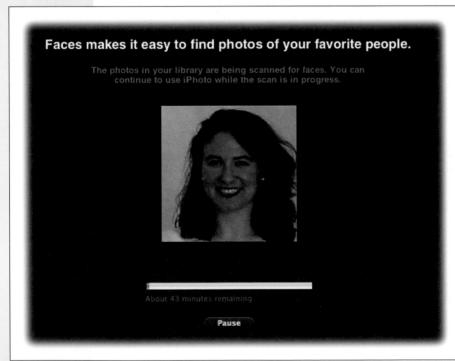

Figure 4-1: Before iPhoto can aet down to the business of recognizing faces, it plows through your photo library detectina faces in your pictures. A progress bar on the screen aives a time estimate. Once iPhoto examines vour library, the face-detection fun beains.

After completing its scan, iPhoto has a good idea of what your social circle looks like. But it still has no idea what those people's names are.

Tagging Faces Automatically

Now that iPhoto has done its face-detection dance, it's time to introduce it to your friends and family. Once you label a face, the program looks around and tries to match it up with other similar faces in the library.

The whole face-tagging process is simple:

1. Select a picture in your iPhoto library.

Choose a photo that has a clear, direct frontal view of a person. Get one that's in focus, free of sunglasses, and unobstructed by hands or other body parts. The program will try to match other pictures in the library with this initial one, and face-recognition technology works best when there's plenty of face to recognize.

2. Click the Name button on the iPhoto toolbar.

The photo opens up to fill the window. If iPhoto has detected faces in the picture, it draws a white box around each one. Under each box is a gray label that says "unknown face" (see Figure 4-2).

Note: iPhoto sometimes gets a little overzealous. It may park white boxes over faces in paintings, statues, Star Wars action figures, or shadows on drapery. In these cases, point the cursor at the top-left corner of the white box and click the \odot to delete it, so that you can go on tagging the actual live humans in the shot.

3. Into that gray text box, type in the name of the person: *Dad*, or *Uncle Robin*, or *Ernest P. McGillicuddy*—whatever you like. Hit the Return key, or click Done, when you're finished editing the name.

Tagging Faces Manually

If you don't see a white box around a face in the photo you selected—a fairly rare occurrence—you can tag the face yourself. Start by clicking the Add Missing Face button under the image (Figure 4-2).

A fresh white square appears, which you can drag over onto that poor, undetected face. Drag the corners of the box to resize it over the face. (Dragging a corner causes both sides of the box to change size, making it a little awkward to get perfectly centered over the face. To better control your box resizing, hold down the Option key as you drag a corner. This stops both sides of the box from moving around and lets you manipulate the size from just the corner you're dragging.)

Click Done when you've got the white square right where you want it. Now click "unnamed" in the gray box and type the real name of the person. Repeat as necessary with any other people you know in the picture.

Faces

Note: While it's not quite as sophisticated as the software the FBI and Interpol are using these days, the face-detection feature in iPhoto '09 generally gets better the more you work with it. But there are still some cases when you'll have to plod through manually.

For example, the program may not recognize shaggy dogs as actually having faces, but you can sail through those pictures of Skipper and use the Add Missing Face button (page 91) to add your pet to the Faces wall. Babies, identical twins, and people wearing sunglasses (or posing at odd angles) may also require manual intervention. But, hey, iPhoto just saved you all that time on everyone else, right?

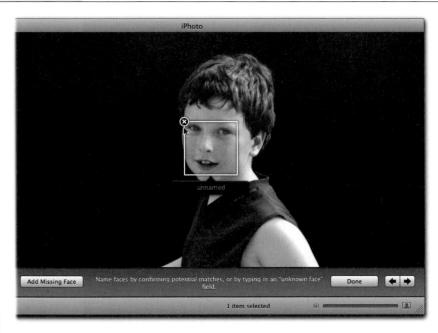

Figure 4-2: Here's how you get started teaching iPhoto about your family and social circles. If iPhoto doesn't draw the white box automatically (it can't find the face), click the Add Missing Face button in the lower-left corner and drag the white square around your subject's face. Click the Done button when the square is positioned, and then add the name of the person next.

Adding More Pictures to a Name

Once you've tagged a person in a photo, click Faces in the Source list. As shown in Figure 4-3, you now see the digital equivalent of a cork bulletin board. On it: Polaroid-style thumbnail shots of each person you've tagged so far, labeled by the name you just assigned. It's like being the casting director in the movie of your life!

Tip: Want to change the size of the headshots displayed on the Faces corkboard? Just drag the Size slider in the bottom-right corner of the iPhoto window. The same slider adjusts the size of the thumbnails on the Confirm Faces screen (page 93). In fact, temporarily making the images smaller lets you drag the mouse over more of them at once to confirm or reject name suggestions.

Once you've put at least one name to a face, iPhoto's powers of recognition really kick in. Here's how to help it match up the rest of the names and faces:

1. Double-click a person on the Faces corkboard.

At the top of the window, you see all the photos you've already tagged with this person's name. Scroll down far enough, and you'll see all the *other* pictures that iPhoto thinks contain this same person. These photos are clumped under the bar titled "So-and-so might also be in the photos below." Here's your chance to tell iPhoto's face-detection software what it got right and what it got wrong.

Figure 4-3:

As your list of names grows, more head-shots appear on your Faces corkboard. To see your pictures of each person, double-click on the face. Use the slider in the bottom-right corner of the iPhoto window to increase or decrease the size and number of headshots in a row.

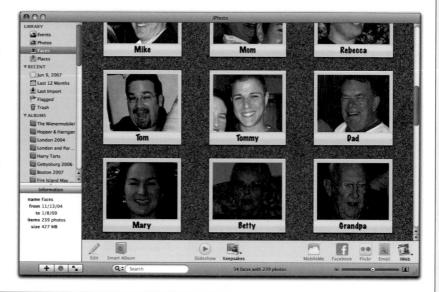

2. On the iPhoto toolbar, click Confirm Name.

The program now displays a screen full of tiles. Each one contains a closeup of the lucky person's face, each one culled from a photo. The caption "click to confirm" appears beneath each one (Figure 4-4).

3. Click a photo once to confirm that iPhoto has correctly matched this face with the name.

When you click a face, the "click to confirm" bar turns green and displays the *name* of the person—for example, Chris. Behind the scenes, iPhoto learns from your selection. "Ah, OK—that's Chris," it says to itself. You've just helped it refine its recognition smarts for the next time.

Tip: If most of the tiles do indeed contain the correct person, you can accept them all at once. Instead of clicking, drag the mouse over a whole batch of photos to enclose them. Just dragging around them turns their captions green.

Faces

4. When you encounter a tile that shows somebody else—iPhoto has picked the wrong person—either Option-click it or double-click it.

The "click to confirm" banner turns red, and the text says, "Not Chris" (or whoever).

Tip: Here again, you can reject a whole bunch of tiles at once. This time, hold down the Option key as you drag the mouse cursor over the faces.

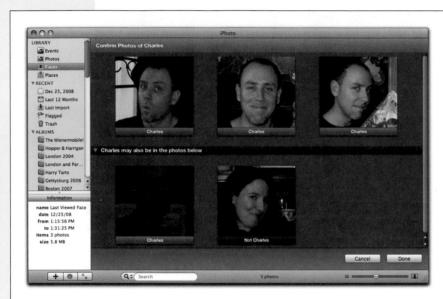

Figure 4-4: You can give iPhoto's powers of recognition a boost by confirmina its correct quesses and rejecting its wrong ones. Photos above the gray bar are confirmed pictures of this Face: photos below it are ones that iPhoto wants you to confirm. Click a picture to confirm it, or Option-click to reject it. The more you work with iPhoto here, the better it aets at identifying the

people vou know.

5. When you're finished accepting or rejecting tiles, click Done.

The more guidance you give iPhoto in identifying people in your photos, the more accurate it gets at recognizing them in new images. With enough input from you, the program has a better chance of telling babies and bald men apart, and even differentiating among your various bald friends.

Tip: If it's obvious (even before you click Confirm Name) that a photo contains the person iPhoto thinks it does in the "So-and-so might also be in the photos below" area, then cut to the chase and just drag the photo into the Confirmed area at the top of the screen. If it's a group shot and you can't quite see the face in the crowd, go to the View area in the iPhoto toolbar and click the Portrait button (the second one from the left) to zoom in to a headshot of the suggested face. The software isn't perfect, but the simple binary direction you give it (confirm, confirm, confirm, reject, confirm, reject) is like using the thumbs-up/thumbs-down button on a TiVo or the Pandora Internet radio station; over time, it gets smarter and smarter about your world.

Naming Faces Anytime

The Name button is always there on the iPhoto toolbar, even after your initial burst of face tagging. As you stroll around your photo library and come upon photos or people you want to add, the Name button awaits. Click it to add names to any photo you have up on screen.

iPhoto is always trying to guess who these people in your life are. For example, if you open up a snapshot from that family reunion and click the Name button, iPhoto will offer a guess if the face looks familiar.

You see the customary white square around the face, but instead of "unnamed" under it, you get a polite question like, "Is this Leroy?" (Figure 4-5).

If it is indeed Cousin Leroy, then click • to confirm and add the picture to Leroy's Faces album. If iPhoto has guessed wrong, then click the • and type in the name that does go with the face.

Figure 4-5: If iPhoto recognizes someone it's seen before, it asks you to verify the person's identity. Click o if iPhoto quessed the right name. Click the 3 if iPhoto missed. and then type in the correct name for the person. As you can see here, iPhoto sometimes gets a little excited detecting faces and points them out even in paintings and other art.

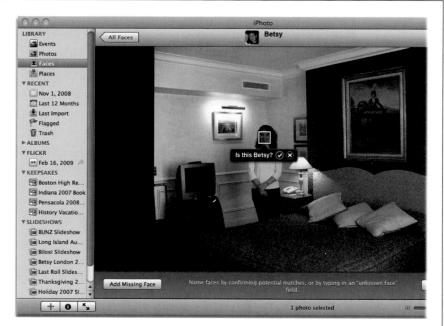

As you add more and more names to your Faces library, iPhoto tracks your typing and offers a blue drop-down list of potential, previously typed names (as well as names that are in your Mac OS X Address Book) that you can select from to save keystrokes. The top of Figure 4-6 shows an example.

Tip: When looking at a photo in Confirm Name mode, click the name on any face tag (Figure 4-6, bottom) to immediately jump into that person's Faces album.

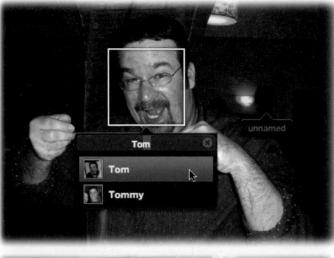

Figure 4-6:

Top: Once you tag a few faces, iPhoto builds a library of names. When you start typing to identify a face, the program cheerfully offers a list of past names and will even suggest names from your Mac OS X Address Book. Click the correct name or hit the \downarrow key until you get to it, and then hit Return to select it.

Bottom: The • after the name is your shortcut to the rest of this person's Faces album. Click it to jump there. Once you land, you can always scroll down to the bottom of the box and confirm the name on a few more photos iPhoto thinks show this person (page 92).

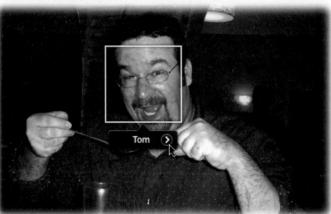

The Payoff

Between iPhoto's own analysis and your patient confirmation of faces, you gradually refine the Faces feature.

Eventually, you wind up with a whole array of people's faces on the Faces corkboard (click Faces in the Source list), as shown in Figure 4-3. The next time you need to get a whole bunch of pictures of a friend, just double-click her thumbnail Polaroid on the Faces corkboard. It's a real time-saver when you need to, say, make that monthly book of grandchild pictures for your parents or make a slideshow timeline of Don's ever-evolving facial hair for his 40th birthday party.

Tip: You can drag a corkboard snapshot directly into the Source list to create a smart album there (Figure 4-7). This album will eternally update itself, auto-adding any confirmed photos of the person that may enter your collection in the future. You can also drag a snapshot onto an existing Face-based smart album to make one that updates with *both* people—very convenient for getting all those pics of the kids or the bowling team guys into one convenient place.

Figure 4-7:

Drag any snapshot onto the Source list to make a new smart album for that person. You can also drag a snapshot onto an existing smart album icon to make one that corrals photos of both people ("Tom or Zach" here) as you update and confirm names in your iPhoto library.

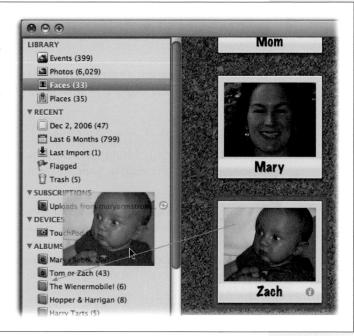

Deleting Faces

OK, you got a little excited by iPhoto's face-detection technology and tagged your annoying co-worker Madge. Look, there she is on the Faces corkboard next to pictures of Mom. If you want to remove a face from the wall, select it and press **%**-Delete. iPhoto asks if you're sure you want to remove this person from Faces. If you are, then click Delete Face and wave goodbye.

If you want to zap multiple people off the wall at once, **%**-click each undesired person, and then press **%**-Delete. Again, confirm your action. (If you want to delete a whole row of people, Shift-click the first and last faces in the row to select them *and* everyone in between.)

Note: Deleting a face from the Faces corkboard never deletes any pictures from the iPhoto library.

Adding More Details to a Face

In addition to neatly lining up mug shots of all your family and friends, the iPhoto Faces album helps you keep track of your pictures (and the people in them) in several other ways. It even saves Facebook friends some time.

Point to any face on the corkboard and click the fin the lower-right corner of the Polaroid frame. The image spins around onscreen and, like the back of a baseball card, gives you more information (Figure 4-8). You see the number of photos (and range of photo dates) you have for this person, along with places to type in the person's full name and email address.

Tip: At this point, you can click the left or right arrows in the box to advance or retreat to the next person on the corkboard. It saves a lot of flipping around if you're going through adding a bunch of names and email addresses at once.

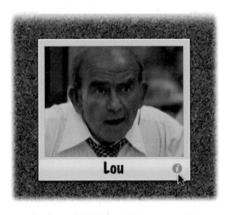

Figure 4-8:

Top: Wave the mouse over the lower-right corner of any face and click the • icon to spin the picture around so you can edit its Info box.

Bottom: If you fill in the person's full name and email address here, any future photos you name-check in iPhoto and upload to Facebook will carry along the same tags and give you more time to be doing other things on Facebook, like SuperPoking your friends.

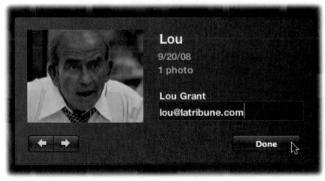

Now, why would you want to add the person's email address here? No, it doesn't automatically add the photo to the appropriate entry in the Mac's Address Book program, or stick that photo onto incoming messages in Mail (although it would be very nice if Apple made that happen...hint, hint).

No, by giving you a place to add the person's email address, iPhoto is banking that this same name and address are also used for the person's account on Facebook, the social-networking site that is a Time Hoover for 175 million people. Later, when you use the new Facebook button (page 198) to post iPhoto pictures on your Facebook page, the name tags you have so carefully assigned go along for the ride, saving you the trouble of tagging them all over again in Facebook.

For more on merging your iPhoto and Facebook lives, skip to Chapter 8.

Organizing the Faces Album

Seeing your friends and family all lined up in iPhoto's Faces view offers a nice sense of organization. (A few years ago, those pictures would still have been falling out of physical photo albums—or still in their envelopes from the drugstore and shoved into the back of a desk drawer.) But even on the corkboard, you can organize the faces still further.

UP TO SPEED

Smart Albums and Happy Faces

iPhoto's smart albums (page 61) are a terrific way to round up all the photos that meet a certain set of conditions—for example, all the ones you shot with a particular camera, or on a particular date. The names you apply to Faces can be smart albums conditions, too.

Say you're planning the Embarrassing Slideshow portion of

the wedding-reception dinner. You need to find all the photos in your library that contain either Mary or Bobby, and photos with both Mary and Bobby together.

Choose File→New Smart Album (or press

Option-**%**-N on the keyboard). Give the album a name; choose Any from the "Match" pop-up menu.

Now, set up the pop-up menus to say "Face" and "is" and then "Mary." Click the + button to add another row; repeat the steps to add "Bobby" as the name on the second line.

When you click OK, a new smart album appears in the Source list. It contains all the photos you've ever tagged of Mary and Bobby, either together or apart, in one handy place. (Later, when you've *geotagged* your photos—see page 101—and want to add Place as a condition, too, you can even make an album of all the times you went skiing up *in Vermont* with

Mary and Bobby.)

You can also set up a smart album to corral all the pictures you haven't gotten around to face-tagging yet. Just choose File—New Smart Album and call it something memorable, like "Untagged photos."

Set up the pop-up menus to say "Face" and "is." In the last box, pick "Unnamed" and click OK to create a smart album of the great untagged.

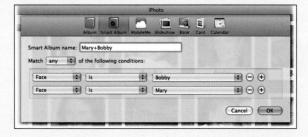

Change the key photo

The key photo is the one that represents a person on the Faces corkboard; it's typically the first one you tagged (Figure 4-9). If that photo doesn't do your friend justice, there are at least three easy ways to change it:

- Click Faces in the Source list. As you slowly move the mouse pointer (don't click) over a face on the corkboard, all the tagged pictures of that person flit by in the frame. When you see the one you want to use, tap the space bar to set it as the key photo.
- Double-click the face to open up the album. Scroll through and select a photo you like better. Choose Events—Make Key Photo. Even if it's a group shot from a distance, iPhoto is savvy enough to zoom in on the person's face.
- If you have a face-tagged photo selected, Control-click (or right-click) it, and then choose Make Key Photo from the shortcut menu.

Figure 4-9:

The key photo represents the person on the Faces corkboard. One easy method to change it: Wave the mouse over the snapshot to see what other pictures have been tagged to the name, and then tap the space bar when you see the one you want to use instead.

Rearrange the order

Would you like to put Mom and Dad together on the board, or get all your soccer team pals in a row? Fortunately, you can drag the Faces snapshots around, as Figure 4-10 illustrates.

Be careful where you drop that face, though. If you accidentally drop the person on somebody *else's* snapshot, you *merge* their two sets of photos, and iPhoto applies the wrong name to all of the faces in the pile you dropped. (If that happens, press **%**-Z, the Undo command).

Tip: Just as you can merge Events (page 47), you can merge Faces. Why would you want to? Well, for example, say you make a typo in someone's name when using the Name button and inadvertently create two Faces for the same person. You can merge the two by dragging the snapshot of the Typo Name right onto the snapshot of the Correct Name and not have to rename a thing.

If it's too late for **%**-Z, double-click the merged pile. Click the Confirm Name button and reject (and eject) the wrong face out of the photo collection, as described on

page 94. (Or Control-click each unwanted photo and choose "This is not [Name]" from the shortcut menu.)

Tip: You can also organize the faces alphabetically. Choose View→Sort Photos→By Name. (That creates an A to Z order. You can also be contrary and go from Z to A; use the same menu and choose Descending.) Switching to name sorting, however, means you can't drag your pals around manually. At least not until you choose View→Sort Photos→Manually.

Figure 4-10:
Rearranging your
Faces board is a
drag—literally. To move
someone, drag the face
to the new place on the
board. The other faces
politely slide over to
make room.

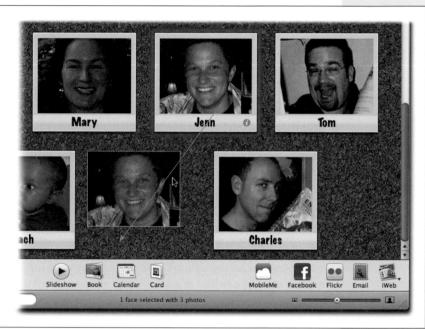

Edit names

Want to change the spelling or fix a typo in the name displayed on the corkboard key photo? Just click the name. The gray box reappears; you can type what you want. Clicking the ③ on the right of the box automatically clears the existing text, but since clicking the name selects it anyway, you can just start typing right over the old name.

Places

Geotagging is the hot new future feature of digital photography. That's when your camera buries longitude and latitude coordinates into each picture it takes (invisibly, the same way it stamps the time and date). That way, you'll always be able to pinpoint where a picture was taken.

There are only two problems with this scenario. First, very few cameras actually contain the necessary GPS circuitry to geotag your photos.

Second, what happens after you geotag your photos? What are you going to do, say, "Oh, yes, I remember that romantic evening at +41° 30′ 18.48″ N, -81° 41′ 55.08″ W"?

iPhoto solves, at least, the second problem. It translates those coordinates to the much more recognizable "Cleveland," or even more precisely down to a street address, like "100 Alfred Lerner Way, Cleveland, Ohio" (which happens to be the address of Cleveland Browns Stadium)—and shows that spot with a red pin on a map right in iPhoto.

This can be really convenient, say, if you've made several trips to London and want to see *all* the pictures taken there over the years, and not just ones from a particular album or Event. (It's also a great way to learn geography.)

Automatically Geotagging Photos

Your photos are probably geotagged when you shoot them if you're using one of the following gadgets:

- A digital camera with a built-in GPS chip, like the Nikon Coolpix P6000.
- A GPS-enabled cellphone, like a recent iPhone.

FREQUENTLY ASKED QUESTION

When You Don't Feel Like Sharing

I'm all for having machines do things for me automatically, but what if I don't want iPhoto revealing where my iPhone pictures were snapped?

These days, privacy concerns run deep; sometimes, you may not want iPhoto blabbing about where you've been.

If this is the case, you have a couple of options. The first one—if you remember to do it in time—is to turn off the GPS feature on your

camera or cameraphone. On the iPhone, for example, go to the Home screen and tap your way through Settings—General—Location Services—Off. Just remember

to turn Location Services back on again the next time you want to use Maps or another location-aware app.

Second, you can tell iPhoto itself not to look up the GPS co-

ordinates embedded in the file. Choose iPhoto→Preferences (or press ૠ-comma) and click the Advanced icon. In the "Look Up Places" section of the box, change "Automatically" to "Never," and then click OK.

You can also delete location information that's already been added to a photo or Event. Just click the in the corner of the photo thumbnail (or Event tile) to call up the Info box. Click the place name listed at the top of the box, click the top to delete it, and then click Done.

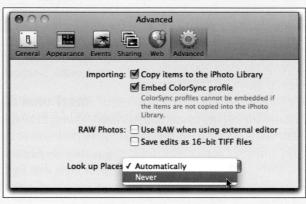

- The Eye-Fi Explore Card. It's a remarkable SD memory card, the kind you put into most camera models, with built-in wireless networking and a pseudo-GPS feature (\$15 a year). See http://bit.ly/8mdAa for details.
- A small GPS-enabled box like the \$90 ATP PhotoFinder that tracks the time and your coordinates as you snap photos—and marries them up with the timestamps on your pictures when you insert the camera's memory card. See *photofinder.atpinc. com* for more information.

If that's your situation, then all you have to do is import the pictures into iPhoto (page 13). When the images appear in the iPhoto window, you can check the location by waving the cursor over the lower-right corner of any image. An ② icon appears, as shown in Figure 4-11. Click it to spin the photo around onscreen.

Figure 4-11:

To see location information, click the **1** button that appears when you wave the mouse over the lower-right corner of any photo in the library. If those MobileMe, Facebook, and Flickr icons in the corner of the iPhoto window have you all excited about sharing now, feel free to flip to Chapter 8.

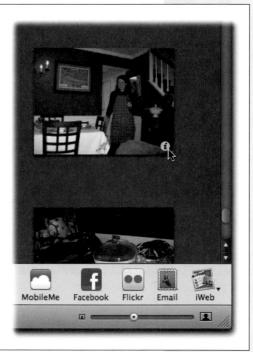

On the "back" of the photo, various bits of information appear, including the name (probably something super-creative like IMG_4576.JPG), the date it was taken, and the *place* where the photo was snapped.

Take a look at the location name or the pin on the miniature map in the center of the Info box; Figure 4-14 shows a geotagged sample. If the map is generally correct, then iPhoto has done its job.

Places

But GPS coordinates can sometimes be off by yards. Or, if the place is wrong and you know it (because you forgot to turn on the Location Services function of your iPhone, for example), don't worry. You can *manually* assign the photo to a place, as described in the next section.

Note: If all the photos in an Event have been geotagged, you get a map with multiple pins showing the various locations. Click the **①** for the Event itself to see it.

Manually Geotagging Photos

But what about photos that don't have geographical information embedded—like the 300 billion photos that have been taken with non-GPS cameras?

In that case, you can geotag them manually.

1. Select a photo (or an Event) or and click the **1** in the lower-right corner.

The photo spins around to reveal several fields of information, including the name of the picture.

2. Click "photo place." Start typing the name of the town, city, or landmark (*Washington Monument*) where the picture was taken.

As shown in Figure 4-12, a pop-up menu appears; iPhoto is trying guess what you're typing, to save you some effort (and spelling). If you see the location in the list, use the arrow keys on the keyboard to select it. Press Return to confirm your choice.

3. If the place you're typing doesn't appear on the list, then click Find on Map.

You're whisked away to the Add New Place screen, shown in Figure 4-13. Click the Google Search tab, and then type in the address (710 west end ave, ny ny, for example, or 2903 weybridge 44120, or the name of the landmark. Hit the Return key. Look at the list of possible matches. Click to select one and drop a yellow pin on the map.

Tip: Once the Google map finds your location, feel free to rename it *Grandma's House* or whatever. (Just click the address in the list at left to open the renaming box.) Later, you'll be able to use iPhoto's Search box to round up all the pictures that were taken at Grandma's House, just by typing *grandm*.

- 4. When the pin is in the right spot, click Assign to Photo.
- 5. When you've finished editing the photo's Info screen, click the Done button.

Tip: Once iPhoto knows where your pictures were taken—because you've geotagged them automatically or manually—that information is preserved if you upload the pictures to Flickr (page 194). Your admirers will be able to see where you took those photos using Flickr's geotag maps.

This approach is usually enough for most people. But if you have really obscure locations or off-the-beaten-path spots to find, you can dig even deeper on the Add New Place screen:

- If you still can't find your desired location with a Google search, get as close as you can to it on the map, and then drag the marker pin to the right place. You can zoom in and out of the map as needed.
- You can drag your way across the map itself—just bear down on the mouse button as you move around the screen.
- To add a really personal location—like a tiny, unnamed fishing lake in the middle of nowhere—type in the name of the nearest town in the Search field. Click the Drop Pin button in the box. When a fresh pin drops onto the map, drag it to the right spot, and then click the Assign to Photo button to plant it.

Figure 4-12:
As you type, iPhoto tries to guess where you're going. If you don't see your locale on the list, then click the New Place bar at the bottom of the list to jump out to the Edit My Places box. There, you get some Google muscle for further searching and a chance to place a location pin on the

map manually.

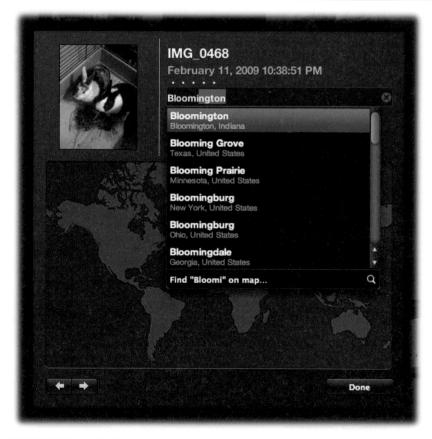

Places

Tip: Want to map photos or an Event to a general area ("Lake Harriet") instead of a specific one (the band shell, the bird sanctuary, the Peace Garden) when you're planting the pin on the map? Just tug the arrows on the edge of the blue circle under the pin to widen the diameter and cover the desired territory.

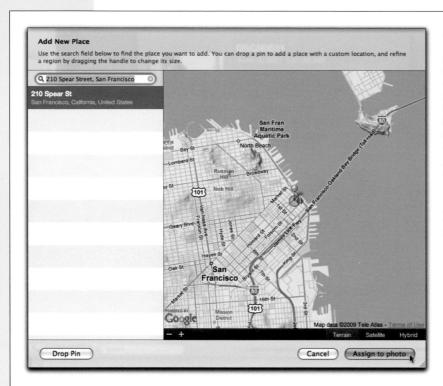

Figure 4-13:
The Add New Place screen gives you detailed search abilities and control over placing pins on the map. As you start typing an address here, iPhoto suggests similar addresses you've previously entered.

To see a list of all your tagged locales, choose Window→ Manage My Places.

Adding Additional Information to a Photo or Event

As you may have noticed, a picture's Info box has room for more information besides just its spot on the map. Here's a quick roundup of what the other controls (Figure 4-14) can do for you:

- Rename the photo. If you're tired of all your pictures being called IMG_this or DSC_that, then click the Name field at the very top of the Info box and type in a better title, like *Baby's first Jell-O parfait* or *Bath time!*
- Rate the photo. See those dots under the date and time line? Swipe the mouse along them to add the number of stars you think the picture deserves. (See page 88 for details on ratings.)
- Add a description. Along with a better title, you can also add details about what's in the photo: "Stevie's first at-bat in the T-ball game" or "Toboggan accident Day 3 of the trip to Liechtenstein."

- Zoom the map. Just below the map, click the + or keys to zoom in and out of the image, anywhere from a close-up street view to a world map.
- Enlarge the map. Next to the zoom buttons is a "Show in Places" option to see the picture in iPhoto's main screen, bigger and more detailed.
- Change the look of the map. With the labeled buttons on the right side of the Info box, you can choose to see the location three different ways: a cartographical Terrain view that shows street names and elevations, a Satellite view with an overhead photo of the area, or Hybrid—a combination of both.
- Move on to the next picture. Two arrows (← and →) sit at the very bottom of the box in the left corner. If you have a lot of photos to pin down to a place, then click the arrow that's pointing in the direction you want to go through your library. This lets you go from Info box to Info box, without having to select and spin each separate photo.

Figure 4-14:
A photo's Info box
can store quite a bit
of information about
it—like names, dates,
and ratings—which you
can use for searching or
making smart albums.
You also get a choice of
map styles and a quick
link to jump out to the
full Places view.

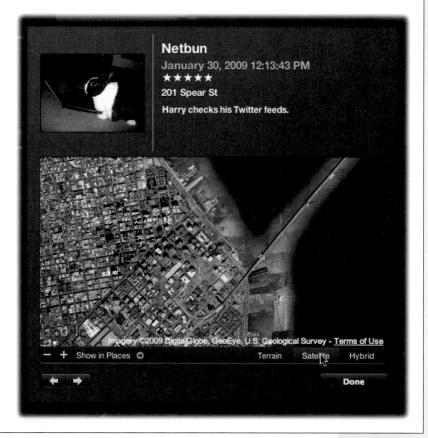

Tip: Once you've geotagged your photos, you can use iPhoto's Search box to find them. Click Events in the Source list, or a particular album. Then, in bottom of the iPhoto window, type what you're looking for, like San Francisco or Wrigley Field. Hit Return to see your results.

Going Places with Places

Now that your photos are geotagged, detailed, and ready, it's time to see how they look in iPhoto '09's Places view. Click Places in the Source list.

World view

In the World view shown in Figure 4-15, a global map fills the screen, festooned with little red pins representing all the pictures you've geotagged. To see the photos attached to a pin, point to that pin and click the **②** next to the place name.

Here are some ways to navigate the map:

- Zoom in by double-clicking on a pin until you get as close as you want.
- Zoom out of the map by Control-clicking (or right-clicking) twice.
- Zoom in or out by dragging the slider in the bottom-right corner of the iPhoto window.
- If you want to travel more incrementally, drag the map itself with the mouse to get to the part you want to see.
- See all your pins on the map at once by clicking the Zoom All button at the bottom of the iPhoto window and pulling back as far as necessary.

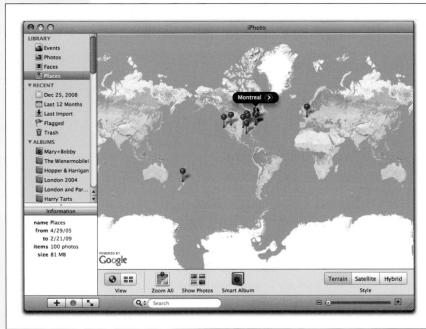

Figure 4-15:
Click the globe icon to see your photo locations in World view. Red pins mark every place on the map where you've got geotagged photos. Point to a pin to see the name of the location, and click the arrow next to it to see the photos themselves.

Along the bottom-right edge of the iPhoto window are buttons for the same three map types that you could see in the Info box's mini-map (page 107): Terrain, Satellite, and Hybrid.

To see all the photos you've mapped, click the Show Photos button at the bottom of the iPhoto window.

Tip: Here's an advanced tip: If your mouse has a scroll wheel on top, you can use it to zoom into iPhoto's maps, just as you can with (for example) Google Maps online. (This really saves a lot of click-stress on the ol' hand bones.) Turning on this feature for iPhoto, though, involves a little minor Mac surgery.

Quit iPhoto and then open the Mac's Terminal program (Applications—Utilities). Type the following command:

defaults write com.apple.iphoto MapScrollWheel -bool YES

Then press Return and quit Terminal.

When you restart iPhoto, you'll have gained the ability to scroll in and out of the Places map by turning the mouse's scroll wheel.

(To go back to the way things were, open Terminal and repeat the above command, but change YES to NO.)

For the lucky owners of MacBook laptops with Multi-Touch trackpads, the same surgery also makes possible two-finger zooming on the trackpad.

Browser view

The Map view is fun and all, but sometimes you want to see all your Places information grouped together in a good, old-fashioned list. Click the Browser button, identified in Figure 4-16.

Longtime fans of iTunes should instantly recognize this look: a series of lists in the top part of the window, and the actual items (photos here, not songs) in each list underneath. Four columns appear in the top part of the window, breaking down each location into smaller and smaller subcategories.

As shown in Figure 4-16, the column farthest to the left has the big overall location: the individual countries where you have tagged photos. As you move to the right, countries get divided into states or provinces, which get narrowed down to cities or towns. It can get as specific as a street address or a landmark, if you've gone that far in your geotagging frenzy.

To see all the photos you've taken in the United States, for example, click United States in the left column. To drill down to see all the photos taken in a particular state, click the state's name. Keep clicking across the columns to get to just the photos taken in a certain town or location.

Places

The photos from each set appear in the iPhoto window, so you can see them as you click through the columns. This trick makes Browser view a little more efficient for finding photos quickly if your Places map has more pins than an acupuncture class.

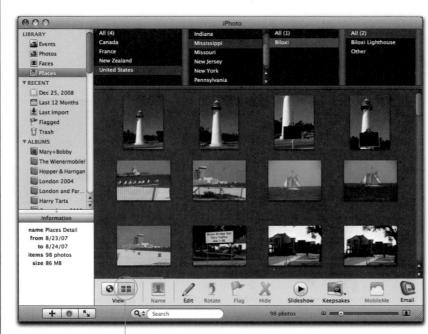

Figure 4-16: It's like iTunes for pictures! Click the Browser button in the iPhoto toolbar (circled here) to leave World view and go to a more text-based place.

The Browser view in iPhoto sorts your photo sets by country, state/province, town, and even down to a landmark, making it easy to pull out just the Biloxi photos from your national tour of America's vanishing lighthouses.

Browser button

Places for Your Smart Albums

Want a self-updating album of all the photos in a certain state or city? Smart albums (page 61) play nice with Places, too, as long as you tell them what you want. Setting up a location-aware smart album is fairly simple, as long as you have an Internet connection to keep the map info from Google flowing. Try this:

- 1. In the Source list, click Places.
- 2. If you've geotagged a photo, it's here somewhere. Click the World View icon at the bottom of the window.

Your own personal map of the world appears, complete with a red pin for every location you've every tagged in a photo.

3. Find the location you want to use for the smart album; click the red pin for it.
In a big blast of colorfull contrast, the red pin turns yellow.

4. Click the Smart Album icon at the bottom of the window.

A fresh, new smart album appears in the Source list, already sporting the name of the location you just chose.

You can also make a smart album that contains photos from *multiple* places. As shown in Figure 4-17, just zoom far enough into the map so that only the desired pinned locations are visible onscreen. Click the Smart Album button; all future photos with geotags in these locations will appear in the album.

Figure 4-17:

To make a smart album based multiple locations, zoom the map until it shows all the pinned places you want to include. Click the Smart Album button at the bottom of the window to make a self-updatina album that includes photos tagged from all these places. It appears in the Source list under an unwieldy name like "United Kinadom. France and more" but you can click to rename it something a little catchier, like "Europe."

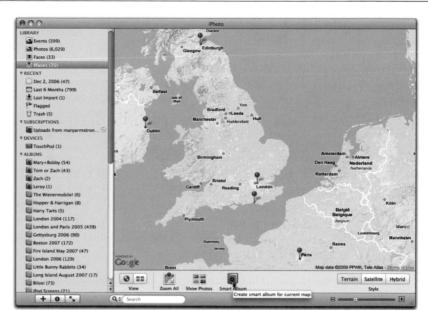

If you don't happen to be online at the time (*the horror!*), you can still set up a smart album without looking at the map:

- 1. Option-click the 🌣 button at the bottom of the iPhoto Source list.
 - The Smart Album box slides down from the top of the iPhoto window.
- 2. Type in a name for the album. Set up the pop-up menus to say "Place" and "contains." In the remaining box, type the location you want to use, like *Pittsburgh* or *Grand Canyon*, and then click OK.

Your new smart album rounds up the photos that match the Place criteria. It also keeps an eye out for photos with matching geotags that may arrive in the future.

Tip: You can commemorate all this geotagging work with a custom map that can be added to a book of your photos. Page 234 has the details.

Editing Your Shots

Straight from the camera, digital snapshots often need a little bit of help. A photo may be too dark or too light. The colors may be too bluish or too yellowish. The focus may be a little blurry, the camera may have been tilted slightly, or the composition may be somewhat off.

Fortunately, one of the amazing things about digital photography is that you can finetune images in ways that, in the world of traditional photography, would require a fully equipped darkroom, several bottles of smelly chemicals, and an X-Acto knife.

OK, iPhoto isn't a full-blown photo-editing program like Adobe Photoshop, but it's getting closer in every version. This chapter shows you how to use each of the tools in iPhoto's digital darkroom to spruce up your photos—and how to edit your photos in other programs if more radical image enhancement is needed.

Editing in iPhoto

You can't paint in additional elements, mask out unwanted backgrounds, or apply 50 different special effects filters with iPhoto, as you can with editing programs like Photoshop. Nonetheless, iPhoto is well-equipped to handle most basic (and not-so-basic) photo fix-up tasks: rotating, cropping, straightening, fixing red-eye, color correction, special effects (like black and white or sepia tone), and tweaking brightness, contrast, saturation, color tint, exposure, shadows, highlights, and sharpness.

Now, all of iPhoto's editing tools live on a toolbar at the bottom of the window. But which window? And how do you get there?

Over the years, Apple has supplied more and more answers to these questions; in hopes of accommodating every conceivable working style, Apple has designed iPhoto

Editing in iPhoto

to offer three different editing-window styles, three different ways to get there, and two different degrees of directness.

Choosing an Editing Window

iPhoto gives you three ways to edit a photo:

- Right in the iPhoto window. *Pros:* You don't lose your bearings; all of the familiar landmarks, including the Source list, remain visible. Simple and reassuring. *Cons:* The picture isn't very big, since it has to fit inside the main iPhoto window.
- In full-screen mode. *Pros*: The photo fills your entire monitor, as big and dramatic as you can possibly see it (at least without upgrading to a bigger screen). Elements like the menu bar, Source list, and thumbnails display are temporarily hidden. *Cons*: You've left the familiar iPhoto world behind; it's almost like you're working in a different program.
- In another program. It's one of iPhoto's slickest tricks: You can set things up so that double-clicking a photo in iPhoto opens it up in a totally different program, like Photoshop. You edit, you save your changes, you return to iPhoto—and presto, the changes you made, apparently behind iPhoto's back, are reflected right there in iPhoto. You can even use the Revert to Original command (page 143) to bring back the original photo later, if necessary.

Pros: Other programs have a lot more editing power. For example, the Auto Levels command in Photoshop and Photoshop Elements is still a better color fixer than iPhoto's Enhance button. Photoshop-type programs are also necessary if you want to scale a photo up or down to specific pixel dimensions, superimpose text on a photo, combine several photos into one (a collage), apply special-effect filters like Stained Glass or Watercolor, or adjust colors in just a *portion* of a photo.

Cons: Well, you're using two programs instead of one. And nobody ever said Photoshop was cheap (although Photoshop Elements has most of the power with a much lower price tag).

Note: iPhoto veterans may notice that Apple has retired a fourth way of opening a photo for editing—in a floating window of its own. Enough was enough.

Getting to Your Favorite Editing Window

To make the matrix of possibilities even more complex, there are at least three ways to get to each of those editing windows:

• Choosing your "most of the time" favorite. Choose iPhoto→Preferences; from the "Edit photo" pop-up menu, specify which of the three editing modes you prefer, as shown in Figure 5-1.

Note: If you choose "In application" from this pop-up menu, a standard Open dialog box appears. You're being asked to specify which external program you'll want to use for your editing (Photoshop, for example). Choose the program you want, and then click Open.

Editing in iPhoto

You've just specified what happens when you open any photo for editing (by clicking the Edit button, for example).

• Opening different editing windows on the fly. Even though you've now told iPhoto which editing window you want to use most of the time, you can still choose a different one *now and then* without having to haul yourself back to Preferences to change the setting.

Figure 5-1:

On the General pane of Preferences, you can specify how and where you want to do most of your editing.

From the "Edit photo" pop-up menu, choose your favorite editing style: "In main window," "Using full screen," or "In Application..." using an external editing program like Photoshop.

While you're here, you can tell iPhoto that you want to double-click a photo to enter Edit mode directly.

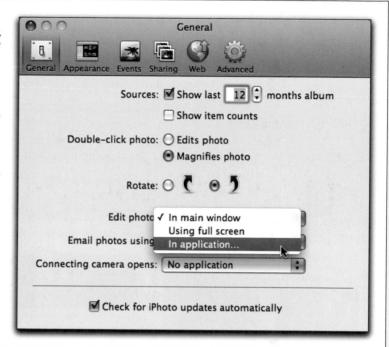

At any time, right out in the thumbnails view, you can Control-click (or right-click) a thumbnail or a photo in its own window; from the shortcut menu, choose "Edit," "Edit using full screen," or "Edit in external editor," depending on your preference.

Tip: There's even a shorter shortcut if you want to open a photo in full-screen mode: Click the little Full Screen icon () beneath the Source list.

What a Double-Click Does

So much red tape, and you still haven't started editing a single photo!

You have one last decision to make, though: what you want iPhoto to do when you double-click a photo thumbnail.

Ordinarily, double-clicking just opens a photo to fill the iPhoto window, so you can get a closer look at it. (No editing tools are available.) Clicking again returns to the

Editing in iPhoto

thumbnails screen. It's a handy way to work in iPhoto '09, and it has its charms—especially if you do more looking than editing.

But the Preferences dialog box (Figure 5-1) offers an alternative meaning for the double-click: opening a photo directly into your chosen editing mode.

This decision is another personal one. If you find that you're usually opening a photo because you want to edit it, then choose "Edits photo" in the Preferences dialog box.

The Toolbar and Thumbnails Browser

In both iPhoto editing window styles, you have at your disposal a *thumbnails browser* at the top of the screen (so you can choose a different photo to work on) and an *editing toolbar* at the bottom (so you can fix up what you're seeing). But you may not see both of these strips unless you know how they work.

• When you're editing in the iPhoto window, the toolbar is always visible at the bottom of the screen. You can hide the thumbnails browser, though, to make more room for the photo: Choose View—Thumbnails—Hide, or just press Option—第-T.

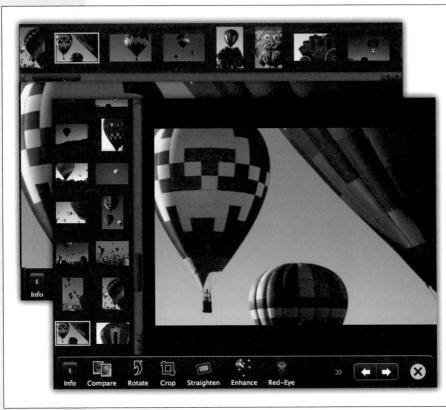

Figure 5-2: Left: Ordinarily, the thumbnails browser appears at the top.

Right: But the browser can appear on either side of the screen—and it can show more than one row or column of thumbnails.

When your cursor moves toward the middle of the screen, the thumbnails and toolbar disappear, making more room for you to enjoy your photograph.

The Toolbar & Thumbnails Browser

Even with the thumbnails browser hidden, you can still move from one photo to the next by pressing the arrow keys on your keyboard.

• When you're in **full-screen mode**, both the toolbar and the thumbnails browser are *self-hiding*. They don't appear unless you push your cursor to the top or the bottom of the screen for a moment.

If you prefer, you can force one or both to remain on the screen all the time, rather than hiding when they're feeling unwanted. Just slide your mouse to the top of the screen so that the menu bar appears. Now choose View—Thumbnails—Always Show or View—Show Toolbar. The thumbnails browser or toolbar now sticks around, even when your cursor is in the middle of the screen. (To restore the self-hiding behavior, choose View—Autohide Toolbar or View—Thumbnails—Autohide Thumbnails.)

Tip: While you're fooling around in the View menu, don't miss some of the cool options for the thumbnails browser. Using the Thumbnails submenu, you can park that browser filmstrip on the side of the screen (left or right)—and you can summon a double, triple, or even quadruple row of thumbnails, as shown in Figure 5-2.

Notes on Full-Screen Mode

Mac screens come in all sizes and resolutions these days, but one thing is for sure: Even the biggest ones usually can't show you an entire digital photo at full size. A 5-megapixel photo (2784×1856), for example, is still too big to fit entirely on Apple's 30-inch Cinema Display (2560×1600 pixels) without shrinking it.

The bottom line: For most of your iPhoto career, you'll be working with scaled-down versions of your photos. That's a particular shame when it comes to *editing* those photos, when you need as much clarity and detail as possible.

That's why the invention of full-screen mode is such a big deal. In this mode, the selected photo is magnified to fill your entire screen. You don't sacrifice a single pixel to menu bars, toolbars, window edges, or other screen-eating elements. It's *awesome*.

Here's what you need to know about full-screen mode:

• The Compare button (at the left end of the self-hiding toolbar) displays the currently selected photo and the one to its right, side-by-side, for handy comparison. To compare the original photo with a different shot, **%**-click the comparison shot you want from the thumbnails browser described above.

To restore the single-photo view, click the Compare button again.

Note: Suppose you're looking at Photo A. When you click the Compare button, iPhoto shrinks Photo A so that you can see Photo B beside it.

At this point, however, Photo B is highlighted, meaning that iPhoto now thinks *that's* the picture you want to work on. So if you click Compare again to turn the effect off, you'll be left with Photo B filling the screen.

Notes on Full-Screen Mode • You're not limited to comparing *two* photos side by side. You can compare three, four, or however many your screen can hold.

If you're the kind of person who thinks ahead, you can select a batch of pictures (using the techniques described on page 48) and *then* go to full-screen view. You'll see all those photos displayed.

If you're *already* in full-screen view, just **%**-click or Shift-click to select additional photos in the thumbnails browser, exactly as described on page 48. iPhoto makes room for all those photos. (To remove a photo from the comparison, **%**-click its thumbnail again.)

- If you click the little button at the left side of the toolbar (when it's visible), you summon a floating-palette version of the regular Info panel (page 64). Here, without leaving the comfort of full-screen view, you can rename a photo, edit its comments, and so on.
- Deleting a photo from full-screen view is really easy; just press the Delete key. The visible photo (or, if you were comparing some, the highlighted photo) immediately disappears. (It's in the iPhoto Trash.) The next photo in the album or library appears in its place.
- To exit full-screen view, either double-click a photo, tap the Esc key, or click the Exit Full-Screen button at the right end of the editing toolbar.

Notes on Zooming and Scrolling

Before you get deeply immersed in the editing process, it's well worth knowing how to zoom and scroll around, since chances are you'll be doing quite a bit of it.

Zooming in Either Editing View

In either of iPhoto's editing views, you can press the number keys on your key-board—0, 1, and 2—to zoom. Hit 1 to zoom in so far that you're viewing every single pixel (colored dot) in the photo; that is, one pixel of the photo occupies one pixel of your screen. The photo is usually bigger than your screen at this point, so you're now viewing only a portion of the whole—but it's great for detail work.

Hit 2 to double that magnification level. Now each pixel of the original picture consumes *four* pixels of your screen, a handy superzoom level when you're trying to edit individual skin cells.

Finally, when you've had quite enough of superzooming, tap your zero (0) key to zoom out again so the whole photo fits in the window.

Zooming in Full-Screen View

Even though you're getting the biggest view of your photo ever available in iPhoto, that's not the end of the magnification possibilities. You can use the Size slider at the bottom of the window (or the 0, 1, or 2 keystroke) to blow it up even more. In fact,

once the photo is enlarged so that it no longer fits on the screen, a handy little navigation panel appears (Figure 5-3). You can change your position on the super-enlarged photo by dragging the tiny "You are here" rectangle within the Navigator.

Figure 5-3:

When you're zoomed in close in iPhoto's full-screen view, the Navigator window appears to help you find your way around your photo. You can move to different areas of the image by dragging the tiny colored rectangle.

Scrolling Tricks (Any Editing View)

Once you've zoomed in, you can scroll the photo in any direction by pressing the space bar as you drag the mouse. That's more direct than fussing with two independent scroll bars.

Better yet, if your mouse has a scroll wheel on top (or a scroll pea, like the Mighty Mouse), you can scroll images up and down while zoomed in on them by turning that wheel. To scroll the zoomed area *horizontally*, press Shift while turning.

The "Before and After" Keystroke

After making any kind of edit, it's incredibly useful to compare the "before" and "after" versions of your photo. So useful, in fact, that Apple has dedicated one whole key (OK, two of the same) to that function: the Shift key on your keyboard.

Hold it down to see your unenhanced "before" photo; release it to see the "after" image.

By pressing and releasing the Shift key, you can toggle between the two versions of the photo to assess the results of the enhancement.

Backing Out

As long as you remain in Edit mode, you can back out of your changes no matter how many of them you've made. For example, if you've adjusted the Brightness and Contrast sliders, you can remove those changes using the Edit→Undo Brightness/Contrast command (ૠ-Z).

Notes on Zooming and Scrolling

The only catch is that you must back out of the changes one at a time. In other words, if you rotate a photo, crop it, and then change its contrast, you must use the Undo command three times—first to undo the contrast change, then to uncrop, and finally to unrotate.

But once you leave Edit mode—either by closing the photo's window, by pressing the Esc key, or by clicking the Done button—you lose the ability to undo your edits. At this point, the only way to restore your photo is to choose Photos—Revert to Original, which removes all the edits you've made to the photo since importing it.

Tip: If you edit your photos in the main iPhoto window, you'll be tempted by the presence of a big fat Done button that you can click when you're finished editing. But if you plan to edit another photo, you can save yourself a click by not clicking on the Done button, and clicking instead on another thumbnail at the top of the editing window. iPhoto saves the changes to your existing image and then opens the next one for you.

The Rotate Button

Unless your digital camera has a built-in orientation sensor, iPhoto imports all photos in landscape orientation (wider than they are tall). The program has no way of knowing if you turned the camera 90 degrees when you took your pictures. Once you've imported the photos, just select the sideways ones and rotate them into position (if you didn't do so during your first perusal of them, as described in Chapter 1).

Remember, you don't have to be in Edit mode to rotate photos. There's a Rotate button right there in the main Photos (thumbnails) view. Even there, you can use one of the following methods to turn them right-side up:

- Choose Photos→Rotate→Counter Clockwise (or Clockwise).
- Click the Rotate button at the bottom of the main iPhoto window. (Option-click this button to reverse the direction of the rotation.)
- Press **%**-R to rotate selected photos counterclockwise, or Option-**%**-R to rotate them clockwise.
- Control-click (or right-click) a photo and choose Rotate→Clockwise (or Counter Clockwise) from the shortcut menu.

Tip: After importing a batch of photos, you can save a lot of time and mousing if you select all the thumbnails that need rotating first (by **%**-clicking each, for example). Then use one of the rotation commands above to fix all the selected photos in one fell swoop.

Incidentally, clicking Rotate (or pressing **%**-R) generally rotates photos *counter-clockwise*, while Option-clicking that button (Option-**%**-R) generally rotates them clockwise. If you want, you can swap these directions by choosing iPhoto—Preferences and changing the Rotate setting on the General pane of the dialog box.

Cropping

Think of iPhoto's cropping tool as a digital paper cutter. It neatly shaves off unnecessary portions of a photo, leaving behind only the part you really want.

You'd be surprised at how many photographs can benefit from selective cropping. For example:

- Eliminate parts of a photo you just don't want. This is a great way to chop your brother's ex-girlfriend out of an otherwise perfect family portrait, for example (provided she was standing at the end of the lineup).
- Improve a photo's composition. Trimming a photo allows you to adjust where your subject matter appears within the frame of the picture. If you inspect the professionally shot photos in magazines or books, for example, you'll discover that many pros get more impact from a picture by cropping tightly around the subject, especially in portraits.
- Get rid of wasted space. Huge expanses of background sky that add nothing to a photo can be eliminated, keeping the focus on your subject.
- Fit a photo to specific proportions. If you're going to place your photos in a book layout (Chapter 9) or turn them into standard-size prints (Chapter 7), you may need to adjust their proportions. That's because there's a substantial discrepancy between the *aspect ratio* (length-to-width proportions) of your digital camera's photos and those of film cameras—a difference that will come back to haunt you if you order prints.

How to Crop a Photo

Here are the steps for cropping a photo:

1. Open the photo for editing.

You can use any of the methods mentioned earlier in this chapter.

2. Click Crop, or press the C key on your keyboard.

The Constrain pop-up menu appears, and a strange white rectangle superimposes itself on your photo (Figure 5-4).

3. Make a selection from the Constrain pop-up menu, if you like.

The Constrain pop-up menu controls the behavior of the cropping tool. When the menu is set to None, you can draw a cropping rectangle of any size and proportions, in essence going freehand.

When you choose one of the other options in the pop-up menu, however, iPhoto constrains the rectangle you draw to preset proportions. It prevents you from coloring outside the lines, so to speak.

The Constrain feature is especially important if you plan to order prints of your photos (Chapter 7). Prints come only in standard photo sizes: 4×6 , 5×7 , 8×10 ,

Cropping

and so on. You may recall, however, that most digital cameras produce photos whose proportions are 4:3 (width to height). This size is ideal for DVDs and iPhoto books, because standard television and iPhoto book layouts use 4:3 dimensions, too—but it doesn't divide evenly into standard print photograph sizes.

That's why the Constrain pop-up menu offers you canned choices like 4×6 , 5×7 , and so on. Limiting your cropping to one of these preset sizes guarantees that your cropped photos will fit perfectly into Kodak prints. (If you don't constrain your cropping this way, Kodak—not you—will decide how to crop them to fit.)

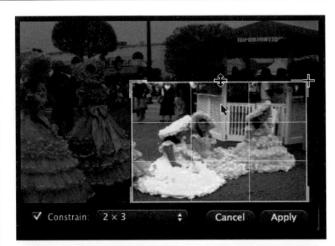

Figure 5-4:

When you crop a picture, you draw a rectangle in any direction using the crosshair pointer to define the part of the photo you want to keep. (You can no longer click to make the selection rectangle disappear entirely, but you can start a new drag, a new rectangle, as often as you like.)

As you drag, the tic-tac-toe grid appears, just in case you want to crop according to the Rule of Thirds. "Rule of whaaaa?" you say? The Rule of Thirds imagines that a photo frame is divided into thirds, both horizontally and vertically, and that these lines and their intersections are the strongest part of the frame. Better composition, the Rule contends, comes from putting the most interesting parts of the image at these four points.

Top: Here, in this improbable illustration, are the three different cursor shapes you may see, depending on where you move the pointer: the + crosshair for the initial drag, the double arrow for reshaping when you're near a boundary, and the arrow pointer for sliding the entire rectangle around the photo.

Bottom: Once you've drawn the rectangle and clicked Apply, the excess margin falls to the digital cutting-room floor, thus enlarging your subject.

Another crop-to-fit option in the Constrain menu lets you crop photos for use as a desktop picture "1024 × 768 [Display]" (or whatever your actual monitor's dimensions are). You'll also find an "Original" option here, which maintains the proportions of the original photo even as you make it smaller, and a Square option.

Tip: Here's a bonus feature: the item in the Constrain pop-up menu called Custom. Inside the two text boxes that appear, you can type any proportions you want: 4×7 , 15×32 , or whatever your eccentric design needs call for.

As soon as you make a selection from this pop-up menu, iPhoto draws a preliminary cropping rectangle—of the proper dimensions—on the screen, turning everything outside it darker.

By the way, iPhoto thinks hard about how to display this rectangle—that is, whether it starts out in either landscape (horizontal) or portrait (vertical) orientation. The rectangle always starts out matching the photo itself: landscape for landscape photos, portrait for portrait photos. You can, however, reopen the Constrain pop-up menu and choose "Constrain as Portrait" or "Constrain as Landscape" to flop the selection rectangle 90 degrees.

Tip: Actually, there's a quicker way to rotate the selection from horizontal to vertical (or vice versa): Option-drag across the photo to draw a new selection rectangle. The selection rectangle crisply turns 90 degrees.

There are three situations when these selection-rectangle rotation tricks don't work. You can't change the rectangle's orientation if you've selected the "Original" option, because its whole point is to preserve the photo's original shape. The " 4×3 (DVD)" and " 16×9 (HD)" options, furthermore, are hard-coded in landscape mode, because they're intended to be shown on a TV set, and most people's TVs don't rotate.

Now, at this point, the cropping area that iPhoto suggests with its dark-margin rectangle may, as far as you're concerned, be just right. In that case, skip to step 6.

UP TO SPEED

When Cropping Problems Crop Up

Remember that cropping always shrinks your photos. Remove too many pixels, and your photo may end up too small (that is, with a resolution too low to print or display properly).

Here's an example: You start with a 1600×1200 pixel photo. Ordinarily, that's large enough to be printed as a high-quality, standard 8×10 portrait.

Then you go in and crop the shot. Now the composition is perfect, but your photo measures only 800×640 pixels. You've tossed out nearly a million and a half pixels.

The photo no longer has a resolution (pixels per inch) high enough to produce a top-quality 8×10 . The printer is forced

to blow up the photo to fill the specified paper size, producing visible, jagged-edged pixels in the printout. The 800×640 pixel version of your photo would make a great 4×5 print (if that were even a standard-size print), but pushing the print's size up further noticeably degrades the quality.

Therein lies a significant advantage of using a high-resolution digital camera (8 or 10 megapixels, for example). Because each shot starts out with such a high resolution, you can afford to shave away a few hundred thousand pixels and still have enough left over for good-sized, high-resolution prints.

Moral of the story: Know your photo's size and intended use—and don't crop out more photo than you can spare.

More often, though, you'll probably want to give the cropping job the benefit of your years of training and artistic sensibility by *redrawing* the cropping area.

4. Drag the corners of the cropping rectangle to adjust its size and shape. Or just create a new cropping rectangle by dragging diagonally across the portion of the picture that you want to *keep*.

As you drag across your photo, the part of the photo that iPhoto will eventually trim away is dimmed out once again (Figure 5-4).

Tip: Even if you've turned on one of the Constrain options in step 3, you can override the constraining by pressing the Shift key after you begin dragging.

Don't worry about getting your selection perfect, since iPhoto doesn't actually trim the photo until you click the Crop button.

5. Adjust the cropping, if necessary.

If the shape and size of your selection area are OK, but you want to adjust which part of the image is selected, then you can move the selection area without redrawing it. Position your mouse inside the selection so that the pointer turns into a hand icon. Then drag the existing rectangle where you want it.

You can also change the rectangle's size. Move your cursor close to any edge or corner so that it changes to a + shape (near the corner) or a double-headed arrow (near the edge). Now you can drag the edge or corner to reshape the rectangle.

If you get cold feet, you can cancel the operation by clicking Cancel or tapping the Esc key.

Note: Despite its elaborate control over the relative dimensions of your cropping rectangle, iPhoto won't tell you its actual size, in pixels. Therefore, if you want to crop a photo to precise pixel dimensions, you must do the job in another program, like Photoshop Elements. (See page 142 for instructions on flipping into a different editing program.)

6. When the cropping rectangle is just the way you want it, click the Apply button, or just press Return.

If throwing away all those cropped-out pixels makes you nervous, relax. If you realize immediately that you've made a cropping mistake, then you can choose Edit — Undo Crop Photo to restore your original. If you have regrets *weeks* later, on the other hand, then you can always select the photo and choose Photos — Revert to Original. After asking if you're sure, iPhoto promptly reinstates the original photo from its backup, discarding every change you've ever made.

Note: When you crop a photo, you're changing it in all the albums in which it appears (page 55). If you want a photo to appear cropped in one album but not in another, you must duplicate it (highlight it and then choose Photos—Duplicate), and then edit each version separately.

Straightening

Many a photographer has remarked that it's harder to keep the horizon straight when composing images on a digital camera's LCD screen than when looking through an optical (eyepiece) viewfinder. Whether that's true or not, off-axis, tilted photos are a fact of photography, and especially of scanning—and iPhoto makes fixing them incredibly easy. Figure 5-5 shows the secrets of the Straighten slider.

Figure 5-5:
The minute you click the Straighten button, iPhoto superimposes a yellow grid on your picture. By moving the slider in either direction, you rotate the image. Use the yellow grid to help you align the horizontal or vertical lines in the photo.

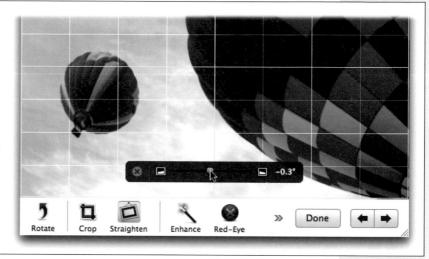

Now, if you think about it, you can't rotate a rectangular photo without introducing skinny empty triangles at the corners of its "frame." Fortunately, iPhoto sneakily eliminates that problem by very slightly magnifying the photo as you straighten it. Now you're *losing* skinny triangles at the corners, but at least you don't see empty triangular gaps when the straightening is over.

In other words, the straightening tool isn't a free lunch. Straightening an image decreases the picture quality slightly (by blowing up the picture, thus lowering the resolution) and clips off tiny scraps at the corners. You have to view the before and after pictures side by side at high magnification to see the difference, but it's there.

So, as cool as the Straighten slider is, it's not a substitute for careful composition with your camera. However, it can help you salvage an otherwise wonderful image that's skewed. (And besides—if you lose a tiny bit of clarity in the straightening process, you can always apply a little sharpening afterward. Read on.)

The Enhance Button

The Enhance button provides a simple way to improve the appearance of less-thanperfect digital photos. You click one button to make colors brighter, skin tones warmer, and details sharper (Figure 5-6). It's a lot like the Auto Levels command in Photoshop.

The Enhance Button

In iPhoto '09, Apple seriously enhanced the Enhance button, helping itself to the professional version in its Aperture photo program. It's almost pure magic now.

As before, the Enhance button analyzes the relative brightness of all the pixels in your photo and attempts to "balance" the image by dialing the brightness or contrast up or down and intensifying dull or grayish-looking color. In addition to this overall adjustment of brightness, contrast, and color, the program makes a particular effort to identify and bring out the subject of the photo. Usually, this approach makes pictures look at least somewhat richer and more vivid.

Figure 5-6:
The Enhance command works particularly well on photos that are slightly dark and that lack good contrast, like the original photo on the left.

To enhance a photo, just click the Enhance button. (You'll find it on the bottom toolbar in either any of iPhoto's editing views.) That's it—there's nothing to select first, and no controls to adjust.

You'll see the effects of your Enhance-button clicking in the histogram (page 132)—a great way to learn about what, exactly, the Enhance button is doing.

Tip: If using the Enhance command improves your photo, but just not enough, then you can click it repeatedly to amplify its effect—as many times as you want, really. However, applying Enhance more than three times or so risks turning your photo into digital mush.

If you go too far, remember that you can press \Re -Z (or choose Edit \rightarrow Undo) to backtrack. In fact, you can take back as many steps as you like, all the way back to the original photo.

Remember that iPhoto's image-correcting algorithms are just guesses at what your photo is supposed to look like. It has no way of knowing whether you've shot an overexposed, washed-out picture of a vividly colored sailboat—or a perfectly exposed picture of a pale-colored sailboat on an overcast day.

The Enhance Button

Consequently, you may find that Enhance has no real effect on some photos, and only minimally improves others. Remember, too, that you can't enhance just one part of a photo—only the entire picture at once. If you want to selectively adjust specific portions of a picture, you need a true photo-editing program like GraphicConverter or Photoshop Elements.

In some cases, you'll need to do more than just click the Enhance button to coax the best possible results from your digital photos. You may have to tweak away with the Brightness and Contrast sliders, as explained later in this chapter.

Red-Eye

Let's say you snap a near-perfect family portrait: The focus is sharp, the composition is balanced, everyone's smiling. And then you notice it: Uncle Mitch, standing dead center in the picture, looks like a vampire bat. His eyes are glowing red, as though illuminated by the evil within.

You've been victimized by *red-eye*, a common problem in flash photography. This creepy possessed-by-aliens look has ruined many an otherwise-great photo (Figure 5-7).

Red-eye is actually light reflected back from your subject's eyes. The bright light of your camera's flash passes through the pupil of each eye, illuminating the blood-red retinal tissue at the back of the eye. This illuminated tissue, in turn, is reflected back into the camera lens. Red-eye problems worsen when you shoot pictures in a dim

Figure 5-7:

Top: When you click the Red-Eye tool, a pop-up message informs you of the next step: Click carefully inside each affected eye.

Ninety-nine percent of the time, the Auto mode exorcizes the red-eye demons with godlike accuracy. But if you want to take matters into your own hands, you can go manual. A slider next to the Auto button lets you adjust the diameter of the crosshair tool. The idea is that now you can precisely correct the offending pupils; in reality, you'll probably end up undoing your work and going back to Auto.

Bottom: Truth be told, the Red-Eye tool doesn't know an eyeball from a pinkie toe. It just turns any red pixels black, regardless of what body part they're associated with. Friends and family members look more attractive—and less like Star Trek characters—after you touch up their phosphorescent red eyes with iPhoto.

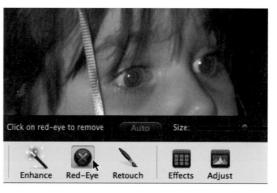

Red-Eye

room, because your subject's pupils are dilated wider, allowing even more light from the flash to illuminate the retina.

Turning up the room's lights or using the camera's red-eye reduction setting (if it has one) before you snap the shutter can help prevent the devil eyes. But if it's too late for that, and people's eyes are already glowing demonically, there's always iPhoto's Red-Eye tool. It lets you alleviate red-eye problems by digitally removing the offending red pixels.

Start by opening your photo for editing. Change the zoom setting, if necessary, so that you have a close-up view of the eye with the red-eye problem.

Now click the Red-Eye button. Most of the time, you can just click the Auto button. If iPhoto senses a face in the photo, it zaps the red-eye for you. If it doesn't, then use the crosshair pointer to click inside each red-tinted eye; with each click, iPhoto neutralizes the red pixels, painting the pupils solid black.

Retouching Freckles, Scratches, and Hairs

Sometimes an otherwise perfect portrait is spoiled by the tiniest of imperfections—a stray hair or an unsightly blemish, for example. Professional photographers, whether working digitally or in a traditional darkroom, routinely remove such minor imperfections from their final prints—a process known as *retouching*, for clients known as *self-conscious*.

iPhoto's Retouch brush lets you do the same thing with your own digital photos. You can paint away scratches, spots, hairs, or any other small flaws in your photos with a few quick strokes.

The operative word here is *small*. The Retouch brush can't completely erase some-body's mustache. It's intended for tiny touch-ups that don't involve repainting whole sections of a photo. (For that kind of photo overhaul, you need a dedicated photoediting program.)

The Retouch brush works its magic by blending the colors in the tiny area that you're fixing. It doesn't *cover* the imperfections you're trying to remove, but blurs them out by softly blending them into a small radius of surrounding pixels. You can see the effect in Figure 5-8.

Tip: The Retouch brush is particularly useful if your photo library contains traditional photographs that you've scanned in. You can use it to wipe away the dust specks and scratches that often appear on film negatives and prints, or those that are introduced when you scan the photos.

Using the Retouch Brush

The Retouch brush appears at the bottom of the window as soon as you open a photo for editing. Once you've selected the Retouch brush, your pointer turns into a small

dotted-line circle. Find the imperfection and "paint" over it, either dabbing or dragging to blend it with the surrounding portion of the picture. You can also use the Size slider to make the Retouch brush size match the size of the unfortunate feature.

Figure 5-8:
Most of the time,
the Retouch brush
works like magic;
sometimes, it creates
bizarre artifacts. In
those cases, hit %-Z
to undo your latest
stroke.

Overall, though, you can see how the Retouch brush can help an original photo (left) by softening wrinkles and hiding blemishes (right), like an application of digital Botox.

Don't overdo it: If you apply too much retouching, the area you're working on starts to look noticeably blurry and unnatural, as if someone smeared Vaseline on it.

Still, if you've used the Retouch brush in previous iPhoto versions, you'll be amazed at how well it works in '09. Here again, Apple cannibalized its own professional software program (Aperture) to give the iPhoto tools a huge upgrade; the Retouch brush in iPhoto is now very powerful indeed. You can paint out not just zits and wrinkles, but even entire shirt stains.

Fortunately, you can use the Edit→Undo command (**%**-Z) to take back as many of your brush strokes as necessary.

Note: On high-resolution photos, it can take a moment or two for iPhoto to process each individual stroke of the Retouch brush. If you don't see any results, wait a second for iPhoto to catch up with you.

The Effects Palette

It's hard to imagine that Apple added this feature because the masses were screaming for it, but never mind. It's here if you want it: a set of five photo effects (like Black & White and Antique), plus three effects that soften a photo's borders.

To open this palette, click the Effects icon shown in Figure 5-9, or tap the letter E key. No matter which editing view you're in (in-window or full-screen), the floating, tic-tac-toe–looking Effects palette appears (also shown in Figure 5-9).

Retouching Freckles, Scratches, and Hairs

There's nothing to it. Click a button to apply the appropriate effect to the photo in front of you:

• B & W (Black and White), Sepia. These tools drain the color from your photos. B & W converts them into moody grayscale images (a great technique if you're going for that Ansel Adams look); Sepia repaints them entirely in shades of antique brown (as though they were 1865 daguerreotypes).

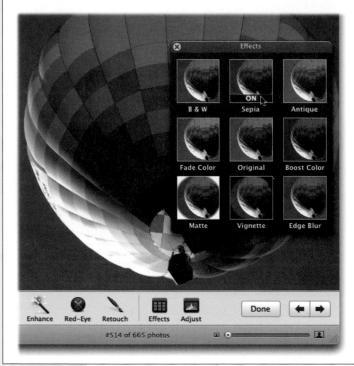

Figure 5-9:

By clicking the Effects button while in Edit mode, you can summon a free-floating palette filled with eight different clickable effects, good for a solid 10 minutes of photo-editing fun.

Shown here is the Sepia effect.

- Antique. A heck of a lot like Sepia, but not quite as severe. Still gets light brownish, but preserves some of the original color—like, say, a photo from the 1940s.
- Fade Color. The colors get quite a bit faded, like a photo from the 1960s.
- Original. Click this center button to undo all the playing you've done so far, taking the photo back to the way it was when you first opened the Effects palette.
- Boost Color. Increases the color saturation, making colors look more vivid.
- Matte. This effect whites out the outer portion of the photo, creating an oval-shaped frame around the center portion.
- Vignette. Same idea as Matte, except that the image darkens toward the outer edges instead of lightening.

• Edge Blur. Same idea again, except instead of creating an oval of white or black around the photo, it creates an out-of-focus oval. The main, central portion of the photo is left in focus.

Tip: You can click any of these Effects buttons repeatedly to intensify the effect. With each click, a number appears on that Effects tile, letting you know how many times you've applied the effect. You can use the forward and reverse arrows on either side of the digit to increase or decrease the effect.

The Adjust Panel

For thousands of people, the handful of basic image-fixing tools described on the previous pages offer plenty of power. But power users don't like having to trot off to a program like Photoshop to make more advanced changes to their pictures, like fiddling with saturation (the intensity of colors) or sharpness.

That's where the Adjust panel comes in (Figure 5-10). It appears whenever you click the Adjust button in either of iPhoto's editing views.

Now, before you let the following pages turn you into a tweak geek, here are some preliminary words of advice concerning the Adjust panel:

• When to use it. Plenty of photos need no help at all. They look fantastic right out of the camera. And plenty of others are ready for prime time after only a single click of the Enhance button described earlier.

The beauty of the Adjust panel, though, is that it permits infinite *gradations* of the changes that the Enhance button makes. For example, if a photo looks too dark and murky, you can bring details out of the shadows without blowing out the highlights. If the snow in a skiing shot looks too bluish, you can de-blue it. If the colors don't pop quite enough in the prize-winning soccer goal shot, you can boost their saturation levels.

In short, there are fixes the Adjust panel can make that no one-click magic button can touch.

- How to play. You can fiddle with an Adjust panel slider in any of three ways, as illustrated in Figure 5-10.
- Backing out. You can always apply the Undo and Revert to Original commands to the work you perform with the Adjust panel. But the panel also has its own Reset button, which essentially means, "Undo all the Adjust-panel changes I've made during this session."

Tip: The Reset button is also useful when you just want to play around with an image. You can make some adjustments, see how they look, and then hit Reset before closing the window or clicking the Done button. In this case, iPhoto leaves the photo just as it was.

The Adjust Panel

• Moving on. The Adjust panel is a see-through, floating entity that lives in a plane of its own. You can drag it anywhere on the screen, and—here's the part that might not occur to you—you can move on to a different photo without having to close the panel first. (Click another photo among the thumbnails at the top of the screen, for example, or click the big Previous and Next arrows at the bottom.)

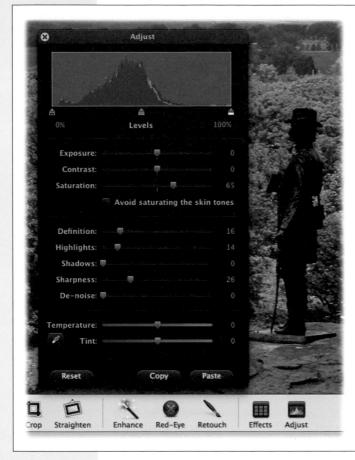

Figure 5-10:

When the Enhance button just doesn't get the results you want, it's time to call up the Adjust panel, which gives you control over many visual aspects of the photo. There are three ways to manipulate the sliders, depending on the degree of fine-tuning you need to do.

You can drag the handle of a slider, of course, but that doesn't give you much accuracy. Sometimes you may prefer to click directly on the slider, which makes the handle jump to the spot. Finally, you can click repeatedly on the ending icons to move the handle in very fine increments.

Introduction to the Histogram

Learning to use the Adjust panel effectively involves learning about its *histogram*, the colorful little graph at the top of the panel.

The histogram is the heart of the Adjust panel. It's a self-updating visual representation of the dark and light tones that make up your photograph. If you've never encountered a histogram before, this may sound a little complicated. But the Adjust panel's histogram is a terrific tool, and it'll make more sense the more you work with it.

Within each of the superimposed graphs (red, blue, green), the scheme is the same: The amount of the photo's darker shades appears toward the left side of the graph; the lighter tones are graphed on the right side.

Therefore, in a very dark photograph—a coal mine at midnight, say—you'll see big mountain peaks at the left side of the graph, trailing off to nothing toward the right. A shot of a brilliantly sunny snowscape, on the other hand, will show lots of information on the right and probably very little on the left.

Those peaks represent the areas in the photo where there's a lot of information. Histograms showing peaks throughout the graph reflect a photo that's balanced, with no super-dark areas or blown-out light areas making steep peaks stacked against the left or right sides. These middle mountains are fine, as long as you have some visual information in other parts of the histogram, too.

The histogram for a *bad* photo, on the other hand—a severely under- or overexposed one—has mountains all bunched at one end or the other. Rescuing those pictures involves spreading the mountains across the entire spectrum, which is what the Adjust panel is all about.

Three Channels

As noted above, the histogram actually displays three superimposed graphs at once. These layers—red, green, and blue—represent the three "channels" of a color photo.

When you make adjustments to a photo's brightness values—for example, when you drag the Exposure slider just below the histogram—you'll see the graphs in all three channels move in unison. Despite changing shape, they essentially stick together. Later, when you make color adjustments using, say, the Temperature slider, you'll see those individual channels move in different directions.

Adjusting the Levels

If the mountains of your graph seem to cover all the territory from left to right, you already have a roughly even distribution of dark and light tones in your picture, so you're probably in good shape. But if the graph comes up short on either the left (darks) or the right (lights) side of the histogram, you might want to make an adjustment.

To do so, drag the right or left pointer on the Levels slider *inward*, toward the base of the "mountain" (Figure 5-11). If you're moving the *right* indicator inward, for example, you'll notice that the whites become brighter, but the dark areas stay pretty much the same; if you drag the *left* indicator inward, the dark tones change, but the highlights remain steady.

Tip: Instead of dragging these handles inward, you can click the slider track itself at the outer base of the mountain. That's faster and gives you better control of the handle's landing point.

Introduction to the Histogram In general, you should avoid moving these endpoint handles inward *beyond* the outer edges of the mountains. Doing so adds contrast, but it also throws away whatever data is outside the handles, which generally makes for a lower quality printout.

Once you have your endpoints set, then turn your attention to the middle marker. This adjustment controls the midtones. The general rule is that you *center* the midtone marker between the shadow marker on the left and the highlight marker on the right. Often, the result is a pleasing rendition of the photo. But you can adjust to taste, too; inching the marker to the left lightens the midtones; moving it to the right darkens them.

Figure 5-11:
Top: One way to fix an image that looks too "flat" is to use the Levels adjustment. Notice how the tonal information is bunched up in the middle of the histogram, with no true highlights or shadows.

Bottom: Move the left and right sliders in, toward the edges of the histogram data, to improve highlights and shadows.

Exposure

In the simplest terms, the Exposure slider makes your picture lighter when you move it to the right and darker when you move it to the left.

Its effects differ slightly depending on the file's format:

- When you're editing JPEG graphics (that is, most photos from most cameras), the Exposure slider primarily affects the middle tones of a photo (as opposed to the brightest highlights and darkest shadows). If you're used to Photoshop, you may recognize this effect as a relative of its *gamma* controls. ("Gamma" refers to the middle tones in a picture.)
- When you're working with RAW files, however (page 23), Exposure is even more interesting. It actually changes the way iPhoto *interprets* the dark and light informa-

tion that your camera recorded when it took the picture. A photographer might say that it's like changing the ISO setting before taking the picture—except that now you can make this kind of change long *after* you snap the shutter.

The Exposure slider demonstrates one of the advantages of RAW. In a RAW file, iPhoto has a lot more image information to work with than in a JPEG file. As a result, you can make exposure adjustments without sacrificing the overall quality of the photograph.

Watch the data on the histogram as you move the Exposure slider. Make sure you don't wind up shoving any of the "mountain peaks" beyond the edges of the histogram box. If that happens, then you're discarding precious image data; when you print, you'll see a loss of detail in the darks and lights.

If you've already adjusted your image using the Levels controls, then you probably won't need to play with Exposure and Contrast. Most images can be fine-tuned with either set of controls (the three markers in Levels, or the dynamic duo of Exposure and Contrast). But very few pictures require both approaches.

Contrast

The Contrast slider changes the shape of the histogram by pushing the data out in both directions. Contrast is the difference between the darkest and lightest tones in your picture. If you increase the contrast, you "stretch out" the shape of the histogram, creating darker blacks and brighter whites (Figure 5-12). When you decrease

Figure 5-12: Instead of working with Levels, you can also use Exposure and Contrast to achieve the same effect shown in Figure 5-11.

Top: Use the Exposure slider to center the data in the middle of the histogram.

Bottom: Then use the Contrast slider to push the data toward both ends of the histoaram.

Contrast

the contrast, you're scrunching the shape of the histogram inward, shortening the distance between the dark and light endpoints. Since the image data now resides in the middle area of the graph, the overall tones in the picture are duller. Photographers might call this look "flat" or "muddy."

Contrast works especially well for these "flat" shots because a single slider moves the histogram in two directions at once (outward toward the edges). You can create a similar effect in Levels by moving the endpoints inward toward the edges of the histogram.

Which approach is better? If the histogram data is centered in the middle of the graph, then Contrast is the easier adjustment because it pushes the data outward evenly. But if the histogram data is skewed to one side or the other, then Levels is the better choice because you can adjust the highlights and shadows independently.

Saturation

Do your reds look washed out or your greens a little dark? You can increase or decrease the intensity of the photo's colors with the Saturation slider. Move it to the right to increase the intensity and to the left for less saturation.

The Adjust box can save you from yourself, at least when it comes to saturation. If you're trying to crank up the color of Cousin Jack's orange shirt—but want to avoid drenching Uncle Jack's face in hyped-up hues—then put a check in the box next to "Avoid saturating the skin tones" under the Saturation slider.

When you increase the saturation of a photo's colors, you make them more vivid; essentially, you make them "pop" more. You can also improve photos that have harsh, garish colors by dialing *down* the saturation so that the colors end up looking a little less intense than they appeared in the original snapshot. That's a useful trick in photos whose *composition* is so strong that the colors are almost distracting.

(iPhoto's Enhance button automatically adjusts saturation when "enhancing" your photos, but it provides no way to control the *degree* of its adjustment.)

FREQUENTLY ASKED QUESTION

Battle of the Sliders

All right, first you said that I can create a well-balanced histogram with the Exposure and Levels sliders. Then you said that the Brightness and Contrast sliders do pretty much the same thing. So which should I use?

Photography forums everywhere are overflowing with passionate comments advocating one approach over the other.

The bottom line is, for most normal JPEG photos, you can use whichever you prefer, as long as you wind up creating a histogram whose peaks generally span the entire graph.

If you have no preference, you may as well get into the habit of using the Exposure and Levels sliders. One day, when you begin editing super-high-quality RAW files (page 23), you'll appreciate the clever way these controls interpret the data from the camera's sensors with virtually no loss of quality.

Highlights and Shadows

Speaking of detail, the Highlights and Shadows sliders are designed to recover lost detail in the highlights and shadows of your photos, turning what once might have been unsalvageably overexposed or underexposed photos into usable shots (Figure 5-13).

Sure, you can find this kind of sophisticated adjustment in Adobe Camera RAW or Aperture—but a program designed for regular folks?

Figure 5-13:

Top: Even though the histogram looks good for this photo—it has a full range of darks and lights—there's a lot of detail lost in the shadows.

Bottom: Drag the Shadows slider to the right. Presto! A whole world of detail emerges from the murk.

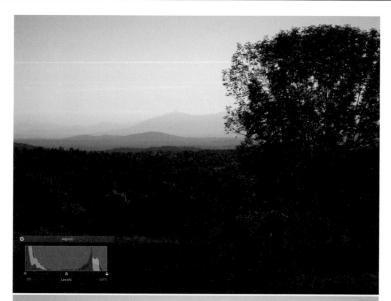

Highlights and Shadows Suppose you've got everything in the photo looking good, except that you don't have any detail in either the brightest parts of the shot or in murky, dark areas. All you have to do is drag the appropriate slider and watch as the detail magically appears from the murk (or the bleached-out brightness). Suddenly, you'll see texture in what was once a washed-out white wall, or detail in what used to be solid black (Figure 5-13), or discover that Uncle Bob's missing black cat was hiding under his chair all along.

You have to be a little careful; if you drag the Shadows slider too far, then everything takes on a strange, radioactive sheen. But used in moderation, these sliders work magic, especially if you're working with RAW files. (This feature, too, has been overhauled and improved in iPhoto '09.)

Definition

A photo's *definition* is its clarity. This slider is new in iPhoto '09, and its effect is hard to describe. Dragging this slider to the right can make a hazy or muddy photo a little bit sharper, but it's not the same as Sharpness, described below. Instead, it adjust the contrast in parts of the photo more delicately (rather than making major moves with the regular Contrast slider). Sometimes the result helps the photo; other times, its effects aren't necessarily an improvement.

Sharpness

The Sharpness command seems awfully tempting. Could technology really solve the problem of blurry, out-of-focus photos?

Well, no.

Instead, the Sharpness tool that appears in iPhoto works by subtly increasing the contrast among pixels in your photo, which seems to enhance the crispness. In pro circles, applying a soupçon of sharpening to a photo is a regular part of the routine.

In iPhoto, move the Sharpness slider to the right to increase the sharpness, or to the left to soften the look.

Now, too much sharpening can also *ruin* a photo, since eventually the pixels become grainy and weird-looking. Fortunately, Apple has mostly protected you from this sort of disaster by keeping both the effects and the side effects of the Sharpness control to a minimum. You can help matters by moving the slider in small increments.

Generally speaking, sharpening should be the last Adjust-panel adjustment you make to the picture. If you apply other corrections after sharpening, you may discover that you have to return and sharpen again.

Also, keep in mind that *softening* (or unsharpening) can be effective for portraits that are "too sharp," or for landscapes where you want to create a more dreamy effect. Sometimes applying just a little softening will smooth out skin tones and take the edge off the overall appearance of a portrait.

De-noise

De-noise

In photographic terms, *noise* means graininess—colored speckles. Noise is a common problem in digital photography, especially in low-light shots taken by inexpensive cameras, as in Figure 5-14. (Some cameras, for example, claim to have "anti-blur" features that turn out to be nothing more than goosed-up ISO [light-sensitivity] settings in low light. But over ISO 800 or so, the resulting digital noise can be truly hideous.)

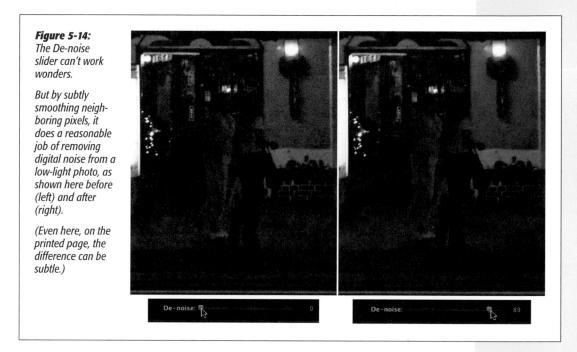

If a photo looks noisy (grainy), you can lessen the effect by moving the De-noise slider to the right. To gauge how much, first zoom in on your image to 100 percent size (press the 1 key); then keep an eye on an dark area or the sky as you move the slider. Generally speaking, moving the slider more than halfway softens your image too much. But a little noise reduction on a grainy shot can be a definite improvement.

Color Balance

If all you ever shoot is black-and-white photos, then Levels or Exposure/Contrast may be all you ever need. If you're like most people, though, you're also concerned about a little thing called color.

Truth is, digital cameras (and scanners) don't always capture color accurately. Digital photos sometimes have a slightly bluish or greenish tinge, producing dull colors, lower contrast, and sickly looking skin tones. In fact, the whole thing might have a faint green or magenta cast. Or maybe you just want to take color adjustment into

Color Balance

your own hands, not only to get the colors right, but also to create a specific mood. Maybe you want a snowy landscape to look icy blue, so friends back home realize just how darned cold it was!

In addition to the Saturation controls (page 136), the Adjust panel offers two other sliders that wield power over this sort of thing: Temperature and Tint. And it offers two ways to apply such changes: the manual way and the automatic way.

Manual Color Adjustment

These sliders in the bottom of the Adjust panel provide plenty of color adjustment power. The Tint and Temperature sliders govern the *white balance* of your photo. (Different kinds of light—fluorescent lighting, overcast skies, and so on—lend different color casts to photographs. White balance is a setting that eliminates or adjusts the color cast according to the lighting.)

For best results, start at the bottom slider and work your way upward.

- Tint. Like the tint control on a color TV, this slider adjusts the photo's overall tint along the red-green spectrum. Nudge the slider to the right for a greenish tint, left for red. As you go, watch the histogram to see how iPhoto is applying the color.
 - Adjusting this slider is particularly helpful for correcting skin tones and compensating for difficult lighting situations, like fluorescent lighting.
- Temperature. This slider, on the other hand, adjusts the photo along the blueorange spectrum. Move the slider to the left to make the image "cooler," or slightly bluish. Move the slider to the right to warm up the tones, making them more orangeish—a particularly handy technique for breathing life back into subjects

POWER USERS' CLINIC

Coping with Fluorescent Lighting

You can correct most pictures using the automatic graybalance feature or the Tint, Temperature, and Saturation sliders described in this chapter. Some images, however, will frustrate you—no amount of tweaking will seem to make their colors look realistic. Pictures taken under fluorescent lighting can be particularly troublesome.

The problem with fluorescent bulbs is that they don't produce light across the entire color spectrum; there are, in effect, spectrum gaps in their radiance. Your best color-correction tool, the Temperature slider, works only on images where a full spectrum of light was captured, so it doesn't work well on fluorescently lit shots.

You'll have some luck moving the Tint slider to the left to remove the green cast of fluorescent lighting. But the overall color balance still won't be as pleasing as with pictures shot under full-spectrum lighting, such as outside on a sunny day.

The best time to fix fluorescent-light color-balance problems, therefore, is at the moment you take the picture. Use the camera's flash, ensuring that it's the dominant light source, where possible. Its light helps to fill in the gaps in the fluorescent spectrum, making color correction much easier in iPhoto later.

Color Balance

who have been bleached white with a flash. A few notches to the right on the Temperature slider, and their skin tones look healthy once again!

Professional photographers *love* having color-temperature control; in fact, many photographers can handle the bulk of their image correction with nothing but the Exposure and Temperature controls.

Automatic Color Correction

Dragging the Tint and Temperature sliders by hand is one way to address color imbalances in a picture. But there's an easier way: iPhoto also contains a handy feature that adjusts both sliders *automatically*.

It relies on your ability to find, somewhere in your photo, an area of what *should* appear as medium gray or white. You can use either. Once you find the gray or white point, iPhoto can take it from there—it can adjust all the other colors in the photo accordingly, shifting color temperature and tint with a single click. This trick works amazingly well on some photos.

Before you use this feature, though, make sure you've already adjusted the overall *exposure* of the photo, using the steps described on the previous pages.

Figure 5-15: Once you have the tones corrected, you can properly adjust the color.

Click the eyedropper to activate Automatic Color Adjustment. Then position the crosshairs on a neutral gray or white area and click. iPhoto adjusts the whole photo's color for you, as shown here.

(Figure 5-11 shows this photo in its "before" condition, with some serious need for color adjustment.)

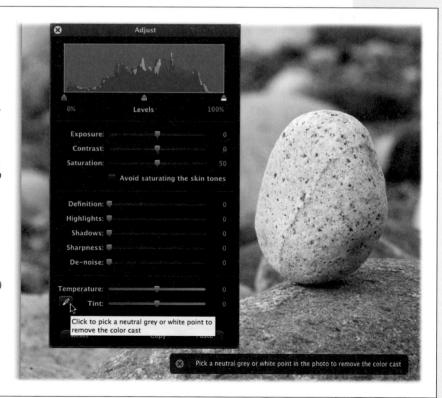

Color Balance

Next, scan your photo for an area that should appear as a neutral gray or clean white. Slightly dark grays are better for this purpose than bright, overexposed grays.

Once you've found such a spot, click the eyedropper icon next to the Tint slider. Your mouse pointer becomes crosshairs that you can position over your gray or white sample. Then simply click.

Instantly, iPhoto automatically adjusts the color-balance sliders to balance the overall color of the photo (Figure 5-15). If you don't like iPhoto's correction, then choose Edit→Undo, and then try again on a different neutral area.

Thankfully, there's a good way to check how well iPhoto corrected the image. Take a look at an area in the picture that should be plain white. If it's clean (no green or magenta tint), then you're probably in good shape; if not, then undo the adjustment and try again.

Tip: If you're a portrait photographer, here's a trick for magically correcting skin tones. The key is to plan ahead by stashing a photographer's gray card somewhere in the composition that can be cropped out of the final print. Make sure the card receives about the same amount of lighting as the subject.

Later, in iPhoto, click the gray card in the composition with the automatic color corrector, and presto: perfect skin tones. Now crop out the gray card and make your print, grateful for the time you've just saved.

Copy and Paste

Working an image into perfect shape can involve a lot of time and slider-tweaking. And sometimes, a whole batch of photos require the same fixes—photos you took all at the same time, for example.

Fortunately, you no longer have to re-create your masterful slider work on each of 200 photos, spending hours performing repetitive work. You can copy the adjustment settings from one photo and paste them onto others.

To do that, open the photo you've edited, open the Adjust panel, and click the Copy button at the bottom. Now move to the next shot (use the Thumbnails browser, for example) and then click the Paste button. All of your corrections are applied to the new picture. You can apply those copied settings to as many more photos as you wish.

Beyond iPhoto

Thanks to the Adjust panel, iPhoto's editing tools have come a long, long way. There's a lot less reason now to invest in a dedicated editing program.

But that doesn't mean that there are *no* reasons left. The Auto Levels command (in Photoshop and Photoshop Elements) is still a better color-fixer than iPhoto's Enhance button, and some people really like the "I'm Feeling Lucky" button in Picasa. Photoshop-type programs are also necessary if you want to superimpose text on a photo, combine several photos into one (a collage or a montage), apply special-effect filters like Stained Glass or Watercolor, or adjust the colors in just a *portion* of a photo.

Photoshop is by far the most popular tool for the job, but at about \$700, it's also one of the most expensive. Fortunately, you can save yourself some money by buying Photoshop Elements instead. It's a trimmed-down version of Photoshop with all the basic image-editing stuff and just enough of the high-end features. It costs less than \$150, and a free trial version is available online.

The Official Way

As noted at the beginning of this chapter, iPhoto makes it very easy to open a photo in another program for editing. You can either use the Preferences dialog box to specify that you always want to edit photos in an external program, or you can Control-click (or right-click) a thumbnail whenever the spirit moves you, and then choose "Edit in external editor" from the shortcut menu.

Either way, the external program opens the photo. When you make your changes and use the Save command, iPhoto registers (and displays) the changes. Best of all, the Revert to Original command is still available; that is, iPhoto "knows about" the external editing.

The Quick-and-Dirty Way

If you don't want to bother with setting up an external editor in Preferences, then you can also open a photo in another program by dragging its thumbnail *right out of the iPhoto window* and onto the other program's Dock icon.

In fact, you can drag several thumbnails at once to open all of them simultaneously.

Either way, they open in that other program, and you can edit happily away.

Caution: When you edit a photo in another program the "quick-and-dirty" way, you're essentially going behind iPhoto's back; the program doesn't have a chance to make a safety copy of the original. Therefore, you're sacrificing your ability to use the Revert to Original command (described below) to restore your photo to its original state in case of disaster.

Reverting to the Original

iPhoto includes built-in protection against overzealous editing—a feature that can save you much grief. If you end up cropping a photo too much, cranking up the brightness of a picture until it seems washed out, or accidentally turning someone's lips black with the Red-Eye tool, you can undo all your edits at once with the Revert to Original command. Revert to Original strips away every change you've ever made since the picture arrived from the camera. It leaves you with your original, unedited photo.

The secret of the Revert to Original command: Whenever you use any editing tools, iPhoto—without prompting and without informing you—instantly makes a duplicate of your original file. With an original version safely tucked away, iPhoto lets you go wild

Reverting to the Original on the copy. Consequently, you can remain secure in the knowledge that in a pinch, iPhoto can always restore an image to the state it was in when you first imported it.

Note: The unedited originals are stored in an Originals folder inside the iPhoto Library package (page 28). The edited versions are in a folder called Modified. (The Modified folder doesn't exist until you edit at least one photo.)

To restore an original photo, undoing all cropping, rotation, brightness adjustments, and so on, select a thumbnail of a photo. Then choose Photos—Revert to Original. Or Control-click (or right-click) a photo and choose Revert to Original from the shortcut menu. (When you're editing a photo, the command says Revert to Previous instead.) Now iPhoto swaps in the original version of the photo—and you're back where you started.

As noted earlier, iPhoto does its automatic backup trick whenever you edit your pictures (a) within iPhoto or (b) using a program that you've set up to open when you edit a picture. It does *not* make a backup when you drag a thumbnail onto the icon of another program. In that event, the Revert to Original command is dimmed when you select the edited photo.

Editing RAW Files

iPhoto can handle RAW—the special, unprocessed file type that takes up a lot of space on your memory card but offers astonishing amounts of control when editing later on the Mac. RAW is generally available only on high-end cameras.

Actually, iPhoto can do more than handle RAW files. It can even edit them...sort of.

iPhoto is, at its heart, a program designed to work with JPEG files. Therefore, when it grabs a RAW file from your camera, it instantly creates a JPEG version of it, which is what you actually see onscreen. The RAW file is there on your hard drive (deep within the labyrinth known as the iPhoto Library package).

But what you see *onscreen* is a JPEG interpretation of that RAW file. (This conversion to JPEG is one reason iPhoto takes longer to import RAW files from a camera than other kinds of files.)

This trick of using JPEG look-alikes as stand-ins for your actual RAW files has two important benefits. First, it lets you work with your photos at normal iPhoto speed, without the lumbering minutes of calculations you'd endure if you were working with the original RAW files. Second, remember that your iPhoto photos are also accessible from within iDVD, iMovie, iWeb, Pages, and so on—programs that don't recognize RAW files.

So the question naturally comes up: What happens if you try to *edit* one of these RAW-file stunt doubles?

Editing RAW Files

No problem. iPhoto accepts any changes you make to the JPEG version of the photo. Then, behind the scenes, it reinterprets the original RAW file, applying your edits. Finally, it generates a new JPEG for you to view.

External RAW Editors

It's nice that iPhoto comes with more powerful editing tools, and it's nice that you can use them with your original RAW files. Nevertheless, iPhoto still isn't Photoshop, and it still doesn't offer every conceivable editing tool. So what happens if you want to edit your RAW files in another program, while still using iPhoto to organize them? Here, life can get a little complicated.

First, choose iPhoto—Preferences and click the Advanced tab (Figure 5-16). Turn on "Use RAW files with external editor." You've just told iPhoto that you want to work with RAW files in a different program, which is probably Adobe Camera Raw (the RAW-file editor that comes with Photoshop).

Figure 5-16:

You can now send an edited RAW file out of iPhoto for more sophisticated editing in a program like Photoshop or Photoshop Elements with a quick double-click. The first step is to turn on the "Use RAW" checkbox in iPhoto's preferences.

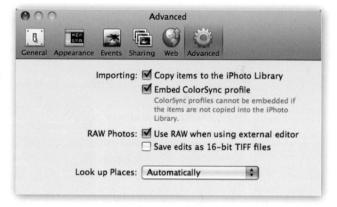

Now, when you open a RAW-file thumbnail for editing, one of two things may happen:

- If you've never edited this RAW file. It opens up in Adobe Camera Raw, ready for editing.
- If you had edited this file in iPhoto. In this situation, iPhoto sends the edited *JPEG* file to Camera Raw instead of the RAW file! And that's probably not what you wanted.

You can correct this case of mistaken identity by closing the photo and returning to iPhoto. Click the RAW file's thumbnail and then choose Photos—Reprocess Raw command. (That's what the Revert to Original command becomes when you' re working with RAW files.) iPhoto strips away your previous edits.

Editing RAW Files

Now you can double-click the picture to open it in your external RAW editor.

But beware! You can't just click the Save button and smile, confident that you'll see the edited version of the photo when you return to iPhoto. (That may be how things work with JPEG graphics, as described earlier in this chapter—but not with RAW-format files.)

Instead, you must use Camera Raw's Save As command to save the edited picture as a *new file* on your hard drive. You'll probably want to export it as a JPEG file, because that's the easiest format to work with in the iLife programs, email, Web, and so on. (Remember, your original RAW file is still tucked away safely in the iPhoto library if you want to revisit it. All you have to do is double-click its thumbnail again, and you're right back in Camera Raw.)

When you click Save, a JPEG version of your edited RAW file is waiting for you on the Desktop. Click Done in Adobe Camera Raw to make it go away.

Your last step, believe it or not, is to *reimport* the edited JPEG file back into iPhoto. First, though, you may want to make sure that the file number (say, IMG_6268.jpg) is the same as the original RAW version in iPhoto (IMG_6268.CR2). Why? Because

FREQUENTLY ASKED QUESTION

In iPhoto, Less is More

I just finished editing a batch of photos, cropping each picture to a much smaller size. But now my iPhoto Library file is taking up more space on my hard drive! How can making the photos smaller increase the size of my photo collection? Shouldn't throwing away all those pixels have the opposite effect—shrinking things down?

Your cropped photos do, in fact, take up much less space than they previously did. Remember, though, that iPhoto doesn't let you monkey with your photos without first stashing away a copy of each original photo, in case you ever want to use the Revert to Original command to restore a photo to its original condition.

So each time you crop a picture (or do any other editing) for the first time, you're actually creating a new, full-size file on your hard drive, as iPhoto stores both the original and the edited versions of the photo. Therefore, the more photos you edit in iPhoto, the more hard drive space your photo collection will occupy.

Incidentally, it's worth noting that iPhoto may be a bit overzealous when it comes to making backups of your originals. The simple act of rotating a photo, for example, creates a backup (which, considering how easy it is to re-rotate it, you might not consider strictly necessary). If you've set up iPhoto to open a double-clicked photo in another program like Photoshop, then iPhoto creates a backup copy even if you don't end up changing it in that external program.

If you have The Library That Ate Cleveland, you can take matters into your own hands. But wading through your iPhoto library and manually tossing out dupes of your photos probably isn't your idea of a good time. Fortunately, you can get technology to do it for you if you have a spare \$8. Yes, for less than the price of a movie ticket, Duplicate Annihilator from Brattoo Propaganda Software promises to comb through your collection and zap those needless copies hogging up your hard drive space. You can snag the software at www.missingmanuals.com/cds.

Duplicate Annihilator methodically compares your images and detects duplicates with a set of algorithms. You can have the program slap a label on the copies or delete the duplicates as it finds them. And getting rid of all those unneeded files means a leaner and zippier iPhoto experience.

you're going to wind up with the edited JPEG *and* the original RAW file side by side in your library.

This roundabout method of editing a RAW file is not, ahem, the height of convenience. However, if you want to use high-level image controls for your RAW files, then this is the path you must take, grasshoppa.

16-Bit TIFF Files Instead of JPEGs

For some time, high-end iPhotonauts bearing fancy cameras and memory cards full of RAW files have groused a bit about their choices. They could keep sending their RAW files on that clumsy round trip to Photoshop, or they could work with iPhoto's converted, lower-quality JPEG files instead.

In iPhoto '09, they have a third option: They can tell iPhoto to convert those RAW files into TIFF files instead of JPEGs.

TIFF, of course, is an uncompressed, extremely high-quality graphics format that's frequently used in the professional printing business. (All of the illustrations in this book, for example, are TIFF files.) If you intend to print high-quality enlargements directly out of iPhoto, then it might be worth telling iPhoto to convert your RAW files into TIFF instead of JPEG.

To make this switch, choose iPhoto→Preferences, click Advanced, and then turn on "RAW Photos: Save edits as 16-bit TIFF files." (This checkbox is visible in Figure 5-16.)

Making this switch involves a price, however.

First, if you've already edited some of your RAW files, then iPhoto has *already* converted them into the JPEG format. You'll have to strip away your edits by highlighting the thumbnails and choosing Photos—Reprocess RAW.

Now when you open those files for editing, they'll turn into fully editable 16-bit TIFF files within iPhoto.

Second, you'll pay an enormous price in hard drive space.

Suppose that you start with a RAW file that takes up about 8 megabytes of space in your iPhoto library. You make a few edits; iPhoto generates a working JPEG that adds another 1.2 megs; fine.

But now you decide to reach for the brass ring of quality, so you instruct iPhoto to reprocess that RAW file and convert it into a TIFF instead. That TIFF version will add 62 megabytes to your library, just for that one picture!

The moral: Save the TIFF-conversion business for your most prized photos, the ones that really merit that file format and all that quality.

And once you've finished working with them, return to the Preferences menu and turn off the checkbox.

Part Two: Meet Your Public

Chapter 6: The iPhoto Slideshow

Chapter 7: Making Prints

Chapter 8: Email, Web Galleries, and Network Sharing

Chapter 9: Books, Calendars, and Cards

Chapter 10: iPhoto Goes to the Movies

Chapter 11: iDVD Slideshows

The iPhoto Slideshow

Photo's slideshow feature offers one of the world's best ways to show off your digital photos. Slideshows are easy to set up, they're free, and they make your photos look fantastic. And in iPhoto '09, they've been given a dose of steroids; the new slideshow Themes turn a humble batch of JPEGs into flying, animated, multipaned video presentations with a single click.

This chapter details not only how to put together an iPhoto slideshow, but also how to create presentations that make you *and* your photos look their absolute best.

About Slideshows

When you run an iPhoto slideshow, your Mac presents the pictures in full-screen mode—no windows, no menus, no borders—with your images filling every inch of the monitor. Professional transitions take you from one picture to the next, producing a smooth, cinematic effect. If you want, you can add a musical soundtrack to accompany the presentation. The total effect is incredibly polished, yet creating a slideshow requires very little setup.

You always begin by selecting the pictures you want—by clicking an album or an Event header, for example. In iPhoto '09, you can also make slideshows based on a particular person on your Faces board or a location in Places. At this point, you can kick off a slideshow in two different ways:

• Instant. Click the Slideshow button in the middle of the iPhoto toolbar. The Themes box pops up, asking you to pick a visual animation style for your slideshow, as described below. Click to pick. If you're feeling industrious, you can also select

About Slideshows

- music and other settings from tabs in the same box. Just want to see the show? Click the Play button.
- Saved. In the early days of iPhoto, each album had its own associated slideshow settings. The album was, in essence, the container for the slideshow.

That was a convenient approach, but not the most flexible. For example, it meant that if you wanted a slideshow that displayed only half the pictures in an album, then you had to make a new album just for that purpose. It also meant that you couldn't create different slideshow versions of the same album's worth of photos—a 2-seconds-per-shot version for neighbors, for example, and a 10-seconds-per-shot version for adoring grandparents.

Now, therefore, iPhoto offers something called a *saved* slideshow, an icon that appears in the Source list and is saved forever, independent of any album. It works a lot like an album in many ways. For example, the photos inside are only "pointers" to the real photos in the library, and you can drag them into any order you like. On the other hand, unlike an album, a saved slideshow contains special advanced controls for building a really sophisticated slideshow.

This chapter covers both of these slideshow techniques.

Slideshow Themes

One of iPhoto '09's best new features is *themed slideshows*. Peppered with fancy graphics and animation, these visual presentation styles spice up your slideshows with a minimum of effort on your part. As shown in Figure 6-1, the first thing iPhoto

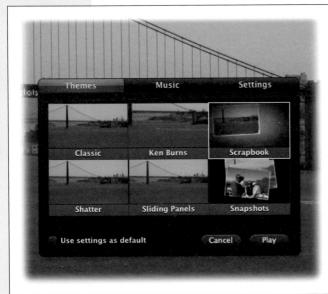

Figure 6-1

Clīck the Slideshow button in the iPhoto window, and the first thing it wants you to do is pick a theme for your show.

Click a theme tile to select it, and then click the Play button if you want to see how your photos do against iPhoto's default music. You can also click the Music and Settings tabs in the box to tinker before the first slide even plays.

About Slideshows

wants you to do when you play an instant slideshow is to pick a theme. Here are your choices:

- Classic. It worked for Coca-Cola, so Apple has rebranded the old iPhoto slideshow style as "Classic." It's classic indeed: Each slide appears for a couple of seconds, filling the screen, then crossfades into the next. You have lots of control over transitions and other effects.
- Ken Burns. If you like that slow pan-and-zoom approach that made the documentary filmmaker famous, you can use it yourself here. There's more on this man and his technique on page 166.
- Scrapbook. Your photos are cleverly animated right into images of old-fashioned scrapbooks, just like Grandma used to make out of paper and glue. The unseen cameraman pans across these scrapbook pages, pausing to admire each photo in them.
- Shatter. Perhaps the most animated of the new iPhoto '09 slideshow themes, Shatter appears to colorfully smash apart your photos across the white expanse of screen—only to reassemble them into the next photo. This hyperkinetic theme works great for slideshows filled with action shots. For weddings or memorials? Not so much.
- Sliding Panels. Another motion-filled theme, Sliding Panels lives up to its name by slipping your photos onto the screen from several directions. It also displays several pictures at once, sort of like the average layout in a celebrity magazine or an episode of "24."
- Snapshots. For those missing the white-bordered prints of yesteryear, this theme slides the old-style photos into the center of the screen. As the next photo arrives, it appears to land on top of the previous few shots, which fade to black-and-white in the background.

Figure 6-2:

The quickest way to kick off a slideshow in iPhoto is to click the Slideshow button in the main iPhoto window. While there's no keyboard shortcut, you can hit any key except the arrow keys and the space bar to stop a show once it's running.

Note: The more heavily animated themes require a lot of computer muscle to play, and not every theme works on every Mac out there. If you're still tooting along on a PowerPC G4 Mac, your theme options are limited to Classic and Ken Burns. If you have a PowerPC G5 with less than 64 megabytes of video memory under the hood, you can use Classic, Ken Burns, Scrapbook, and Sliding Panels. The newer Intel-chip Macs with more than 64 megabytes of video memory can choose from all six themes in iPhoto '09.

Instant Slideshows

An *instant* slideshow, for the purposes of this book, is one that you begin by clicking the triangular Slideshow button beneath the main iPhoto window, as shown in Figure 6-2. Instant slideshows are not quite as instant as they used to be in past versions of the program, but with the built-in themes, you get a slick, fancy slideshow in just a couple of clicks.

Selecting a Slideshow Theme

After you click the Slideshow button on the main iPhoto window, the screen expands to full view and the Themes box pops up.

1. Click to select one of the six themes, shown in Figure 6-1.

Point to a theme thumbnail without clicking to see a tiny preview of what it does. If you click "Use settings as a default," then iPhoto saves these settings, but only for *this* slideshow—not for all your slideshows from here on out.

2. Add music and transition settings to slides by clicking the Music and Settings tabs.

Each theme comes with its own default soundtrack. In fact, Apple paid a lot of money for them; they include such famous copyrighted tunes as "You've Got a Friend in Me" (Randy Newman) and the theme from "Peanuts" (Vince Guaraldi). But if you don't care for the canned music or pre-selected transitions, click the appropriate tabs and make adjustments. The following sections explain.

3. Click the Play button.

The slideshow begins.

What to Do During a Slideshow

If you wiggle your mouse while the slideshow is playing, you get the control panel shown in Figure 6-3. Here's what you can do while this display is onscreen:

- Pause the show, or click the arrow buttons to skip forward or back.
- Click the slides icon to reopen the Themes chooser shown in Figure 6-1, if the current theme is not rocking your world.
- Click the musical-notes button to open the Music chooser, described on page 156.

Instant Slideshows

- Click the icon to open the Settings panel. Here, you can change the timing and transition settings for the slideshow (page 158).
- Finally, click **②** to close the full-screen view, end the slideshow, and go back to the regular iPhoto window.

Note: It's not your imagination; buttons for Rotate, Ratings, and Delete This Photo are no longer part of the slideshow control bar.

Figure 6-3:
As the slideshow progresses, you can pause the show, go backward, or get to the settings for Themes, music, and transitions, all courtesy of this onscreen control bar.

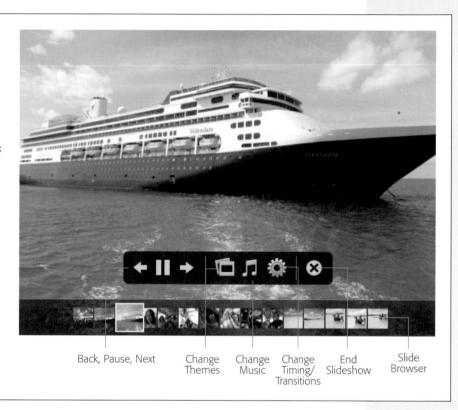

But fiddling with the slideshow settings isn't the only fun you can have during playback. If you move your mouse pointer to the bottom of the screen, you can also summon the slide browser: a row of thumbnails that illustrate which pictures you've chosen for inclusion in this show, and in which order they'll play.

A white border indicates which picture is playing now, but the real point is that you can click any other thumbnail to jump around in the show.

If you wait long enough without clicking anything, both the control bar and the slide browser eventually disappear, returning the full glory to the slideshow in progress.

Instant Slideshows

Music: Soundtrack Central

Perhaps more than any other single element, *music* transforms a slideshow, turning your ordinary photos into a cinematic event. When you pair the right music with the right pictures, you do more than just show off your photos; you create a mood that can stir the emotions of your entire audience. So if you really want your friends and family to be transfixed by your photos, then add a soundtrack.

That's especially easy if, like many Mac OS X fans, you've assembled a collection of your favorite music in iTunes, the MP3-playing software that comes with every Mac.

For the background music of an iPhoto slideshow, you have the choice of an individual song from your iTunes library or an entire *playlist*. Gone are the days of listening to the same tune repeating over and over again during a lengthy slideshow—a sure way to go quietly insane (unless, of course, you *really* like that song).

The possibilities of this new feature are endless, especially combined with iPhoto's smart albums feature. You can create a smart album that contains, say, only photos of your kids taken in December, and give it a soundtrack composed of holiday tunes, created effortlessly using a smart playlist in iTunes. Instant holiday slideshow!

Your first iPhoto slideshow is born with a few ready-to-use soundtracks—as noted earlier, they include expensively licensed songs from Randy Newman, Miles Davis, and "Peanuts."

These six songs are listed in the Theme Music folder, which is identified in the Source pop-up menu (Figure 6-4). In that same Source menu, you can also choose Sample

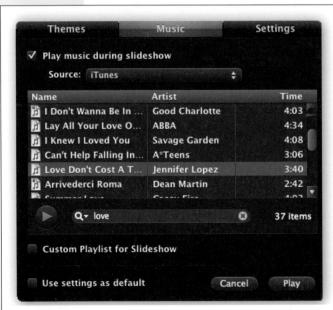

Figure 6-4:

The Music tab of the Slideshow dialog box lets you choose a playlist or your entire iTunes library from the Source menu. By clicking the column headings, you can sort the song list by Name, Artist, or Time. You can also use the Search box, as shown here, to pinpoint an individual song.

If you have a long slideshow, use the list to choose an iTunes playlist rather than a single song. iPhoto repeats the song (or playlist) for as long as your slideshow lasts. Inspired to make a playlist right here? Turn on the "Custom Playlist for Slideshow" box and drag song titles from the list above into it.

Music; here, you find 11 more slideshow-worthy tracks, including two hits from J.S. Bach and some other instrumentals from various musical genres.

Of course, you can also choose music from your own collection. If, from that Source pop-up menu, you choose GarageBand, you're offered any musical masterpieces you've created yourself, using the GarageBand music-recording software.

Most people, however, will be more inclined to choose iTunes from this list. At that point, every track and playlist in your iTunes library automatically appears here. You can search and sort through your songs and playlists, just as though you were in iTunes itself.

In other words, you can use this list either to select an entire playlist to use as your soundtrack, or to call up a playlist for the purpose of listing the individual songs in it, thereby narrowing your search for the one song you seek.

- To listen to a song before committing to it as a soundtrack, click its name in the list, and then click the Play button (►). (Click the same button, darkened during playback, when you've heard enough.)
- To use an entire playlist as a soundtrack for your slideshow, select it from the list. At slideshow time, iPhoto begins the slideshow with the first tune in the playlist and continues through all the songs in the list before starting over.
- To use an individual song as a soundtrack, click its name in the list. That song will now loop continuously for the duration of the slideshow.
- Rather than scroll through a huge list, you can locate the tracks you want by using the capsule-shaped Search box below the song list. Click in the Search field, and then type a word (or part of a word) to filter your list. iPhoto searches the Artist, Name, and Album fields of the iTunes library and displays only the matching entries. To clear the search and view your whole list again, click the ③ in the search box.
- Click one of the three headers—Artist, Name, or Time—to sort the iTunes music list by that header.
- You can also change the arrangement of the three columns by grabbing the headers and dragging them into a different order.
- "Custom Playlist for Slideshow" lets you whip up a mini-playlist right here, right now. When you turn on this option, an empty list box appears below the list of songs. Scroll through the songs in the top part of the box; when you find one you want to include in the slideshow, drag its tiny icon down into the lower box. (You can see this process under way in Figure 6-9.) Drag the tracks up and down within the playlist to rearrange them.

Once you've settled on (and clicked) an appropriate musical soundtrack for the currently selected album, you can turn on "Use settings as default" (to memorize that choice without starting the slideshow) or Play (to begin the slideshow right now). From now on, that song or playlist plays whenever you run a slideshow from that album.

Instant Slideshows

Alternatively, if you decide you don't want any music to play, then turn off the "Play music during slideshow" checkbox above the list.

Different Shows, Different Albums

You can save different slideshow settings for each icon in your Source list.

To save settings for a specific photo album, for example, first choose the album from the Source list, and then click the Slideshow button on the iPhoto toolbar to open the Slideshow dialog box (Figure 6-1). On the Music and Settings tabs, you can pick the speed, order, repeat, and music settings you want; finally, turn on "Use settings as default." The settings you saved automatically kick in each time you launch a slideshow from that album.

Slideshow Settings

With Theme and Music taken care of, the third tab on the Slideshow box handles just about everything else that makes a great presentation. On this tab, you can fiddle with the timing between slides, the Hollywood-style transitions between each shot, titles and captions, and other elements that influence the slideshow's look and feel. The options available depend on which theme you're using.

Slide Timing

If left to its own devices, iPhoto advances through your pictures at the rate of one photo every 5 seconds. That's an awfully long time to stare at a single picture. Fortunately, you can change the rate.

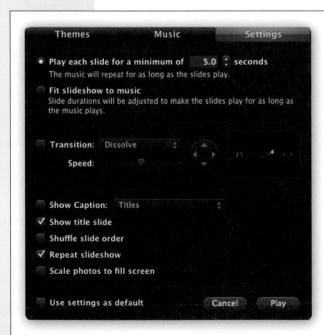

Figure 6-5:

The controls on the Settings tab let you fine-tune the timing and transition between slides. Turn Transition and use the pop-up menu to try out different effects (like "Dissolve" or "Wipe") for getting from one slide to the next.

In the lower part of the box, you can also choose to display the titles, locations, and descriptions you may (or may not) have spent hours adding to your photos.

Turn on "Use settings as default" if you want to save your tinkerings. "Default" here does not mean the default settings for all your iPhoto slideshows, though—just this one. In the Settings tab of the Slideshow dialog box, use the "Play each slide for a minimum or __ seconds" controls to specify a different interval, as shown in Figure 6-5.

Want all the slides to play out over the duration of the song—no matter how long the time is between each one? Turn on "Fit slideshow to music."

Tip: You can also adjust the speed *during* the slideshow, just by pressing the \uparrow or \downarrow keys. Behind the scenes, iPhoto adjusts the number of seconds in the Slideshow dialog box accordingly.

Transitions

Themes like Shatter and Sliding Panels use special transition (crossfade) styles between images. But if you're using the Classic or Ken Burns themes for your show, you can choose from 13 different types of transition effects between slides—for example, the classic crossfade or dissolve, in which one slide gradually fades away as the next "fades in" to take its place. Here's a summary:

- None. An abrupt switch, or simple cut, to the following image.
- Cube. Imagine that your photos are pasted to the sides of a box that rotates to reveal the next one. If you've ever used Mac OS X's Fast User Switching feature, you've got the idea.
- Dissolve. This is the classic crossfade.
- **Droplet.** This wild effect resembles animated, concentric ripples expanding from the center of a pond—except that a new image forms as the ripples spread.
- Fade Through Black. After each slide has strutted and fretted its time upon the stage, the screen fades momentarily to black before the next one fades into view. The effect is simple and clean, like an old-fashioned living-room slideshow. Along with Dissolve, this effect is one of the most natural and least distracting choices.
- Flip. The first photo seems to flip around, revealing the next photo pasted onto its back.
- Mosaic Flip Large, Mosaic Flip Small. The screen is divided into several squares, each of which rotates in turn to reveal part of the new image, like puzzle pieces turning over. (The two options refer to two sizes of the puzzle pieces.)
- Move In. Photos slide in undramatically from the edges of the screen.
- Page Flip. Apple's just showing off here. The first photo's lower-right corner actually peels up like a sheet of paper, revealing the next photo "page" beneath it.
- Push, Reveal, Wipe. Three variations of "new image sweeping onto the screen." In Push, Photo A gets shoved off the other side of the screen as Photo B slides on. In Reveal, Photo A slides off, revealing a stationary Photo B. And in Wipe, Photo A gets covered up as Photo B slides on.
- Twirl. Photo A appears to spin furiously, shrinking to a tiny dot in the middle of the screen—and then Photo B spins onscreen from that spot. The whole thing

Slideshow Settings

feels a little like the spinning-newspaper effect used to signify breaking news in old black-and-white movies.

In most cases, choosing a transition effect makes two additional controls "light up" just below the pop-up menu:

- Direction. This determines the direction the new image enters from. Choose Right to Left, Top to Bottom, or vice versa in both cases. (Most people find left to right the most comfortable way to experience a transition, but a slow top-to-bottom wipe is pleasant, too.)
- Speed. Move the slider to the right for a speedy transition, or to the left for a leisurely one. Take into account your timing settings. The less time your photo is onscreen, the better off you are with a fast transition, so that your audience has time to see the picture before the next transition starts. However, moving the Speed slider *all* the way to the right produces a joltingly fast change.

Show Caption

Need some words to go with the music? Use the pop-up menu to show text like descriptions, places, dates, or titles.

As noted on page 43, every photo in your collection can have a name—a title, in other words. And if you want to show off your geotagged (page 101) pictures from your cross-country trip, it's easy to put all those place names and descriptions up on the big screen. If you turn on this option, iPhoto superimposes the selected text in big white type on the lower corner of the image, as shown in Figure 6-6.

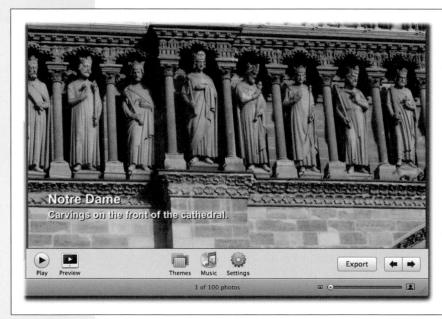

Figure 6-6: If you don't feel like narrating your slideshow over and over, then fill in the title, place, date, or description fields in the photo's Info box (page 106). When it comes time to set up the slideshow, turn on Show Caption in the Settings box and then choose the text you want to display. When you play the slideshow, iPhoto lets your viewers know what they're looking at.

Needless to say, the cryptic file names created by your digital camera (IMG_0034.jpg) usually don't add much to your slideshow. But if you've taken the time to give your photos helpful, explanatory names ("My dog, age 3 months") then by all means turn on the "Show captions" checkbox and choose the text you want to display.

Show Title Slide

Show titles? Sure—Fiddler on the Roof! West Side Story! Cats!

Just kidding.

Turn on "Show title slide" if you want the first slide in the show to display the name of the album, face, or place you're using. (Try it before you chuck it; it's actually a great way to start the slideshow.)

Repeat Slideshow

When iPhoto is done running through all your photos in a slideshow, it ordinarily starts playing the whole sequence from the beginning again. If you want your photos to play just once through, then turn off "Repeat slideshow."

Shuffle Slide Order

An iPhoto slideshow normally displays your pictures in the order they appear in the photo-viewing area. But if you'd like to add a dash of surprise and spontaneity to the proceedings, then turn on "Shuffle slide order." Now iPhoto shuffles the pictures into whatever random order it pleases.

Scale Photos to Fill Screen

If any photos in your slideshow don't match your screen's proportions, then you may want to turn on "Scale photos to fill screen." For example, if your slideshow contains photos in portrait orientation—that is, pictures taken with the camera rotated—iPhoto normally fills up the unused screen space on each side with vertical black bars.

Turning on "Scale photos" makes iPhoto enlarge the picture so much that it completely fills the screen. This solution, however, comes at a cost: Now the top and bottom of the picture are lost beyond the edges of the monitor.

When the middle of the picture is the most important part, this option works fine. If it's not, and the black bars bother you, then the only other alternative is to crop the odd-sized pictures in the slideshow album to match your monitor's shape. (See "Cropping" on page 121.)

Note: This option doesn't mean "Enlarge smaller photos to fill the screen." iPhoto always does that. This option affects only photos whose *proportions* don't match the screen's.

Picking Photos for Instant Slideshows

Among the virtues of instant slideshows is the freedom you have to choose which pictures you want to see. For example:

Slideshow Settings

• If no photos are selected, iPhoto exhibits all the pictures currently in the photoviewing area, starting with the first photo in the album, Face, or Event.

Most people, most of the time, want to turn one *album* into a slideshow. That's easy: Just click the album before starting the slideshow. It can be any album you've created, a smart album, the Last Import album, or one of iPhoto's Recent collections. As long as no individual pictures are selected, iPhoto uses all the pictures in the album currently open.

Tip: You can also create an instant slideshow from multiple albums. That is, you can select more than one album simultaneously (by **%**-clicking them); when you click Play, iPhoto creates a slideshow from all of their merged contents, in order.

- If *one* photo is selected, iPhoto uses that picture as its starting point for the show, ignoring any that come before it. Of course, if you've got the slideshow set to loop continuously, then iPhoto will eventually circle back to display the first photo in the window.
- If you've selected more than one picture, iPhoto includes *only* those pictures.

Photo Order

iPhoto displays your pictures in the same order you see them in the photo-viewing area. In other words, to rearrange your slides, drag the thumbnails around within their album. Just remember that you can't drag pictures around in an Event, a Face, a Place, a smart album, the Last 12 Months collection, or the Last Import folder—only within a photo album.

Note: If iPhoto appears to be shamelessly disregarding the order of your photos when running a slideshow, it's probably because you've got the "Shuffle slide order" option turned on in the Slideshow dialog box, as described on page 161.

Saved Slideshows

iPhoto also offers *saved* slideshows, each of which appears as an icon in your Source list. The beauty of this system is that you can tweak a slideshow to death—you can even set up different transition and speed settings for *each individual slide*—and then save all your work as an independent clickable icon, ready for playback whenever you've got company. Saved slideshows are also a snap to shuttle over to your iPod or iPhone for musical memories on the go (page 266).

Here's how you create and fine-tune a saved slideshow:

1. Select the photos you want to include.

You can select either a random batch of slides (using any of the techniques described on page 48) or an icon in the Source list (like an album, a Place, or a Face).

Tip: By Shift-clicking or **%**-clicking, you can actually select several icons in the Source list simultaneously. When you proceed to step 2, iPhoto will intelligently merge their photo contents into one glorious slideshow.

2. Click the + button beneath the Source list.

A box slides down, just like the one in Figure 6-7. Click the Slideshow icon and give it a name. Click Create.

Figure 6-7:

After you click the + button at the bottom of the iPhoto Source list, this box appears. Here, you can pick the type of album or project you want to make (a slideshow, in this case), and give it a proper name; after you click Create, you'll find its icon in the Source list.

Thunder rumbles, the lights flicker—and you wind up in the slideshow editing mode shown in Figure 6-8, which has some features of Edit mode and some features of regular old thumbnail-organizing mode.

Figure 6-8:

In the slideshow editor, the window shape is designed to mimic your Mac's monitor shape (or whatever screen proportions you've specified in the Settings box); that's why gray bars may appear. The Themes, Slides, and Settings buttons let you finesse the slideshow as you go. Click the Preview button to see the show play within the iPhoto window.

Saved Slideshows

At the same time, a new icon with the name you chose appears in the Source list. (The icon looks like a little pile of actual slides.)

3. Choose a playback order for your pictures.

The trick here is to drag the thumbnails at the top of the window horizontally. Don't forget that you can move these en masse, too. For example, click slide number 1, Shift-click slide number 3, and then drag the three selected thumbnails as a group to a different spot in the lineup.

4. Click the Theme button to choose one of the six themes (page 152).

The tiny thumbnail image gives the vaguest hint of what to expect. But if you hate the theme, you can change it later.

5. Click the Music and Settings buttons to set up the global playback options.

That is, set up the preferences that affect *all* slides in the show (like timings and transitions), using the controls at the bottom of the window. You can read about what these controls do in the next section.

6. If you like, walk through the slides one at a time, taking the opportunity to set up their individual characteristics.

For example, you can choose one slide to linger longer on the screen, another to dissolve (rather than wipe) into the next picture, and so on.

7. Preview the show.

If you click the Preview button, iPhoto plays a miniature version of the slideshow right in the window.

8. Roll it!

When everything looks ready, click the Play button (the big one, next to Preview) to play the actual slideshow.

When it's over, you can do all the usual things with the slideshow icon that now resides in your Source list:

- Delete it. Drag it onto the iPhoto Trash icon, as you would an album. When you're asked if you're sure, click Delete or press the Return key.
- File it away. Drag it into an iPhoto folder (page 63) to keep it organized with the related albums and books.
- Rename it. Double-click its icon and then type away.
- Edit it. Click its icon and then change the bottom-of-screen controls.

Saved Slideshows

Global Settings

As indicated by the preceding steps, you can make two kinds of changes to a saved slideshow: global ones (which affect all slides) and individual ones.

Most of the global options are hiding behind the Music and Settings buttons, which summon the two dialog boxes shown in Figure 6-9.

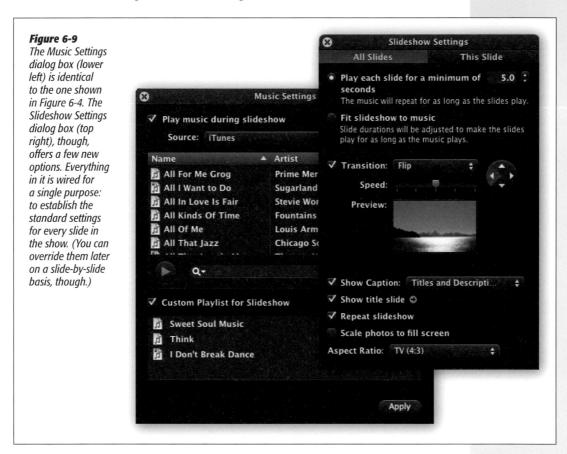

The Themes dialog box

This is the same box with the same six themes you saw before. If you decide the Snapshots theme just doesn't work for a slideshow of the high-school football game, then pick another theme there.

The Music Settings dialog box

The Music Settings dialog box should look familiar; it's identical to the dialog box shown in Figure 6-4. Here's where you choose the music to accompany your slideshow, as described on page 156.

The Slideshow Settings dialog box

The Slideshow Settings button, however, brings up a dialog box that only *seems* familiar (Figure 6-9, top right). It's actually got two different tabs here: All Slides and This Slide. As you can probably guess, the All Slides tab makes global changes across the whole show, while This Slide affects just the picture on the screen.

All Slides

The All Slides tab in the Slideshow Settings box for the Classic and Ken Burns themes contains many of the same options described earlier (transition style, slide duration, Ken Burns effect, choice of music track or playlist, options to show your photos' titles and ratings, and so on).

Note: The Shatter, Sliding Panels, Scrapbook, and Snapshot themes handle their own transitions and have fewer options in the Slideshow Settings box.

In this incarnation, though, you get a few new options. First, iPhoto wants to know how it should handle slideshows that aren't exactly the same length as the music you've selected for their soundtracks. Your options are "Repeat music during slideshow" (loops the music as necessary to fit the slides) or "Fit slideshow to music" (plays the music only once, but squeezes or stretches the slides' time on the screen to fit the music).

Down at the bottom of the box, you get an Aspect Ratio pop-up menu. Here, you can tell iPhoto what *shape* the screen will be.

FREQUENTLY ASKED QUESTION

The Ken Burns Effect

Hey! Who's this Ken Burns guy, and what's his effect?

Apple first introduced what it calls the "Ken Burns effect" in iMovie, not iPhoto. It's a special effect designed to address the core problem associated with using still photos in a movie—namely, that they're *still!* They just sit there without motion or sound, wasting much of the dynamic potential of video.

For years, professional videographers have addressed the problem by using special sliding camera rigs that produce gradual zooming, panning, or both, to bring photographs to life.

Among the most famous practitioners of this art is Ken Burns, the creator of PBS documentaries like *The Civil War* and *Baseball*—which is why Apple, with Burns' permission, named the feature after him.

And now your own humble slideshows can have that graceful, animated, fluid Ken Burns touch or even a whole Ken Burns theme. No photo ever just sits there motionless on the screen. Instead, each one flies gracefully inward or outward, sliding and zooming.

It's a great effect, but it can occasionally backfire, too. Every now and then, for example, the actual subject of the photo won't be centered, or the photo won't make it completely onto the screen before the next one begins to zoom on. (One of the virtues of the *saved* slideshow, described on page 162, is that *you* control where the Ken Burns panning and zooming begins and ends.)

Now, that may strike you at first as a singularly stupid statement. After all, doesn't the Mac know what shape its own screen is? But there's more to this story: Remember that you can build slideshows that aren't intended to be played on your screen.

You might want to export a slideshow to play on other people's screens, or even on their TV sets, by burning the slideshow to a DVD. That's why this pop-up menu offers four choices: This Screen; HDTV (16:9) for high-definition TV sets and other rectangular ones, TV (4:3) for standard squarish TV sets, or iPhone (3:2), for slideshows you plan to export to your nifty Apple smartphone.

In any case, the changes you make here affect *all* photos in the slideshow. Click OK when you're done, confident in the knowledge that you can always override these settings for individual slides.

Individual-Slide Options

The All Slides side of the Settings box offers plenty of control, but the changes you make there affect *every* slide in the show. But by clicking the This Slide tab when you have a photo on screen, iPhoto '09 gives you control over *individual* slides. For example:

Color options

Certain photos may have more power with special tint effects. Here, iPhoto lets you change the color of the selected photo to Black & White, Sepia (brownish, old-fashioned monochrome), or Antique, which offers a sort of faded, flattened look to the photo's colors.

Slide timing

As you know, the Slideshow Settings dialog box (Figure 6-9, top) is where you specify how long you want each slide to remain onscreen—in general. But if you want to override that setting for a few particularly noteworthy shots, the This Slide tab (Figure 6-10) has the solution.

With the specially blessed photo on the screen before you, summon the Settings box and click This Slide. Use the "Play this slide for __ seconds" control to specify this slide's few seconds of fame.

Transition

The options in this pop-up menu are the different crossfade effects (Cube, Dissolve, and so on) that you can specify for the transition from one slide to another. (Whatever you choose here governs the transition *out* of the currently selected slide; every slideshow *begins* with a fade-in from black.)

Transition speed and direction

You can also control the speed of the transitions on a slide-by-slide basis, and even which direction the transition effect proceeds across the screen (for transition styles that offer a choice).

Cropping and zooming

Here's a totally undocumented feature: You can choose to present only *part* of a photo in a slideshow, in effect cropping out portions of it, without actually touching the original.

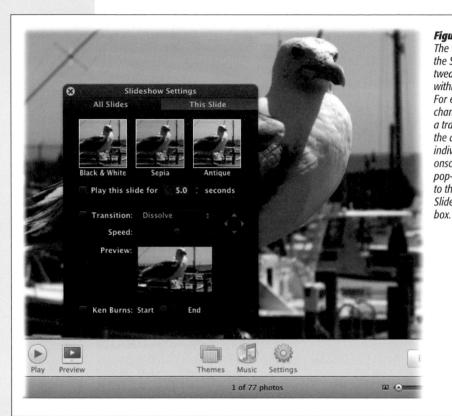

Figure 6-10
The "This Slide" pane in the Settings box lets you tweak individual slides within the slideshow. For example, it lets you change the speed of a transition effect and the amount of time an individual slide stays onscreen. The Transition pop-up menu is identical to the one on the All Slides tab of the Settinas

To enlarge the photo (thus cropping out its outer margins), just drag the Size slider at the lower-right corner of the iPhoto window. Whatever photo size you create here is what will appear during the slideshow.

What you may not realize, though, is that you can also drag *inside* the picture itself to shift its position onscreen. Between these two techniques—sizing and sliding—you can display a very specific portion of the photo. (Heck, you could even present the photo *twice* in the same slideshow, revealing half of it the first time, half of it the next.)

The Ken Burns checkbox

If you flip back a few pages, you'll be reminded that the Ken Burns effect is a graceful, panning, zooming effect that brings animation to the photos of your slideshow, so that they float and move instead of just lying there.

You'll also be reminded that when you apply the effect to an entire slideshow, you have no control over the pans and zooms. iPhoto might begin or end the pan too soon, so that the primary subject gets chopped off. Or maybe it zooms too fast, so that your viewers never get the chance to soak in the scene—or maybe it pans or zooms in the wrong direction for your creative intentions.

Fortunately, the Ken Burns controls located here let you adjust every aspect of the panning and zooming for one photo at a time. (Note: The settings you're about to make *override* whatever global Ken Burns setting you've made.) As you can see in Figure 6-11, it works like this:

Figure 6-11:

The idea behind the Ken Burns effect is that you set up the start and end points for the gradual zooming/panning effect. iPhoto, meanwhile, automatically supplies the in-between frames, producing a gradual shift from the first position to the second. In this case, the Ken Burns effect lets you save the "punch line" of this story-telling photo for the end of its time onscreen.

Top: Open the Slideshow Settings box and click the This Slide tab. Turn on Ken Burns (so to speak). Click Start. Use the Size slider (lower right) to magnify the photo, if you like. Once you've magnified it, you can drag inside the photo to reposition it inside the "frame" of your screen.

Bottom: Click End. Once again, use the Size slider, and then drag inside the photo, if you like, to specify the final degree of zoom and movement. In this shot, on the red grape, you can see the tiny "grabbing hand" cursor that appears whenever your mouse wanders into the magnified-photo area.

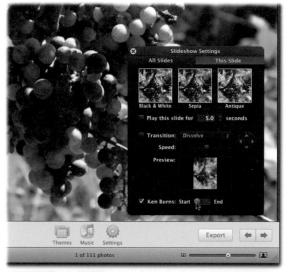

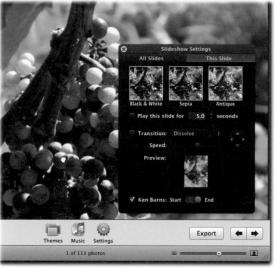

 Select the photo. Click Settings→This Slide and turn on the Ken Burns checkbox at the bottom of the window.

If more than one photo is selected, iPhoto applies the effect only to the first one.

2. Click Start. Drag the Size slider (at the lower-right corner of the box) until the photo is as big as you want it at the *beginning* of its time onscreen. Drag inside the picture itself to adjust the photo's initial position.

In other words, you're setting up the photo the way it appears at the beginning of its time onscreen. Often, you won't want to do anything to it at all. You want it to start on the screen at its original size—and then zoom in from there.

But if you hope to create a zooming *out* effect, then begin here by dragging the Size slider to the right, magnifying the photo, and then dragging the picture itself to center it properly.

3. Click End. Use the Size slider to set up the picture's final degree of magnification. Drag inside the photo to specify the photo's final position.

You've set up the starting and ending conditions for the photo.

Take a moment now to click the Preview button. The animated photo goes through its scheduled motion inside the window, letting you check the overall effect. Repeat steps 2 and 3 as necessary.

FREQUENTLY ASKED QUESTION

Slideshow Smackdown: iPhoto vs. iMovie

I've read that iMovie makes a great slideshow program, too. Supposedly, I can import my photos, add music, and play it all back, full-screen, with cool cross-dissolves, just like you're saying here. Which program should I use?

The short answer: iPhoto for convenience, iMovie for control.

In iMovie, you can indeed import photos. Just as in iPhoto, you have individual control over their timing, application of the Ken Burns effect, and transitions between them.

But the soundtrack options are much more expansive in iMovie. Not only can you import music straight from a music CD (without having to use iTunes as an intermediary), but you can actually record narration into a microphone as the

slideshow plays. And, of course, you have a full range of title and credit-making and special-effects features at your disposal, too.

Still, iPhoto has charms of its own. Creating a slideshow is much less work in iPhoto, for one thing. If you want a slideshow to loop endlessly—playing on a laptop at somebody's wedding, for example, or at a trade show—iPhoto is also a much better bet. (iMovie can't loop.)

Remember, too, that iPhoto is beautifully integrated with your various albums. Whereas building an iMovie project is a serious, sit-down-and-work proposition that results in one polished slideshow, your Photo library has as many different slideshows as you have albums—all ready to go at any time.

Tip: If you accidentally set up the End position when you actually meant to set up the Start position, then Option-click the word "Start." iPhoto graciously copies your End settings into the Start settings. Now both Start and End are the same, of course, but at least you can now edit just the End—only one set of settings instead of two. (The same trick works in the other direction.)

Now that you've specified the beginning and ending positions of the photo, iPhoto interpolates, calculating each intermediate frame between the starting and ending points you've specified.

Click the Preview button to see the fully animated results of your programming.

Slideshow Tips

The following guidelines will help you build impressive slideshows that truly showcase your efforts as a digital photographer:

Picture Size

Figure 6-12:

Choosing photos for your slideshow involves more than just picking the photos you like the best. You also have to make sure you've selected pictures that are the right size.

iPhoto always displays slideshow photos at full-screen dimensions—and on today's monitors, that means at least 1024×768 pixels. If your photos are smaller than that, then iPhoto stretches them to fill the screen, often with disastrous results (Figure 6-12).

happens when a 320 × 240 pixel photo ends up in a slideshow. Projected at full-screen dimensions, a photo that looks great at its normal size hope as it and adapted.

Here's an example of what

size becomes jagged-edged and fuzzy—unflattering to both subject and photographer. If you plan to use your photos in a slideshow, make sure your digital camera is set to capture pictures that are at least 1024 × 768 pixels.

Note: Although iPhoto blows up images to fill the screen, it always does so proportionately, maintaining each photo's vertical-to-horizontal aspect ratio. As a result, photos often appear with vertical bars at the left and right edges when viewed on long rectangular screens like the Apple Cinema Display, the 17-inch iMac, and so on. To eliminate this effect, see "Scale Photos to Fill Screen" on page 161.

Determining the size of your photos

If you're not sure whether your photos are big enough to be slideshow material, iPhoto provides two easy ways to check their sizes:

- Click a thumbnail in the photo-viewing area, and then look at the Size field in the Information pane. (If the Information pane isn't open, then click the little **6** button beneath the Source list.) You'll see something like "1600 × 1200." That's the width and height of the image, measured in pixels.
- Select a thumbnail and choose Photos→Show Extended Photo Info, or press Option-\(\mathbb{H}\)-I, to open the Show Extended Photo Info window. The width and height of the photo are the first two items listed in the Image section of the Photo pane.

As shown in Figure 6-12, very small photos are ugly when blown up to full-screen size. Very large ones look fine, but iPhoto takes longer to display them, and the crossfade transitions might not look smooth. For the best possible results, make your photos the same pixel size as your screen.

Here are a few other ways to make sure your slideshows look their best:

- To whatever degree possible, stick with photos in landscape (horizontal) orientation, especially if you have a wide monitor screen. With portrait-oriented (vertical) photos, iPhoto displays big black borders along the sides.
- For similar reasons, try to stick with photos whose proportions roughly match your screen. If you have a traditionally shaped screen, use photos with a 4:3 width to height ratio, just as they came from the camera. However, if you have a widescreen monitor (Cinema Display, 17-inch iMac, and so on), then photos cropped to 6:4 proportions are a closer fit.

Tip: If you don't have time to crop all your odd-sized or vertically oriented photos, then consider using the "Scale photos" feature described on page 161. It makes your pictures fill the screen nicely, although you risk cutting off important elements (like heads and feet).

- Preview images at full size before using them. You can't judge how sharp and bright
 an image is going to look based solely on the thumbnail.
- Keep the timing brief when setting the playing speed—maybe just a few seconds per photo. Better to have your friends wanting to see more of each photo than to have them bored, mentally rearranging their sock drawers as they wait for the show to advance to the next image. Remember, you can always pause a slideshow if someone wants a longer look at one picture.

- Consider the order of your photos. An effective slideshow should tell a story. You might want to start with a photo that establishes a location—an overall shot of a park, for example—and then follow it with closeups that reveal the details.
- If your viewers fall in love with what you've shown them, you have four options: (a) save the slideshow as a QuickTime movie that you can email them or burn onto a CD for their at-home enjoyment (Chapter 10); (b) turn the show into an interactive DVD using Apple's iDVD software (Chapter 11); (c) create a MobileMe slideshow (page 201); or (d) make your admirers buy their own Macs.

Slideshows and iDVD

Instead of running a presentation directly from iPhoto, you can send your slideshow—music and all—from iPhoto to iDVD, Apple's simple DVD-authoring software. Using iDVD, you can transform the pictures from your album into an interactive slideshow that can be presented using any DVD player. (Just picture the family clicking through your photos on the big-screen TV in the den!)

Learn how to perform the iPhoto-to-iDVD conversion in Chapter 11.

Tip: With iPhoto '09, you can also export the slideshow as a QuickTime file perfectly formatted to play on an iPod, iPhone, or Apple TV. Chapter 10 explains how.

Making Prints

here's a lot to love about digital photos that remain digital. You can store thousands of them on a single DVD; you can send them anywhere on earth by email; and they won't wrinkle, curl, or yellow until your monitor does.

Sooner or later, though, most people want to get at least some of their photos on paper. You may want printouts to paste into your existing scrapbooks, to put in picture frames on the mantel, to use in homemade greeting cards, or to share with your Luddite friends who don't have computers.

Using iPhoto, you can create such prints using your own printer. Or, for prints that look, feel, and smell like the kind you get from a photo-finishing store, you can transmit your digital files to Kodak Print Services, an online photo-processing service. In return, you receive an envelope of professionally printed photos on Kodak paper that are indistinguishable from their traditional counterparts.

This chapter explains how to use each of iPhoto's printing options, including the features that let you print greeting cards, contact sheets, and other special items from your digital photo collection. (Ordering greeting cards, postcards, calendars, and books is covered in Chapter 9.)

Making Your Own Prints

Using iPhoto to print your pictures is pretty easy. But making *great* prints—the kind that rival traditional film-based photos in their color and image quality—involves more than simply hitting the Print command.

One key factor, of course, is the printer itself. You need a good printer that can produce photo-quality color printouts. Fortunately, getting such a printer these days is pretty

easy and inexpensive. Even some of the cheapo inkjet printers from Epson, HP, and Canon can produce amazingly good color images—and they cost less than \$100. (Of course, what you spend on those expensive ink cartridges can easily double or triple the cost of the printer in a year.)

Tip: If you're really serious about producing photographically realistic printouts, consider buying a model that's specifically designed for photo printing, such as one of the printers in the Epson Stylus Photo series or the slightly more expensive Canon printers. What you're looking for is a printer that uses six, seven, or eight different colors of ink instead of the usual "inkjet four." The extra colors do wonders for the printer's ability to reproduce a wide range of colors on paper.

Even with the best printer, however, you can end up with disappointing results if you fail to consider at least three other important factors when trying to coax the best possible printouts from your digital photos. These factors include the resolution of your images, the settings on your printer, and your choice of paper.

Resolution and Shape

Resolution is the number of individual pixels squeezed into each inch of your digital photo. The basic rule is simple: The higher your photo's resolution, or *dpi* (dots per inch), the sharper, clearer, and more detailed the printout will be. If the resolution is too low, you end up with a printout that looks blurry or speckled.

Low-resolution photos are responsible for more wasted printer ink and crumpled photo paper than any other printing snafu, so it pays to understand how to calculate a photo's dpi when you want to print it.

Calculating resolution

To calculate a photo's resolution, divide the horizontal or vertical size of the photo (measured in pixels) by the horizontal or vertical size of the print you want to make (usually measured in inches).

Suppose a photo measures 1524×1016 pixels. (How do you know? See Figure 7-1.) If you want a 4×6 print, you'll be printing at a resolution of 254 dpi (1524 pixels divided by 6 inches = 254 dpi), which will look fantastic on paper. Photos printed on an inkjet printer look their best when printed at a resolution of 200 dpi or higher.

But if you try to print that same photo at 8×10 , you'll get into trouble. By stretching those pixels across a larger print area, you're now printing at just 152 dpi—and you'll see a noticeable drop in image quality.

While it's important to print photos at a resolution of 200 to 300 dpi on an inkjet printer, there's really no benefit to printing at higher resolutions—600 dpi, 800 dpi, or more. It doesn't hurt anything to print at a higher resolution, but you probably won't notice any difference in the final printed photos, at least not on inkjet printers. Some inkjets can spray ink at finer resolutions—720 dpi, 1440 dpi, and so on—and

using these highest settings produces very smooth, very fine printouts. But bumping the resolution of your *photos* higher than 300 dpi doesn't have any perceptible effect on their quality.

Figure 7-1: 000 Extended Photo Info 000 To select the best size for a LIBRARY printout, you need to know a Width: 2,448 pixels **Events** photo's size in pixels. iPhoto Height: 3.264 nixels Photos reveals this information in two Original Date: 8/16/2008 5:59:17 PM **■** Faces convenient places. First, when a Places Digitized Date: 8/16/2008 5:59:17 PM photo is selected, its dimensions RECENT appear in the Info panel in the _ Aug 14, 2008 Name: IMG 1478.IPG main window (left). Second, Last 6 Months Size: 2.1 MB you can choose Photos→Show Last Import Modified: 8/17/2008 5:21:23 PM Extended Photo Info to see Flagged 63 Imported: 8/17/2008 5:21:33 PM the same information in the Trash Extended Photo Info window **▼ SUBSCRIPTIONS** (riaht). GPS Latitude: 41.013218" N Unloads from m W ALBUMS GPS Longitude: 72.483833" W GPS Altitude: -Mary+Bobby Tom or Zach Place: Cutchoque 7ach Cutchoque Suffolk Informatio New York title Annie on the Porch United States date 8/16/2008 Camera time 5:59:17 PM rating **** Maker: Canon keyword Model: Canon PowerShot G9 kind JPEG Image Software: size 2448 × 3264 2 1 MR Exposure description + 0 5

Aspect ratio

You also have to think about your pictures' aspect ratios—their proportions. Most digital cameras produce photos with 4:3 proportions, which don't fit neatly onto standard print paper $(4 \times 6 \text{ and so on})$. You can read more about this problem on page 121. (Just to make sure you're completely confused, some sizes of photo paper are measured height by width, whereas digital photos are measured width by height.)

If you're printing photos on letter-size paper, the printed images won't have standard Kodak dimensions. (They'll be, for example, 4×5.3 .) You may not particularly care. But if you're printing onto, say, precut 4×6 photo paper (which you choose in the File \rightarrow Page Setup dialog box), you can avoid ugly white bands at the sides by first cropping your photos to standard print sizes.

Tweaking the Printer Settings

Just about every inkjet printer on earth comes with software that adjusts various print quality settings. Usually, you can find the controls for these settings right in the Print dialog box that appears when you choose File—Print. In iPhoto '09, you don't have to fiddle and fuss with additional menus or boxes here. *This* version of the program knows that if you're printing in iPhoto, you're going to be making a photographic print, and it gives you an appropriate Print box (Figure 7-2).

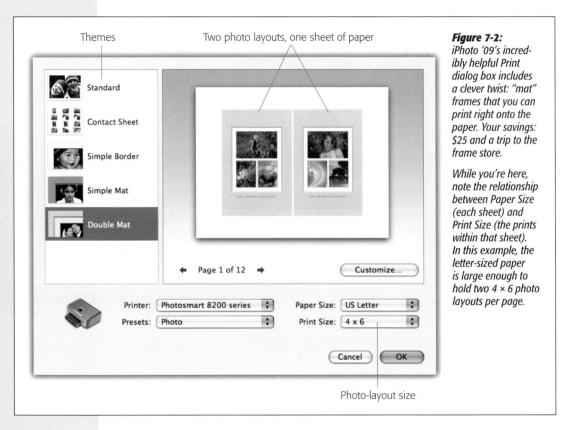

Before you print, verify that you've got these settings right. On most printers, for example, you can choose from several different quality levels when printing, like Draft, Normal, Best, or Photo. There might also be a menu that lets you select the kind of paper you're going to use—plain paper, inkjet paper, glossy photo paper, and so on.

Choose the wrong settings, and you'll be wasting a lot of paper. Even a top-of-the-line Epson photo printer churns out awful photo prints if you feed it plain paper when it's expecting high-quality glossy stock. You'll end up with a smudgy, soggy mess. So each time you print, make sure your printer is configured for the quality, resolution, and paper settings that you intend.

Paper Matters

When it comes to inkjet printing, paper is critical. Regular typing paper—the stuff you'd feed through a laser printer or copier—is too thin and absorbent to handle the amount of ink that gets sprayed on when you print a photo. You may end up with flat colors, slightly fuzzy images, and paper that's rippled and buckling from all the ink. For really good prints, you need paper designed expressly for inkjets.

Most printers accommodate at least five grades of paper. Among them:

- Plain paper. The kind used in most photocopiers.
- High-resolution paper. A slightly heavier inkjet paper—not glossy, but with a silky-smooth white finish on one side.
- Glossy photo paper. A stiff, glossy paper resembling the paper that developed photos are printed on.
- Matte photo paper. A stiff, non-glossy stock.
- Most companies also offer an even more expensive glossy *film*, made of polyethylene rather than paper (which feels even more like traditional photographic paper).

These better photo papers cost much more than plain paper, of course. Glossy photo paper, for example, might run \$25 for a box of 50 sheets, which means you'll be spending about 50 cents per 8×10 print—not including ink.

Still, by using good photo paper, you'll get much sharper printouts, more vivid colors, and results that look and feel like actual photographic prints. Besides, at sizes over 4×6 or so, making your own printouts is still less expensive than getting prints from the drugstore, even when you factor in printer cartridges and photo paper.

Tip: To save money, use plain inkjet paper for test prints. When you're sure you've got the composition, color balance, and resolution of your photo just right, then load up your expensive glossy photo paper for the final printouts.

Printing from iPhoto, Step by Step

Here's the sequence for printing the iPhoto '09 way:

Phase 1: Choose the photos to print

Just highlight the ones you want, using the techniques described on page 48.

You can also print a photo right from Edit mode; the Print command is accessible in all of iPhoto's modes.

When you're ready, choose File→Print, or press **%**-P, or click Print on the toolbar. The everything-you-need iPhoto Print dialog box appears (Figure 7-2).

As you examine this dialog box, it's important to understand the difference between a *photo layout* and a *page*.

Most people are used to printing one photo per sheet—for example, one photo on each 4×6 page. But in iPhoto '09, you can place several photos onto one 4×6 photo layout, and several layouts on each sheet of paper. For example, in Figure 7-2, each photo layout holds three pictures. And each letter-sized page holds two of those photo layouts.

No question about it: With great flexibility comes great complexity.

Phase 2: Choose a printing style (theme)

Here's another thing to consider in iPhoto '09: a choice of printing styles called *themes*, some of which permit colored borders or even captions.

These are your options:

- Standard. You get no borders—just plain, unadorned photos, with optional captions and white, gray, or black margins.
- Contact Sheet. This means thumbnails—many of them—on each printed sheet. You control how many rows and columns appear, and what information appears beneath each thumbnail (date, name, camera model, shutter speed, and so on).

The Contact Sheet option prints out a *grid* of photos, tiling as many as 120 pictures onto a single letter-size page (eight columns of 14 rows, for example).

Photographers use contact sheets as a quick reference tool when organizing photos—a poor man's iPhoto, if you think about it. But this printing option is also handy in some other practical ways. For example, by printing several pictures side by side on the same page, you can easily make quality comparisons among them without using several sheets of paper.

You can also use contact sheet printing to make test prints, saving ink and paper. Sometimes a 2×3 print is all you need to determine if a picture is too dark or if its colors are wildly off when rendered by an inkjet printer. Don't make expensive full-page prints until you're sure you've adjusted your photo so that it will print out correctly.

- Simple Border. This puts up to four photos on each layout—or multiple copies of the same photo on each sheet, like school portrait packages. You can add captions, and you can add a white, gray, or black "frame" around the whole thing—even an oval one.
- Simple Mat, Double Mat. A mat, in the real framing biz, is a cardboard frame that's placed around the photo to give it more impact. iPhoto '09's clever twist is that it can print this mat directly onto the paper, saving you the hassle of cutting rectangles (and your finger), with an X-Acto knife.

You get a choice of color (or, for Double Mat, a choice of two contrasting colors), as well as all the same layout options as Simple Border.

Click the theme you want. If you're printing more than one sheet (for example, more than one Standard, Border, or Mat picture), click the "Page 1 of 3" arrows to walk through the previews of each.

Phase 3: Choose print and paper sizes

At the bottom of the Print Settings dialog box (Figure 7-2), specify what size photo paper you're putting into the printer, and what size you want each photo layout to be.

Most of the time, if you have a standard photo inkjet printer, these will be one and the same. You'll want 4×6 prints on 4×6 paper, for example. But as noted in Figure 7-2, if the paper size is much larger than the print size, you might be able to get more than one print (that is, photo layout) per sheet.

Phase 4: Adjust the layout

The samples you see in the Themes dialog box are just starting points; you have many more options to choose from.

To see them, click Customize. Now you return to the main iPhoto window, where you land in the miniature page-layout program shown in Figure 7-3.

Figure 7-3:
In this mini layout program, use the pop-up buttons at the bottom to specify your color, border, and layout preferences.

Click a photo to

Click a photo to make its Zoom slider appear, as shown by the cursor at top. Drag the slider to enlarge the photo.

At this point, you can drag inside the photo to adjust its position within its "frame." Doubleclick a photo to open it into Edit mode.

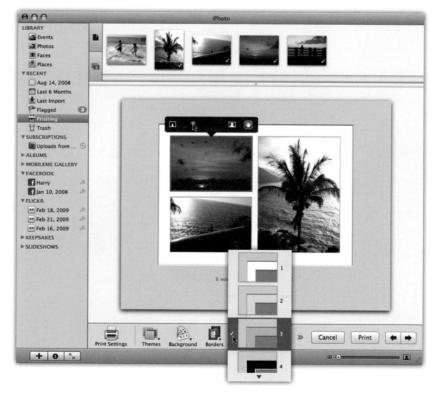

Tip: Until you either print or click Cancel, a new icon appears in your Source list, called Printing. While you're preparing your printout, you can click other Source-list icons and do other iPhoto work. You can return to your printout-in-waiting at any time by clicking that Printing icon.

You can also add new photos to the printout by dragging their thumbnails from other Events or albums right onto the Printing icon.

Chapter 9 contains a much more detailed look at iPhoto's page-layout mode, but here are the basics.

At the top of the window, you see the thumbnails of the photos you've selected for printing; a checkmark indicates a photo that you've already placed into a photo layout. (They all *start out* with checkmarks, but you might decide to remove a photo from a layout by dragging it out of its box.)

Note: The two tiny icons to the left of the thumbnails govern which thumbnails you see: thumbnails for the page layouts themselves, or thumbnails of the actual photos targeted for printing.

You can drag a photo into one of the rectangular placeholder spots on the photopage layout to replace whatever's there. You can even drag photos more than once, to get multiple copies.

Here, the pop-up buttons along the bottom of the window offer you hours of cosmetic tweaking pleasure. For example:

GEM IN THE ROUGH

Portraits & Prints

iPhoto's Layouts pop-up menu offers some rudimentary combination templates like the portrait galleries delivered by

professional photographers, but it doesn't offer much flexibility. You can't specify that you want more than four photos per sheet, for example.

Fortunately, a \$30 companion program called Portraits & Prints nicely compensates for iPhoto's printing weaknesses. (You can download it from, for example, the "Missing CD" page at www. missingmanuals.com.)

Once again, the idea is that you drag selected photos directly out of the iPhoto window and, in this case, into the Portraits & Prints window. There, you

can boost or reduce color intensity, sharpen, crop, rotate, add brightness, and remove red-eye. (If you designate Por-

traits & Prints as your preferred external editing program, then changes you make in Portraits & Prints will be reflected in iPhoto's thumbnails.)

But all that is just an appetizer for the main dish: a delicious variety of printing templates, like the one shown here. The program comes with six "portrait sets" that let you arrange different pictures at different sizes on the same sheet. You can even save

your layouts as *catalogs*, so you can reuse them or reprint them at a later date.

- Print Settings. Click to return to the main printing dialog box shown in Figure 7-2.
- Themes. Choose among Standard, Simple Border, or a Mat option (without having to go back to the box in Figure 7-2).
- Background. Specify what color you want to fill the margins of the paper, even for Standard layouts.
- Borders. For all themes except Contact Sheet, you get a choice of border colors, thickness, and styles for the printed-on frame or mat, as shown at bottom in Figure 7-3. (For Contact Sheet, you get a Columns slider instead, which lets you control how many columns of thumbnails appear on each page—and therefore how small they are.)
- Layout. There's a lot of design power hiding in this little pop-up menu. You can specify how many photos you want per page; whether you want horizontal (land-scape) or vertical (portrait) orientation; and, for most themes, whether you want a caption text box to appear beneath the layout, so you can identify what you're printing.
- Adjust. Click one photo (once) in the layout to make the Adjust button available. When you click Adjust, you get the Adjust *palette* shown in Figure 7-4. It's a near twin to the Adjust panel described on page 131.

None of this affects the original photos in your library.

Bottom: In Settings, you can make a few more miscellaneous tweaks to the layout.

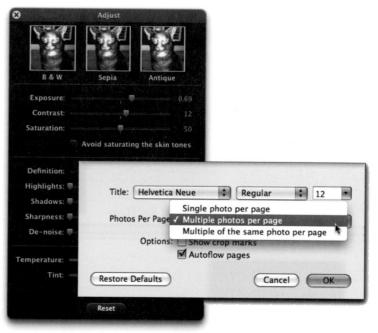

The changes you make here don't have any effect on the actual photos in your library. These are temporary changes that affect only this printed version.

• Settings. This button summons the dialog box shown at right in Figure 7-4, which contains an oddball assortment of miscellaneous commands. Here's where you can specify the type size and font for your captions; make crop marks appear in the printout (for ease of aligning if you plan to use a paper cutter); or turn on "Autoflow pages" (which makes the photos you selected pour themselves into a multi-photo layout automatically).

The most interesting control here is the Photos Per Page pop-up menu.

Tip: This pop-up menu is dimmed unless, in the Print Settings box (Figure 7-2), you've specified a page size large enough to hold more than one photo layout.

Ordinarily, iPhoto attempts to print as many photo layouts as possible on each sheet of paper; in other words, the factory setting is "Multiple photos per page." But if you don't want that paper-saving arrangement, you can choose "Single photo per page" instead. You'll get *one* photo layout per sheet, with a lot of white space.

Or, if you choose "Multiple of the same photo per page," you get that school photo-sampler effect (one 5×7 , two wallet-size...).

Phase 5: Print

When the layout(s) look good, click the big Print button at the bottom of the window. Only now do you see the more standard Print dialog box. Here's where you choose which printer you want, how many copies, and so on.

Finally, click the Print button (or press Return). Your printer scurries into action, printing your photos as you've requested.

Tip: The PDF button, a standard part of all Mac OS X Print dialog boxes, lets you save a printout-in-waiting as a PDF file instead of printing it on paper. It lets you convert any type of iPhoto printout to PDF. Choose Save as PDF from the PDF pop-up button, name the PDF in the Save to File dialog box, and then click Save. (Saving the file can take awhile if you're converting several pages of photos into the PDF.)

Ordering Prints Online

Even if you don't have a high-quality color printer, traditional prints of your digital photos are only a few clicks away—if you have an Internet connection and you're willing to spend a little money, that is.

Thanks to a deal between Apple and Kodak, you can order prints directly from within iPhoto. After you select the size and quantity of the pictures you want printed, one click is all it takes to have iPhoto transmit your photos to Kodak Print Services and bill your credit card for the order. The rates range from 12 cents for a single 4×6 print to about \$15 for a jumbo 20×30 poster. Within a couple of days, Kodak sends you finished photos printed on high-quality glossy photographic paper.

Tip: If you plan to order prints, first crop your photos to the proper proportions (4×6 , for example) using the Crop tool, as described in Chapter 5. Most digital cameras produce photos whose shape doesn't quite match standard photo-paper dimensions. If you send photos to Kodak uncropped, you're leaving it up to Kodak to decide which parts of your pictures to lop off to make them fit. (More than one Mac fan has opened the envelope to find loved ones missing the tops of their skulls.)

By cropping the pictures to photo-paper shape before you place the order, *you* decide which parts get eliminated. (You can always restore the photos to their original uncropped versions using iPhoto's Revert to Original command.)

Here's how the print-buying process works:

1. Select the photos you want to print.

Click an album to order prints of everything in it, or select only specific photos.

2. Choose File → Order Prints (or click the Order Prints toolbar button).

Now the Mac goes online to check in with the Kodak processing center. (If the Mac can't make an Internet connection, then the Order Prints window, shown in Figure 7-5, doesn't open.)

3. Click Set Up Account, if necessary.

The Set Up Account button appears at the lower-right corner of the dialog box if you've never before ordered anything from Apple. Clicking it initiates a series of dialog boxes where you surrender your identity and credit card info. You'll also see the option to turn on the "1-Click Ordering system," which is mandatory if you want to order prints. (All of this is a one-time task designed to save you time when you place subsequent orders.)

Note: If you already have an account to buy music and movies at the iTunes Store, then you don't need to set up a new one to buy photo prints. You can use the same name and password here, and Apple will happily bill the same credit card.

For details on the process, see page 252. When the Summary screen finally appears, click Done to return to the Order Prints window.

4. Select the sizes and quantities you want.

If you want a 4×6 print or two of every photo, then just use the Quick Order pop-up menu at the top of the dialog box.

For more control over sizes and quantities of individual photos, then fill in the numbers individually for each photo, scrolling down through the dialog box as necessary. The total cost of your order is updated as you make selections.

As you order, pay heed to the alert icons (little yellow triangles) that may appear on certain lines of the order form (visible in Figure 7-5). These are iPhoto's standard warning symbols, declaring that certain photos don't have a high enough

Ordering Prints Online

resolution to be printed at the specified sizes. A photo that looks great at 5×7 may look terrible as a 16×20 enlargement. Unless you're the kind of person who thrives on disappointment, *never* order prints in a size that's been flagged with a low-resolution alert.

Tip: You'll see the same warning icon when you print your own photos and order photo books, cards, or calendars (Chapter 9). As always, you have few attractive choices: You can order a smaller print, not order a print at all, or order the print and accept the lower quality that results.

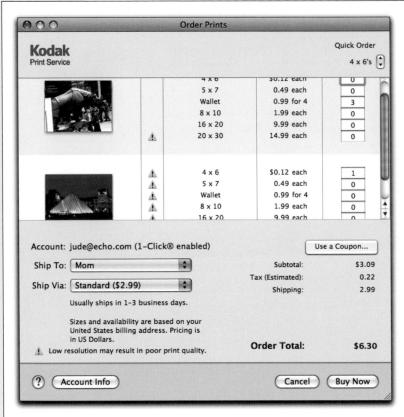

Figure 7-5:

The Order Prints window lets you order six different types of prints from your photos—from a set of four wallet-sized prints to mammoth 20 × 30 posters. Use the scroll bar on the right to scroll through all the photos you've selected to specify how many copies of each photo you want to order.

Note the yellow alert triangles next to certain print sizes. iPhoto is telling you the photo you're ordering is too low resolution for the size in question.

If you need to change your shipping, contact, or credit card information, then click the Account Info button to modify your Apple ID profile.

5. Click the Buy Now button.

Your photos are transferred, your credit card is billed, and you go sit by the mailbox.

A dialog box appears, showing the reference number for your order and a message saying you'll be receiving a confirmation via email.

A batch of 24 standard 4×6 snapshots costs about \$3, plus shipping, which is probably less than what you'd pay for processing a roll of film at the local drugstore. (You also don't have to pay for the gas to get there or the hassle of traffic and parking.)

Better yet, you get to print only the prints that you actually want, rather than developing a roll of 36 prints only to find that just two of them are any good. It's far more convenient than the drugstore method, and it's a handy way to send top-notch photo prints directly to friends and relatives who don't have computers. Furthermore, it's ideal for creating high-quality enlargements that would be impossible to print on the typical inkjet printer.

UP TO SPEED

How Low Is Too Low?

When you order photos online, the Order Prints form automatically warns you when a selected photo has a resolution that's too low to result in a good-quality print. But just what does Kodak consider too low? Here's the list of Kodak's official minimum resolution recommendations.

To order this size picture:Your photo should be at least:Wallet-sized 640×480 pixels 4×5 768×512 pixels 5×7 1152×768 pixels 8×10 1536×1024 pixels

These are *minimum* requirements, not suggested settings. Your photos will look better in print, in fact, if you *exceed* these resolution settings.

For example, a 1536×1024 pixel photo printed at 8×10 inches meets Kodak's minimum recommendation but has an effective resolution of 153×128 dpi—a relatively low resolution for high-quality printing. A photo measuring 2200×1760 pixels, printed at the same size, would have a resolution of 220 dpi—and look much better on paper, with sharper detail and subtler variations in color.

Email, Web Galleries, and Network Sharing

I olding a beautifully rendered glossy color print created from your own digital image is a glorious feeling. But unless you have an uncle in the inkjet cartridge business, you could go broke printing your own photos. Ordering high-quality prints with iPhoto is terrific fun, too, but it's slow and expensive.

For the discerning digital photographer who craves both instant gratification and economy, the solution is to put your photos *online*—by emailing them to others, posting them on the Web, or sharing them with other people on your home or office network.

All of this is particularly easy and satisfying in iPhoto '09, *especially* if you are a fan of Facebook or Flickr.

Emailing Photos

Emailing from iPhoto is perfect for quickly sending off a single photo—or even a handful of photos—to friends, family, and co-workers. (If you have a whole *batch* of photos to share, on the other hand, consider using the Web-publishing features described later in this chapter.)

The most important thing to know about emailing photos is this: *Full-size photos are usually too big to email.*

Suppose, for example, that you want to send three photos along to some friends—terrific shots you captured with your 7-megapixel camera.

First, a little math: A typical 7-megapixel shot might consume 3 megabytes of disk space. So sending along just three shots would make at least a 9-megabyte package.

Emailing Photos

Why is that bad? Let us count the ways:

- It will take you a long time to send.
- It will take your recipients a long time to download. During that time, the recipients must sit there, not even knowing what they're downloading. And when you're done hogging their time and account fees, they might not consider what you sent worth the wait.
- Even if they do open the pictures you sent, the average high-resolution shot is much too big for the screen. It does you no good to email somebody a 7-megapixel photo (for example, 3072×1728 pixels) when his monitor's maximum resolution is only 1280×800 . If you're lucky, his graphics software will intelligently shrink the image to fit his screen; otherwise, he'll see only a gigantic nose filling his screen. But you'll still have to contend with his irritation at having waited for so much superfluous resolution.
- The typical Internet account has a limited file-attachment size. If the attachment exceeds 5 MB or so, the message may bounce back or clog the mailbox. Your massive 9-megabyte photo package will push your hapless recipient's mailbox over its limit. She'll miss out on important messages and be very, very angry.

It's all different when you use iPhoto. Instead of unquestioningly attaching a multimegabyte graphic to an email message and sending off the whole bloated thing, its first instinct is to offer you the opportunity to send a scaled-down, reasonably sized version of your photo instead (see Figure 8-1). If you take advantage of this feature, your modem-using friends will savor the thrill of seeing your digital shots without enduring the agony of a half-hour email download.

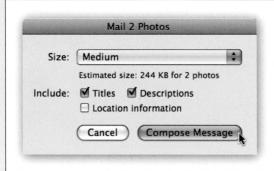

Figure 8-1:

The Mail Photo dialog box not only lets you choose the size of photo attachments, but it also keeps track of how many photos you've selected and estimates how large your attachments are going to be, based on your selection.

In iPhoto '09, you can have the message display any location (geotagging) information you've added to your photos (Chapter 4), as well as their titles and descriptions.

The Mail Photo Command

iPhoto doesn't have any emailing features of its own. All it can do is get your pictures ready and hand them off to your existing email program. iPhoto works with four of the most popular Mac email programs—Microsoft Entourage, America Online, Qualcomm's Eudora, and Apple's own Mail (the free email program that came with your copy of Mac OS X).

If you use Apple's Mail program to handle your email, you're ready to start emailing photos immediately. But if you want iPhoto to hand off to AOL, Entourage, or Eudora, then you have to tell it so. Choose iPhoto→Preferences (or press ૠ-comma), click General, and then choose the email program you want from the Mail pop-up menu.

Once iPhoto knows which program you want to use, here's how the process works:

1. Select the thumbnails of the photo(s) you want to email.

You can use any of the picture-selecting techniques described on page 48. (If you fail to select a thumbnail, you'll get an error message asking you to select a photo and try again.)

2. Click the Email icon at the bottom of the iPhoto window.

The dialog box shown in Figure 8-1 appears.

3. Choose a size for your photo(s).

This is the critical moment. As noted, iPhoto offers to send a scaled-down version of the photo. The Size pop-up menu in the Mail Photo dialog box, shown in Figure 8-1, offers four choices.

Choose Small (Faster Downloading) to keep your email attachments super-small (320×240 pixels)—and if you don't expect the recipient of your email to print the photo. (A photo this size can't produce a quality print any larger than a postage stamp.) On the other hand, your photos will consume less than 100 K apiece, making downloads quick and easy for those with dial-up connections.

Choosing Medium yields a file that will fill a nice chunk of your recipient's screen, with plenty of detail. It's even enough data to produce a slightly larger print—about 2×3 inches (640×480 pixels). Even so, the file size (and download time) remains reasonable; this setting can trim a 2 MB, 4-megapixel image down to an attachment of less than 150 K.

The Large (Higher Quality) setting downsizes even your large photos to about 450 K, preserving enough pixels (1280×960) to make good 4×6 prints and completely fill the typical recipient's screen. In general, send these sparingly. Even if your recipients have a cable modem or DSL, these big files may still overflow their email boxes.

Despite all the cautions above, there may be times when a photo is worth sending at Actual Size (Full Quality), like when you're submitting a photo for printing or publication. This works best when both you and the recipient have high-speed Internet connections and unlimited-capacity mail systems.

In any case, this option attaches a copy of your original photo at its original dimensions.

Note: iPhoto retains each picture's proportions when it resizes them. But if a picture doesn't have 4:3 proportions (maybe you cropped it, or maybe it came from a camera that wasn't set to create 4:3 photos), then it may wind up *smaller* than the indicated dimensions. In other words, think of the choices in the Size pop-up menu as meaning, "this size or smaller."

4. Include Titles, Descriptions, and Location Information, if desired.

Turn on these checkboxes if you want iPhoto to copy the title of the photo and any text stored in the Descriptions field into the body of the email—as well as where it was taken, if you've geotagged the picture. When Titles is turned on, iPhoto also inserts the photo's title into the Subject line of the email message.

Note: If multiple photos are selected when you generate an email message, the Titles option produces a generic subject line: "5 great iPhotos" (or whatever the number is). You can edit this proposed text, of course, before sending your email.

5. Click Compose.

At this point, iPhoto processes your photos—converting them to JPEG format and, if you requested it, resizing them. It then launches your email program, creates a new message, and attaches your photos to it. (Behind the scenes, iPhoto uses AppleScript to accomplish these tasks.)

6. Type your recipient's email address into the "To:" box, and then click Send.

Your photos are on their merry way.

Tip: iPhoto always converts photos into JPEG format when emailing them. If you to want preserve the files' original format when emailing Photoshop files or PDFs, *don't* use the Mail Photo feature. Instead, create a new email message manually, and then drag the thumbnails from iPhoto directly into the message window to attach them. (If you want to resize the photos, export them first using the File→Export command, which offers you a choice of scaling options.)

FREQUENTLY ASKED QUESTION

Using iPhoto with PowerMail, QuickMail Pro, MailSmith...

Hey, I don't use Entourage, Eudora, AOL, or Apple Mail! How can I get iPhoto to send my photos via QuickMail Pro? It's not listed as an option in iPhoto's Mail Preferences.

You're right. Even if you have a different email program selected in the Internet panel of System Preferences, iPhoto still won't fire up anything but Entourage, AOL, Eudora, or Mail when you click the Compose button.

There's a great workaround, though, thanks to the programming efforts of Simon Jacquier. Using his free utility, iPhoto Mailer Patcher, you can make iPhoto work obediently with MailSmith, PowerMail, QuickMail Pro, or even the aging Claris Emailer. It replaces the Mail button on iPhoto's bottom-edge panel with the icon of your preferred email program. You can download iPhoto Mailer Patcher from http://homepage.mac.com/jacksim/software.

Publishing Photos on the Web

Putting your photos on the Web is the ultimate way to share them with the world. If the idea of enabling the vast throngs of the Internet-using public to browse, view, download, save, and print *your* photos sounds appealing, read on. It's amazingly easy to get your photos from iPhoto to the Internet.

Three Roads to Webdom

iPhoto actually provides three different Web-publishing routes.

• The easiest, most hands-off approach. Publish your pictures to a Facebook page, Flickr account, or MobileMe Gallery. Anyone with a Web browser can now admire your photography.

Flickr.com, the world's most popular photo-sharing site, offers free basic accounts for anyone. You get a nice personal page to upload 100 megabytes' worth of photos every month. And if that's not enough, you can give Flickr \$25 a year and upload as many photos as you want.

Facebook.com, on the other hand, has become *the* destination for people (175 million of them, and growing) to post news, details, and pictures of themselves and their friends online. The site offers photo-album space you can share with your Facebook friends—and the ability to email photo-album links to anyone, not just other Facebook members.

MobileMe, on the other hand, is Apple's \$100-a-year suite of Web services. It includes email accounts, secure file backup, address book and calendar synchronization (among Macs, PCs, and iPhones), Web-site hosting—and Galleries. These are the most gorgeous photo presentations on the Web. And since you have iPhoto, publishing to a MobileMe account is literally a one-click affair. (See page 203 for details on signing up.)

These kinds of online galleries show your photos to best advantage, big and clear. You can password-protect your pictures; you can permit people to download your full-res photos; and you can add new photos right from your cameraphone or email program.

- More effort, more design options. Use iWeb, one of the other iLife programs. iPhoto can hand off any batch of photos to iWeb with only a couple of mouse clicks; from there, you can post them online with a single command.
- For the experienced Web page designer. If you already have a Web site, you can use either of two approaches to generate Web pages (HTML documents): the Export command or the Send to iWeb command. You can upload these files, with the accompanying graphics, to your Web site, whether that's a MobileMe account or any other Web-hosting service. (Most Internet accounts, including those provided by AOL and Earthlink, come with free space for Web pages uploaded in this way.)

Publishing Photos on the Web

This is the most labor-intensive route, but it offers much more flexibility to create more sophisticated pages if you know how to work with HTML. It's also the route you should take if you hope to incorporate the resulting photo gallery into an existing Web site (that is, one in which the photos aren't the only attraction).

All of these methods are detailed in the following pages.

Flickr

Flickr.com is an insanely huge and busy international photo-sharing site; it's not uncommon for its members worldwide to upload 30,000 photos and videos *a minute*. The site recognizes geotagged photos and displays them on a map, so those pictures you so carefully pinpointed back in Chapter 4 take their location information with them.

iPhoto '09 can send photos directly to your Flickr page. No more plug-ins or third-party export software needed, as in earlier versions. All you need is a Flickr account.

To get one, just bop over to www.flickr.com and sign up. If you're only a casual photographer, the free account will probably do you just fine. You can upload up to 100 megabytes of photos, and two 90-second video clips, a month. If you're serious about sharing, sign up for the \$25-a-year Flickr Pro account. By going Pro, you can upload an unlimited number of photos per month and even post high-definition video clips to your Flickr page.

Either way, you're in for quite a ride. Flickr isn't just a place to post your photos on the Web for your friends and family to see, although it's great for that. It's also a place for photo fans to comment on your photos, link to one another's photo pages, search for photos by keyword (before visiting a place, for example), and so on.

Note: Flickr's privacy settings let you keep personal photos out of the public view. Though the site, you can set up lists of Friends and Family so that only the people you have placed on these lists can see specified sets of pictures. (Flickr's FAQ has details at www.flickr.com/help/faq.)

Once you have your Flickr account, it's time to link it to iPhoto and transfer some photos:

1. In iPhoto, select some pictures that you want to share on Flickr.

You can select whole albums or pick and choose from your library (see page 48).

2. Click the Flickr button on the iPhoto toolbar.

If you *have* no Flickr button to click on the toolbar, then choose View→Show in Toolbar→Flickr. (You can also just choose Share→Flickr if you're more into menus than buttons.)

3. Sign into your Flickr account.

If you're not already logged in, then you're asked for your Flickr user name and password. You must also agree to let Flickr use its software to snag copies of your photos. Once you agree, you can go back to iPhoto.

Tip: If you forgot to sign up for an account in your excitement about this whole Flickr thing, you can actually sign up here while on the Flickr Web site.

4. An iPhoto dialog box appears, asking you privacy and file-size questions.

Here, you can pick how visible the pictures are in the real world—just seen by You, Friends, Family, Family *and* Friends, or Anyone. You can also pick the size—Web, Optimized, or Actual—as shown in Figure 8-2.

Figure 8-2:
Before it publishes the photos to your Flickr page, iPhoto wants to know what size to make them. Web and Optimized upload the fastest. Actual Size can take some time if you have a lot of big 12-megapixel shots to publish.

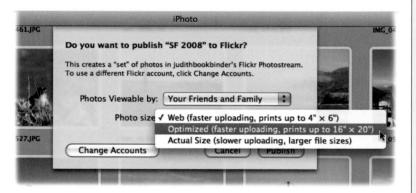

5. Click Publish.

Thanks to your Internet connection, iPhoto hands off the pictures to Flickr so that the world (or the subset of the world you've permitted) can see them. If you uploaded an album, its name now appears in the Flickr area of the iPhoto Source list. If you just selected a bunch of photos, the date of the earliest one appears under Flickr in the Source list.

Note: Any keywords you've applied to your pictures in iPhoto (page 83) are converted into Flickr tags when you publish them on the site. So if you've added the keywords *panda*, *National Zoo*, and *Washington DC* to all your panda pictures from that trip to the National Zoo, other Flickr members doing searches for photos tagged with *panda*, *National Zoo*, or *Washington DC* will see your pictures in their search results—if you've got your privacy settings configured to let anyone see your photos.

To see the photos in that album in iPhoto, click its icon in the Source list. In the black bar at the top of the iPhoto window, you get a link to the Flickr page where copies of these photos now reside as well. What iPhoto calls *albums*, Flickr calls *sets*, and your Flickr page now has a new set of the photos right up there on the Web.

Tip: You can change the album name by clicking it in the iPhoto Source list and typing in a new one. When you change the name of the album in iPhoto, the corresponding set name on Flickr also updates, too. Creepy! It works the other way, too: Changing the set name on Flickr also changes the icon name in iPhoto.

iPhoto Places on Flickr maps

If you spent time earlier tagging your photos to geographic locations (Chapter 4) or had the camera do it for you (page 102), then your careful attention to detail is about to pay off. All the location data you so carefully embedded in your photos goes with them when they travel up the Net from iPhoto on your Mac to Flickr on the Web.

Once the photos land on your Flickr page, a small Map link appears underneath them (Figure 8-3), inviting visitors to click and see where the pictures were taken. Once clicked, a Yahoo map opens up in the browser and marks the spot based on the location information embedded in the picture.

Tip: iPhoto and Flickr.com synchronize location information, too. So if you add location info to published photos on Flickr, it magically appears on the photos in iPhoto. So if you do your geotagging on your Flickr page during slow moments at work, your efforts won't be in vain.

Figure 8-3:

If you didn't geotag your photos in Places before you sent them to Flickr, you can tag them on the Web site. Click "Add to your map" (highlighted here) on a photo's Flickr page.

Flickr opens its own map page, which works a lot like the Google Map used by iPhoto.

The location information from any published photos you map on the Flickr site gets synced up with the same picture in your iPhoto library.

Any keywords (page 83) you applied to your pictures in iPhoto now show up as Flickr tags (also shown at left) when you publish them online.

Now, there might be some occasions when you don't want this information out there on the Web—for example, when location information might ruin your alibi. You can, of course, change your Flickr privacy settings, as described above, to limit who can see your pictures. (For more on Flickr's privacy settings, see www.flickr.com/help/faq.)

But if you don't feel like mucking around in Flickr account settings and don't want to take the location information out of the photos, you can stop iPhoto from including it when it sends the pictures up to Flickr. Choose iPhoto—Preferences—Web

and turn off "Include location information for published photos." (On the flip side, if you want the photos to show location information in Flickr but they aren't, make sure that Preferences checkbox is turned *on*.)

While this stops iPhoto from including the location info, it doesn't mean you can't put certain photos on the Flickr map. It just means you have to do it by hand.

To map a photo after it's been published to Flickr, click its thumbnail to see the photo on its own page. There, click the "Add to your map" link, shown in Figure 8-3. As with iPhoto, you can type in an address or drag the map to a spot to place the photo, then click the "Save to map" button.

You can also map a bunch of photos at once. On Flickr, click the Organizr link at the top of the page. On the Organizr screen, click the Map tab and then drag your photos from the strip at the bottom of the screen to the desired spots on the map.

Adding more photos to published Flickr sets

Once you've published an album to Flickr, adding more photos to the set is easy. When you have new pictures you'd like to add to the Flickr page, just drag them from the iPhoto window to the Flickr icon in the Source list, as shown in Figure 8-4. If you've published multiple albums to Flickr, drag those photos onto the set.

Figure 8-4:

After you drag new photos on top of the chosen Flickr set in the Source list, iPhoto gets to work uploading them to your Flickr page on the Web.

Flickr traffic goes both ways between the photosharing site and iPhoto. If you make a change to a published photo on Flickr—like renaming the photo or placing it on a map—iPhoto updates its own copy of the photo with the new information.

You're not just limited to your own Flickr pictures in iPhoto, either. When you subscribe to Flickr feeds from other people (page 210), you can see their photos by clicking the appropriate album in the Subscriptions area of the Source list.

After you drag the photos onto the Flickr icon, click the Publish icon (\mathfrak{A}) next to the album name. The Circular Arrows of Sync (\mathfrak{S}) appear to let you know those photos are on their way up to Flickr.

This syncing process goes two ways, by the way. When you upload photo to this same album set on Flickr (using Flickr's own uploading tools or from your phone), small Web-size copies of those same photos show up in your iPhoto library. Even though the resolution isn't very high, you can export these copies out of iPhoto.

Deleting photos from Flickr

The old saying, "What goes up must come down" isn't exactly true here—with Flickr, it's more like, "What goes up must come down when you realize that photo is outdated, embarrassing, or no longer serves any purpose up there on the Web."

To remove individual pictures from an online Flickr set, select the ones you want to wipe and press the Delete key. Flickr and iPhoto dance (\mathcal{G}) and the photos are now offline. The originals, however, are still safe at home in your iPhoto library.

Another way to yank those photos down: when you have the Flickr album open in the iPhoto window, select the images and choose Share→Unpublish.

You can also pull a whole album/set down from Flickr at once. Just click its icon in the Flickr area of the Source list and press the Delete key. When the dialog box pops up to ask if you're sure, click Delete.

Note: When deleting on the iPhoto end, you get the option to import any photos you added to the set from the Flickr side back into iPhoto. These aren't high-resolution versions, though, just the small Web editions.

Facebook

From its humble beginnings in 2004 as an online directory for Harvard students, Facebook has exploded into the world's most popular social-networking site with more than 175 million members around the world. The concept is ingenious: You sign up for an account at *www.facebook.com*, create a "profile page" where you add résumé-like details, plus lists of your favorite books, movies, and quotes.

Through tools on Facebook, you link your profile to the profiles of your friends. Once you have "friended" someone this way, you can see each other's profile pages and socialize in the virtual realm.

You can also upload pictures to photo albums on your profile page so your Facebook friends can see them. Once on Facebook, you can even "tag" a friend by name in those photos so you, your pal—and all the friends you *both* have—can see those pictures.

With iPhoto '09, this whole photo-uploading part is a piece of cake.

Once you have your Facebook account, it's time to link it to iPhoto and transfer some photos:

1. In iPhoto, select the pictures you want to publish to your Facebook page.

You can select whole albums or arbitrary batches of photos (see page 48 for photogathering tips).

2. Click the Facebook button on the iPhoto toolbar.

If you have no Facebook button on the toolbar, choose View→Show in Toolbar→Facebook. (Choosing Share→Facebook is another option.)

3. Sign into your Facebook account (Figure 8-5).

If you're not already logged in, you're asked to supply your Facebook user name and password. Facebook also prompts you for permission for it and iPhoto to communicate. (If you wandered into iPhoto's Facebook button by accident and don't yet have an account, there's a link to sign up for Facebook here, too.)

Figure 8-5:

To upload photos to Facebook from iPhoto, you first need to log into your Facebook account. After you type in your email address and password, you need to agree to one more piece of business: allowing Facebook's iPhoto Uploader program to touch your stuff as it publishes the pictures to your profile page.

Once you agree, adding pictures to your Facebook albums is as quick and easy as it is to add them to Flickr sets—drag, drop, and go.

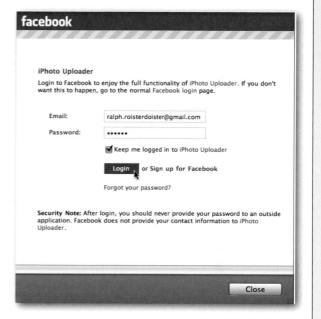

4. An iPhoto dialog box appears, asking you privacy questions.

Facebook wants to know who can see your uploaded pictures. You can choose only the people you've personally accepted on your Friends list, the Friends of your Friends, or any Facebook user who happens by.

5. Click Publish.

Sit back as iPhoto passes the pictures over to Facebook. If you uploaded an album, its name now appears in the Facebook area of the iPhoto Source list. If you just

Facebook

selected a bunch of photos, the date of the earliest one selected appears under Facebook in the Source list. (You can change this later.)

To see the photos in that album in iPhoto, click its icon in the Source list. In the black bar at the top of the iPhoto window, you also get a link to the Facebook page where copies of these photos are posted.

Note: If there's more than one avid Facebooker uploading pictures through the same copy of iPhoto, then the Source list displays each member's published Facebook albums in separate folders, labeled by Facebook member name. Figure 8-6 shows what to expect.

Figure 8-6:

Facebook is so popular that everyone in the house probably has an account. Once each member logs in and publishes photos to their respective profile pages, iPhoto organizes everyone into folders.

Click the flippy triangle next to each name to see the albums published by that Facebook devotee.

The Circular Arrows of Sync indicate that the selected album is in the process of updating Facebook with a new picture uploaded by iPhoto.

To change the name of the published album from iPhoto, click its entry in the Source list and type in a new name. The new name appears on Facebook when the album syncs. Likewise, you can change the album name on Facebook by clicking the Photos tab on your profile page, selecting the album, and then clicking Edit Photos. When the album opens to reveal all the pictures inside, click the Edit Info tab and type in a new name for the album.

Tip: You can use Facebook to share albums even with people who aren't members. Click the Photos tab on your profile page and open the album you want to share. At the bottom of the album page, there's a line saying something like "Show people this album by sending them this public link: www.facebook.com/album. php?aid=2014616&id=1536543211&l=06a80." Cut and paste that link into an email message and send it off to invite one of the six people not yet on Facebook to see your photos.

Automatic photo-tagging in Facebook

Remember how much fun you had back in Chapter 4 getting iPhoto to recognize your friends with the grinding analytic power of Faces? If you took the time to add full names and email addresses to the snapshots on your Faces corkboard (page 98), then tagging your Facebook friends in photos is pretty much a done deal.

Once you upload name-tagged photos to Facebook, friends you've identified in the pictures are also pinged with Facebook's own photo-tagging tool. In other words, if you've filled in Ralph's info on his Faces snapshot in iPhoto, Facebook blabs to all your mutual friends that you've just tagged Ralph in a photo.

Depending on your Facebook settings, all your friends can see a thumbnail of the Ralph-tagged photo and can click a link to see it in full. If you're always tagging your pals on Facebook, iPhoto can save you a lot of time.

Note: If you know you've face-tagged someone on the corkboard but the photo tags aren't showing up on Facebook, check the name and email address you entered on the **1** side of the Faces snapshot (page 98). Those must match the name and email address the person uses for his Facebook account.

Adding more photos to Facebook albums

Now that you've published an album to Facebook, adding more photos to it is as easy as dragging them out of the iPhoto window and onto the album's icon in the Facebook area of the Source list. After you drag the photos onto the appropriate Facebook album icon, then click \mathfrak{A} next to the album name to sync 'em up.

As with Flickr, syncing is a two-way street between Facebook and iPhoto. If you move a photo into a different published Facebook album, add a picture to the album, or change album names and photo titles, iPhoto updates its own copies, too.

Deleting photos from Facebook

As addictive and fun as Facebook can be, it's also a place where ids run wild. When you're ready to take those embarrassing party pictures down or delete entire albums, just select them in the iPhoto Source list and hit the Delete key. (Make sure you're deleting them from the Facebook icon and not from the Photos area; deleting pictures from Photos deletes them from iPhoto.)

Another way to remove them is to select the images you want to remove from a published Facebook album and choose Share→Unpublish.

Similarly, deleting albums through your Facebook page removes the published versions from iPhoto. If you added pictures to a published album through Facebook and then want to delete the whole album later, iPhoto asks if you want to import those added pictures to its own library.

The MobileMe Gallery

If you have a MobileMe account and a high-speed Internet connection, you're in for a real treat. iPhoto can publish your pictures to a gorgeous, interactive Web-based gallery—a delight for anyone who knows its Web address (and who *also* has a high-speed connection).

The MobileMe Gallery

As with Flickr and Facebook, publishing couldn't be simpler:

1. Choose the photos you want to publish.

You can click an album or an Event, or you can just select a batch using the techniques described on page 48.

2. Choose Share→MobileMe Gallery.

Or click the MobileMe button on the toolbar, if you see it. If you don't see it, and you'd like to, choose View—Show in Toolbar—MobileMe.

Note: If, at this point, iPhoto doesn't yet know your MobileMe account information, a dialog box offers you a Sign In button (in case you're already a member) and a Learn More button (in case you're not; see the box below).

At this point, you see the dialog box shown at top in Figure 8-7.

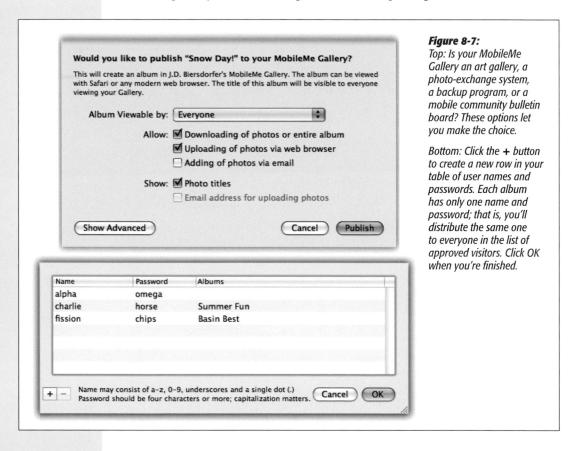

3. Specify who can see your pictures.

The "Album Viewable by" pop-up menu lets you specify who can see your photos. After all, not every picture in your life is appropriate for every rabble-rouser out there. (You know who you are, senators' children.)

If you choose Everyone, well, then there are no restrictions on who can call up your photos. If you choose Only Me, then you've pretty much guaranteed that nobody sees your pictures unless they're sitting there beside you.

There is, fortunately, an in-between option. If you choose Edit Names and Passwords, you get the dialog box shown at the bottom of Figure 8-7, where you can create a name and password for this album. You can distribute this name and password to friends and relatives to ensure that only the lucky few can get in.

Note: As the dialog box mentions, capitalization counts when you make up these passwords; *fruitcake* and Fruitcake are two different things.

UP TO SPEED

Getting a MobileMe Account

MobileMe, Apple's subscription online service, provides everything you need to put a collection of your photos online-and on your network. Unfortunately, the service isn't free. A membership will set you back \$100 per year.

MohileMe MobileMe stores your email, contacts, calendar, photos and files in an online "cloud, and keeps your Mac, PC, iPhone, or iPod touch up to date. Are you a MobileMe member? Try MobileMe for free. Sign into your account to set up MobileMe Sign up now and experience MobileMe for 60 days at no charge. on this computer. Member Name: Password: (Sign In

The good news is that Mac OS X makes it incredibly easy to sign up for an account, and a two-month trial account is free. (There are a few limitations on the trial account: it grants you 20 MB of iDisk space instead of 20 gigabytes, for

example.) If you don't already have an account, here's how you get one:

Choose **★**→System Preferences. When you click the MobileMe icon, click Learn More under the "Try MobileMe for free" heading.

Now you go online, where your Web browser opens up to the MobileMe sign-up screen. Fill in your name and address, make up an account name and password, and, if you like, turn off the checkbox that invites you to receive junk mail.

You're also asked to make up a question and answer

a

(such as, "First grade teacher's name?" and "Flanders"). If you ever forget your password, the MobileMe software will help you-provided you can answer this question correctly. Click Continue.

An account summary screen now appears:

print it or save it. On the next screen, the system offers to send an email message to your friends letting them know about your new email address (which is whatever-nameyou-chose@me.com).

Learn More...

The final step is to return to the MobileMe pane of System Preferences. Fill in the account name and password you just composed. You're now ready to use your MobileMe account.

After you've created some names and passwords and clicked OK, you return to the Publish dialog box. Make sure that the correct name is visible in the pop-up menu.

4. Turn on the other checkboxes to configure your gallery.

"Allow: Downloading of photos or entire album" means that the Download button in the MobileMe Gallery will be available. Anyone who clicks it can download the full-size, full-resolution copy of that photo.

If you're worried that people might try to make money off your masterful photographic work, don't turn this on.

"Allow uploading of photos via Web browser" is even more intriguing. It means that visitors to your gallery can post photos of their own, adding to this online album, whether they're on Mac OS X or Windows. Details appear on page 207.

Tip: You can upload photos from an iPhone directly to your gallery, too (assuming you've entered your MobileMe account information on your iPhone, and assuming you've already published at least one Web gallery). In the Photo-viewing program, tap the Send icon, and then choose Send to MobileMe. Choose the gallery you want to receive your photo, and then click Send.

It's important to note that iPhoto performs a *two-way sync* with the gallery. If you add photos to the published album, they show up on the Web automatically—and if someone *else* adds photos, they show up in your copy of *iPhoto* automatically!

"Allow: adding of photos by email" may be cooler yet. It lets anyone add photos by sending them to your gallery's secret, unique email address.

You won't discover the private email address until after you've published the gallery (Figure 8-8). Once you do, you'll find it in the upper-right corner of the iPhoto window.

So how are would-be emailers supposed to know the secret address? Depends on how private you want to be.

If you turn on "Show email address for uploading photos," then the MobileMe Gallery's email address appears when visitors click the Send to Album button at the top of the Web gallery itself. (It's one of the buttons barely visible at top left in Figure 8-8.)

If you leave that option turned off, then nobody will know the gallery's email address...unless you email it to them.

"Show: Photo titles" means that the names of your pictures (as you've typed them in iPhoto) will appear on the Web.

Click the Advanced button in the left corner of the box to get to even more settings. Here, you can turn on the checkbox next to "Hide album on my Gallery page" if

you want to publish this particular set of pictures—but keep them from showing up alongside all the other albums on your MobileMe Gallery page.

If you've turned on the checkbox that allows people to download copies of your photos, then the pop-up menu next to Download Quality is available. You can choose Optimized (smaller, faster, not as nice to print large) or Actual Size (the same resolution as what you originally uploaded).

Figure 8-8: "Published" icons Gallery URL Gallery email address When you click a gallery's icon in the Source LIBRARY list, things jdbiersdorfer-93f2@post.me Events look a little Photos different. ■ Faces STUDY Places W RECENT Mar 1, 2009 Last 12 Months Last Import Flagged Trash **► SUBSCRIPTIONS** ► ALBUMS W MORILEME GALLERY - Pets NYC Vacation Boston Trip ▶ FACEBOOK FIICKR ► KEEPSAKES ▶ SLIDESHOWS Harry & Carrie () Slideshow Edit Hide Keepsakes Tell a Friend Settings + 0 % Q = Search . 6 photo

5. Click the Publish button (.M).

iPhoto sends your photos off to Webland and posts them in your gallery. It can take quite awhile—a minute per picture, for example.

When it's all over, the iPhoto window looks like Figure 8-8. You'll notice a few changes:

• In the Source list, there's a new heading called MobileMe Gallery. Your newly published album's name is listed here. So are any other albums you publish.

You can change what's in the gallery by adding, deleting, or editing the thumbnails within it. Then click the "Published" icon on your gallery's name, as identified in Figure 8-8.

- At the top of the window, the name, Web address, and email address of this gallery appear. Click the tiny right-pointing arrow to open the published version of the gallery in your Web browser.
- At the bottom of the window, click Settings. The box shown in Figure 8-7 reappears, so that you can change your mind about any of your gallery's options.
- Click Tell a Friend, also at the bottom of the window, to fire up your email program. iPhoto generates a new outgoing message automatically, complete with instructions in the body. They say: "You've been invited to view an album on MobileMe Gallery." A big View Album button in the middle of the message body gives its readers a quick-click trip to your photos.

The message goes on to provide the user name and password, if you've established one. If you've enabled downloading or uploading, it adds, "You can add to this album by mobile phone or email," along with the MobileMe-generated email address to use for uploading new pictures to your album.

Using MobileMe Gallery

Once your fans arrive at the Web address you've given them, they're in for a rollicking good time. They can walk through your little art show using any of four super-slick slideshows (shown in Figure 8-9):

• Grid is the standard layout. Your photos appear as thumbnails, which you can click for a larger view.

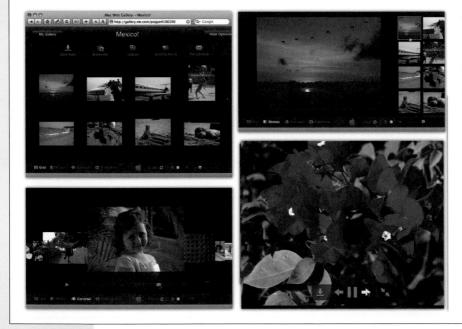

Figure 8-9: Your finished Web gallery at work. Clockwise from top left: Grid, Mosaic, Slideshow, and Carousel presentation modes.

- Mosaic offers a "table of contents" of thumbnails on the right side; click one to see that photo at full (or at least fuller) size in the middle of the window. The advantage here is that you don't lose sight of the full photo array; you can jump among them without proceeding in sequence.
- Carousel is a lot like Cover Flow (in Mac OS X Leopard or on the iPod). This show, too, lets you keep track of where you are in the stack of pictures; as you drag the horizontal scroll bar (or drag the photos themselves), the photos fly past, enlarging to a decent size as they pass the center point.
- Slideshow, of course, is a traditional slideshow, where your visitor doesn't have to do anything but sit back and watch as the pictures parade across the screen, complete with crossfades between them. (A control bar with Download, Previous, Next, Pause, and Exit Full Screen buttons is available, however, when a little more interactivity is desired. Wiggle the mouse to make it appear.)

There are some handy buttons across the top, too (visible, though tiny, at top left in Figure 8-9):

- Download. If you've given permission, visitors can download the full-resolution photos to their own hard drives. This is a great way to supply your pictures to other people, anywhere in the world, who might want to print them—without dealing with the hassles and file-size limits of email.
- Subscribe. See page 209 for details.
- Upload. Your public can click this button to upload new photos to your gallery, if you've permitted it. Once they prove that they're human (see Figure 8-10), they click Choose Files. Next, they find and highlight their own photos to upload, and then click Select. The files are automatically uploaded and posted on your gallery.

If you permit uploading, your visitors will see an Upload button in your Gallery. It produces this box, where uploaders can enter a name and email address. They must also type in the distorted characters in the middle; that's to prove that they're human, and not one of those spam-generating software robots

that cruise the Web,

causing destruction.

Figure 8-10:

- Send to Album. Others can click this button to reveal the gallery's private email address, if you've permitted emailing photos.
- Tell a Friend. Click to send a link to your gallery to someone else by email. Spread the word!

At the bottom of the window, the four Color buttons let viewers change the background color of the gallery: Black, dark gray, light gray, or white. Finally, the Size slider at the lower right controls the thumbnail size in Grid and Mosaic views.

Turning Off Your MobileMe Albums

You'll always know how many albums you've published in your MobileMe Gallery, because they're listed right there in the Source list.

It's very easy to take one down, too, once it's outlived its usefulness: Click the album's name, and then press Delete.

If it contains photos that were synced to your copy of iPhoto from the gallery (for example, photos submitted by other people), a message appears to warn you that those pictures are about to be obliterated. (It also gives you an "Import photos to your library before deleting this album" checkbox.)

FREQUENTLY ASKED QUESTION

Photocasting, R.I.P.

What happened to photocasting?

Photocasting was a hot new feature of iPhoto 6. But in iPhoto '08, it was replaced by the .Mac Web Gallery photo feed, which has *now* been replaced by the MobileMe feed.

Photocasting was a direct pipe from your copy of iPhoto into somebody else's. You could "publish" an album (baby pictures, for example); they could "subscribe" to it (grandparents, let's say). Whenever you made changes to that album—you added more photos, for example—the grandparents saw the changes in their own copies of iPhoto.

They could also drag your photos into their own copies of iPhoto—the full-resolution originals.

So why is it gone? Maybe not enough people used it, or maybe Apple wants to push sales of its MobileMe accounts (required for the gallery feature).

If you upgraded to iPhoto '09, any albums you had photocast continue to work. But their Web address (URL) has changed, and it's up to you to notify everyone who subscribed to them. (To find the new URL, click the album in the Source list; the URL appears at the top of the window. Your fans should choose File—Subscribe to Photo Feed, and then paste in this new address.) And you can't create *new* photocasts.

If you have a MobileMe account, you can also change your Photocast albums into Web galleries, described in this chapter; people with iPhoto '08 can still subscribe to your photos and, if you permit it, download them or even add their own pictures.

Here's how: Select the Photocast album in your Source list, and then click Unpublish on the toolbar. When that button changes to say MobileMe, click it; next, survey the publishing options, and then publish away.

Then, it disappears, not only from your Source list, but also from the Web and from any subscribers' copies of iPhoto. And you reclaim that much of your MobileMe storage space.

There's another way to shut down the album: Choose Share→Unpublish.

Subscribing to Published Albums

If your screaming fans have iPhoto '08 or later, they can subscribe to your MobileMe Gallery. That means that if you make changes to the gallery—adding or removing pictures, say—those changes are soon thereafter reflected in the iPhoto libraries of your subscribers. Photo-feed subscriptions are a fantastic way for grandparents and other interested parties to keep in touch with the photos of your life, with zero effort on their part and very little on yours.

You can subscribe to someone's iPhoto feed in two ways. Both of them require that you know the gallery's Web address, as sent to you by its creator:

- Visit the album's Web page on the MobileMe Gallery. Click the Subscribe button; in the confirmation box, click Subscribe.
- In iPhoto, choose File→Subscribe to Photo Feed. In the resulting box, paste the gallery address, and then click Subscribe. (Press **%**-U to get there faster.)

Once you've subscribed to someone's MobileMe gallery, a new icon appears in your Source list under a new heading: "Subscriptions." When you click it, the main Photos view changes to show you the latest pictures from that gallery. (It can take awhile for the photos to appear the first time you subscribe, though. Best not to sit there waiting for it; go do something else and come back later.)

Figure 8-11:

In the Web panel of iPhoto Preferences, you can tell iPhoto how often to check for new photos from the people on your Subscriptions list.

You can also check to see how much of your precious MobileMe space is getting used up from photos and other files stored on the iDisk. If things get tight, then you have two choices: Dump stuff off your iDisk or click the Buy More button and rent extra server space from Apple.

Ordinarily, your copy of iPhoto doesn't check the gallery to see if there are changes until you click the $\mathcal O$ button next to the gallery's name. But if you have an always-on Internet connection (like a cable modem or DSL), you can request that iPhoto check for changes *automatically*; there's no downside, and you're saved a few exhausting clicks.

To do that, choose iPhoto—Preferences—Web (Figure 8-11). From the "Check for new photos" pop-up menu, you can choose "Every hour," "Every day," or "Every week."

Subscribing to Flickr feeds

Through the magic of RSS (Really Simple Syndication), you can keep an eye on the pictures that your friends are uploading to their own Flickr pages, right from the comfort of your own iPhoto window. All you need to do is subscribe to their Flickr feeds.

Suppose you want to see the soccer photos that your Flickr buddy "SirLexington" uploads every week:

1. Get the address of the Flickr feed.

Visit your pal's Flickr collection on the Web and scroll down to the bottom of the page. Look for the symbol with the line "Subscribe to SirLexington's photostream" next to it. Links for Latest, geoFeed, and KML are here.

Control-click (or right-click) the or on Latest, and then choose Copy Link Location from the shortcut menu. (The geoFeed link is the feed for photos that have embedded location information; the KML shows photos tagged in the Google Earth program.)

2. In iPhoto, choose File→Subscribe to Photo Feed.

You can also just press **ૠ**-U. In the resulting box, paste the feed URL, and then click Subscribe.

3. Admire the photos.

Under the Subscriptions area of the iPhoto Source list, you now have an album called "Uploads from SirLexington." Click the album icon to see Lex's latest Flickr uploads in your iPhoto window.

These are small Web versions of the pictures, but you can see them even when you're not online. You can even drag the photos out of the iPhoto window to the desktop, although they're not big enough to print very well.

As with MobileMe Gallery, you can set your iPhoto preferences to automatically or manually check for updates to the feed (Figure 8-11).

iPhoto to iWeb

Here it is—the second-easiest way to publish your photos on the Web. Your photos end up on a handsome-looking Web page in just a few quick steps, with far more design freedom than the Web galleries give you.

1. In iPhoto, select the photos you want to put on the Web, or click the album that contains them.

The selection can be one you've dragged pictures into, a smart album, the Last Import album, a year album, and so on. Or use the selection techniques described on page 48 to isolate a bunch of photos within an album.

Note: The iWeb photo-gallery template can't handle more than 99 photos per Web page. If you want to publish more than that, you'll have to create a series of separate pages.

2. Choose Photos—Send to iWeb—Photo Page (or, if the iWeb button appears on the toolbar at the bottom of the screen, choose Photo Page from its pop-up menu).

If you choose Photos—Send to iWeb—Blog instead, you'll create a different sort of Web page—not so much an art gallery as a daily journal page, with spaces where you can type up comments about your pictures. The steps are exactly the same as described here, except that you should begin by selecting, at most, three photos.

After a moment, iWeb appears.

3. Choose from the list of themes (color/design schemes).

The window immediately displays a mock-up of your finished Web page (Figure 8-12), displaying the thumbnails in whatever order they appeared in iPhoto.

FREQUENTLY ASKED QUESTION

Where Did All the Photos Go?

When iWeb transfers my photos to the MobileMe Web site, where are they going?

Everything gets stored on your iDisk, the virtual disk that comes with your MobileMe account. (Your iDisk looks and behaves like a miniature hard drive, but it's really just a privately reserved chunk of space on one of Apple's secure servers.)

The HTML pages generated by iWeb automatically go in the Web→Sites→iWeb folder on your iDisk. (In fact, if you know how to use a Web page creation program like Dreamweaver, you can make changes to your Web pages by editing these documents.)

The photos themselves get dumped into folders called Images within that iWeb folder on the iDisk.

iPhoto to iWeb

4. Edit the page title, subtitle, and individual photo titles.

Don't be concerned by the presence of all the Latin ("Lorem ipsum dolor amet..."); that's intended to be placeholder text. Drag your cursor through it and type new stuff to replace it.

If you don't bother changing the photo names, iPhoto will simply use whatever titles the photos have in the program itself.

5. Edit the design of the photo grid, if you like.

Click any photo thumbnail. As shown in Figure 8-12, a palette of photo-grid options appears. You can control how many columns appear, how many lines you want for each caption, and so on.

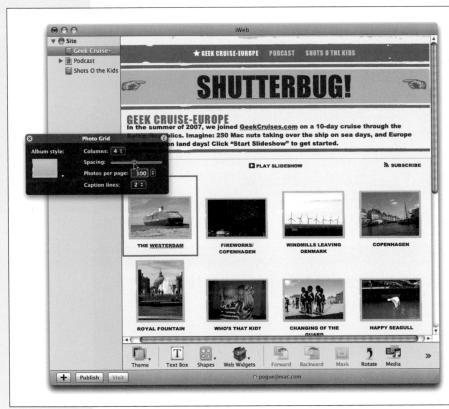

Figure 8-12: In iWeb, iPhoto shows you what your yet-to-bepublished Web page is going to look like.

To adjust the layout, click any photo to open the Photo Grid panel. Here, you can adjust the thumbnail spacing, number of columns, photos per page, and so on.

6. Click the Publish button (shown at lower left in Figure 8-12).

This is the big moment: iPhoto connects to the MobileMe Web site, scales down your photos to a reasonable size, and then transfers them to the server. This magic requires, of course, that you already have a MobileMe account, and that you've entered your account name and password. It can also take a *very* long time.

When the uploading process is complete, as indicated by the alert dialog box, you can go to the page and see your results.

Note: You don't *have* to have a MobileMe account to use iWeb. If you maintain your own Web site, for example, choose File→"Publish to a Folder" in this step. You wind up with a folder of correctly linked HTML documents and images folders on your hard drive. All you have to do is upload them manually to your Web site, as described on page 218.

If you include larger photos in your Web page, iPhoto automatically scales them down to reasonably sized JPEG files, so that they can be more easily loaded and displayed in a Web browser. If you want your Web pages to include *exact* copies of your original photos—regardless of size or file format—use the Export option described on page 214.

What you get when you're done

When you see what you've created with iWeb, you'll be impressed: It's a professional-looking, stylishly titled Web page with thumbnails neatly arranged in a grid. Clicking a thumbnail opens an enlarged version of the picture in its own window; clicking the Start Slideshow button creates a full-window, beautiful slideshow complete with Previous and Next buttons and, when you move the cursor to the top of the window, even a little thumbnail browser. You can return to your main index page at any time by closing the slideshow window.

Tip: In the URLs for your MobileMe-hosted Web sites (such as http://me.com/casey/Site/GeekCruise-Europe.html), capitalization counts—a point not to be forgotten when you share the site's address with friends. If you type one of these addresses into a Web browser with incorrect capitalization, you'll get only a "missing page" message.

Then again, maybe it's better to send your friends a much shorter, easier-to-remember address. You can convert long URLs into shorter ones using a free URL redirection service. At www.tinyurl.com, for example, you can sign up to turn http://me.com/gladys/Site/pickles.html into http://tinyurl.com/5k9q5b. (Or do your own shopping for similar services by searching Google for "free URL redirection.")

Editing or deleting the Web page

Within iWeb, make your changes (delete photos or add them using the Media Browser, rearrange them, rename them, and so on) and then click the Publish button again at the bottom of the screen. iWeb sets about updating the gallery online.

To delete a photo-gallery page, click its name in iWeb's left-side panel (the Site Organizer), and press the Delete key. Then click Publish at the bottom of the window (meaning, "OK, make the online version of my site match what I now have in iWeb").

Deleting a photo page like this also deletes all of the online photo files, which frees up space on your iDisk.

Exporting iPhoto Web Pages

If you already have your own Web site, you don't need MobileMe or iWeb to create an online photo album. Instead, you can use iPhoto's Export command to generate HTML pages that you can upload to any Web server. You're still saving a lot of time and effort—and you still get a handy thumbnail gallery page.

The Web pages you export directly from iPhoto don't include any fancy designs or themed graphics. In fact, they're kind of stark; just take a look at Figure 8-13.

Figure 8-13:
Here's what a Web
page exported straight
from iPhoto looks like.
The no-frills design
is functional, but not
particularly elegant.
You have no control
over fonts or sizes. On
the other hand, the
HTML code behind this
page is 100 percent
editable.

But they offer more flexibility than any of the MobileMe galleries. For example, you can specify the dimensions of thumbnails and images, and choose exactly how many thumbnails you want included on each page.

This is the best method if you plan to post the pages you create to a Web site of your own—especially if you plan on tinkering with the resulting HTML pages yourself.

Preparing the Export

Here are the basic Web exporting steps:

1. In iPhoto, select the photos you want to include on the Web pages.

The Export command puts no limit on the number of photos you can export to Web pages in one burst. Select as many photos as you want; iPhoto will generate as many pages as needed to accommodate all the pictures in your specified grid.

Tip: If you don't select any photos, iPhoto assumes you want to export all the photos in the current album, including the Library or the Last Import album.

2. Choose File→Export, or press Shift-\- E.

The Export Photos dialog box now appears.

3. Click the Web Page tab.

You see the dialog box shown in Figure 8-14.

Figure 8-14:

As you change the size of the thumbnail grid or the size of the thumbnails, the number of pages generated to handle the images changes. The page count, based on your current settings, appears just to the right of the Rows field. The total count of the photos you're about to export appears in the lower-left corner of the window.

The Template pop-up menu offers to put a little frame around each thumbnail. And if you turn on the "Show metadata" checkbox, then when someone clicks a thumbnail to open the full-size photo, the camera, shutter, aperture, exposure, and other photographic data appear for analysis and admiration. And new in iPhoto '09: the ability to provide the location information in geotagged pictures.

Page						
Title:	The Wier	he Wienermobile!				
Columns:	3	Rows:	10		1 Page	
Template:	Plain		1			
Background:			Text (Color:		
Thumbnail			Image			
Max width	: 240		Ma	ax width:	640	
Max height	: 240		Ma	x height:	640	
☐ Show ti	itle			Show title	2	
Show comment			☐ Show comment			
				Show me		

4. Set the Page attributes, including the title, grid size, and background.

The title you set here will appear in the title bar of each exported Web page, and as a header in the page itself.

Tip: For maximum compatibility with the world's computers and operating systems—if you're trying to get a lot of international visitors to check out your photos—then use all lowercase letters and no spaces.

Use the Columns and Rows boxes to specify how many thumbnails you want to appear across and down your "index" page. (The little "1 page" indicator tells you how many pages this particular index gallery requires.)

If you'd like a background page color other than white, click the rectangular swatch next to the word Background, and follow the instructions in Figure 8-15. You can also pick a color for the text that appears on each page by clicking the Text Color swatch.

Figure 8-15:

Left: Drag the right-side slider all the way up to see the spectrum of colors available to you. Drag downward to view darker colors.

Right: Alternatively, click one of the other color-picking buttons at the top of the dialog box. The crayon picker delights with both ease of use and creative color names, like Banana.

You can even choose a background *picture* instead of a solid background color. To make it so, click the Image button, and then the Set button to select the graphics file on your hard drive. Be considerate of your audience, however. A background graphic makes your pages take longer to load, and a busy background pattern can be very distracting.

5. Specify how big you want the thumbnail images to be, and also specify a size for the expanded images that appear when you click them.

The sizes iPhoto proposes are fine *if* all your photos are horizontal (that is, in landscape orientation). If some are wide and some are tall, however, you're better off specifying *square* dimensions for both the thumbnails and the enlarged photos— 240×240 for the thumbnails and 640×640 for the biggies, for example.

6. Turn on "Show title," "Show comment," "Show metadata," and "Include location," if desired.

"Show title" draws upon the titles you've assigned in iPhoto, centering each picture's name underneath its thumbnail. The larger version of each picture will also bear this name when it opens into its own window.

Turning on "Show comment" displays any text you've typed into the Description field for each picture in iPhoto. Depending on which checkboxes you turn on, you can have the comments appear under each thumbnail, under each larger image, or both.

"Show metadata" will display reams of photographic data (shutter speed, aperture, flash status, and so on) beneath each larger image.

Finally, "Include location" lets the photo take along any geotags showing where it was taken. If you have privacy concerns, it's best to leave this one turned off.

7. Click Export.

The Save dialog box appears.

8. Choose a folder to hold the export files (or, by clicking New Folder, create one) and then click OK.

The export process gets under way.

Examining the Results

When iPhoto is done with the export, you end up with a series of HTML documents and JPEG images—the building blocks of your Web-site-to-be. A number of these icons automatically inherit the name of the *folder* into which you've saved them. If you export the files into a folder named "Tahiti," for example, you'll see something like Figure 8-16:

• Tahiti.html. This is the main HTML page, containing the first thumbnails in the series that you exported. It's the home page, the index page, and the starting point for the exported pages.

This is what a Web site looks like before it's on the Internet. All the pieces are here, filed exactly where the home page (called, in this example, Tahiti.html) can find them.

- Page1.html, Page2.html... You see these only if you exported enough photos to require more than one page of thumbnails—that is, if iPhoto required *multiple* "home" pages.
- Tahiti-Thumbnails. This folder holds the actual thumbnail graphics that appear on each of the index pages.
- Tahiti-Pages. This folder contains the HTML documents (named Image1.html, Image2.html, Image3.html, and so on) that open when you click the thumbnails on the index pages.
- Tahiti-Images. This folder houses the larger JPEG versions of your photos. Yes, these are the *graphics* that appear on the Image.html pages.

Tip: Some Web servers require that the default home page of your site be called *index.html*. To force your exported Web site to use this name for the main HTML page, save your exported pages into a folder called "index." Now the home page will have the correct name (*index.html*) and all the other image and page files will be properly linked to it. (After exporting, feel free to rename the folder. Naming it "index" was necessary only during the exporting process.)

Once you've created these pages, it's up to you to figure out how to post them on the Internet where the world can see them. To do that, you'll have to upload all the exported files to a Web server, using an FTP program like the free RBrowser (available from the "Missing CD" page of www.missingmanuals.com).

Only then do they look like real Web pages.

Enhancing iPhoto's HTML

If you know how to work with HTML code, you don't have to accept the unremarkable Web pages exported by iPhoto. You're free to tear into them with a full-blown Web authoring program like Adobe Dreamweaver or the free KompoZer (www.kompozer. net) to add your own formatting, headers, footers, and other graphics. (Heck, even Microsoft Word lets you open and edit HTML Web pages—plenty of power for changing iPhoto's layout, reformatting the text, or adding your own page elements.)

If you're a hard-core HTML coder, you can also open the files in a text editor like BBEdit or even TextEdit to tweak the code directly. With a few quick changes, you can make your iPhoto-generated Web pages look more sophisticated and less generic. Here are some of the changes you might want to consider making:

- · Change font faces and sizes.
- Change the alignment of titles.
- Add a footer with your contact information and email address.
- Add *metadata* tags (keywords) in the *page header*, so that search engines can locate and categorize your pages.
- Insert links to your other Web sites or relevant sites on the Web.

If you're *not* an HTML coder—or even if you are—you can perform many of these adjustments extremely easily with the BetterHTMLExport plug-in for iPhoto, described next.

Better HTML

iPhoto's Export command produces simple, serviceable Web page versions of your photo albums. Most people assume that if they want anything fancier, they need either HTML programming chops or a dedicated Web design program.

Actually, though, you can add a number of elegant features to your photo site using an excellent piece of add-on software that requires absolutely no hand coding or special editing software.

Figure 8-17:

Top: BetterHTMLExport works by adding a new panel called Better Web Page to the standard Export Photos dialog box. It in turn offers panels of features for customizing the Web pages you export from iPhoto. For instance, you can have your pages display your titles and comments beneath all thumbnail images. Other gems include the Links On Bottom and Links On Top checkboxes, shown below.

Bottom: Thanks to these numbered links, your viewers won't have to keep ducking back to the index page to jump to a different photo; they'll have a row of underlined number buttons (1 2 3 4 5) to click at the top or bottom of each page. BetterHTMLExport can also add the "index" link that returns you to the main thumbnail page and the Original Photo link that loads the original photo file-at full, multimegapixel size.

It's the fittingly named BetterHTMLExport, an inexpensive iPhoto plug-in that extends the features of iPhoto's own HTML Exporter (Figure 8-17). (See page 303 for more on iPhoto plug-ins.)

You can download a copy of BetterHTMLExport from the "Missing CD" page of www.missingmanuals.com, among other places. The version for iPhoto '09 is a \$20 shareware program.

Here are some of the great things you can do with BetterHTMLExport:

- Add comments (not just titles) on index and image pages.
- Insert "Previous" and "Next" links on each individual image page, so that you can jump from picture to picture without returning to the index (thumbnail) page.
- Control the JPEG quality/compression setting used to create copies of your photos.
- Create links to your *original* images instead of just JPEG versions of them.
- Choose where on the page you want to include navigation hyperlinks.

Photo Sharing on the Network

One of the coolest features of iTunes is the way you can "publish" certain playlists on your home or office network, so that other people in the same building can listen to your tunes. Why shouldn't iPhoto be able to do the same thing with pictures?

In fact, it can. Here's how it works.

Figure 8-18:

If you turn on "Share entire library," you make all your pictures available to others on the network—and doom your fans to a lifetime of waiting while gray empty boxes fill their iPhoto screens.

Alternatively, click "Share selected albums" and then turn on the individual albums that you want to make public.

Either way, turning on Sharing makes only photos available on the network—not movie clips.

Photo Sharing on the Network

For this example, suppose that you're the master shutterbug who has all the cool shots. On your Mac, choose iPhoto—Preferences and click Sharing. Turn on "Share my photos" (Figure 8-18).

You might be tempted to turn on "Share entire library," so that no crumb of your artistry will go unappreciated—but don't. Even the fastest Macs on the fastest networks will grind to a halt if you try to share even a medium-sized photo library. You are, after all, attempting to cram gigabytes of data through your network to the other Macs.

It's far more practical to turn on the checkboxes for the individual albums you want to share, as shown in Figure 8-18.

Unless you also turn on "Require password" (and make up a password), everyone on the network with iPhoto 4 or higher can see your shared pictures.

Finally, close the Sharing window.

At this point, other people on your network will see *your* albums show up in *their* Source lists, above the list of their own albums; see Figure 8-19. (Or at least they will if they have "Look for shared photos" turned on in their iPhoto Preferences.)

Figure 8-19:

You can't delete or edit the photos you've summoned from some other Mac. But you can drag them into your own albums (or your own library) to copy them. (The Shares heading appears in your Source list only if iPhoto detects at least one shared iPhoto collection on the network.)

When you've had enough, click the **b** button. The flippy triangle, the list of albums, and the **b** button itself disappear. The names of shared collections (like "King's Library" in this example) remain on the screen, in case you want to bring them back for another look later.

As you may know, when you share iTunes music over a network, other people can only *listen* to your songs—they can't actually *have* them. (The large, well-built lawyers of American record companies have made sure of that.)

But iPhoto is another story. Nobody's going to issue you a summons for freely distributing your own photos. So once you've jacked into somebody else's iPhoto pictures via the network, feel free to drag them into your own iPhoto albums, thereby copying

Photo Sharing on the Network them onto your own Mac. Now you can edit them, print them, and otherwise treat them like your own photos.

Photo Sharing Across Accounts

Mac OS X is designed from the ground up to be a *multiple-user* operating system. You can set up Mac OS X with individual *user accounts* so that everyone must log in. When the Mac starts up, in other words, you have to click your account name and type a password before you can start using it.

Upon doing so, you discover the Macintosh universe just as you left it, including *your* icons on the desktop, Dock configuration, desktop picture, screen saver, Web browser bookmarks, email account, fonts, startup programs, and so on. This accounts feature adds both convenience and security. As you can imagine, this feature is a big deal in schools, businesses, and families.

It also means that each account holder has a separate iPhoto Library folder. (Remember, it lives inside your own Home folder.) The photos *you* import into iPhoto are accessible only to you, not to anyone else who might log in. If you and your spouse each log into Mac OS X with a different account, you each get your own Photo Library—and neither of you has access to the other's pictures in iPhoto.

But what if the two of you *want* to share the same photos? Ordinarily, you'd be stuck, since iPhoto can't make its library available to more than a single user. You could transfer the photos by CD or by setting up a .Mac photo gallery, of course, but here are two easier solutions to this common conundrum:

Easy Way: Share Your Library

iPhoto's sharing feature isn't just useful for sharing photos across the network. It's equally good at sharing photos between *accounts* on the same Mac.

To make this work, iPhoto has to be running in the account that will be sharing the pictures. And you have to turn on Fast User Switching. (To find this checkbox, open the Accounts panel of System Preferences. Click the Login Options button.)

Now you're ready. Log in as, say, Dad. Share some albums.

Now Mom chooses her name from the little Fast User Switching menu at the upperright corner of the screen, thereby switching to her own account (and shoving Dad's to the background). She'll find that Dad's albums show up in her copy of iPhoto, exactly as shown in Figure 8-20. She can copy whichever pictures she likes into her own albums.

Geeky Way: Move the Library

The problem with the Share Your Library method is that you wind up with *copies* of the pictures. In some situations, you may want to work on exactly the same set of pictures. You want, in other words, to share the *same iPhoto Library*.

What will trip up any normal person's attempt to share an iPhoto Library is a little thing called *permissions*. That term refers to the insanely complex web of invisible Unix codes that keep your files and folders out of the hands of other account holders, and vice versa.

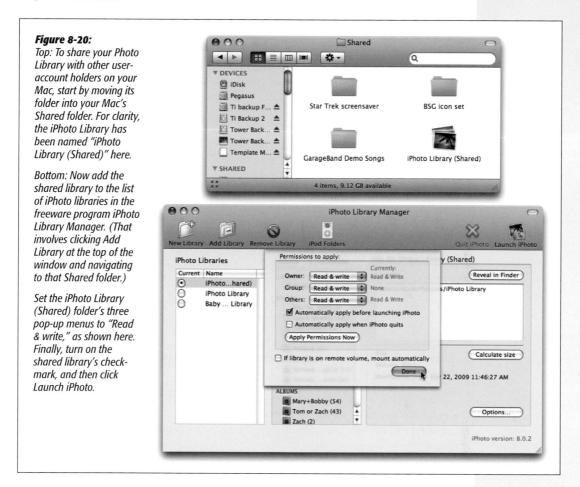

One easy way to sidestep this problem is to put the iPhoto library on an external hard drive that both Macs can access. (Just don't both of you access the same library at the same time.)

If that's not possible, then here's a more elaborate method, a two-step maneuver that requires the assistance of a piece of free software. First, put your photo library somewhere where every account holder has access to it. Second, change its permissions from "mine" to "everyone's." Here's the drill (quit iPhoto first):

1. In the Finder, drag your iPhoto Library icon into the Shared folder.

Your iPhoto Library contains all your pictures (and all the information associated with them, like albums, comments, and so on). It's probably sitting, at this

Photo Sharing Across Accounts

moment, in your Home→Pictures folder. To move it, you'll probably have to open two Finder windows side-by-side, so you can see your starting and ending points at the same time.

Your destination is the Shared folder, which is in your Macintosh HD→Users folder. Drag the iPhoto Library into the Shared folder.

You've done most of the setup. Now comes a step that each account holder must take individually. Suppose, for example, that you're now Mom.

2. Log in to your account. Don't open iPhoto yet. Open iPhoto Library Manager instead.

The gloriously useful (and gloriously free) iPhoto Library Manager program is described at length in Chapter 13. (You can download it from, for example, the "Missing CD" page at www.missingmanuals.com.)

3. Click the Add Library button. Navigate to the Macintosh HD→Users→Shared folder, click the iPhoto Library, and then click Open.

Now the shared photo library appears in iPhoto Library Manager's list of libraries, as shown in Figure 8-20. Make sure it's highlighted.

4. Click Options. Set all three pop-up menus to "Read & write," as shown in Figure 8-20. Also turn on "Automatically apply before launching iPhoto."

You have just made Dad's iPhoto Library folder your own. And every time you open iPhoto (from within iPhoto Library Manager, that is), those pesky permission bits will be set automatically to give you ownership for this editing session.

5. Select iPhoto Library in the list at left, and then click Launch iPhoto.

Incredibly, iPhoto opens up that iPhoto library in your account—even if it wasn't yours to begin with. You're free to edit the photos. And you won't have to repeat any of these steps, either; from now on, just opening iPhoto (from within iPhoto Library Manager) takes you straight to the pictures.

Better yet, each family member (account holder) can set things up the same way for themselves, by repeating steps 2 through 5. (Only one person can actually have the library open for editing at a time, though.)

Books, Calendars, and Cards

A t first, gift-giving is fun. During those first 10, 20, or 40 birthdays, anniversaries, graduations, Valentine's Days, Christmases, and so on, you might actually *enjoy* picking out a present, buying it, wrapping it, and delivering it.

After a certain point, however, gift-giving becomes exhausting. What the heck do you get your dad after you've already given him birthday and holiday presents for 15 or 35 years?

If you have iPhoto, you've got an ironclad, perennial answer. The program's Book feature lets you design and order (via the Internet) a gorgeous, professionally bound photo book, printed at a real bindery and shipped to the recipient in a slipcover. Your photos are printed on glossy, acid-free paper, at 300 dots per inch, complete with captions, if you like. It's a handsome, emotionally powerful gift *guaranteed* never to wind up in the attic, at a garage sale, or on eBay.

These books (\$20 and up) are amazing keepsakes to leave out on your coffee table—the same idea as most families' photo albums, but infinitely classier and longer lasting (and not much more expensive).

Since iPhoto's debut, in fact, the self-publishing business has expanded. You can now create equally great-looking calendars (covering any year, or any group of months that works for you), postcards, and greeting cards. In iPhoto '09, your hardcover books even come with glossy paper dust jackets, with text and photos on the overleaf and back cover.

Fortunately for you, the designing and ordering tools are the same for all of these photo-publishing categories. This chapter begins with a tour of the book-making process and follows up with calendars, greeting cards, and postcards.

Phase 1: Pick the Pix

Phase 1: Pick the Pix

The hardest part of the whole book-creation process is winnowing your photos to the ones you want to include. Many a shutterbug eagerly sits down to create his very first published photo book—and winds up with one that's 98 pages long (that is, \$107).

In most of Apple's ready-made book designs, each page of your photo book can hold a maximum of six or seven pictures. (Older book designs called Catalog and Yearbook, which could hold up to 32 tiny pictures per page in a grid, are gone from iPhoto '09. No great loss, really; at that size, your pictures didn't exactly sing. The whole thing more closely resembled, well, a catalog or a yearbook.)

Even the six-per-page limit in most themes doesn't necessarily mean you'll get 120 photos into a 20-page book, however. The more pictures you add to a page, the smaller they have to be, and therefore the less impact they have. The best-looking books generally have varying numbers of pictures per page—one, four, three, two, whatever. In general, the number of pictures you'll fit in a 20-page book may be much lower—50, for example.

Either way, sifting through your brilliant pictures and choosing the most important few can be an excruciating experience, especially if you and a collaborator are trying to work together. ("You can't get rid of that one! It's adorable!" "But honey, we've already got 139 pictures in here!" "I don't care. I love that one.")

You can choose the photos for inclusion in the book using any selection method you like. You can open an Event, pick and choose among your entire library (page 48), or file them into an album as a starting point. You can even select a group of albums that you want included, all together, in one book.

If you opt to start from an album, take this opportunity to set up a preliminary photo sequence. Drag the pictures around in the album to determine a rough order. You'll have plenty of opportunity to rearrange the pictures on each page later in the process, but the big slide-viewer-like screen of an album makes the process easier. Take special care to place the two most sensational or important photos first and last. They'll be the ones on the cover and the last page of the book; if you're making a hardbound book (which includes a paper dust jacket), then you need special photos for the inside front and back flaps and back cover, too.

Phase 2: Publishing Options

Once you've selected an album or a batch of photos, click the Book button (or click Keepsakes and then choose Book from the pop-up menu) below the main picture area. You can also click the + button under the Source list and click the Book button.

Now you see something like Figure 9-1: a dialog box in which you can specify what you want your book to look like. The dialog box looks pretty simple, but it's crawling with important design options.

Book Type

The Book Type pop-up menu, shown open in Figure 9-1, lets you specify whether you want to publish your book as a hardbound volume (classier and more durable, but more expensive); as a paperback; or with a wire spiral binding. If you choose the softcover or wire-bound option, then you also have a choice of book sizes. The options are 11×8 inches, which feels the slickest and most formal; 8×6 , which is more portable; and (for softcover only) 3×2 .

Figure 9-1:
You can change these settings later, even after you've started laying out your book pages. But if you have the confidence to make these decisions now, you'll save time, effort, and (if you want captions for your photos) possibly a lot of typing.

This last option gives you a tiny, wallet-size flip book, with one photo filling each page, edge to edge. You must order these in sets of three (for \$12), which suggests that Apple imagines them to serve as simultaneous giveaways to relatives, wedding guests, business clients, and so on. In any case, they're absolutely adorable (the booklets, not the business clients).

Note: In iPhoto versions of old, at this point, you'd specify whether you wanted your hardbound book to have single-sided or double-sided pages. (Softcover and wire-bound books are always printed on both sides of the page.) In iPhoto '09, you don't make that decision, as hardcover books are all double-sided now.

Theme Choices

And now, the main event: choosing a *theme*—a canned design, typography, and color scheme—for the cover and pages of your book. The scrolling list of named icons at

Phase 2: Publishing Options

the left side of the dialog box contains 13 professionally designed page templates, each dedicated to presenting your photos in a unique way.

As you click each one's name in the list, the right side of the dialog box reveals a photograph of a representative book that's been published in that style.

Apple's photobook themes offer a variety of dynamic visual styles intended to pop your photos off the page. Some are designed to cover even the background of the page with textures, shadows, passport stamps, ripped-out clippings, and other photorealistic simulations.

Here's a brief description of each (you can see a selection in Figure 9-2):

• Picture Book. This design's motto could be "maximum photos, minimum margins." There's nowhere for text and captions, and the photos stretch gloriously from one edge of the page to the other—a *full bleed*, as publishers say.

This dramatic design can be emotionally compelling in the extreme. You can opt to have a single caption appear at the bottom of a page (no matter how many photos—from one to 16—appear on it). But the absence of text and minimization of white space seems to make the photos speak—if not shout—for themselves.

(Plenty of people start out believing that captions will be necessary. But once they start typing "Billy doing a belly flop" or "Dad in repose," they realize they're just restating the obvious.)

Tip: Keeping in mind that the book is published horizontally, in landscape mode, will help you maximize page coverage. For example, on pages with only one photo, a horizontal shot looks best, since it'll fill the page, edge to edge. On pages with two photos, two side-by-side vertical (portrait-mode) shots look best. They'll appear side by side, filling the page top to bottom.

• Travel. This theme wins the award for Biggest Overhaul From iPhoto '08 to iPhoto '09. Nine new color choices are now available for page backgrounds, and the theme offers 20 different map layouts for adding custom cartography. (Remember all those photos you geotagged back in Chapter 4? There's another benefit on the horizon.) Photos are given a graphic treatment that makes them appear to have been taped into a scrapbook, usually at a slight angle to the page. Some seem to have been built from 25 smaller ones, all assembled into one larger mosaic image. Adding captions to the pages is optional; if you want them, they'll appear on strips that look like they've been ripped, jagged edge and all, from a piece of stationery.

Overall, the effect is casual and friendly—not what you'd submit to *National Geographic* as your photographic portfolio, of course, but great as a cheerful memento of some trip or vacation.

• Simple Border, Line Border, Textured Border. These three are all variations on (ahem) a theme. They differ only in the kind of border that appears around each individual photo.

The Border designs are characterized by plenty of "white space" (margins around each photo and each page); crisp 90-degree lines (no photos cocked at an angle); and up to four photos per page. A caption can appear at the bottom of each page, if you like. And you can choose the background color you want for the page itself.

• Snapshots. This layout goes for that scrapbook-done-in-a-hurry look. All the photos, up to six per page, are slightly askew and often overlapping. They all have white margins, as though they're bordered prints from the 1970s.

Figure 9-2:
As you click the names of the themes (in the dialog box shown in Figure 9-1), you see a little photographic preview of what the book will look like.

Pay special attention to the selection of fonts, the availability of captions, and the photo sizes.

Snapshot

Family Album

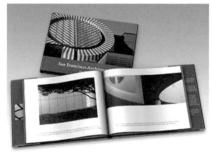

Contemporary

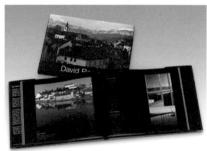

Folio

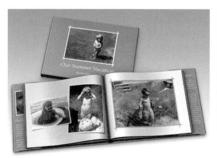

Crayon

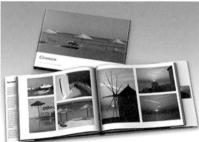

Modern Lines

Phase 2: Publishing Options

- Modern Lines. Each page can have up to four photos on it, with plenty of white margin, plus fine gray "modern lines" that separate the pictures. You can add a one-line caption to the bottom of each page, or you can leave the pages text-free.
- Formal. Think "wedding" or "graduation." When you order this book, the photos are printed to look like they've been mounted on fancy album pages. You can choose, for each page, either a textured or untextured gray background; up to six photos can occupy a page. (The texturing is a hoax, of course. The paper is the same acid-free, shiny stuff of every iPhoto book; it's just *printed* to look like it's textured.)

You'll have the chance to add a short caption to the bottom of each page.

- Watercolor. "Watercolor," in this case, refers to the page backgrounds, which appear in gentle, two-toned pastel colors. This time, you can choose to have your photos "mounted" on the pages either slightly askew, for an informal look, or neatly parallel to the page edges. Note, though, that this design doesn't offer an option for photo captions, so you'll have to let the pictures tell the story.
- Contemporary. The page backgrounds are white, the photos are all clean and square to the page, and captions, if you want them, appear in light gray, modern type. The maximum number of photos on a page is three, ensuring that they remain large enough to make a bold statement. Clearly, though, Apple's hoping that you'll choose only one maximum-impact photo per page; it offers you four different "white-space" treatments for one-photo pages.
- Folio. This design is among the most powerful of the bunch, primarily because of the glossy jet-black page backgrounds. (You can also choose plain white.) It looks really cool.

This template must have been some designer's pet project, because it's the only one that offers special layout designs for a title page, About page, and explanatory-text page, all done up in great-looking fonts in white, gray, and black. Caption space is also provided.

- Family Album. OK, now Apple's officially gone nuts with this "printing pages to look like they're physical scrapbook pages." In this design, photos look like they've been affixed to the page using every conceivable method: attached using "photo corners," taped into photo montages made up of 25 smaller images, licked like giant postage stamps with perforated edges, fastened by inserting their corners into little slits in the page, or even inserted into one of those school-photo binders with an oval opening so your charming face peers out. Up to six pictures can occupy a page; a page caption is optional.
- Crayon. Here's another design where the pages are photographically printed to look like they're textured paper. For each page, you can choose either a photosmounted-askew layout or—get this—a straight layout in which each photo has a frame "drawn" around it with a crayon. And to keep with that Crayola-ish theme, you can choose from any of six background colors for each page.

You can place up to six photos on a page. You're offered the opportunity to include a caption at the bottom of each page.

The Options+Prices button in the corner of the dialog box takes you online to a special Web page that fills you in on the details of the options you've selected, including the maximum number of pages, dimensions, and, oh yeah...the price.

Once you've settled on a design theme for your book, your initial spate of decision-making is mercifully complete. Click Choose.

Tip: You can always revisit your choice of theme—or even book type (size, hardcover, and so on)—by clicking the Themes button on the iPhoto toolbar.

Phase 3: Design the Pages

Two things now happen. First, a new icon appears in your Source list, representing the book layout you're about to create. You can work with it as you would other kinds of Source-list icons. For example, you rename it by double-clicking, file it in a folder by dragging it there, delete it by dragging it to the iPhoto Trash, and so on.

Note: If you're used to some previous iPhoto version, then the book icon is a happy bit of news. It means that a book is no longer tied to an album. Therefore, rearranging or reassigning photos in the original album no longer wreaks havoc with the book design that's associated with it.

Second, you now see something like Figure 9-3: a miniature page-layout program. The page you're working on always appears at nearly full size in the main part of the window.

Up above, you see a set of thumbnails, either of your photos or of your book pages (more on this in a moment); that's what Apple calls the *photo browser*. (All of this should sound familiar if you've used iPhoto '09's very similar printout-design mode, described in Chapter 7.)

Once you've selected an album and a theme, the most time-consuming phase begins: designing the individual pages.

At the moment, your book is completely blank; gray rectangles appear where pictures ought to be. It's your job to put the photos on the pages. And there are two ways to go about it:

• Use the Autoflow button. You can use this button if you're in a hurry or you're not especially confident in your own design skills. iPhoto arranges the photos, in the sequence you've specified, on successive pages of the book.

No doubt, it's a fast and easy way to lay out the pages of your book, but of course you may not agree with iPhoto's choices. It may clump that prizewinning shot of the dog nosing the basketball through the hoop on the same page as three less-impressive pictures.

On the other hand, you can always touch up the layout afterward, accepting *most* of iPhoto's design but punching it up where necessary, as described on the following pages.

• Manually. You can drag photo thumbnails directly onto the gray rectangles, thus assembling your book by hand.

Open a Page

That photo browser at the top of the window has two functions, as represented by the two tiny icons at its left edge.

When you click the top one (the page button), you see a scrolling parade of miniatures of the pages in your book. When you click one of the page thumbnails, the larger working image of that page appears in the main editing area.

When you click the bottom one (the tiny stack-of-photos button), you see a scrolling parade of the *photos* you've selected for inclusion. (You can see this view of the photo browser in Figure 9-3.) A checkmark on a thumbnail indicates that you've placed that photo onto one of your pages.

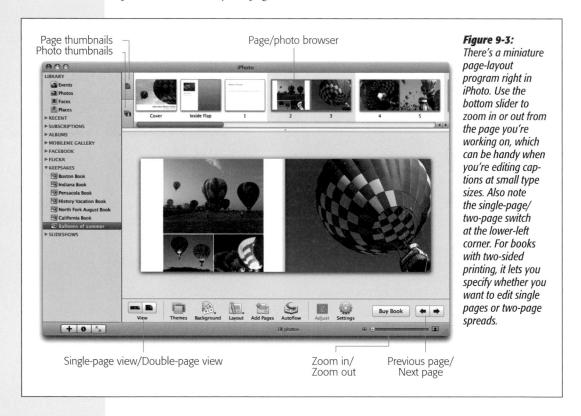

This area is also convenient for dragging the photos into a satisfying sequence before you transfer them onto the book's pages.

For the sake of sanity, in this chapter, when that browser is displaying photos, it'll be called the *photo browser*; when it's showing thumbnails of pages, it'll be called the *page browser*.

In any case, the first step in building your book is to click the thumbnail of the page you want to work on. The first ones in the page browser represent the cover, the inside flap (for hardcover books), and an Introduction page.

The layout corresponding to whichever thumbnail you clicked appears in the main picture area.

Choose a Page Layout

If you flip through your empty book, you can see that iPhoto has cheerfully suggested varying the number of photos per page. Two-per-page on the first page, a big bold one on the next, a set of four on the next, and so on.

If you approve of these photos-per-page proposals, great. You can go to work choosing which photos to put on each page, as described in the following pages.

Sooner or later, though, there will come a time when you want three related photos to appear on a page that currently holds only two. That's the purpose of the Layout pop-up menu shown in Figure 9-4. It's a list of the different page designs that Apple has drawn up to fit the overall design theme you've selected.

You control how many pictures appear on a page by choosing from the Layout popup menu. These are your choices:

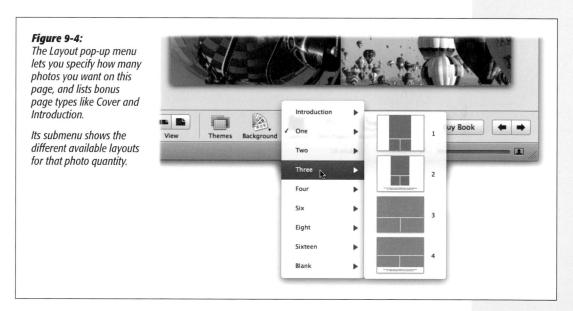

• Cover. The first page layout in your book *must* have one of the Cover designs—and only the first page layout *can* use the Cover designs. (For a hardcover book, the cover appears on the glossy dust jacket. The cover of the actual book inside the dust jacket displays only the title of the book, embossed into the suedelike material.)

In iPhoto '09, you actually have a choice of cover layouts. For example, in the Cover submenu of the Layout pop-up menu, you're usually offered a choice of one huge photo (and no text), a big photo with a title beneath, or several smaller photos plus a title.

• Introduction. In most themes, this special page design has no photos at all. It's just a big set of text boxes that you can type (or paste) into. Here's where you can let the audience know about the trip, the company, or the family; tell the story behind the book; praise the book's lucky recipient; scare off intellectual-property thieves with impressive-sounding copyright notices; and so on.

Tip: An Introduction page doesn't have to be the first page of the book after the cover. Truth is, you can turn any page into an Introduction page. Such pages make terrific section dividers.

They're especially useful in designs where no text accompanies the photos. In this case, an Introduction page can set the scene and explain the following (uncaptioned) pages of pictures.

• Map. Although the Travel theme goes to town with map styles, you can add an *actual* map page to any theme in the list. (A map can't be on a book's cover or dust jacket, however.) Location information doesn't have to be embedded in the pictures if you want to add a map, but if you've got geotagged photos in the mix, the map page automatically displays *that* area of the world.

Figure 9-5:

After adding a map page, the customization begins. Click the map to call up the black Editing pane, where you can plot new points by clicking the + button in the bottom corner. Turn on the Show Lines box to connect the dots on the map.

Control-clicking (or rightclicking) the map brings up a shortcut menu of other options. When the plotting's done, click the gray background area in the iPhoto window to close the Editing pane.

You can fine-tune the locations on the map in a number of ways, like dragging the map image around within the page until it shows the area you want. You can also click the map to call up the Editing pane, which has a slider at the top to adjust the size of the area on display (Figure 9-5). In the Editing pane, you can also add a title and a list of places to plot on the map; click the + in the bottom corner to add a location. (To delete a location, select it and click the - button.)

Maps are a great way to illustrate the route of a cross-country trip or multidestination vacation. To add "Indiana Jones"-style lines linking each location on the journey, turn on Show Lines (shown in Figure 9-5). Locations are linked in the order they appear in the Places list. If you need to change the order of the lines connecting each place, drag the location name to the correct spot on the list.

Control-click (or right-click) the map to get a shortcut menu full of other options. Here, you can choose to show or hide titles and text, display location names, enhance the map's look with textures and shadows, or even display a compass on the page. Commands for centering the map on your marked locations, changing the line style, or returning to the journey's starting point are here, too. And if you want to just start over, choose Reset Map from the menu.

• One, Two, Three, Four... These commands let you specify how many photos appear on the selected page. iPhoto automatically arranges them according to its own internal sense of symmetry. (Most themes offer up to six photos per page.)

Use these options to create a pleasing overall layout for the book and to give it variety. Follow a page with one big photo with a page of four smaller ones, for example.

You can also use these commands to fit the number of photos you have to the length of your book. If you have lots of pictures and don't want to go over the 20-page minimum, then choose higher picture counts for most pages. Conversely, if iPhoto warns you that you have blank pages at the end of your book, then spread your photos out by choosing just one or two photos for some pages.

• Title, Text, About, Contact. Some themes, especially the Folio theme, offer their own private page designs. In general, they're designed to hold specialized blobs of text that are unique to that book design.

FREQUENTLY ASKED QUESTION

Doubling the Cover Photo

I want to use my cover photo as one of the pages in the book, just like they do in real coffee-table photo books. How do I do it? In other words, just because a thumbnail has a checkmark (meaning that you've already used it) doesn't mean you can't use it again.

No big deal. In iPhoto '09, you can use a single photo on as many different book pages as you like.

• Blank. Here's another way to separate sections of your book: Use an empty page. Well, empty of *pictures*, anyway; most of the new iPhoto '09 themes still offer a choice of "look" for a blank page, such as a choice of color or simulated page texture.

Once you've chosen how *many* photos you want on a page, the Layout pop-up menu's submenus become available to you. As shown at right in Figure 9-4, it contains tiny thumbnail representations of the photo layouts available. If you choose Three as the number of photos, for example, the Three submenu may offer you a couple of different arrangements of those three photos—big one on top, two down the side, or whatever.

Lay Out the Book

The key to understanding iPhoto '09's book-layout mode is realizing that all photos are *draggable*. Dragging is the key to all kinds of book-design issues.

In fact, between dragging photos and using a handful of menu commands, you can perform every conceivable kind of photo- and page-manipulation trick.

Ways to manipulate photos

Here are all the different ways to move photos around in your book (see Figure 9-6 for a summary):

- Swap two photos on the same page (or two-page spread) by dragging one directly on top of the other. When the existing picture sprouts a colored border, let go of the mouse button; the two pictures swap places.
- Move a photo to a different page of the book by dragging it from the main layout area onto a different page thumbnail in the page browser.
- Remove a photo from a page by clicking its icon and then pressing your Delete key. The checkmark on its icon in the photo browser disappears.
- Remove a photo from the book altogether by clicking its icon in the photo browser and then pressing the Delete key. It disappears from both the layout and the photo browser, although the actual photo is still in your library.
- Add a photo to a page by dragging it out of the photo browser onto a *blank* spot of the page. iPhoto automatically increases the number of photos on that page, even changing the Layout pop-up menu to match.

Note: You can't create a layout that doesn't exist using this technique. If there are three photos on a page, and you add a fourth, iPhoto switches to the next *available* layout, which might be one with six photos.

- Swap in a photo by dragging it out of the photo browser *onto* a photo that's already on a page of your book. iPhoto swaps the two, putting the outgoing photo back into the photo browser.
- Add new pictures to the photo browser by dragging them onto the book's Sourcelist icon. For example, you can click any Event, album, smart album, slideshow, or the Library icon to see what photos are inside—and then drag the good ones onto your book icon.

Figure 9-6:
iPhoto's book-layout
mode is crawling
with tricks that let
you move photos
around, add them to
pages, remove them,
and so on. The fun
begins when you finally understand the
difference between
the page browser
(top) and the photo
browser (bottom).

For example, you can add new photos to your book only via the photo browser. Use the page browser more as a navigational tool.

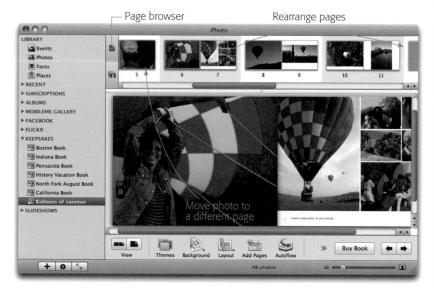

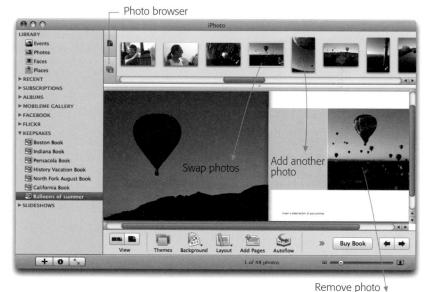

Once these photos have arrived in the photo browser, you can drag them onto individual pages as described above.

- Fill in an empty gray placeholder frame by dragging a photo onto it from the photo browser.
- Fill in *all* the gray placeholders with photos by clicking the Autoflow button at the bottom of the window. Clicking Autoflow "pours" all the unplaced photos into the gray placeholders of your book, front to back. When they arrive, they'll be in the same order as they appeared in the photo browser.

If the results aren't quite what you expected, you can always use the Edit→Undo command to backtrack.

• Enlarge or crop a picture, right there on the page, by clicking it. A tiny Zoom slider appears above the photo, which you can use to magnify the picture or shift it inside its boundary "frame" (Figure 9-7). For now, it's worth remembering that this trick is helpful when you want to call attention to one part of the photo, or to crop a photo for book-layout purposes without actually editing the original.

Tip: You may be startled to discover that iPhoto does a fairly smart job about placing photos within their little confined placeholders when you zoom in. That's face recognition at work—it attempts to avoid lopping off people's faces.

Figure 9-7:

Top: Single-click a photo to make its Zoom slider appear. Drag the slider to the right to enlarge the photo within its rectangular frame on the page.

Bottom: At this point, you can drag inside the photo to adjust its position within its "frame."

None of this affects the actual photo (as using the iPhoto cropping tool would). You're basically just changing the relationship between the photo and its boundary rectangle on the page template. Of course, you'll have to be careful not to enlarge the photo so much that it triggers the dreaded yellow-triangle low-resolution warning. (See the box on page 249 for more on yellow warning triangles.)

• Shove one overlapping photo "under" another by Control-clicking it (or right-clicking) and, from the shortcut menu, choosing Send to Back. Figure 9-8 reveals all.

Figure 9-8:

In some book themes, photos have been "tossed" onto the page so that they overlap slightly. In the rare event that an important part of a photo is covered up by another, you can rearrange their front-to-back order using the shortcut menu shown at left. Here, the lower photo (left) is being slipped underneath the upper photo (right).

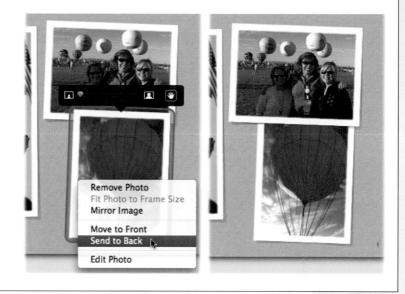

• Edit a photo by clicking it and then clicking the Adjust button. The Adjust panel appears, offering controls over brightness, contrast, exposure, saturation, sharpness, tint, and so on. Use it as described on page 131.

The beauty of that method is that you never have to leave the page-layout mode. You get to see the effects of your editing right on your photo, right in place.

But for more serious editing, double-click a placed photo instead. In a flash, book-layout mode disappears, and you find yourself in the Edit mode, described in Chapter 5.

Now you have even more editing controls: Rotate, Crop, Straighten, Red-Eye, Retouch, and all the other goodies described in Chapter 5.

When you're finished editing, click Done. You return to the book layout mode, with the changes intact.

(None of these edits affect the original photos, though. In essence, you can edit the same photos in different ways in every single book or project—all without touching the originals.)

Phase 3: Design the Pages

Ways to manipulate pages

Photos aren't the only ones having fun. You can drag and manipulate the pages themselves, too:

- Move pages around within the book by dragging their thumbnails horizontally in the page browser.
- Remove a page from the book by clicking its photo-browser icon and then either pressing Delete or choosing Edit—Remove Page. (If you use the Delete-key method, iPhoto asks if you're sure you know what you're doing.)

Note that removing a page never removes any *pictures* from the book. You're just removing the checkmark from that photo's thumbnail in the photo browser. But removing a page *does* vaporize any captions you've typed in.

• Insert a new page into the book by clicking the Add Pages button at the bottom of the window, or by choosing Edit—Add Page.

Before you go nuts with it, though, note that iPhoto inserts the new page *after* the page you're currently viewing. It's helpful, therefore, to begin by first clicking the desired thumbnail in the page browser.

Empty gray placeholders appear on the new pages, ready to fill. (iPhoto takes it upon itself to decide how many photos appear on the new page.)

Tip: As a shortcut, you can also Control-click (or right-click) a blank spot on any page and, from the shortcut menu, choose Add Page or Remove Page.

Layout strategies

Sometimes chronological order is the natural sequence for your photos, especially for memento books of trips, parties, weddings, and so on. Of course, nothing's stopping you from cheating a bit—rearranging certain scenes—for greater impact and variety.

As you drag your pictures into order, consider these effects:

- Intersperse group shots with solo portraits, scenery with people shots, vertical photos with horizontal ones.
- On multiple-photo pages, exploit the direction your subjects face. On a three-picture page, for example, you could arrange the people in the photos so that they're all looking roughly toward the center of the page, for a feeling of inclusion. You might put a father looking upward to a shot of his son diving on a photo higher on the page, or siblings back-to-back facing outward, signifying competition.
- Group similar shots together on a page.

Backgrounds

In iPhoto '09, you can choose the background color of the page. To do that, click the page, and then click the Background pop-up button. You may have only two choices

Phase 3: Design the Pages

(like black or white), or you may have a half-dozen options (a range of pastels, say), depending on the theme you've chosen.

Most intriguingly, you can use one of your *photos* as a background, and then adjust its transparency so that it forms a faded image behind the placed photos. Figure 9-9 has the details.

Figure 9-9:

Top: To install a picture as a photographic backdrop, choose the Photo Background (the final listing) in the Background pop-up menu, as shown here.

Then drag the photo you want onto a blank spot of the gray background, also shown here.

Bottom: Click once on the page-background photo to open the adjustment controls shown here. Using the top slider, you can adjust the cropping and positioning of the photo (Figure 9-7); using the lower slider, you can change the transparency of the photo. The idea is that a background photo should be fainter and subtler than the foreground shots.

Phase 3: Design the Pages

Making Your Photos Shape Up

iPhoto's design templates operate on the simple premise that all of your photos have a 4:3 aspect ratio. That is, the long and short sides of the photo are in four-to-three proportion (four inches by three inches, for example).

In most cases, that's what you already have, since those are the standard proportions of standard digital photos. If all your pictures are in 4:3 (or 3:4) proportion, they'll fit neatly and beautifully into the page-layout slots iPhoto provides for them.

Figure 9-10:

Top: When you first start working on a book, the photos all look nice together. They nestle nicely side by side. Every now and then, however, you may be disheartened to find that iPhoto is lopping off something it shouldn't.

Bottom: If you Control-click a photo and choose Fit Photo to Frame, you'll discover that the problem is a photo that doesn't have 4:3 proportions (on this page, that's three of them). iPhoto thought it was doing you a favor by blowing it up enough to fill the 4:3 box. Now you get ugly white gaps, but, hey, at least you're seeing the entire photo.

But not all photos have a 4:3 ratio. You may have cropped a photo into some other shape. Or you may have a camera that can take pictures in the newfangled 16:9 ratio (like a high-definition TV screen), or the more traditional 3:2 film dimension, which work better as 4×6 prints.

When these photos land in one of iPhoto's page designs, the program tries to save you the humiliation of misaligned photos. Rather than leave unsightly strips of white along certain edges (therefore producing photos that aren't aligned with one another), iPhoto automatically blows up a miscropped photo so that it perfectly fills the 4:3 space allotted to it. Figure 9-10 shows the effect.

Unfortunately, this solution isn't always ideal. Sometimes, in the process of enlarging a nonstandard photo to fill its 4:3 space, iPhoto winds up lopping off an important part of the picture.

Here, you have two alternatives. First, you can use the Fit Photo to Frame Size command described in Figure 9-10.

Second, you can crop your non-4:3 photos using the Constrain pop-up menu (page 164) set to " 4×3 (Book)." This way, *you* get to decide which parts of the photo get lopped off. (Or just use the adjustment technique shown in Figure 9-7.)

Page Limits

The book can have anywhere from 20 to 100 double-sided pages (or, to break it down, 10 to 50 actual sheets of paper between the covers). Of course, if you really have more than 100 pages' worth of pictures, there's nothing to stop you from creating multiple books. (*Our Trip to New Jersey, Vol. XI*, anyone?)

Hiding Page Numbers

Don't be alarmed if iPhoto puts page numbers on the corners of your book pages—that's strictly a function of the theme you've chosen. (Some have numbering, some don't.) In any case, you never have to worry about a page number winding up superimposed on one of your pictures. A picture *always* takes priority, covering up the page number.

Even so, if it turns out that your theme *does* put numbers on your pages, and you feel that they're intruding on the mood your book creates, you can eliminate them. Click the Settings button at the bottom of the window. In the resulting dialog box, you'll see a "Show page numbers" checkbox that you can turn off.

Tip: As a shortcut, you can also Control-click (or right-click) a blank spot on any page and, from the shortcut menu, choose Show Page Numbers to turn it on or off.

Phase 4: Edit the Titles and Captions

Depending on the theme and page-layout template you've chosen, iPhoto may offer you any of several kinds of text boxes that you can fill with titles, explanations, and captions by typing or pasting (Figure 9-11):

Phase 4: Edit the Titles and Captions • The book title. This box appears on the book's cover. If it's a hardbound book, it's actually foil-stamped into the cover material; it also appears on the dust jacket.

When you first create a book, iPhoto proposes the *album's* name as the book name, but you're welcome to change it.

A second text box, set with slightly smaller type formatting, appears below the title. Use it for a subtitle: the date, "A Trip Down Memory Lane," "Happy Birthday Aunt Enid," "A Little Something for the Insurance Company," or whatever.

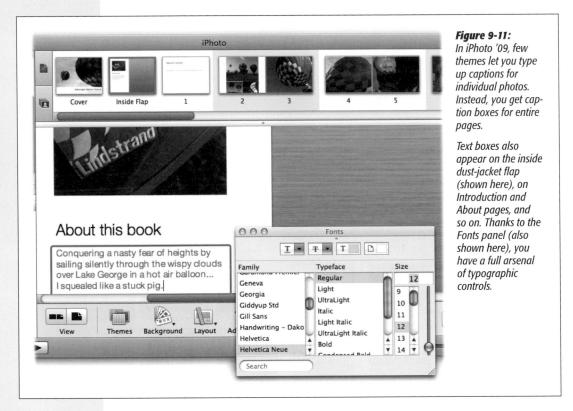

- The dust jacket. If you order a hardbound book, you've got that glossy dust jacket to consider. You can type up marketing blather or other descriptive material to appear on the inside front cover flap, just like on a book at Barnes & Noble. You're also allowed a couple of lines of text on the back cover, which might be the same as the title and subtitle but doesn't have to be.
- Introduction, Chapter. Applying the Introduction or Chapter page design to a page produces a huge text block that you can fill with any introductory text you think the book needs. The Layout pop-up menu usually offers you a choice of text-block designs—one or two columns, for example.

- Captions. Apple really, really does not want you adding a caption to *each photo*. Every theme lets you caption an *entire page* (see Figure 9-11), but only the Folio theme lets you caption each photo—and it limits you to two photos per page, max.
- Text Page, About, Contact. The Folio theme, intended as a showcase for photographers to display their best work, offers three additional text-page options. Text Page is just a striking, simple, title-plus-text-block affair that lets you describe the book, chapter, or photo grouping. About is the same thing, but it offers one big title and one subtitle in addition to the text block. Finally, Contact is filled with places to list your phone number, Web site, email address, and so on—along with the contact info for your agent.

Editing Text

In general, editing text on the photo page is straightforward:

- Click inside a text box to activate the insertion-point cursor, so you can begin typing. Zoom in on the page (using the Size slider at lower right) and scroll it, if necessary, so the type is large enough to see and edit. Click outside a text box—on another part of the page, for example—to finish the editing.
- You can select text and then use the Edit menu's Cut, Copy, and Paste commands to transfer text from box to box.
- You can also move selected text *within* a text box by dragging it and dropping it. The trick is to hold down the mouse button for a moment before dragging. Add the Option key to make a copy of the selected text instead of moving it.
- Double-click a word, or triple-click a paragraph, to neatly highlight it.
- Press Control-right arrow or Control-left arrow to make the insertion point jump to the beginning or end of the line.
- To make typographically proper quotation marks (curly like "this" instead of like "this"), press Option-[and Shift-Option-[, respectively. And to make a true long dash—like this, instead of two hyphens—press Shift-Option-hyphen.

Formatting Text

iPhoto offers tremendous control over the fonts, sizes, colors, and styles of the text in your book. Here's a summary of your typographical freedom:

• Standard typefaces. To choose the basic font for each *category* of text box—book title, photo name, caption, or whatever—throughout the entire book, click the Settings button at the bottom of the window. (If the iPhoto window is very narrow, then the Settings command may be hiding in the >> menu at the lower-right corner of the window.)

You get the dialog box shown in Figure 9-12, where you can make your selections.

Phase 4: Edit the **Titles and Captions** • Font exceptions, text colors. If you want to override the standard typeface for a certain text box, you can. Choose Edit→Fonts→Show Fonts (第-T); the standard Mac OS X Fonts panel appears (visible in Figure 9-12). Here, you have complete access to all your Mac's fonts. You can choose special text effects, shadowing, and even colors for individual text selections. Yes, the bright, multicolored result might look a little bit like it was designed by Barney the Dinosaur, but the color option is worth keeping in mind when you're preparing a book chronicling, say, someone's fourth birthday party.

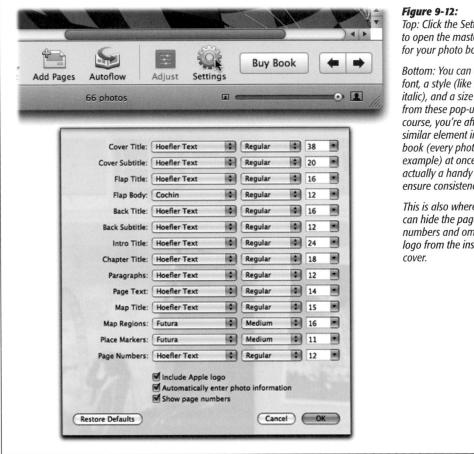

Top: Click the Settings button to open the master fonts list for your photo book.

Bottom: You can choose a font, a style (like bold or italic), and a size (in points) from these pop-up menus. Of course, you're affecting every similar element in the entire book (every photo title, for example) at once, but that's actually a handy way to ensure consistency.

This is also where you can hide the page numbers and omit the Apple logo from the inside back

· Character formatting. If you select some words and then Control-click (rightclick) them, a shortcut menu appears. Its Font submenu offers Bold, Italic, and Underline choices, which iPhoto applies to the highlighted text. (The Edit→Font menu also works, but it offers only Bold and Italic.)

Phase 4: Edit the Titles and Captions

Tip: Can't seem to get the size, placement, or variety of type that you want? Then the heck with iPhoto and its straitjacketed text boxes—you can use whatever type you want.

All you have to do is jump into a graphics program, like Photoshop Elements, AppleWorks, or GraphicConverter. Create a graphic document that's 1350×1800 pixels, with a resolution of 150 dots per inch. Now fill it with text, using the graphic software's text tools. You have complete freedom of fonts and placement.

Finally, bring this graphic into iPhoto. Use it as a single "photo" on the page where you want the text to appear. It's crude and crazy, but it works!

Check Your Spelling

Taking the time to perfect your book's text is extremely important. A misspelling or typo you make here may haunt you (and amuse the book's recipient) forever.

As in a word processor, you can ask iPhoto to check your spelling in several ways:

• Check a single word or selection. Highlight a word, or several, and then choose Edit—Spelling—Check Spelling (**%**-semicolon). If the word is misspelled, in iPhoto's opinion, then a red dotted line appears under the word. Proceed as shown in Figure 9-13.

Figure 9-13:

Control-click (or right-click) any word that's underlined with a red dotted line. If the resulting shortcut menu contains the correct spelling, choose it. Otherwise, if the word in your text box is fine as it is, click either Ignore Spelling ("Stop underlining this, iPhoto. It's a word I want spelled this way, so let's go on.") or Learn Spelling ("This name or word is not only correctly spelled. but it is also one that I may use again. Add it to my Mac OS X dictionary so you'll never flag it again.").

Phase 4: Edit the Titles and Captions

- Check a whole text block. Click inside a title or comment box, and then choose Edit→Spelling→Spelling (ૠ-colon). The standard Mac OS X Spelling dialog box appears.
- Check as you type. The trouble with the spelling commands described here is that they operate on only a single, tiny text block at a time. To check your entire photo book, you must click inside each title or caption and invoke the spelling command again. There's no way to have iPhoto sweep through your entire book at once.

Your eyes might widen in excitement, therefore, when you spot the Edit→ Spelling→Check Spelling While Typing command. It makes iPhoto flag words it doesn't recognize *as you type them*.

Sure enough, when this option is turned on, whenever you type a word that's not in iPhoto's dictionary, iPhoto adds a colorful dashed underline. (Technically, it underlines any word not in the *Mac OS X* dictionary, since you're actually using the standard Mac OS X spelling checker—the same one that watches over you in Mac OS X's Mail program, for example.)

To correct a misspelling that iPhoto has found in this way, Control-click (or right-click) it. A shortcut menu appears. Now proceed as shown in Figure 9-13.

Listen to Your Book

Unfortunately, even a spellchecker won't find missing words or awkward writing. For those situations, what you really want is for iPhoto to *read your text boxes aloud* to you.

No problem: Just highlight some text by dragging through it, and then Control-click (or right-click) the highlighted area. The same shortcut menu shown in Figure 9-13 appears, containing the Speech submenu. From it, you can choose Start Speaking and Stop Speaking, which makes iPhoto start and stop reading the selected text aloud. It uses whatever voice you've selected in Mac OS X's System Preferences—Speech control panel.

Phase 5: Preview the Masterpiece

Ordering a professionally bound book is, needless to say, quite a commitment. Before blowing a bunch of money on a one-shot deal, you'd be wise to proofread and inspect it from every possible angle.

Print It

As any proofreader can tell you, looking over a book on paper is a sure way to discover errors that somehow elude detection onscreen. That's why it's a smart idea to print out your own, low-tech edition of your book at home before beaming it away to Apple's bindery.

While you're in Book mode, choose File—Print. After the standard Mac OS X Print dialog box appears, fire up your printer, and then click Print when you're ready. The

result may not be wire-bound and printed on acid-free paper, but it's a tantalizing preview of the real thing—and a convenient way to give the book one final look.

Slideshow It

Here's a feature that might not seem to make much sense at first: After you're finished designing a book, you can *play* it—as a slideshow.

Just click the ▶ button at the bottom of the screen.

UP TO SPEED

The Heartbreak of the Yellow Exclamation Point

As you work on your book design, you may encounter the dreaded yellow triangle exclamation point like the one shown here. It appears everywhere you want to be: on the corresponding page thumbnail, on the page display, on the page preview (which appears when you click Preview), and so on.

If you actually try to order the book without first eliminating the yellow triangles, you even get a warning in the form of a dialog box.

Sometimes the problem is that you've tried to put too much text into a text box. So no big deal; just edit it down.

But if the triangle appears on a photo, you have a more worrisome problem: At least one of your photos doesn't have enough resolution (enough pixels) to reproduce well in the finished book. If you ignore the warning and continue with the ordering process, you're likely to be

disappointed by the blotchy, grainy result in the finished book.

You may remember from Chapter 1 that the resolution of your digital camera is relatively irrelevant if you'll only be showing your pictures onscreen. It's when you try to print

them that you need all the megapixels you can get—like now.

The easiest solution is to shrink the photo on its page. And the easiest way to do that is to increase the number of pictures on that page. Or, if your page design has places that hold both large and small photos, you can drag the

problem photo onto one of the smaller photos, swapping the large and small positions.

Decreasing a picture's size squeezes its pixels closer together, improving the dots-per-inch shortage that iPhoto is so boldly warning you about.

If even those dramatic steps don't eliminate the yellow warning emblems, try to remember whether you ever cropped the photo in question. If so, your last chance is to use the Photos—Revert To Original command (page 143). Doing so will undo any cropping you did to the

photo, which may have jettisoned a lot of pixels that you now need. (If Revert To Original is dimmed, then you never performed any cropping, and this last resort is worthless.)

Finally, if nothing has worked so far, then your only options are to eliminate the photo from your book, or to order the book anyway.

Phase 5: Preview the Masterpiece

When you click that button, the screen goes black and a "Preparing Slideshow..." box appears. Depending on the complexity of your book layout, it may take iPhoto a minute or two to compose itself and generate the slideshow. Once the show starts in glorious full-screen mode, it comes up in the Classic slideshow theme (page 153). To change the music or transitions, wiggle the mouse to get to the full-screen toolbar and click the Music or Settings icons.

Once you're satisfied, the show kicks in, displaying the cover of your book before moving on to each individual page, one at a time. (This is probably one of the easier ways to get a book turned into a movie.)

Viewing your book as a slideshow is primarily a proofreading technique. It presents each page at life size, or even larger than life, without the distractions of menus or other iPhoto window elements, so that you can get one last, loving look before you place the order.

But book slideshows are also kind of cool for another reason: They present a more varied look at your photos than a regular slideshow. That is, your photos appear in page groupings, with captions, groupings, and backgrounds that there'd otherwise be no way to create in a slideshow.

Turn It into a PDF File

You've almost certainly encountered PDF (Portable Document Format) files before. Many a software manual, Read Me file, and downloadable "white paper" come in this format. When you create a PDF document of your own, and then send it off electronically to a friend, it appears to the recipient *exactly* as it did on your screen, complete with the same fonts, colors, page design, and other elements. They get to see all of this even if they don't *have* the fonts or the software you used to create the document. PDF files open on Mac, Windows, and even Linux machines—and you can even search the text inside them.

If you suspect other people might want to have a look at your photo book before it goes to be printed—or if they'd just like to have a copy of their own—a PDF file makes a convenient package.

Here's how to create a PDF file:

- 1. With your book design on the screen in front of you, choose File \rightarrow Print.
 - The Print dialog box appears.
- 2. Click the Save as PDF button, if you have one, or choose "Save PDF" from the PDF pop-up button.

The Save sheet appears.

- 3. Type a name for the file, choose a folder location for it, and then click Save.
 - Your PDF file is ready to distribute. (Fortunately, the recipients will be able to correct the rotation within Adobe Acrobat using its View—Rotate Counterclockwise command, or within Preview using the Tools—Rotate commands.)

Phase 6: Send the Book to the Bindery

When you think your book is ready for birth, click Buy Book.

After several minutes of converting your screen design into an Internet-transmittable file, iPhoto offers you a screen like the one shown in Figure 9-14.

That is, assuming you don't get any of iPhoto's prepublication warnings first—namely, that you haven't filled in all the default text boxes, like the title and subtitle; that some of your text boxes or photos bear the yellow-triangle low-resolution warning (see the box on page 249); that your book is "incomplete" (you didn't fill in all the gray placeholder rectangles with pictures); and so on.

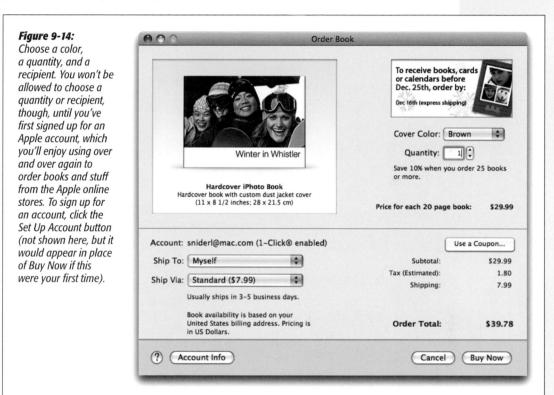

At this stage, your tasks are largely administrative.

• Choose a cover color (hardback books only). Use the Cover Color pop-up menu to choose Black or Brown. You're choosing the color of the leatherlike cover material; remember, it'll ordinarily be completely hidden by the paper dust jacket, whose looks you've presumably already determined. (If you're ordering more than one book, they must all be the same color.)

Phase 6: Send the Book to the Bindery

- Inspect the charges. If you've gone beyond the basic 20 pages, you'll see that you're about to be charged between 30 cents and \$1 per additional page, depending on the book type.
- Indicate the quantity. You can order additional copies of the same book. Indeed, after you've spent so much time on a gift book for someone else, you may well be tempted to order yourself a copy.

Your Apple ID and 1-Click Ordering

You can't actually order a book until you've signed up for an Apple account and turned on "1-Click Ordering."

However, you may well already have an Apple account if, say, you've ever bought something from an online Apple store or the iTunes Store. Whether you have or not, ordering your first iPhoto book requires completing some electronic paperwork, like this:

1. In the Order Book dialog box (Figure 9-14), click Set Up Account.

This button appears only if you've never ordered an iPhoto book before. (It doesn't actually appear in Figure 9-14; it would be where Buy Now appears.) In any case, an Apple Account Sign-In screen appears. If you already have an Apple account, type in your Apple ID and account password here. (An Apple ID is your email address; it's your .Mac address, if you have that.)

When you're finished, click Sign In. On the next screen, make sure 1-Click Ordering is turned on. Click Edit Shipping, if you like, to supply any addresses you plan to use repeatedly for shipping books and Kodak prints to. Finally, click Done. Skip to step 2.

If you've never established an Apple account before, then click Create Account, and enjoy your whirlwind tour through Apple's account-signup dialog boxes. You'll be asked to provide your contact info and credit-card number, make up a password, and indicate whether you want to receive Apple junk mail. You'll also be offered the chance to set up a number of addresses for people you may want books shipped to.

You wind up right where you started: at the Order Book screen. This time, however, the controls at the bottom are "live" and operational.

2. From the Ship To pop-up menu, choose the lucky recipient of this book.

If it's you, choose Myself. If not, you can choose Add New Address from this pop-up menu.

Note: You can order books if you live in Europe, Japan, or North America, but Apple offers shipping only to people in your own region.

If you wind up at the 1-Click Account Summary screen after this detour, then click Done.

3. From the Ship Via pop-up menu, indicate how you want the finished book shipped.

For U.S. orders, "Standard" shipping takes about four days and costs \$8. "Express" means overnight or second-day shipping (depending on when you place the order) and costs \$15. An additional book sent to the same address costs another \$1 for Standard shipping, or \$2 for Express.

4. Indicate how many copies of the book you want, using the Quantity control.

You'll see the Order Total updated.

5. Click Buy Now.

You've already stored your credit card information, so there's nothing to do now but wait for your Mac to upload the book itself. After a few minutes, you'll see a confirmation message.

6. Go about your life for a few days, holding your breath until the book arrives.

And when it does, you'll certainly be impressed. The photos are printed on Indigo digital presses (fancy, digital, four-color offset machines). The book itself is classy, it's handsome...and it smells good!

Photo Calendars

Custom-made photo books? Old hat, dude. Nowadays, the kids at school are buzzing about the other custom stuff you can order: calendars, greeting cards, and postcards. (Mugs and bumper stickers will have to wait for iPhoto '10 or '11.)

The calendars are absolutely beautiful—and, in iPhoto '09, bigger than earlier versions $(10.4 \times 13 \text{ inches})$. As shown in Figures 9-15 and 9-16, each is wire-bound, with a big Picture of the Month (or Pictures of the Month) above, the month grid below. You can customize each calendar with text, titles, national holidays, events imported from your own iCal calendar, and even little thumbnail photos on the date squares.

If you've ever designed an iPhoto book, designing an iPhoto calendar will give you an overwhelming sense of déjà vu. The calendar-design module is almost identical to the book-design module, except that it's turned 90 degrees. That is, the photo/page browser runs vertically down the side, rather than across the top.

Anyway, here's the drill:

Phase 1: Choose the Photos

Pick out pictures for the cover photo, the "picture of the month" photos, and any pictures you want to drag onto individual date squares. You can select an Event, a full album, several albums, or any group of thumbnails in the viewing area.

Phase 2: Choose the Calendar Design

Click the Keepsakes button on the iPhoto toolbar, and then choose Calendar.

Photo Calendars

A dialog box appears, filled with miniature calendar designs (Figure 9-15, top). These are the calendar design *themes*, which are just like the book themes described earlier in this chapter. Once again, click a miniature to see what the finished calendar will look like. The designs differ in photo spacing, the font used for the dates, the availability of captions, and so on.

Click the theme you want, and then click Choose. Now the dialog box shown at bottom in Figure 9-15 appears; here's where you can set up your calendar. For example, you can specify what period you want the calendar to cover.

Figure 9-15:

Top: All the calendar themes are, well, designs for calendars. The differences among them have to do with font choices, photo placement, and background pattern.

Bottom: As indicated by the "Start calendar on" controls, your calendar doesn't have to start with January, and it can include any number of months up to 24 (two years).

As for "Import iCal calendars:" you can turn on the checkboxes individually for each calendar (that is, category) that you've set up in iCal: Work, Social, Home, Sports League, Casey Stuff, whatever.

The "Show national holidays" pop-up menu lets you fill your calendar with important holidays. The United States dates include things like Valentine's Day, Lincoln's Birthday, and Thanksgiving; the French dates include Whit Sunday, Assumption Day, and Bastille Day (in English); and the Malaysian holidays are along the lines of Merdeka, Awal Ramadan, and Yang Di-Pertua of Sarawak's Birthday.

But you knew that.

Finally, if you keep your calendar in iCal (the calendar program in your Applications folder), you can choose to have those events appear on your new photo calendar (Figure 9-15, bottom).

As a bonus, you can turn on "Show birthdays from Address Book." That's a reference to the Mac OS X address-book program, which—along with names, addresses, and phone numbers—has a space to record each person's birthday. Incorporating them into your *printed* calendar means that you'll never forget a loved one's (or even a liked one's) special day.

Tip: This isn't the only chance you'll have to make these settings. You can return to this Settings dialog box at any time—when you're moving to Malaysia, for example, and want to change the holiday listings—by clicking the Settings button at the bottom of the calendar-design window.

When you're finished setting things up, click OK; you arrive in the calendar-design module. A new icon appears in the Source list, representing the calendar you're creating; you can file it into a folder, rename it, or trash it just as you would a slideshow or a book. You're ready for the fun part: installing your photos onto the calendar pages.

Phase 3: Design the Pages

Each page "spread" of the calendar shows a month grid on the lower page (below the spiral binding), and a "photo of the month" above (Figure 9-16). On each upper page, you'll find gray placeholder rectangles where you can install your favorite photos.

You put your own pictures into those gray boxes exactly the way you do when designing photo books. That is, you can let iPhoto fill those gray boxes automatically (by clicking the Autoflow button at the bottom of the window), or you can drag pictures onto them one at a time from the left-side waiting area.

You'll find these gray rectangles in three places:

- The cover. Choose one really good picture to grace the front. This is what the recipient (even if it's you) is going to see when first unwrapping the calendar.
- The upper page ("picture of the month" space). Illustrate each month with an especially appropriate photo—or more than one. Use the Layout pop-up menu to choose Two, Three, or whatever; some themes let you place as many as seven pictures above the spiral binding.

Photo Calendars

• Individual date squares. This is the part that might not have occurred to you: dragging photos onto *individual squares* of the calendar. Put people's faces on their birthday squares, for example, or vacation shots on the dates when you took them.

Tip: Once you've dropped a picture onto a calendar square, you can double-click it to open the handy editing window shown in Figure 9-17.

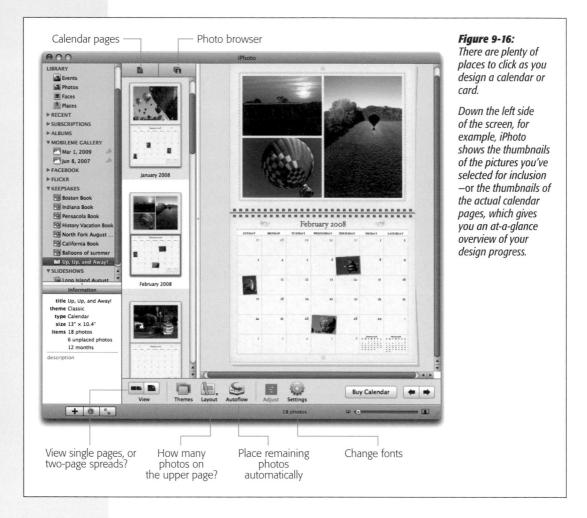

When you're finished editing January (or whatever), click one of the big black arrow buttons (lower right) to move on to the next month whose page you want to design.

Tip: You can edit photos right on the calendar-page layouts, just as you can edit photos in book layouts. Double-click to enter editing mode, or single-click to open the Adjust panel. No changes you make here affect the original photo in your library.

Figure 9-17:

This palette appears when you double-click a photo you've dropped on a date square. You can use the slider to enlarge the picture within its little box; drag inside the picture to reposition it in the frame; or type a caption into the text box at the bottom.

Turn on the Caption checkbox to make it appear, and don't miss the four-way "compass" that determines where the caption appears, relative to the date square: above, below, to the left, or whatever.

WORKAROUND WORKSHOP

Secrets of the Apple Book-Publishing Empire

It's no secret that when you order prints of your photos via the Internet, Kodak makes the prints. But neither temptation nor torture will persuade Apple to reveal who makes the gorgeous iPhoto books.

It didn't take long for Mac fans on the Internet, however, to discover some astonishing similarities between iPhoto books and the books created by a firm called MyPublisher.com. The pricing, timing, and books themselves are all identical. (When asked if it's Apple's publishing partner, MyPublisher .com says, "We don't discuss our partner relationships," which means "Yes.")

iPhoto-generated books are more elegantly designed than the ones you build yourself at MyPublisher.com. And it's certainly

easier to upload books directly from iPhoto, rather than to upload photo files one at a time using your Web browser.

Still, you should know that building your books directly at MyPublisher.com offers greater design freedom than iPhoto does. You have a wider choice of cover colors and materials (even leather), you can add borders around the pages, and you have much more flexibility over the placement of photos and text.

In fact, it's easy to get carried away with these options and produce something absolutely ghastly, which is probably why Apple chose to limit your options. This way, you simply can't go wrong.

Phase 4: Edit the Text

Once your calendar is photographically compelling, you can finish it off with titles, captions, and other text.

The cover, for example, offers both a main title and a subtitle. Click the placeholder words to select and replace them with new text of your own.

You can also double-click any date to open up a text box that you can type into (like "Robin's Graduation" or "Company Picnic"; see Figure 9-17). If the date has a photo on it, you can type into the caption box. If not, you just get a straight-ahead text box that suffices to label that particular date square.

Tip: Once the caption box is open, you don't have to close it and reopen it for another date. Each time you click a square on the calendar, the caption box automatically changes to show its text contents. (This trick also applies to the photo box shown in Figure 9-17.)

Just as with books, you can change the font formatting—either globally (for all pages) or for just some selected text:

- To change the font globally, click the Settings button on the iPhoto toolbar. In the resulting dialog box, click the Styles tab. Use the individual pop-up menus (for Cover Subtitle, Comments, Page Text, and so on) to specify the fonts and sizes you want. (If you decide that Apple's original font assignments were actually better than what you've come up with, click Restore Defaults.)
- To change the font for just one word (or sentence, or whatever), highlight it by dragging across it. Choose Edit→Font→Show Fonts to make the standard Mac OS X Fonts panel appear.

Phase 5: Order the Calendar

When you've said to yourself, "I'm [your name here], and I approve of this calendar," then click the Buy Calendar button.

If you've left any gray boxes empty (without putting your photos into them), or if any caption placeholders are still empty, an error message appears. You won't be able to order the calendar without filling the gray boxes, although leaving captions empty is OK. (The calendar will simply print without any text there. Not even the dummy placeholder text will print.)

After a moment, your Mac connects to the Internet, and you see the Order Calendar dialog box. It looks and works identically to the Order Book screen (Figure 9-14), except that the pricing is a little different and you don't choose a color for the cover. (A 12-month calendar costs \$20. Each additional month adds another \$1.50 to the price.)

Assuming you're all signed up as a certified Apple customer (page 252), all you have to do is specify how many copies you want, where you want them shipped, and via which method (Standard or Express). Click Buy Now, and mark off the very few days on your old calendar as you wait for the new one to arrive.

Greeting Cards and Postcards

Why stop at books and calendars? iPhoto also offers greeting-card and postcard designs (Figure 9-18). These items, too, are professionally printed using your own photographic material, look great, and don't cost an arm and a leg.

If you've read about how you design and order books or calendars, the description of the card-ordering process will feel like déjà vu all over again—only simpler.

1. In your iPhoto collection, click the photo you want on the front of the card. Click the Keepsakes icon at the bottom of the window, and then choose Card.

The familiar Themes dialog box appears, this time showing card designs (Figure 9-18).

Tip: If you select more than one photo in this step, you'll have the option of trying different photos on the card's front to see which you like best.

Figure 9-18:
At first, all 30 Apple card designs appear in the scrolling window; if you want to narrow them down a bit, click a category name at left (like Seasonal or Baby/Kids).
And above all, remember to make

And above all, remember to make a selection from the pop-up menu at top: either Greeting Card or Postcard.

2. From the pop-up menu at the top, choose either Greeting Card or Postcard. Then click the design you want.

iPhoto offers about 30 different card-front designs: holiday-themed cards, thank-you notes, baby announcements, birthday cards, invitations, and so on.

3. Click Choose.

Greeting Cards and Postcards

You arrive in the now-familiar iPhoto page-design screen, where you can adjust the photo, card background, and text (Figure 9-19). You'll see two rectangles here: the inside and outside (of a greeting card) or front and back (of a postcard).

An icon now appears in your Source list, too, representing the card in progress.

4. Adjust the photo.

If you single-click the photo, you enter the picture-adjustment mode described on page 238. That is, you can drag the slider to enlarge the photo, or drag the picture to adjust its position inside the "frame." Double-click to open editing mode.

You can also replace the photo. If you had the foresight to choose several candidates in step 1, then a thumbnail browser appears at the top of the window. You can drag these thumbnails directly into the card's photo area to try them out.

If you didn't think ahead, all is not lost. Click the album that contains the photos you want to try as alternatives, and then drag their thumbnails onto the card's icon in the Source list. When you click that icon now, you'll see the thumbnail browser containing the designated photo choices.

5. Adjust the background and design.

The Background pop-up icon (at the bottom of the window) offers some alternative color schemes for the margins around the front-cover photo (and the corresponding accents on the inside or back of the card); see Figure 9-19.

The contents of the Design pop-up menu, on the other hand, change depending on whether you've clicked the front of the card or the inside/back. For the front, you get alternative layouts of text and photo (like adding the option to type a caption on the front of the card, or rounding the corners of the photo). If you've clicked the back of a postcard, then you get to choose a standard mailable postcard back (with lines where you can write in a name and address, for example), or a nonmailable design that looks more like the inside of a greeting card.

GEM IN THE ROUGH

A Pop-Up You Might Miss

Don't miss the "pop-up icon" called Design (at the bottom of the window). It offers variations on the photo layout for each month's upper page.

In most themes, those variations don't amount to much. The Design pop-up menu usually offers only two choices: one design with a place to type a picture caption, and another

without. But in some themes, like the Paper Animals and Baby designs, the Design pop-up menu offers as many as eight different designs—different background patterns for your photos, for example.

(The Design pop-up menu for greeting cards varies based on which theme you choose; Holiday/Events cards have the most options.) The Orientation pop-up menu lets you specify whether this card is folded at the top or the left side (Horizontal or Vertical).

6. Edit the text.

Double-click any bit of placeholder text on the screen to open its text box for editing. (It's generally uncool to send out baby-announcement cards bearing the legend, "Insert a name here.")

Tip: Don't forget that you can zoom in on any part of your card by dragging the slider at the lower-right corner of the screen.

Figure 9-19:

The Background pop-up menu offers a choice of color schemes (and, in some designs, patterns) for the background and interior of the card.

Greeting cards are 5 × 7 inches, come with a matching envelope, and cost \$2 each (in quantities up to 24; discounts kick in at larger quantities). Postcards are 4 × 6 and cost \$1.50 each. (Here again, they cost less if you order 25 or more, and even less in quantities above 50.)

You can also edit the type styles and fonts, exactly as described on page 245.

7. Order the card.

When the card looks good, click Buy Card. Your Mac goes online, and the Order Card dialog box appears. Here you'll discover that you're allowed to buy cards individually (you don't have to buy, say, 12 in a box—thanks, Apple!).

These cards are cheap enough and amazing enough that you should consider making them part of your everyday arsenal of social graces. After all, you're living in an era where very few other people can pull off such a thing—and you'll be the one who gets credited with the computer savvy and design prowess.

iPhoto Goes to the Movies

s Chapter 6 makes clear, once you select your images and choose the music to go with them, iPhoto orchestrates the production and presents it live on your Mac's screen as a slideshow.

Which is great, as long as everyone in your social circle lives within six feet of your screen.

The day will come when you want friends and family who live a little farther away to be able to see your slideshows. That's the beauty of QuickTime, a portable multimedia container built into every Mac. Even if the recipient uses a Windows PC—hey, every family has its black sheep—your photos will meet their public; QuickTime movies play just as well on HPs and Dells as they do on iMacs and MacBooks.

iPhoto '09 makes it even easier than before to convert those photos into mini-movies. A new Slideshow Export option lets you save your slideshows to QuickTime movie files that play flawlessly on the iPod, iPhone, Apple TV, and other video-watching gadgets. If you want something smaller and simpler, you can also export your photos to a standalone QuickTime movie. In either case, you'll then have a file on your hard drive that you can email to other people (including Windows people), post on your Web page for downloading, burn onto a CD, and so on.

Before You Export the Slideshow

You have two ways to convert your masterpiece to a video file: Slideshow Export and QuickTime Export, both described in this chapter. But no matter which method you choose, before you send your "slideshow movie" to hapless relatives who'll have to

Before You Export the Slideshow endure downloading it over a dial-up connection, make sure it's worth watching in the first place.

Perfect the Slideshow

As you review your presentation, place the pictures into the proper sequence, remembering that you won't be there to verbally "set up" the slideshow and comment as it plays. Ask yourself, "If I knew nothing about this subject, would this show make sense to me?"

You might decide that your presentation could use a few more descriptive images to better tell the story. If that's the case, go back through your master photo library and look for pictures of recognizable landmarks and signs. Put one or two at the beginning of the show to set the stage. For example, if your slideshow is about a vacation in Washington, D.C., then you might want to open with a picture of the Capitol, the White House, or the Lincoln Memorial.

Tip: If you don't have any suitable opening shots in your library, or even if you do, another option is to begin your show with a few words of text, like opening credits. You can let iPhoto do the job, or, for something more elaborate, create a JPEG graphic containing the text in a program like Pages or Photoshop. (Make sure this graphic matches the pixel dimensions of your slideshow, as described in the following section.) Then drag the file right into your slideshow album, placing it first in the sequence. You've got yourself an opening title screen.

Which photos make the cut

If you're used to the slideshow feature described in Chapter 6, then the method for specifying which photos are exported to your QuickTime movie might throw you.

- If *one* thumbnail is selected, that's all you'll get in the finished QuickTime movie—the world's shortest slideshow. (This is the part that might throw you: An iPhoto slideshow would begin with that one selected photo and then move on from there, showing you all the rest of the photos in the album.)
- If several thumbnails are selected, only they make it into the slideshow movie.
- If *no* thumbnails are selected, the entire album's worth of photos wind up in the show.

When you're ready to convert your presentation to a movie, you need to make yet another decision: Do you want to do it the easy way, or the way that gives you more control?

Two Ways to Make Movies

Earlier versions of iPhoto offered one way to export your photos as a slideshow: Export a basic QuickTime movie. You can still do that—and that method has its advantages, namely smaller file size. But now, in addition to the time-honored QuickTime export, iPhoto '09 gives you an even easier way: Slideshow Export.

The Slideshow Export feature lets you convert your instant and saved slideshows into custom-sized QuickTime movies designed to look good on specific screens, like an iPhone or a laptop. And these easy-to-save clips even retain the fancy theme animations, music, and other settings of an iPhoto slideshow, described back in Chapter 6.

To use Slideshow Export, all you need is...a slideshow.

Exporting an Instant Slideshow

That instant slideshow is up on your Mac's screen now, full of great freshly uploaded pictures of the kids. And you *really* want to take a copy of it with you on your iPod Touch before you have to leave for the airport in a few hours. Here's what to do:

The Export Photos box pops up onscreen.

Figure 10-1:

The new Slideshow Export option in iPhoto '09 takes the guesswork out of getting the right settings. Based on what you (or your recipient) will use for movie-watching, choose the size of your exported slideshow from the left. The box shows you what the resolution will be and what gadgets the video works best with. For iPod/iPhone transfer, turn on the option to send the movie to the iTunes library.

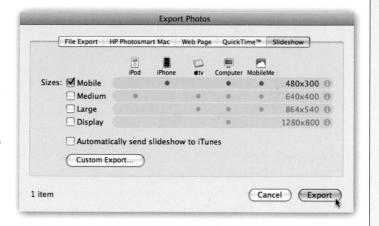

2. Click the Slideshow tab and see Figure 10-1.

You now have another choice to make: what you want to play the slideshow *on*—TV, computer screen, iPhone, or whatever. Here, iPhoto '09 politely takes all the guesswork out of the settings you need for that slideshow to look good on the iPod Touch. The box even shows you what pre-configured sizes work best on which screens. Here's the rundown:

- Mobile. With a resolution of 480 × 300 pixels, this size is good for iPhones, iPod Touches, and uploading to a MobileMe Gallery (page 201). This setting also makes a smallish file to watch on the computer.
- Medium. If you have an Apple TV hooked up to your widescreen set, this is the smallest export size you should consider. The 640×400 resolution looks good on the computer or MobileMe Gallery (but takes longer to upload). It's also the one

Two Ways to Make Movies

- to choose if you plan to copy the slideshow to your iPod to play there—or pipe up to a pal's TV set after you connect the two boxes with an iPod AV cable.
- Large. At 864×540 pixels, this size looks even better on the Apple TV, computer, or MobileMe player—but makes for a bigger file hogging up space somewhere.
- Display. If you want a slideshow that looks great on a Cinema Display or other large screen, go for this 1280×800 pixel option. Be prepared for a hefty file.

Note: If you want precise control over things like audio and video compression settings, click Custom Export and then click the Options button. Those settings are for AV Club members who really like to bang around under the hood of a video file; they're described on page 278 (the options, not the AV Club members).

3. Send the file to iTunes (or not).

If you want to send the exported file right into iTunes for easy syncing to the iPod Touch or iPhone, turn on "Automatically send slideshow to iTunes." If you don't want the file in iTunes, turn off the box; the exported file lands in Home→Pictures→iPhoto Slideshows.

4. Click Export.

iPhoto exports the slideshow as a QuickTime-friendly .*m4v* file. The export process may take several minutes. (Motion-heavy themes like Shatter take longer to export than, say, a straightforward Classic slideshow.) If you opted to send the file to iTunes, then iPhoto kicks the exported slideshow into the Movies area of your iTunes library. From there, it's one quick sync to Podville.

Exporting a Saved Slideshow

That masterpiece of a slideshow you spent all weekend slaving over—one of the *saved* slideshows described on page 162—is easy to export. In fact, it's even easier than exporting an instant slideshow:

- 1. In the Slideshow area of the iPhoto Source list, select the chosen production.
 - The saved creation appears in the iPhoto window.
- 2. Click the big, fat Export button on the iPhoto toolbar, shown in Figure 10-2.

The button takes you right to the box shown in Figure 10-1. Follow steps 2 through 4 in the previous section to export your saved Slideshow to the chosen format.

Figure 10-2:

Exporting a saved slideshow doesn't get any easier than this. Just select the show in the Source list and click the Export button on the toolbar. You don't even have to root around in menus to find an export option (although File—Export works, too).

That's it. Copy that file onto an iPod, burn it to a disc (page 276), or do whatever you want with it.

Tip: With all the music and animations, exported slideshows can be pretty big—35 megabytes or more for a 40-slide show with all the bells and whistles. That's too big to email, but there are other ways of getting it to your friends over the Internet. For one, you can use the file-transfer feature of instant-messaging programs like iChat or AIM to send the file from your Mac to your recipient's computer. Or if you have a MobileMe account, you can drag the file to your iDisk and then, at *me.com,* click the Share Files button to send a message to a friend. The message contains a link for your pal to directly download the file from your iDisk—no muss, no fuss.

Exporting a QuickTime Movie

The two slideshow-exporting tricks described on the previous pages are so easy, the manual effort of the older Save as QuickTime command might seem obsolete. Unfortunately, all of those special effects and fancy graphics have two drawbacks: They take a lot of time to export, and they create huge files that are too big to email.

If that's a problem, you can ditch all those pre-formatted slideshow themes and, instead, simply save an album or a selected bunch of photos as a humble set of moving pictures. Simple QuickTime movies can be as small as a megabyte and much easier to send around the Internet to friends. You can even add a little music to perk things up.

Here are the steps involved in creating this older, simpler sort of slideshow movie:

Step 1: Choose QuickTime

Select an album or group of photos and choose File→Export. The Export Photos dialog box appears, as shown in Figure 10-3. Click the QuickTime tab, where you have some important decisions to make.

Step 2: Choose the Movie Dimensions

Specifying the width and height for your movie affects not only how big it is on the screen during playback, but also its file size, which may become an issue if you plan to email the movie to other people. iPhoto generally proposes 640×480 pixels. That's an ideal size: big enough for people to see some detail in the photo, but usually small enough to send, in compressed form, by email.

Proportion considerations

All of these suggestions assume, by the way, that your photos' dimensions are in a 4:3 ratio, the way they come from most cameras. That way, they'll fit nicely into the standard QuickTime playback window.

But there's nothing to stop you from typing other numbers into the Width and Height boxes. If most of the shots are vertical, for example, you'll want to reverse the proposed dimensions so that they're 480×640 , resulting in a taller, thinner playback window.

Exporting a QuickTime Movie

Size considerations

As you choose dimensions, bear in mind that they also determine the *file size* of the resulting QuickTime movie. That's not much of an issue if you plan to play the movie from a CD, DVD, or hard drive. (And in that case, you might want to generate your movie from a saved slideshow instead, as described on page 266.) But if you plan to send the movie by email or post it on a Web page, watch out for ballooning file sizes that will slow dial-up sufferers to a crawl.

For example, an 18-slide movie with an MP3 music soundtrack would take up 3.1 MB on your hard drive (at 640×480 pixels)—and at least that much in your recipients' email inboxes. Scaling it down to half that size in each dimension (320×240) would shave off about a third, resulting in a 2.4 MB file.

You could eliminate the music soundtrack, which would shrink the movie to a mere 350 K—but who wants a silent movie?

Fortunately, there is a middle road. It involves some work in iTunes and a slight reduction in sound quality, but reducing the file size of the music track can result in substantial file shrinkage. See the box on the next page for details.

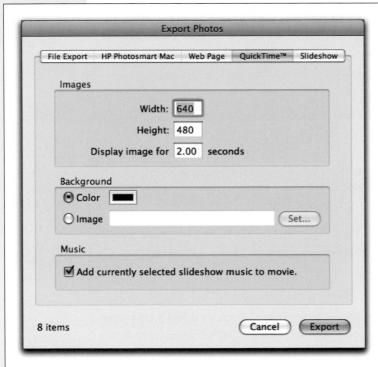

Figure 10-3:

Here's the Export dialog box with the QuickTime tab selected. This is the air lock, the womb, the last time you'll be able to affect your movie before it's born. You're free to change these dimensions, however. If the movie will be played back from a hard drive, you may want to crank up the dimensions closer to the size of the screen itself: 800 × 600 is a safe bet if you're not sure. Remember, though, you have to leave some room for the QuickTime Player controls so that your audience can start and stop the movie.

268

Step 3: Choose the Seconds per Photo

How many seconds do you want each picture to remain on the screen before the next one appears? You specify this number using the "Display image for ___ seconds" box in the QuickTime Export dialog box.

Step 4: Choose the Background Colors

The color or image you choose in the Background section of the dialog box will appear as the first and last frames of the export. It will also fill in the margins of the frame when a vertically oriented or oddly proportioned picture appears.

Solid colors

To specify a solid color, click the color swatch next to the Color button. The color picker described in the figure on page 216 appears.

Generally speaking, white, light gray, or black makes the best background. Black is particularly good if you've bought QuickTime Pro (page 271) and want to present your slideshow in full-screen mode, which turns the Mac into a virtual movie screen and makes the borders between your movie and the screen indistinguishable.

POWER USERS' CLINIC

Musical Liposuction

If you're struggling with the size of a QuickTime movie slideshow that's too big for emailing, consider shrinking the size of the music track. By cutting its *bit rate* (a measure of its sound quality) from 192 to 128 kbps, for example, the file size for a hypothetical 320 × 240 pixel movie would shrink from 2.1 MB to 1.5 MB—and most people playing the movie over typical computer speakers wouldn't hear the difference.

This kind of surgery requires iTunes, the music-management software that comes with every Mac.

Start by choosing iTunes—Preferences. In the Preferences dialog box, click General, and then click the Import Settings button. From the Import Using pop-up menu, choose MP3 Encoder. Then, from the Setting pop-up menu, choose, for example, "Good Quality (128 kbps)." (A lower Custom number will result in even smaller files, although the sound quality may suffer.) Click OK to close the dialog box.

Now highlight the track you want to add to your slideshow, and then choose Advanced—Create MP3 Version.

iTunes converts the song into a duplicate copy that has the new, lower sample rate (quality setting). The song's name appears in your iTunes Music Library list just below the original. (You might want to rename it to differentiate it from the original, higher-quality song by highlighting it and then choosing File→Get Info. Click Info in the resulting dialog box.)

Now return to iPhoto. Click the album you're going to import, click the Play Slideshow triangle below the Source list, click the Music tab, and finally select your new resampled song from the list of titles in the dialog box. Click Save Settings.

When you export the slideshow to QuickTime, you'll find that it's much more svelte, but the music sounds practically identical to the puffier version.

Exporting a QuickTime Movie

Background graphics

If you click the Image button and then the Set button next to it, you can navigate your hard drive in search of a *graphics* file to use as the slideshow background. This is where a graphics program like Photoshop or GraphicConverter comes in handy. By designing a picture there (in dimensions that match your movie) and exporting it as a JPEG file, you have complete freedom to control the kind of "movie screen" your QuickTime slideshow will have.

Step 5: Export the Movie

Having specified the dimensions, frame rate, music, and background for your movie, there's nothing left but to click the Export button in the dialog box. You'll be asked to specify a name and folder location for the movie (leaving the proposed suffix .mov at the end of the name, as shown in Figure 10-4), and then click Save. After a moment of computing, iPhoto returns to its main screen.

Figure 10-4:

You may spend a lot of time creating your saved slideshow movie, but it won't take you long to configure the Export dialog box. Your options are limited here. Clearly, the iPhoto engineers figured that at this point, you'd spent quite enough time making artistic decisions.

Once iPhoto finishes its work, you have your slideshow intact as a QuickTime file with its transitions, effects, and music. It's really quite astounding.

Press **%**-H to hide iPhoto; then navigate to the folder you specified and double-click the movie to play it in QuickTime Player, the movie-playing program that comes with every Mac. When the movie opens, click the Play triangle or press the space bar to enjoy your newly packaged slideshow (Figure 10-5).

Whenever playback is stopped, you can even "walk" through the slides manually by pressing the right arrow key twice (for the next photo) or the left arrow key once (for the previous one).

Tip: Even Windows PC users can enjoy your QuickTime movies—if they visit www.apple.com/quicktime/download to download the free QuickTime Player program for Windows.

Figure 10-5:
Once you're in QuickTime
Player, you can control the
playback of the slideshow
in a number of ways. If
you don't feel like clicking
and dragging onscreen
controls, the arrow keys
adjust the volume (up and
down) or step through
the photos one at a time

(riaht and left).

Fun with QuickTime

The free version of QuickTime Player is, well, just a player. If you're willing to pay \$30, however, you can turn it into QuickTime *Pro*, which offers a few special features relevant to iPhoto movie fans (or their Windows-using relatives who buy it):

- Play movies in full-screen mode. QuickTime Pro can play video in full-screen mode—no menu bar, Dock, window edges, or other distracting elements. In effect, it turns your laptop screen into a portable theater.
- Edit your flicks. QuickTime Pro lets you trim off excess footage, add an additional soundtrack, or even add a text track for subtitles (captions). It's also great for combining or editing down the little movies that iPhoto downloads from your digital camera.
- Adjust video and audio. Only the Pro version lets you fine-tune your video and audio controls—Brightness, Treble, Bass, and so on—and then save those settings with your movie.
- No more nagware. Upgrading eliminates the persistent "Upgrade Now" dialog box that appears when you open the regular Player program.

Fun with QuickTime If you decide that the upgrade is worthwhile, visit www.apple.com and click the QuickTime tab. There you'll find the links that let you upgrade your free QuickTime player to the Pro version. In exchange for \$30, you'll be given a registration number that "unlocks" QuickTime's advanced features. (To input the serial number in QuickTime Player, choose QuickTime Player—Preferences—Registration, and then click the Registration button.)

Then you'll be ready for the following tricks.

Play Movies at Full Screen

If you've upgraded to QuickTime Pro, here's how to create a full-screen cinematic experience.

First, use a black background when you export your movie from iPhoto. That way, there will be no frame marks or distracting colors to detract from your images. Furthermore, the black bars on the sides of vertically oriented photos will blend in seamlessly with the rest of the darkened monitor, so that nobody is even aware that the photo has been rotated. Those black bars will also fill in the gap between the standard monitor shape and the nonstandard ones preferred by Apple these days (such as the screens on the extra-wide Cinema Display, the iMac, or Apple laptops).

Second, export your movie in as large a size as will fit on your screen. That means dimensions of 1280×800 , or whatever matches your monitor's current setting. (To find out, choose $\clubsuit \rightarrow$ System Preferences and then click the Display icon.) Your images will occupy more of your Mac's display area, imparting greater impact.

Once you've exported your movie, presenting it in "theater mode" is as simple as choosing QuickTime Player—Peferences—Full Screen. Then set up the dialog box as shown in Figure 10-6.

Figure 10-6:

QuickTime has size preferences for all kinds of movies. To get to the settings, choose QuickTime Player→Preferences and then click the Full Screen button in the box.

Here, you can tell QuickTime how you want to see various types of movies: actual size, smaller, bigger, and so on.

Once you've created a slideshow movie, keep in mind that nothing's etched in stone—at least not if you have QuickTime Pro. Suppose you don't care for the empty frames of background color (or background picture) that iPhoto adds automatically at the beginning and end of your movie. Or what if, thanks to an unforeseen downsizing, a graduation, or a romantic breakup, you want to delete a photo or two from an existing movie? Using QuickTime Pro, you can snip unwanted photos or frames right out.

Selecting footage

Before you can cut, copy, or paste footage, QuickTime Pro needs to provide a way for you to specify *what* footage you want to manipulate. Its solution: the two tiny L-shaped handles that sprout out of the left end of the horizontal scroll bar (called the *scrubber*), as shown in Figure 10-7. These are the "in" and "out" points; by dragging these handles, you can enclose the scene you want to cut or copy.

Tip: You can gain more precise control over the selection procedure shown in Figure 10-7 by clicking one of the handles and then pressing the right or left arrow keys to adjust the selection a frame at a time.

Or try Shift-clicking the Play button. As long as you hold down the Shift key, you continue to select footage. When you release Shift, you stop the playback; the selected passage then appears in gray on the scrubber bar.

Figure 10-7:

To select a particular scene, drag the tiny L-shaped handles apart until they enclose the material you want, or use the clicking/Shift-clicking trick shown here. As you drag or click, QuickTime Player updates the movie picture to show you where you are. The material you select is represented by a gray strip in the scrubber bar.

Everything between them is selected.

Fun with QuickTime

Once you've highlighted a passage of footage, you can proceed as follows:

- Jump to the end or beginning of the selected footage by pressing Option-right arrow or Option-left arrow key.
- Deselect the footage by dragging the two L-shaped handles together again.
- Play only the selected passage by choosing View—Play Selection Only. (The other View menu commands, such as Loop, apply only to the selection at this point.)
- Drag the movie picture out of the Player window and onto the desktop, where it becomes a *movie clipping* that you can double-click to view.
- Cut, copy, or clear the highlighted material using the commands in the Edit menu.

Advanced Audio and Video Controls

One of the difficulties of creating multimedia productions is that there's no standard calibration for all the various computers that might play them. For example, a slideshow that your friend creates on his Dell computer might look washed-out on your Mac.

Luckily, QuickTime Pro offers a solution (see Figure 10-8).

Figure 10-8:

Should you inherit movies with poor audio and video, QuickTime Player Pro gives you some useful audio and video controls to compensate.

Fortunately, you can adjust the brightness, balance, bass, or treble using these general controls. The trick is to show and hide them by choosing Window—Show A/V Controls.

For real comedy, don't miss the Playback Speed slider, either...

Exporting Edited Movies

After you've finished working on a soundtrack or movie, you can send it back out into the world by choosing File→Save As. At this point, you can specify a new name for your edited masterpiece. You must also choose one of these two options:

- Save as a self-contained movie. This option produces a new QuickTime movie—the one you've just finished editing.
- Save as a reference movie. You'll almost never want to use this option, because it produces a very tiny file that contains no footage at all; it's like an alias of the movie you edited. It works only as long as the original, *unedited* movie remains on your drive. If you try to email the newly saved file, your unhappy recipient won't see anything at all.

Managing Movies Imported from Your Camera

Digital-camera movies were once a novelty that few cared about. Today, though, they've become a convenient way to record video without lugging around a camcorder. Current digicams can capture movies with standard (640×480) or even high-definition TV resolution, TV smoothness (30 frames per second), and sound.

When you import your movies into iPhoto, the program cheerfully adds those video files to your library, denoted by a little camcorder icon and a duration indicator.

But iPhoto doesn't provide any tools to edit the video, to combine it with other snippets, or even to watch it. When you double-click an imported movie, iPhoto hands it off to QuickTime Player in a separate window.

iPhoto doesn't update the movie thumbnail when you edit and save the file, either. You may have cut out the opening scene of a clip in QuickTime Pro—say, Aunt Betty tripping over the garden hose—but she'll still be there in your thumbnail library, even though that particular moment of video is now on the cutting-room floor. The only workaround is to save the cleaned-up version to your hard drive and then import it back into iPhoto.

Editing Digital-Camera Movies

To edit your camera-captured movies, open iMovie (the video-editing component of your iLife suite). In the Event Library at the left side of the window (choose Window—Event Library if you don't see it), click iPhoto Videos. Drag the clip you want right into iMovie's Project area.

The end.

All right, there's a *little* more to it—like learning how to *use* iMovie—but that's a different book. The point here is that you can incorporate movies from iPhoto's library in whatever iMovie project you have open, ready to edit as you would any other clips.

Tip: Want a great way to organize your camera's movies all at once? Create a new smart album, as described in Chapter 2. Set it up so that the pop-up menus and text boxes in the New Smart Album dialog box say "Photo" "is" "movie." You'll always find all your movies safely collected in this self-updating smart album.

Editing Digital-Camera Movies

Editing Digital-Camera Movies in QuickTime Pro

If learning iMovie seems like overkill for some little project—if all you want to do is combine a few clips into one longer flick, for example—then you can get by with nothing more than QuickTime Pro.

Suppose, for example, that you want to combine two movies called Clip A and Clip B. Open both of them by double-clicking their thumbnails in iPhoto.

Tip: If your digital camera captures video at 640×480 pixels (that's full-screen TV size), you can add video to your exported slideshows. To do so, export an instant slideshow as described on page 265, taking care to save the result at 640×480 pixels. Open the exported slideshow in QuickTime Pro, along with the desired movie clip. Using the Select, Copy, and Add commands described previously, you can now create presentations beyond anything you ever expected from iPhoto.

Then follow along with this quick refresher that covers the basic editing techniques for this project:

- Trim. You can use this command to trim unwanted footage from the beginning or end of a movie clip. First, move the bottom triangles on the scrubber bar to the in and out points of the footage you want to keep, as shown in Figure 10-7. When you choose Edit→Trim to Selection, QuickTime Player eliminates the white area on the scrubber bar, retaining the gray area.
- Select, Copy, Add. Many digital cameras allow you to shoot only 30 seconds or a couple of minutes of video at a time. So to construct your movie, you can use these commands to combine short clips into a longer presentation.

The procedure is a lot like copying and pasting text. In Clip A—the one that will become the master, fully assembled version—click the far-right triangle to move the scrubber head to the end.

Now open Clip B. Choose Edit→ Select All to highlight the whole clip; then choose Edit→Copy. The selected video and audio are now on the clipboard.

Return to Clip A; choose Edit→Add to Movie. (Don't choose Edit→Paste, or you'll *replace* the video in Clip A.) The Clip B video now appears at the end of the movie. You'll see that its duration indicator changes to reflect the added length.

• Save As. Choose File—Save As. Give your combined movie a new name, click "Make movie self-contained," and then click Save. (As noted earlier, don't use the regular Save command unless you intend to *replace* the original movie clip in iPhoto with your edited one.) Once you've stored the new version on your hard drive, you can drag it back into iPhoto.

Burning a Slideshow Movie CD or DVD

If your slideshow lasts more than a minute or two, it's probably too big to send to people by email. One alternative: Burn them a CD or DVD. Here's how the process goes:

1. Prepare your exported movie.

Since file size isn't as much of an issue, you can make your slideshow dimensions 640×480 , 720×480 , 800×600 , or any other size that fits on the computer screen. There's no need to throttle down the music quality, either.

Tip: To make things easy for the audience (even if it's only you), you can turn on the Auto Play feature, which will make the movie play immediately after being double-clicked. (Savings: one click on the ▶ button.)

To turn on Auto Play, start by opening the movie in QuickTime Pro. Choose Window→Show Movie Properties. In the Properties dialog box, click the Presentation tab, and then turn on "Automatically play movie when opened." Save the movie as usual.

2. Put a blank CD or DVD in your burner.

A few seconds after you insert the disc, a message asks what you want to do with the blank disc. Choose Open in Finder and click OK.

Now the disc's icon appears on your desktop as "Untitled CD" or "Untitled DVD." You can rename it by clicking its name and then typing away.

3. Drag the movie(s) onto the disc's icon.

These are, of course, the slideshow movies you've exported from iPhoto or the video clips from your digital camera.

4. Click once on the disc icon and then choose File→Burn [the disc's name].

A confirmation dialog box appears (Figure 10-9).

Figure 10-9: You have one last chance to change your mind before you burn the disc. If everything's a go, then click Burn.

5. Edit the disc's name, and then click Burn.

The Mac saves the movies onto the CD or DVD.

Burning a QuickTime Movie CD When the process is complete, eject the disc. It will play equally well on Mac OS 9, Mac OS X, and Windows computers that have QuickTime Player installed.

By the way, Mac OS X 10.5 (Leopard) has another approach: Choose File→New Burn Folder from the File menu. A new folder called Burn Folder appears on your desktop. Name it anything you want, and then drag your movies inside. Now open the folder and click the Burn button in the upper-right corner. The Mac asks for a blank CD or DVD and then walks you through the process of burning it.

Slideshow Movies on the Web

Chapter 8 offers complete details for posting individual photos on the Web. But with just a few adjustments to the instructions, you can just as easily post your slideshow movies on the Web, too, complete with music.

Preparing a Low-Bandwidth Movie for the Web (No Transitions)

You could, of course, just make a slideshow movie as described on the previous pages, and then slap it up on the Web. Unfortunately, a movie like that would involve quite a wait for your Web visitors. They would click the movie's icon to view it—and wait while the entire 3 MB movie downloads. Only then could they begin watching it.

But if you have QuickTime Pro, you can create movies that start playing almost immediately when Web visitors click them. Here's how to preprocess your finished slideshow movie so that it will start faster online. Open your movie in QuickTime Pro, and then follow these steps:

1. Choose File→Export.

The "Save exported file as" dialog box appears. Make sure that the Export pop-up menu says "Movie to QuickTime Movie" and the Use pop-up menu says "Most Recent Settings."

Tip: In QuickTime Pro, choose File→Export for Web to quickly pop out an exported slideshow in a standard size for Web or iPhone browser, complete with instructions and pre-formatted HTML code for posting on your site.

2. Click Options.

The Movie Settings dialog box appears (Figure 10-10, bottom). Your job is to format the movie so that it will look good without taking a long time to download.

3. Under Video, click Settings. In the Compression Settings dialog box (Figure 10-10, top), choose "Photo – JPEG" from the first pop-up menu.

This format is compact and high quality, making it a good choice for slideshows.

4. In the Frame Rate box, select Current from the pop-up menu.

The resulting file will be small, but you'll lose the crossfades between slides, if you used them.

5. Drag the Quality slider to Medium or High, and then click OK.

You return to the Movie Settings dialog box.

6. Click the Size button. Enter 320 in the Width box and 240 in the Height box; click OK.

Use a larger size only if you're sure that your audience members all have high-speed Internet access.

7. Under Sound, click Settings. In the Sound Settings dialog box, choose AAC from the Compressor pop-up menu, and then click OK.

The AAC Music format produces high-quality music at very small file sizes, which is just what you'd hope for in Web-played movies. (If your movie has a spoken dialog track rather than music, then use the Qualcomm PureVoice codec instead.)

You return once again to the Movie Settings box. Here, confirm that the Prepare for Internet Streaming checkbox is turned on, and that Fast Start is selected in its pop-up menu. These settings are responsible for QuickTime's fast-playback feature, in which your viewers don't have to wait for the *entire* movie to download

Figure 10-10: Top: These are good video settings for an exported slideshow Web movie; it will consume only 1 megabyte for a 20-slide show at 320 × 240 pixels, with music. By choosing Current for your Frame Rate, you're telling QuickTime to be very frugal with the data rate. Your pictures will still look great, but you'll lose those elegant dissolve transitions. The images will simply cut

Bottom: These settings will help you prepare your movie for Web serving. After you've tried an export or two, you can play with the adjustments to customize your slideshow even further.

from one to the next.

Slideshow Movies on the Web

before playback starts. Instead, they'll have to wait for only a quarter or half of it, or whatever portion is necessary to play the entire movie uninterrupted while the latter part is still being downloaded.

8. Click OK, and then click Save.

Your slideshow takes a few minutes to export. But once the process is complete, you're ready to upload the file to your Web site.

Note: Once you've optimized and exported your slideshow in QuickTime Pro, don't use the File—Save or File—Save As command after making changes to the movie. If you do, you'll automatically turn off the Fast Start option you built in when you exported the movie.

It's OK to make further changes. But when you're finished, use the File→Export command again, repeating the previous steps, to preserve the movie's Web-optimized condition.

Preparing a High-Bandwidth Movie for the Web (with Transitions)

If you expect that your viewers all have high-speed Internet connections (or if they're on your same office network), then you can retain the elegant between-slide transitions that you've worked so hard to perfect. In this scenario, file size isn't so important.

The steps are the same as those outlined in the previous section, but you use a few different settings in the Compression Settings dialog box (steps 2 through 7). For example, choose MPEG-4 Video as the Compression Type and 15 as the Frame Rate.

Tip: If your movie will be played back from a hard drive, CD, or DVD (instead of over the Web or a network), you can be even more generous with the quality and file sizes. You can bump the frame rate (video smoothness) to 30 frames per second and the data rate to 200 or more.

Uploading to a MobileMe Gallery

If you maintain your own Web site, upload the movie as you would any graphic. Create a link to it in the same way. Your movie will start to play in your visitors' Web browsers when they click that link.

But if you have a MobileMe account, posting the movie is even easier. You can bring it into iMovie '09 as described earlier in this chapter and then save it directly to YouTube or your MobileMe gallery; in iMovie '09, just choose Share—YouTube or Share—MobileMe Gallery.

If that detour to iMovie seems like overkill, you can also upload your photo movie right into your MobileMe Gallery from the Web. When your movie file is ready, open your browser. Go to *www.me.com* and sign in.

1. Click the Gallery icon.

You land on your MobileMe Gallery page, where all your uploaded photos and albums live.

2. Click the + button below the list of albums on the left side of the page.

Name the new album and adjust your settings for privacy and downloading.

3. Click Create.

You have now created an album for your movie. A green arrow appears in the middle of the screen, urging you to upload something.

4. Click the arrow.

A box like the one in Figure 10-11 asks you to choose files for your new album. Select your exported movie file on your hard drive, and then upload it.

The slideshow movie appears in the MobileMe Gallery. Your pals can find it at http://gallery.me.com/[YourMobileMeName]. Your die-hard fans can even use the RSS button in the corner of the page to subscribe to it, so they get notified every time you're inspired to upload new photos or videos.

Figure 10-11: MobileMe Gallery After MobileMe ◆ ► W A A thttp://www.me.com/gallery/io ~ Qprompts you, choose the slideshow movie vou'd http://gall like to upload. Let the site take its time My Gallery pulling up a copy Uploads of your magnum ▼ AL RUMS opus. Jun 8, 2007 Once it's up there, regular visitors to Mar 1, 2009 your MobileMe Boston Trip Gallery can watch the show from the comfort of their Choose files to upload to "Boston Trip" own Web browsers. Supported formats include JPEG, GIF, PNG and MOV. Learn more. Maximum allowed file size is 1 GB Close window when complete Cancel Choose...

iDVD Slideshows

et's face it. Most of the methods iPhoto gives you to show off your prize photos are geek techniques like sending them by email, posting them on a Web page, turning them into a desktop picture, and so on. All these methods involve making your audience sit, hunched and uncomfortable, around a *computer* screen.

Now imagine seating them instead in front of the big-screen TV in the family room, turning down the lights, cranking up the surround sound, and grabbing the DVD remote to show off the latest family photos.

You can do it. Thanks to iDVD (part of the iLife package), you can create DVD-based slideshows from your photo collection, complete with soundtracks and navigational menus and screens just like the DVDs you rent from Blockbuster.

This chapter covers the basics of how to bring your photos from iPhoto to iDVD and how to customize, preview, and burn your slideshows once you've exported them to iDVD.

The iDVD Slideshow

You don't actually need iPhoto to create a slideshow in iDVD. By itself, iDVD has all the tools you need to create interactive DVDs that include movies and soundtracks as well as slideshows.

But using iPhoto can save you a lot of time and trouble. You can use iPhoto to preview, edit, and organize all your photos into albums. Then, once your photos are arranged into neatly organized albums, one click hands them off to iDVD, which converts them into a DVD-readable format. iDVD also hooks up all the navigational links and menus needed to present the show.

Creating an iDVD Slideshow

Creating a DVD of your own photos entails choosing the photos that you've organized in iPhoto, selecting a theme, building menus, and configuring the settings that determine how your slideshow will look and operate. Finally, you can preview the entire DVD (without actually burning a disc) to test the navigation, pacing, and other settings. When the whole thing looks right, you burn the final disc.

You can begin in either of two ways: from iPhoto or from iDVD. The following pages walk you through both methods.

Starting in iPhoto

By beginning your odyssey in iPhoto, you can save a few steps.

1. Select the photos you want to turn into a slideshow.

You can select a freely chosen batch of individual photos (see the selection tricks on page 48) or you can click almost anything in the Source list—like an album, smart album, the Last 12 Months icon, or whatever.

If you select a slideshow icon, you'll commit the entire slideshow, complete with transition effects and music (Chapter 6), to DVD. (Once it's in iDVD, you won't be able to make changes to the slides or music.)

You can even select multiple albums in the Source list at once. If you want to include an entire Event in the slideshow, click Events and then click the Event thumbnail. Either way, you can't have more than 99 photos in a slideshow.

Tip: Remember that if your photos aren't in the same aspect ratio as the screen they'll be viewed on, then they'll wind up flanked by black bars.

Figure 11-1:

If you don't see an iDVD button at the bottom of the iPhoto window, you can trigger the command by choosing Send to iDVD from the Share menu.

Or, if you'd rather install an iDVD button at the bottom of the window for quicker access, choose View→Show in Toolbar→Send to iDVD.

2. Choose Share→Send to iDVD (Figure 11-1).

This is the big hand-off. iDVD opens up a default presentation window (see Figure 11-2). See how the names of your selected albums are already listed as menu items that can be "clicked" with the DVD's remote control?

Figure 11-2:
The name of each exported album appears on the main menu page. Click a name once to select it, and (after a pause) click again to edit it. Double-click a menu title to open a window where you can view the included pictures

Read on to learn how to change the menu screen's design scheme.

and change their

order.

Technically, at this point, your slideshow is ready to meet its public. If you're looking for some instant gratification, click the ▶ button at the bottom of the window to flip iDVD into Preview mode. Then click the name of your album as it appears on the DVD menu page to begin the show. Use the iDVD remote control shown in Figure 11-7 to stop, pause, or rewind the show in progress.

To really make the finished show your own, though, you'll want to spend a few minutes adding some custom touches. See "Customizing the Show" on page 286.

Starting in iDVD

You can also begin building the show right in iDVD. To see how, click the Media button, and at the top of the panel, click Photos (see Figure 11-3). You now see a tiny iPhoto window, right there in iDVD, complete with thumbnails of your photos (and movie clips), your Source list, and even a Search box.

Each album you drag out of the list and onto the main iDVD stage area becomes another menu name that your audience will be able to click with their remotes. (If the album won't "stick" and bounces back to the Source list, it's because either that album or that menu screen is too full. iDVD doesn't like albums that hold more than 99 photos, or menu screens with more than 12 buttons.)

Tip: You can also drag photos, or folders full of them, right off your Finder desktop and onto the main menu screen to install them there as slideshows.

Figure 11-3:

Look familiar? Yep, it's your Source list from iPhoto.

All the hard work you've done in iPhoto orienting your photos and organizing them into albums pays off now, when you're designing your DVD. You can even use the search box at the bottom to find photos by name or comments.

Even your iPhoto movie clips appear here. That's handy, because you can use movie clips in iDVD in so many ways—as filler for a drop zone (page 287), as a menu background, or as even as a standalone movie on the DVD.

If you've selected some music to accompany the slideshow of that album in iPhoto, then iDVD remembers, and plays it automatically when you play the DVD slideshow.

To assign different music, double-click the name of your slideshow to reveal the Slideshow Editor window shown in Figure 11-4. Click Audio at the top of the Media pane and survey your iTunes collection. When you find a song or playlist that seems right, drag its name onto the little square Audio well, also shown in Figure 11-4. (Click the Return button to return to the menu-design page.)

Customizing the Show

iDVD provides an impressive number of options for customizing the look, feel, and sound of the slideshow you create, including its overall design scheme. Here's how to add a personal touch:

1. Choose a Theme.

Click the Themes button at the bottom of the iDVD window to reveal the list of ready-to-use visual themes that you can apply to your slideshow. Click a theme to apply it to your DVD's main-menu screen.

Figure 11-4: In the Media pane, click Audio. You see your entire list of iTunes music—in fact, you

even see your playlists here.

To avoid the musicending-too-soon syndrome, you can drag an entire playlist into the little Audio well beneath the slide display. Your DVD will play one song after another according to the playlist.

2. Add your own background graphics, if you like.

You can drag a photo into any theme's background. (Click Media, then Photos, and then drag a picture's thumbnail directly onto any blank area of the main menu screen.) Some let you drop a photo into more interesting, animated *regions* of the background called *drop zones*, as described in Figure 11-5.

3. Add, remove, and reorder your pictures.

When you bring albums into iDVD directly from iPhoto, your photos arrive in the same sequence as they appeared within their iPhoto albums. Once you're in iDVD, however, you can change the order of these photos, remove them from the show, or add others.

Tip: In iDVD '09, movies can be part of your slideshows, too. Drag them right into your slideshow among the photos; during playback, they play in sequence.

To edit a slideshow in this way, double-click its title on the DVD menu page ("Dog Pictures" in Figure 11-5, for example).

Figure 11-5:
In this animated mainmenu screen (the default theme, called Revolution), the words of the title and the photos on the cylinder are animated; they rotate.

As for the photos on the cylinder: They're "drop zones," which are areas that you can fill with photos or movies of your choosing. Click the Media button, click Photos or Movies, and drag the pictures or movies you want directly into the drop zones.

And if they're moving too fast, click the third round button below the center of the screen. That's the Drop Zone button, showing individual icons for each drop zone.

The slideshow editing window shown in Figure 11-6 appears. In this window, you can also set up other options, like switching between automatic and manual advancing of photos, selecting a different soundtrack, and adding navigation buttons to a slideshow.

You can rearrange the slides by dragging them (the other slides scoot aside to make room), delete selected slides by pressing the Delete key, or add more pictures by dragging new photos from the Media pane or the Finder.

Then, of course, there are the controls at the bottom of the window. They offer a great deal of control over the show. For example:

Slide Duration lets you specify how much time each slide spends on the screen before the next one appears: 1, 3, 5, or 10 seconds, or Manual. Manual means that your audience will have to press the Next button on the remote control to change pictures.

Then there's the Fit to Audio option, which appears in the pop-up menu only after you've added a sound file to your slideshow. In this case, iDVD determines the

timing of your slides automatically—by dividing the length of the soundtrack by the number of slides in your show. For example, if the song is 60 seconds long and the show has 20 slides, each slide will sit on the screen for 3 seconds.

Transition lets you specify any of several graceful transition effects—Dissolve, Cube, and so on—to govern how one slide morphs into the next. Whatever transition you specify here affects all slides in the show.

Slideshow volume, of course, governs the overall audio level.

Five more controls pop up when you click the Settings icon:

Loop slideshow makes the slideshow repeat endlessly.

Display navigation arrows adds Previous and Next navigation arrows to the screen as your slideshow plays. Your audience can click these buttons with their remote controls to move back and forth in your slideshow.

The arrows aren't technically necessary, of course. If you set your slides to advance automatically, you won't need navigation arrows. And even if you set up the slideshow for manual advance, your audience can always press the arrow buttons on their DVD remote to advance the slides. But if you think they need a visual crutch, this option is here.

Figure 11-6:

Changing the sequence of slides involves little more than dragging them around on this "light table." As in iPhoto, you can select multiple slides at once and then drag them en masse.

Don't miss the tiny icon at the top-right corner of the window. It switches to a list view that still lets you drag photos up or down to rearrange them.

Click Return to go back to your main-menu design screen.

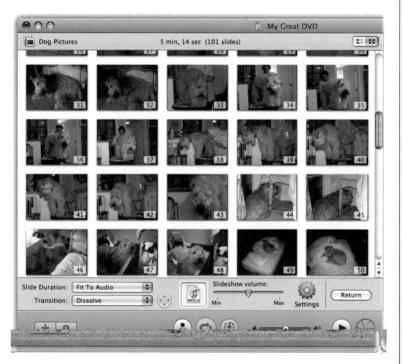

Add image files to DVD-ROM is an interesting one. When iDVD creates a slideshow, it scales all of your photos to 640×480 pixels. That's ideal for a standard television screen, which can't display any resolution higher than that.

But if you intend to distribute your DVD to somebody who's computer savvy, you may want to give them the original, full-resolution photos. They won't see these photos when they insert the disc into a DVD player. But when they insert your DVD into their computers, they'll see a folder filled with the original, high-res photos, suitable for printing, using as Desktop wallpaper, paying you for, and so on. (You've created a disc that's both a DVD-video disc and a DVD-ROM.)

Show titles and comments means that any text you've added to your photos in iPhoto (their names or descriptions) will also appear on the screen during DVD playback. You can edit them right in iDVD.

Duck audio while playing movies lets music in a video clip override the DVD's own soundtrack.

4. Add more slideshows, if you like.

If you're making a "Family Photos 2009" DVD, for instance, you might create a separate slideshow called Holidays. To do that, click the + button in the main iDVD window; from the pop-up menu, choose Add Slideshow. Double-click it to open your secondary, empty menu page. Then drag albums onto it from the mini-iPhoto browser shown in Figure 11-3.

At any time, you can return to the main menu by clicking the Return button. Don't forget to rename the My Folder menu button to say, for example, "More Pix."

Previewing the DVD

Your last step before burning a disc is to test your DVD presentation to check navigation, timing, photo sequences, and so on.

Figure 11-7

When you put iDVD in Preview mode (by clicking the Preview button) a small remote control panel appears next to the main window. It works just like your real DVD player's remote control. You can pause, rewind, or fast-forward slideshows. Clicking the Menu button takes you out of a slideshow and back

1. Click the ▶ button.

iDVD switches into Preview mode, which simulates how your disc will behave when inserted into a DVD player. This is a great chance to put your DVDin-waiting through its paces before wasting an expensive blank disc.

- 2. Use the iDVD remote control to click your menu buttons, stop, pause, or rewind the show in progress (Figure 11-7).
- 3. Click the Exit button on the "remote" when you're finished.

When everything in the DVD looks good, you're ready to master your disc. Insert a blank disc in your SuperDrive and then click the Burn button (just to the right of the Volume slider).

Extra Credit: Self-Playing Slideshows

As you work on your DVD menu structure, iDVD builds a handy map behind the scenes. You can use it to add or delete DVD elements, and you can doubleclick one of the icons to open the corresponding menu, movie, or slideshow.

To view the map, just click the Map button at the bottom of the main iDVD window (Figure 11-8). The element you were working on appears with colored highlighting. (Click the Map button again to return to the menu screen you were working on.)

But the map is more than just a pretty navigational aid. It also makes possible a selfplaying slideshow, one that plays automatically when the DVD is inserted, before your viewers even touch their remote controls.

Figure 11-8: The Map view is most

useful when you're creatina a complex DVD with nested menu screens, like one you might rent from Blockbuster.

But for slideshow purposes, its most useful feature is the AutoPlay icon. Any pictures or albums you drag onto this tile begin to play automatically when you insert the DVD into a DVD player-no remote-control fussing required.

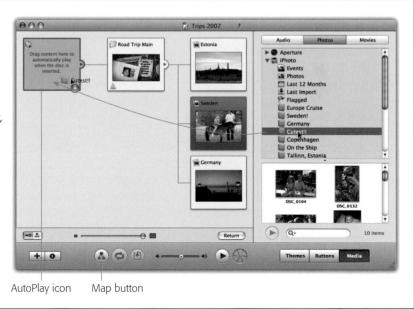

Extra Credit: Self-Playing Slideshows Once you've got the Photos list open in the Media pane, as shown in Figure 11-8, you can also drag an entire iPhoto album onto the AutoPlay icon. Alternatively, in the Customize panel, you can click and **%**-click just the photos you want, and then drag them en masse onto the AutoPlay icon. In fact, you can even drag photos—as a group or in a folder—right out of the Finder and onto this icon.

To control how long your still image remains on the screen, or how quickly your autoplay slideshow plays, double-click the AutoPlay tile. You arrive at the slideshow editor shown in Figure 11-6, where you can adjust the timing, transition, and even the audio that plays behind the pictures.

If you decide to replace your autoplay material, just drag new stuff right onto it. Or, to eliminate the autoplay segment, drag it right off the AutoPlay tile. It disappears in a little puff of Mac OS X cartoon smoke.

You can design a project that way for the benefit of, for example, technophobic DVD novices whose pupils dilate just contemplating using a remote control. They can just insert your autoplay-only DVD and sit back on the couch as the pictures flash by automatically.

It's even possible to create a DVD that consists *only* of autoplay material, a slideshow that repeats endlessly during, say, your cocktail reception—no menu screen ever appears. Just highlight the autoplay tile and then choose Advanced→Loop Slideshow. You've got yourself a self-running, self-repeating slideshow of digital photos that plays on a TV at a party or wedding reception. The DVD will loop endlessly—or at least until it occurs to someone in your audience to press the Menu or Title button on the remote. The Menu button redisplays the previous menu screen; the Title button causes a return to the main menu.

Part Three: iPhoto Stunts

Chapter 12: Screen Savers, AppleScript, and Automator

Chapter 13: iPhoto File Management

Screen Savers, AppleScript, and Automator

You've assembled libraries of digital images, sent heart-touching moments to friends and family via email, published your recent vacation on the Web, authored a QuickTime movie or two, and even boosted the stock price of Canon and Epson single-handedly through your consumption of inkjet printer cartridges. What more could there be?

Plenty. This chapter covers iPhoto's final repertoire of photo stunts, like turning your photos into one of the best screen savers that's ever floated across a computer display, plastering one particularly delicious shot across your desktop, calling upon AppleScript to automate photo-related chores for you, and harnessing iPhoto's partnership with Automator. (This chapter's alternate title: "Miscellaneous iPhoto Stunts that Didn't Really Fit the Outline.")

Building a Custom Screen Saver

Mac OS X's screen saver feature is so good, it's pushed more than one Windows person over the edge into making the switch to Mac OS X. When this screen saver kicks in (after several minutes of inactivity on your part), your Mac's screen becomes a personal movie theater. The effect is something like a slideshow, except that the pictures don't simply appear one after another and sit there on the screen. Instead, they're much more animated. They slide gently across the screen, zooming in or zooming out, smoothly dissolving from one to the next.

Mac OS X comes equipped with a few photo collections that look great with this treatment: forests, space shots, and so on. But let the rabble use those canned screen savers. You, a digital master, can use your own photos as screen saver material.

Building a Custom Screen Saver

Meet the Screen Saver

When you're ready to turn one of your own photo collections into a screen saver, fire up iPhoto. Collect the photos in an album, if they're not in one already (Chapter 2).

Open the System Preferences icon in the Mac's Dock, and then click the Desktop & Screen Saver panel (shown in Figure 12-1). Set up your screen saver options as described in the box on the next page, and then close System Preferences.

Tip: Horizontal shots fill your monitor better than vertical ones—the verticals have fat black bars on either side to fill the empty space.

If your camera captures images at a 3:2 width-to-height ratio instead of 4:3, or if you have an Apple widescreen monitor (like the 15-inch PowerBook screen or the 17-inch iMac screen), there's one more step. You might want to crop the photos, or copies of them, accordingly to maximize their impact.

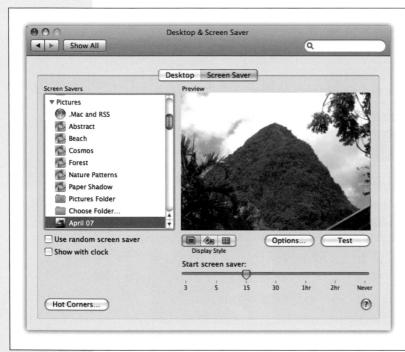

Figure 12-1:
In Mac OS X 10.3 and later, all of your iPhoto albums are listed in the Screen Saver panel of the Desktop & Screen Saver preferences window.
Just pick the one you want to use as a screen saver, or click iPhoto Selection (in the upper part of the list) to "play" whatever pictures you've selected in iPhoto. Mac OS X turns your photos into a smooth, full-screen slideshow.

Ready to view the splendor of your very own homemade screen saver? If you have the patience of a Zen master, you can now sit there, motionless, staring at your Mac for the next half an hour or so—or as long as it takes for Mac OS X to conclude that you're no longer working and finally begin displaying your images on the screen.

Or you can just click the Test button to see the effect right now.

Tip: Your screen saver slideshows look best if your pictures are at least the same resolution as your Mac's monitor. (In most cases, if your digital camera has a resolution of 1 megapixel or better, you're all set.)

If you're not sure what your screen resolution is, go to System Preferences and click the Displays icon (or just consult the Displays mini-menu next to your menu bar clock, if it appears there).

One-Click Desktop Backdrop

iPhoto's desktop-image feature is the best way to drive home the point that photos of your children (or dog, or mother, or self) are the most beautiful in the world.

UP TO SPEED

Screen Saver Basics

You don't technically need a screen saver to protect your monitor from burn-in. Today's flat-panel screens never burn in, and even the latest CRT monitors wouldn't burn an image into the screen unless you left them on continuously for two years.

No, screen savers are about entertainment, pure and simple.

In Mac OS X, when you click a module's name in the screen saver list, you see a mini version of it playing back in the Preview screen.

You can control when your screen saver takes over your monitor. For example, the "Start screen saver" slider lets you specify when the screen saver kicks in (after what period of keyboard or mouse inactivity).

When you click the Hot Corners button, you're presented with a pane than lets you turn each corner of your monitor into a hot spot. Whenever you roll your cursor into that corner, the screen saver either turns on instantly (great when you happen to be shopping on eBay at the moment your boss walks by) or stays off permanently (for when you're reading onscreen or watching a movie). If you

use Mac OS X 10.3 or later, you can use two corners for controlling the screen saver and the other two to activate Exposé (Mac OS X's window-hiding feature).

In any case, pressing any key or clicking the mouse always removes the screen saver from your screen and takes you back to whatever you were doing.

The Options button reveals the additional settings illustrated here, some of which are very useful. Turn off "Crop slides to fit on screen," for example, if you want the Mac to show each photo, edge to edge (even if it has to use black bars to fill the rest of your monitor); otherwise, it enlarges each photo to fill the screen, often lopping off body parts in the process. (If "Crop slides" is on, then you can also turn

on "Keep slides centered" to prevent the Mac from panning across each photo.)

And turning off "Zoom back and forth," of course, eliminates the majestic, cinematic zooming in and out of successive photos that makes the screen saver look so darned cool.

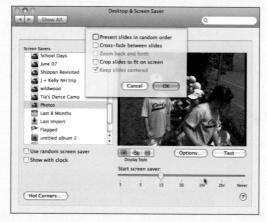

One-Click Desktop Backdrop

You pick one spectacular shot to replace the standard Mac OS X swirling blue desktop pattern or outer-space photo. It's like refrigerator art on steroids.

Creating wallpaper in iPhoto is so easy that you could change the picture every day—and you may well want to. In iPhoto, click a thumbnail, and then click the Set Desktop button on the bottom panel (or choose Share—Set Desktop). Even though the iPhoto window is probably filling your screen, the change happens instantly behind it. Your desktop is now filled with the picture you chose.

Note: If you choose *several* thumbnails or an album, iPhoto assumes that you intend to make Mac OS X *rotate* among your selected photos, displaying a new one every few minutes on your desktop throughout the day. To confirm its understanding, Mac OS X opens up the relevant panel of System Preferences, so that you can click the Desktop tab and specify *how often* you want the photos to change.

Just three words of advice. First, choose a picture that's at least as big as your screen $(1024 \times 768 \text{ pixels}, \text{for example})$. Otherwise, Mac OS X will stretch it to fit, distorting the photo in the process. If you're *really* fussy, you can even crop the photo first to the exact measurements of the screen; in fact, the first command in iPhoto's Constrain pop-up menu (page 121) lists the exact dimensions of your screen, so you can crop the designated photo (or a copy of it) to fit precisely.

Second, horizontal shots work much better than vertical ones; iPhoto blows up vertical shots to fit the width of the screen, potentially chopping off the heads and feet of your loved ones.

Finally, if a photo doesn't precisely match the screen's proportions, note the pop-up menu shown at the top of Figure 12-2. It lets you specify how you want the discrepancy handled. These are your choices:

- Fill screen. This option enlarges or reduces the image so that it fills every inch of the desktop. If the image is small, the low-resolution stretching can look awful. Conversely, if the image is large and its dimensions don't precisely match your screen's, parts get chopped off. At least this option never distorts the picture, as the "Stretch" option does (below).
- Stretch to fill screen. Use this option at your peril, since it makes your picture fit the screen exactly, come hell or high water. Unfortunately, larger pictures may be squished vertically or horizontally as necessary, and small pictures are drastically blown up and squished, usually with grisly results.
- Center. This command centers the photo neatly on the screen. If the picture is larger than the screen, you see only the middle; the edges of the picture are chopped off as they extend beyond your screen.

But if the picture is smaller than the screen, it won't fill the entire background; instead it just sits right smack in the center of the monitor at actual size. Of course, this leaves a swath of empty border all the way around your screen. As a remedy, Apple provides a color-swatch button next to the pop-up menu. When you click

One-Click Desktop Backdrop

it, the Color Picker appears so that you can specify the color in which to frame your little picture.

• Tile. This option makes your picture repeat over and over until the multiple images fill the entire monitor. (If your picture is larger than the screen, no such tiling takes place. You see only the top center chunk of the image.)

And one last thing: If public outcry demands that you return your desktop to one of the standard system backdrops, open System Preferences, and then click the Desktop & Screen Saver icon. There, click the Desktop button if necessary, choose Apple Backgrounds or Solid Colors in the list box at the left of the window, and then take your pick.

Figure 12-2:
If your photo doesn't fit the

If your photo doesn't fit the screen perfectly, choose a different option from the pop-up menu in the Desktop & Screen Saver preference panel.

While you're in the Desktop & Screen Saver or Screen Effects preferences pane, you might notice that all of your iPhoto albums are listed below the collection of images that came with your Mac. You can navigate through those albums to find a new desktop image. This approach isn't as fast (or fun) as picking pictures in iPhoto, but if for some reason iPhoto isn't open on your Mac (heaven forbid!), you can take care of business right there in System Preferences.

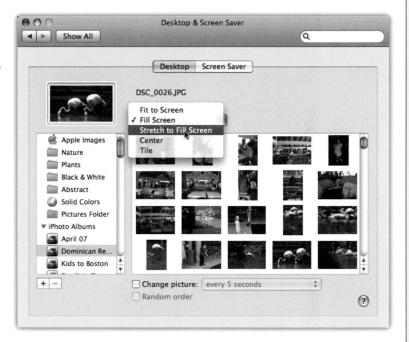

Exporting and Converting Pictures

The whole point of iPhoto is to provide a centralized location for every photo in your world. That doesn't mean that they're locked there, however; it's as easy to take pictures out of iPhoto as it is to put them in. Spinning out a photo from iPhoto can be useful in situations like these:

 You're creating a Web page outside of iPhoto and you need a photo in a certain size and format.

Exporting and Converting Pictures

- You shot a bunch of 10-megapixel photos, but you're running out of disk space, and you wish they were all 6-megapixel shots instead. (They'd still have plenty of resolution, but not so much wasted space.)
- You're going to submit some photos to a newspaper or magazine, and the publication requires TIFF-format photos, not iPhoto's standard JPEG format.
- Somebody else on your network loves one of your pictures and would like to use it as a desktop background on *that* machine.
- You want to set free a few of the photos so that you can copy them *back* onto the camera's memory card. (Some people use their digicams as much for *showing* pictures to their friends as for *taking* them.)
- You want to send a batch of pictures on a CD or DVD to someone.

Exporting by Dragging

It's amazingly easy to export photos from iPhoto: Just drag their thumbnails out of the photo viewing area and onto the desktop (or onto a folder, or into a window on the desktop), as shown in Figure 12-3. After a moment, their icons appear.

The drag-and-drop method has enormous virtue in its simplicity and speed. It does not, however, grant you much flexibility. It produces JPEG files only, at the original camera resolution, with the camera's own cryptic naming scheme.

Figure 12-3:
The drag-and-drop technique produces full-size
JPEG graphics, exactly as they appear in iPhoto.
Their names, however, are not particularly userfriendly. Instead of "Lasso Towel," as you named it
in iPhoto, a picture might wind up on the desktop
named 200205040035140.jpg or IMG_5197.jpg.

Exporting and Converting Pictures

Exporting by Dialog Box

To gain control over the dimensions, names, and file formats of the exported graphics, use the Export command. After selecting one picture, a group of pictures, or an album, you can invoke this command by choosing File→Export (Shift-ૠ-E).

The greatly enhanced Export Photos dialog box appears, as shown in Figure 12-4. Click the File Export tab, if necessary, and then make the following decisions:

Figure 12-4:

The Export Photos dialog box gives you control over the file format, names, and dimensions of the pictures you're about to send off from iPhoto. You can also include the photo's map coordinates by turning on the Location Information box.

The number of photos you're about to export appears in the lower-left corner of the box.

You can even tell iPhoto to use whatever names you gave your pictures, instead of the original, incomprehensible file names bestowed by your camera. To do so, choose "Use title" from the File Name pop-up menu.

And don't miss the Custom option in the Size pop-up menu. For the first time, iPhoto lets you export scaled-down versions of your photos, de-megapixeling them for email, Web pages, desktop pictures, folder-window pictures, and so on.

File format

You can use the Format pop-up menu to specify the file format of the graphics that you're about to export. Here are your options:

• Original. iPhoto exports the images in whatever format they were in when you imported them. If the picture came from a digital camera, for example, it's usually a JPEG.

If your camera captured a RAW photo (page 23), though, the Original option is even more valuable. It lets you export the original RAW file so that you can, for example, work with your RAWs in a more sophisticated editor like Adobe's Camera Raw, which comes with Photoshop. (The original file doesn't contain any edits you've made to that photo, however.)

• JPEG. This abbreviation stands for Joint Photographic Experts Group (that's the group of geeks who came up with this format). The JPEG format is, of course,

Exporting and Converting Pictures

the most popular format for photos on the Internet (and in iPhoto), thanks to its high image quality and small file size.

Note: If you choose JPEG, you can also use the JPEG Quality pop-up menu to specify a quality level (High, Medium, and so on), with the understanding that the files get bigger as the quality does.

- TIFF. These files (whose abbreviation is short for Tagged Image File Format) are something like JPEG without the "lossy" compression. That is, they maintain every bit of quality available in the original photograph, but usually take up much more disk space (or memory-card space) as a result. TIFF is a good choice if quality is more important than portability.
- PNG. This relatively new format (Portable Network Graphics) was designed to replace the GIF format on the Web. (The company that came up with the algorithms behind the GIF format exercised its legal muscle…long story.)

Whereas GIF graphics generally don't make good photos because they're limited to 256 colors, PNG is a good choice for photos (except the variation called *PNG-8*, which is just as limited as GIF). The resulting files are smaller than TIFF images, yet don't exhibit any compression-related quality loss, à la JPEGs. Not all graphics programs and Web browsers recognize this relatively new format, but the big ones—including iPhoto, GraphicConverter, Photoshop, and most recent browser versions—all do.

Titles and Keywords

iPhoto maintains two names for each photo: its *original file name*, as it appears in the Finder, and its *iPhoto title*, the one you may have typed in while working in the program.

If you turn on the "Title and keywords" box, then each exported file has the name you gave it in iPhoto. It also has, stored invisibly, any keywords you assigned to it (page 83). That's a big deal, because it means that (a) you'll be able to find it on your Mac with a Spotlight search, and (b) if you import it into another iPhoto library, it remembers the keywords you gave it.

Size options

Remember that although digital camera graphics files may not always have enough resolution for prints, they generally have far *too much* resolution for displaying on the screen.

Using these controls, you can depixelize your photos, shrinking them down to something more manageable.

Your choices are Low (320×240 pixels, suitable for emailing or Web pages visited by dial-up victims); Medium (640×480 , good for email or Web sites again); Large (1280×960 , nice for slideshows); Full Size (whatever the photo is now, best for printing); and Custom.

Exporting and Converting Pictures

If you choose Custom, you get the curious new controls shown in Figure 12-4, where a Max pop-up menu lets you specify the maximum pixel measurement for each photo's height, width, or both.

Why didn't Apple just offer you Height and Width boxes? Because the exported photos might have all different proportions, so saying, "Export these at 800×600 " wouldn't always make sense. This way, you're specifying the *maximum* dimensions on one side or both.

File Name

From this pop-up menu, specify how you want the exported files to be named:

- Use title. The exported files are named whatever you named them within iPhoto.
- Use filename. The exported files bear their original, underlying names given to them by your camera, like DSC_0192.jpg or IMG_4821.JPG.
- Sequential. The files will be named Bad Hair Day 1, Bad Hair Day 2, and so on. (In the "Prefix for sequential" box, type *Bad Hair Day* or whatever you like.)
- Album name with number. This option tells iPhoto to name your exported photos according to their album name—and sequence within that album. If an exported photo is the fourth picture in the first row of an album titled Dry Creek, iPhoto will call the exported file "Dry Creek–04.jpg." Because *you* determine the order within an album (by dragging), this is the only option that lets you control the numbering of the exported result.

Plug-Ins and Add-Ons

On one thing, friends and foes of Apple can all agree: iPhoto is no Photoshop. iPhoto was deliberately designed to be simple and streamlined.

Yet Apple thoughtfully left the back door open. Other programmers are free to write add-ons and plug-ins—software modules that contribute additional features, lend new flexibility, and goose up the power of iPhoto.

And yet, with great power comes great complexity—in this case, power and complexity that Apple chose to omit. But at least this plug-in arrangement means that nobody can blame *Apple* for junking up iPhoto with extra features. After all, *you're* the one who installed them.

A couple of the most important plug-ins and accessory programs are described in the relevant chapters of this book:

- **BetterHTMLExport** is designed to lend flexibility to the Web pages that iPhoto generates. (See page 219.)
- Portraits & Prints vastly expands iPhoto's printing features. It lets you create a multiple-photo layout on a single sheet of paper for printing. (See page 182.)

Plug-Ins and Add-Ons As the popularity of iPhoto grows, new add-ons and plug-ins will surely sprout up like roses in your macro lens. It's worthwhile to visit the Version Tracker Web site from time to time (*www.versiontracker.com/macosx*). Search for *iPhoto*; you'll be surprised at the number of goodies just waiting for you to try.

AppleScript Tricks

AppleScript is the famous Macintosh *scripting language*—a software robot that you can program to perform certain repetitive or tedious tasks for you.

iPhoto '09 is fully *scriptable*, meaning that AppleScript gurus can manipulate it by remote control with AppleScripts that they create. (It even works with Automator, the program in Mac OS X 10.4 and later that makes programming even easier than using AppleScript. See the following section.)

But even if you're not an AppleScript programmer yourself, this is still good news, because you're perfectly welcome to exploit the ready-made, prewritten AppleScripts that other people come up with.

For years, Apple paved the way for all kinds of AppleScript fun with its AppleScripts for iPhoto—a free suite of AppleScripts that automated a whole bunch of useful iPhoto tasks. They're gone now, unfortunately; as 2009 dawned, these scripts vanished completely from the Web. You can Google till you're blue in the face, and there's not a single copy left.

Other people have created cool scripts, though—people known simply as Brian or Joe, for example. You can find them by Googling *iPhoto AppleScripts*.

Automator Tricks

If you use your Mac long enough, you're bound to start repeating certain jobs over and over again. Automator is a program that lets you teach your Mac what to do, step by step, by assembling a series of visual building blocks called actions. Drag actions into the right order, click a big Run button, and your Mac faithfully runs each action one at a time.

As it turns out, Automator works great with iPhoto. By following "recipes" that you find online—or the sample described here—you can add all kinds of new, timesaving features to iPhoto and your Mac.

The Lay of the Land

To open Automator, visit your Applications folder. Open Automator, choose Photos & Images, and you'll see something like Figure 12-5, starring these key elements:

Library list

The Library list shows you every program on your Mac that can be controlled by Automator actions: iPhoto, Safari, TextEdit, iTunes, and so on. When you select a program, the Action list shows you every action (command) that the chosen program

understands. When you find an action you want to use in your workflow, you drag it to the right into the large Workflow pane to begin building your software robot.

Figure 12-5: 000 Untitled To write an Automator 属 () () program (workflow), click the function you Actions Variables Q Name want (in the far left 🔻 💃 Get Specified Finder Items W Library Change Type of Images column). Then, locate Calendar Create Thumbnail Images a specific action (in Contacts Crop Images the second column). × Developer Download Pictures Files & Folders Filter iPhoto Items Finally, double-click M. Fonts Find iPhoto Items that action's name, or (Internet Flip Images drag it, to place it into Mail Mail Get Selected iPhoto Items (Add...) (Remove) the far-right column. Movies Get Specified iPhoto Items Music M Import Files into iPhoto Results Options Description New iPhoto Album PDFs Photos X New PDF Contact Sheet Import Files into iPhoto 0 Text New QuickTime Slideshow Fresh Scans Magnet Files into iPhoto M Delete the Source Images After Importing Them Results Options Description This action imports files into an iPhoto alhum **☆**- ▼ -111 ===

Action list

This list shows you the contents of whatever categories you've selected in the Library list. (The category names were rewritten in Mac OS X 10.5.) If, for example, you selected Photos in the Library list, the Action list would show you all the Safari actions available on your Mac. To build your own workflow, you have to drag actions *from* the Action list and into the Workflow pane. (Double-clicking an action does the same thing as dragging it.)

Workflow pane

The Workflow pane is Automator's kitchen. It's where you put your actions in whatever order you want, set any action-specific preferences, and fry them all up in a pan.

But the Workflow pane is also where you see how the information from one action gets piped into another, creating a stream of information. That's how the Workflow pane differentiates Automator from the dozens of nonvisual, programming-based automation tools out there.

When you drag an action out of the Action list and into the Workflow pane, any surrounding actions scoot aside to make room for it. When you let go of the mouse, the action you dragged materializes right there in the Workflow pane.

Tip: If you select an action in the Action list and press Return, Automator automatically inserts that action at the bottom of the Workflow pane.

Automating iPhoto

To help you get started, here's a very short workflow (automated software sequence) that you can construct in minutes (or download, already completed, from www. missingmanuals.com). It adds a handy menu command to your Mac, which lets you access your iPhoto photos from within any Mac program, without having to fire up iPhoto first.

Here's how to build this workflow yourself.

1. Open Automator.

It's in your Applications folder. In the Mac OS X 10.5 version, click Custom, and then click the Choose button in the starting-points screen.

2. In the Library column, click Photos.

The Action column now displays the commands that Automator can issue to the Finder (Figure 12-5).

3. In the Action column, double-click "Ask for Photos."

It appears in the rightmost column as step 1. You've just told Automator, "Open the Mac OS X Media Browser." Your work is done. (This isn't an especially complicated script.)

Now you have to put this command somewhere accessible.

4. Choose File→Save As Plug-In. From the "Plug-in for" popup menu, choose Script Menu. Name your new workflow (something like *Dave's Photo Browser*), and then click Save.

GEM IN THE ROUGH

The Scanner/Cellphone Auto-Import Workflow

Here's another handy Automator example that's especially useful if you have a scanner or a cameraphone. (Unless you have an iPhone, which shows up in iPhoto like a camera.)

In a new, empty Automator document (see step 1 above), click Files & Folders in the Library. Then double-click "Get Specified Finder Items" in the Actions list, which sends it over into the workflow pane.

Now, in the Photos category, find the action called "Import Files into iPhoto," and double-click that one to make it appear below the first step. Use the pop-up menus to specify which iPhoto album you want your scanned or cameraphone pictures to wind up in. Finally, turn on "Delete the Source Images After Importing Them." (You can see all of this in Figure 12-5.)

Now choose File→Save As Plug-in. Type a name for your new command, like "Auto-Import to iPhoto," and from the "Plug-in for" pop-up menu, choose Folder Actions. From the Attached to Folder pop-up menu, choose the folder where your scans or cameraphone photos usually wind up in the Finder. Turn on Enable Folder Actions. Click Save.

From now on, every time a photo lands in whatever folder you've set up to receive your scanned or cellphone photos, it gets auto-imported into iPhoto—without any further effort by you.

Automator Tricks

The fruit of all this labor is a new command—that *you wrote*—called Dave's Photo Browser (or whatever) in your Script menu.

From now on, whenever you choose this new command, the standard Mac OS X media-browser dialog box appears (Figure 12-6). It offers full access to the photos and movies in your iPhoto library—and it makes them available in any program that can accept pasted graphics or movies. No longer must you sit there and wait while iPhoto opens up, just so you can grab one particular picture.

Figure 12-6:

Your completed Automator software robot appears in the Script menu.

When you choose its name, you get the standard Mac OS X media browser, as shown here—but it's not confined to programs like iMovie and Keynote, as it usually is. It's now available in any program. Like TextEdit, pictured here.

iPhoto File Management

Por years, true iPhoto fans experienced the heartache of iPhoto Overload—the syndrome in which the program gets too full of photos, winds up gasping for RAM, and acts as if you've slathered it with a thick coat of molasses. And for years, true iPhoto fans have adopted an array of countermeasures to keep the speed up, including splitting the Photo library into several smaller chunks.

Now that iPhoto can manage 250,000 pictures per library, such drastic measures aren't generally necessary.

Nonetheless, learning how iPhoto manages its library files is still a worthy pursuit. It's the key to swapping photo libraries, burning them to CD or DVD, transferring them to other machines, and merging them together.

About iPhoto Discs

iPhoto discs are CDs or DVDs that you can create in iPhoto to archive your entire library—or any selected portion of it—with just a few mouse clicks.

The beauty of iPhoto's Burn command is that it exports much more than just the photos themselves to a disc. It also copies the thumbnails, titles, keywords, comments, ratings, and all the other important data about your iPhoto library. Once you've burned all this valuable information to disc, you can do all sorts of useful things:

- Make a backup of your whole photo collection for safekeeping.
- Transfer specific photos, albums, or a whole iPhoto library to another Mac without losing your keywords, descriptions, ratings, and titles.

About iPhoto Discs

- Share discs with other iPhoto fans so that your friends and family can view your photo albums in their own copies of iPhoto.
- Offload photos to CD or DVD as your photo collection grows, to keep your current iPhoto library at a trim, manageable size.
- Merge separate libraries (such as the one on your laptop and the one on your iMac) into a single master iPhoto library.

Note: One thing an iPhoto disc is *not* good for is sharing your photos with somebody who doesn't have iPhoto! Page 313 has the details, but the bottom line is this: An iPhoto disc is designed *exclusively* for transferring pictures into another copy of iPhoto.

Burning an iPhoto CD or DVD

All you need to create an iPhoto disc is a Mac and a blank disc.

1. Select the photos that you want to include on the disc.

You can hand-select some photos (page 48), click a Source list icon (Event, album, book, or slideshow), or click the Photos icon to burn your whole photo collection.

In any case, the photo-viewing area should now be showing the photos you want to save onto a disc.

2. Choose Share→Burn.

A dialog box appears, prompting you to insert a blank disc. Pop in the disc; the dialog box vanishes after a few moments.

Note: If you plan to use this feature a lot, then install the Burn button onto the bottom edge of the iPhoto window by choosing View—Show in Toolbar—Burn.

3. Check the size of your selection to make sure it will fit.

Take a look at the Info panel at the bottom of the iPhoto window, as shown in Figure 13-1; the little graph shows you how much of the disc will be filled up. If the set of photos you want to burn is smaller than 650 or 700 megabytes (for a CD), 4.3 gigabytes (for a DVD), or 8 gigs (for a dual-layer DVD), then you're good to go. You can burn the whole thing to a single disc.

If your photo collection is larger than that, however, it's not going to fit. You'll have to split your backup operation across multiple discs. Select whatever number of photo albums or individual pictures *will* fit on a single disc, using the indicator shown in Figure 13-1 as your guide. (Also shown in the figure: the Name box, where you can name the disc you're about to burn.)

For example, you might decide to copy the 2007 folder onto one disk, the 2008 folder onto another, and so on, using the calendar feature (page 80) to round up your photos by year.

About iPhoto Discs

After burning one disc, select the next set of photos, and then burn another CD or DVD. Burn as many discs as needed to contain your entire collection of photos. If and when you ever need to restore your photos from the multiple discs, you'll be able to merge them back together into a single iPhoto library using the technique described in "Merging Photo Libraries" later in this chapter.

4. Click the Burn button.

As you can see in Figure 13-1, you'll either get a "not enough space" message or a "Burn Disc" message. If you get the latter, you're ready to proceed.

Figure 13-1:

Top: Once you've clicked Burn and inserted a blank disc, this Info panel lets you know how close you are to filling the disc. The indicator icon updates itself as you select or deselect photos and albums to show you how much free space is available on the disc.

Middle: If your photos take up more space than is available on the disc, the little disc icon turns red—and when you click Burn, you see the Disc Full message shown here.

Bottom: If all is well, however, you get this message instead. Click Burn and sit back to enjoy the fruits of your Mac's laser.

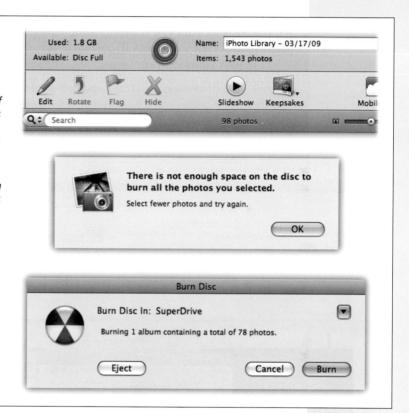

5. Click Burn.

First, iPhoto makes a *disk image*—a sort of pretend disc that serves as a temporary holding area for the photos that will be burned. Next, iPhoto copies the photos from your iPhoto Library to the disk image.

Finally, the real burning begins. When the process is done, your Mac spits out the finished CD or DVD, ready to use, bearing whatever name you gave it.

About iPhoto Discs

Tip: You can safely bail out of the disc-creating process at any time by clicking the Cancel button when the Progress dialog box first appears.

But don't click the Stop button once the Burning dialog box appears. At that point, your disk drive is already busy etching data onto the disc itself. Clicking Stop brings the burning to a screeching halt, leaving you with a partially burned, nonfunctioning disc.

What you get

The finished iPhoto disc contains not just your photos, but a clone of your iPhoto Library as well. In other words, this disc includes all the thumbnails, keywords, comments, ratings, photo album information—even the unedited original versions of your photos that iPhoto keeps secretly tucked away.

If you want to view the contents of your finished disc in iPhoto, pop it back into the drive. If iPhoto isn't running, your Mac opens it automatically.

Moments later, the icon for the CD or DVD appears in the Source list of the iPhoto window, as shown in Figure 13-2. If you click the disc's icon, the photos it contains appear in the photo-viewing area, just as if they were stored in your library.

You can't make changes to them, of course—that's the thing about CDs and DVDs. But you can copy them into your own albums, and make changes to the copies.

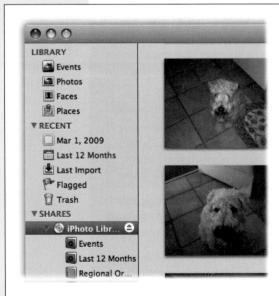

Figure 13-2:

Pop an iPhoto CD or DVD into your Mac and it appears right along with your albums in iPhoto. Click on the disc icon itself (as shown here) or one of the disc's album icons to display the photos it contains. In essence, iPhoto is giving you access to two different libraries at once—the active photo library on your Mac's hard drive and a second library on the disc.

When Not to Burn

The Burn command is convenient for creating quick backups, archiving portions of your library, or transferring photos to another Mac. But it's definitely *not* the best

way to share your photos with Windows folks, or even other Mac folks still clinging to Mac OS 9.

Think about it: Burning an iPhoto disc automatically organizes your photos into a series of numerically named subfolders inside an iPhoto Library, surrounded by scads of special data files like .attr files, Library.cache, and Dir.data. All of this makes perfect sense to iPhoto but is mostly meaningless to anyone—or, rather, any computer—that doesn't have iPhoto. A Windows person, for example, would have to dig through folder after folder on your iPhoto CD to find and open your photos.

So if the destination of your CD or DVD isn't another iPhoto nut, *don't* use the Burn command. Instead, export the photos using the File Export or Web Page options described in Chapter 8. The pictures won't have any ratings, comments, keywords, and so on, but they'll be organized in a way that's much easier for the non-iPhoto world to navigate.

iPhoto Backups

Bad things can happen to digital photos. They can be accidentally deleted with a slip of your pinkie. They can become mysteriously corrupted and subsequently unopenable. They can get mangled by a crashed hard drive and be lost forever. Losing one-of-a-kind family photos can be extremely painful—and in some documented cases, even marriage-threatening. So if you value your digital photos, you should back them up regularly, perhaps after each major batch of new photos joins your collection.

If you're using Mac OS X 10.5 and its Time Machine feature, then you can safely skip this section. You're already covered; your entire machine is constantly backed up (page 339).

If you have a MobileMe account and you're using its Backup program, you can use its canned iLife backup template to make sure that all your photos, movies, and music are backed up.

But you can also back up your stuff manually; read on.

Backing Up to CD or DVD

The most convenient do-it-yourself way to back up your iPhoto library is to archive it onto a blank CD or DVD using iPhoto's Burn command, as described on the previous pages. If anything bad ever happens to your photo collection, you'll be able to restore your library from the backup discs, with all your thumbnails, keywords, comments, and other tidbits intact.

To restore your photo collection from such a backup, see "Merging Photo Libraries" later in this chapter.

Backing Up Without a CD Burner

Even if, for some strange reason, you don't want to burn a disc (maybe your burner is dead, or you don't have the time to wait for the burning), backing up thousands of

iPhoto Backups

photos is still a simple task. After all, one of iPhoto's main jobs is to keep all your photos together in *one* place—one icon that's easy to copy to a backup disk of any kind.

That all-important icon is the *iPhoto Library*, which resides inside the Pictures folder of the Home folder that bears your name. If your user name (the short name you use to log into Mac OS X) is *Casey*, then the full path to your iPhoto Library file from your main hard drive window drive is Macintosh HD \rightarrow Users \rightarrow Casey \rightarrow Pictures \rightarrow iPhoto Library.

As described in Chapter 2, the iPhoto Library contains not just your photos, but also a huge assortment of additional elements:

- · All the thumbnail images in the iPhoto window
- The original, safety copies of photos you've edited in iPhoto
- Various data files that keep track of your iPhoto keywords, comments, ratings, and photo albums

To prepare for a disaster, you should back up *all* these components.

To perform a complete backup, copy the entire iPhoto Library icon to another location. Copying it to a different hard drive—to an iPod, say, or to the hard drive of another Mac via the network—is the best solution. (Copying it to another folder on the *same* disk means you'll lose both the original iPhoto Library and its backup if, say, your hard drive crashes or your computer is hit by an asteroid.)

Note: Of course, you can also back up your photos by dragging their thumbnails out of the iPhoto window and into a folder or disk on your desktop, once you've dragged the iPhoto window to one side.

Unfortunately, this method doesn't preserve your keywords, comments, album organization, or any other information you've created in iPhoto. If something bad happens to your iPhoto Library, then you'll have to import the raw photos again and reorganize them from scratch.

Managing Photo Libraries

iPhoto can comfortably manage around 250,000 photos in a single collection, give or take a few thousand, depending on your Mac model and how much memory it has.

But for some people, 250,000 pictures is a bit unwieldy. It makes them nervous to keep that many eggs in a single basket. They wish they could break up the library into several smaller, easier-to-manage, easier-to-back-up chunks.

If that's your situation, then you can archive some of the photos to CD or DVD using the Burn command described earlier, and then *delete* the archived photos from your library to shrink it down in size. For example, you might choose to archive older photos, or albums you rarely use.

Note: Remember, archiving photos to disc using the Burn command doesn't automatically remove them from iPhoto; you have to do that part yourself. If you don't, your library won't get any smaller. Just make sure that the CD or DVD you've burned works properly before deleting your original photos from iPhoto.

iPhoto Disk Images

The one disadvantage of that offload-to-disc technique is that it takes a big hunk of your photo collection *offline*, so that you can no longer get to it easily. If you suddenly need a set of photos that you've already archived, you have to hunt down the right disc before you can see the photos. That could be a problem if you happen to be on the road in New York and need the photos you left on a DVD in San Francisco.

Here's a brilliant solution to that disc-management problem: Turn your iPhoto discs into *disk image files* on your hard drive.

Open Disk Utility (which sits in your Applications—Utilities folder); then insert the iPhoto CD or DVD you've burned. In the left pane of the Disk Utility window, click the disc's icon. (Click the CD or DVD icon bearing a plain-English name, like "iPhoto Library"—usually it's the last one listed. Don't click the icon bearing your CD burner's name, like "PIONEER DVR-103.")

Then choose File—New—Disk Image From [Disc Name], or click the New Image button in the toolbar at the top of the window. In the Convert Image dialog box, you can type a name for the disk image you're about to create. (You can even password-protect it by choosing AES-128 from the Encryption pop-up menu.) Choose a location for the disk image, like your desktop, and then click Save.

You've just created a disk image file whose name ends with .dmg. It's a "virtual CD" that you can keep on your hard drive at all times. When you want to view its contents in iPhoto, double-click the .dmg icon. You'll see its contents appear in the form of a CD icon in the iPhoto album list, just as though you'd inserted the original iPhoto disc.

You can spin off numerous chunks of your iPhoto collection this way, and "mount" as many of them simultaneously as you like—a spectacular way to manage tens of thousands of photos, chunk by chunk, without having to deal with a clumsy collection of discs.

Multiple iPhoto Libraries

Now that iPhoto can hold 250,000 photos per library, there's not as much need to split it into separate libraries as there once was. Still, there are two good reasons why you might want to consider it:

- Splitting your collection into several libraries may make iPhoto itself faster, especially during scrolling, because there are fewer photos in it.
- You can keep different types of collections or projects separate. You might want to maintain a Home library for personal use, for example, and a Work library for images that pertain to your business. Or you can start a new library every other year.

Managing Photo Libraries

Creating new libraries

iPhoto provides a built-in tool for creating fresh libraries and switching among several of them:

1. Quit iPhoto.

You're going to do the next step in the Finder.

2. While pressing the Option key, open iPhoto again.

When iPhoto starts up, it senses that you're up to something. It offers you the chance to create a new library, or to choose an existing one (Figure 13-3).

3. Click Create New. In the following dialog box, type a name for the new library (like *iPhoto Library 2*), and click Save.

You're offered not only the chance to create a new library, but also to choose a location for it that's not your regularly scheduled Pictures folder.

When iPhoto finishes opening, all remnants of your old iPhoto library are gone. You're left with a blank window, ready to import photos.

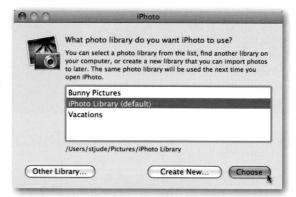

Figure 13-3:

If you hide the iPhoto Library from iPhoto, the program invites you either to find it or to create a new one. If your goal is to begin a fresh library for the new year, for example, click Create New. Click Choose to pick an existing library.

Using this technique, you can spawn as many new photo libraries as you need. You can archive the old libraries on CD or DVD, move them to another Mac, or just keep them somewhere on your hard drive so that you can swap any one of them back in whenever you need it.

As for *how* you swap them back in, you have two options: Apple's way, and an easier way.

Swapping libraries (Apple's method)

Once you've built yourself at least two iPhoto libraries, you can use the same Option-key trick (see step 2 above) to switch among them. When the dialog box in Figure 13-3 appears, select the library you want to open in the list, and then click Choose.

If you don't see the library you want, then click Other Library and hunt it down on your hard drive.

When iPhoto finishes reopening, you'll find the new set of photos in place.

Swapping libraries (automatic method)

If that Option-key business sounds a little disorienting, you're not alone. Brian Webster, a self-proclaimed computer nerd, thought the same thing—but *he* decided to do something about it. He wrote iPhoto Library Manager, a shareware program that streamlines the creation and swapping of iPhoto libraries. Waste no time in downloading it from this book's "Missing CD" page at *www.missingmanuals.com* or Brian's own site at http://homepage.mac.com/bwebster/.

The beauty of this program is that it offers a tidy list of all your libraries; you can switch among them with two quick clicks.

Here are a few pointers for using iPhoto Library Manager:

Figure 13-4: 000 iPhoto Library Manager iPhoto Library Manager lets you switch among as many different iPhoto Info for Default iPhoto Libraries Albums in libraries as vou want. Se-Current Name lect a library from the list LIBRARY Reveal in Finder Default Photos (6032) on the left. Click Launch /Users/stjude/Pictures/iPhoto Library 0 Vacations RECENT iPhoto (or Relaunch 0 Photo Class Mar 1, 2009 (3) iPhoto) to view the Last 6 Months (802) photos from that library. Last Import (3) Size: --Calculate size Flagged (3) When you click a library Version: 8.0 SURSCRIPTIONS name at left, the middle Modification Date: Mar 01, 2009 09:46:16 PM Juploads ...212 (20) column shows its albums and other details. Mary+Bobby (54) Options. Tom or Zach (43) iPhoto version: 8.0

- The program doesn't just activate *existing* iPhoto libraries; it can also create new libraries for you. Just click the New Library button in the toolbar, choose a location and name for the library, and then click OK (see Figure 13-4).
- You still have to quit and relaunch iPhoto for a change in libraries to take effect. Conveniently, iPhoto Library Manager includes Quit iPhoto and Launch iPhoto buttons in its toolbar.

Tip: You can also switch libraries using the pop-up menu from iPhoto Library Manager's Dock icon.

Merging Photo Libraries • iPhoto Library Manager is fully AppleScriptable. If you're handy with writing AppleScript scripts (Chapter 12), then you can write one that swaps your various libraries automatically with a double-click.

Merging Photo Libraries

You've just arrived home from your photo safari of deepest Kenya. You're jet-lagged and dusty, but your MacBook Pro is bursting at the seams with fresh photo meat. You can't wait to transfer the new pictures into your main iPhoto library—you know, the one on your Mac Pro Core Trio with 4 gigs of RAM and a 45-inch Apple Imax Display.

Or, less dramatically, suppose you've just upgraded to iPhoto '09. You're thrilled that you can fit 250,000 pictures into a single library—but you still have six old iPhoto 5 library folders containing about 10,000 pictures each.

In both cases, you have the same problem: How are you supposed to merge the libraries into a single, unified one?

How Not to Do It

You certainly can combine the *photos* of two Macs' photo libraries—just export them from one (File→Export) and then import them into the other (File→Import to Library). As a result, however, you lose all of your album organization, comments, and keywords.

Your next instinct might be: "Hey, I know! I'll just drag the iPhoto Library icon from computer number 1 into the iPhoto window of computer number 2!"

Big mistake. You'll end up importing not only the photos, but also the original versions of any photos that you edited. You'll wind up with duplicates or triplicates of every photo in the viewing area, in one enormous, unmanageable, uncategorized, sloshing library. (At least iPhoto '09 is smart enough not to import all the thumbnail images, as earlier iPhoto versions did.)

You could also use iPhoto CDs or DVDs as intermediaries, but that's time-consuming and uses up blank discs.

The Good Way

No, the only sane way to merge libraries is to use iPhoto Library Manager, described above. For \$20, you can unlock some features that aren't available in the free version—including a miraculously simple Merge Libraries command.

All you have to do is choose File→Merge Libraries. The dialog box shown in Figure 13-5 appears. Turn on the checkboxes of the libraries you want to merge, and proceed as shown in Figure 13-5.

Tip: Set up the merge and then go to bed. It can take awhile.

Beyond iPhoto

Depending on how massive your collection of digital photos grows and how you use it, you may find yourself wanting more file-management power than iPhoto can offer. Maybe you wish you could organize 500,000 photos in a single catalog, without having to swap photo libraries or load archive DVDs. Maybe you have a small network, and you'd like a system that lets a whole workgroup share a library of photos simultaneously.

Figure 13-5:

Turn on the checkboxes of the libraries you want to combine (left column).

To combine them into a new library, leave New Library selected in the right column.

Or, to add them to an existing library, select the existing library on the right.

Then click Continue—and walk away.

Note: The merging process preserves all keywords, ratings, photo titles, albums, and editing you've done. It doesn't maintain books, calendars, saved slideshows, or smart albums.

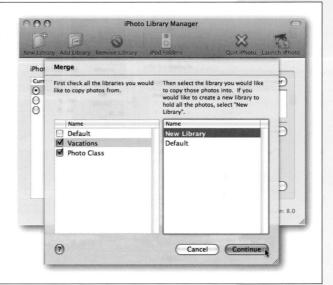

To enjoy such features, you'll have to move beyond iPhoto into the world of *digital asset management*, which means spending a little money. Programs like Extensis Portfolio (\$200, www.extensis.com), Canto Cumulus (\$100, www.canto.com), Microsoft Expression Media (formerly iView MediaPro, \$200, www.microsoft.com/expression), Adobe Photoshop Lightroom (\$300, www.adobe.com/lightroom), and Apple's own Aperture (\$200) are terrific programs for someone who wants to take the next step up, as shown in Figure 13-6. (These companies offer free trial versions on their Web sites.)

Here are a few of the stunts these more advanced programs can do that iPhoto can't:

- Create custom fields to store any other kind of information you want about your files—dates, prices, Web addresses, and so on.
- Track graphics files stored in any location on a network, not just in a specific folder.
- Catalog not just photos, but other file types, too: QuarkXPress and InDesign documents, QuickTime movies, sound files, PowerPoint slides, and more flavors of RAW files than iPhoto understands.

Beyond iPhoto

- Share a catalog of images with dozens of other people over a network.
- Customize the fonts, colors, and borders of the thumbnail view.
- Create catalogs that can be read on both Macs and Windows PCs.
- Display previews of "offline" photo files that aren't actually on the Mac at the moment (they're on CDs or DVDs on your shelf, for example).

Some of the features in this list were obviously developed with professionals in mind, like graphic designers and studio photographers. But this kind of program is worth considering if your photo collection—and your passion for digital photography—one day outgrows iPhoto.

Library Develop Slideshow Print Web Navigator Print Web Navigator Print Web Hadaga According Revived Sept Shideshow Print Web Hadaga According Revived Sept

Figure 13-6

Aperture is one of several programs that do what iPhoto does—and a lot more besides.

Here, for example, is Aperture's version of the full-screen editing mode. One key difference: When you make changes, Aperture doesn't duplicate the photo file (and use up disk space), as iPhoto does. It just remembers which changes you've applied, and can undo them in any sequence.

What's also nice about Aperture is that it works well with iMovie. For example, it seamlessly imports iMovie libraries, complete with albums, keywords, ratings, and so on.

Bottom: Adobe Photoshop Lightroom is Aperture's archrival. Among other features, it can upload changed galleries directly to the Web, without requiring an FTP program.

Part Four: Appendixes

Appendix A: Troubleshooting

Appendix B: iPhoto '09, Menu by Menu

Appendix C: Where to Go From Here

Troubleshooting

• Photo isn't just a Mac OS X program—it's a *Cocoa* Mac OS X program, meaning that it was written exclusively for Mac OS X. As a result, it should, in theory, be one of the most rock-solid programs under the sun.

Still, iPhoto does have its vulnerabilities. Many of these shortcomings stem from the fact that iPhoto works under the supervision of a lot of cooks, since it must interact with plug-ins, connect to printers, talk to Web servers, and cope with an array of file corruptions.

If trouble strikes, keep hands and feet inside the tram at all times—and consult the following collection of problems, solutions, questions, and answers.

The Most Important Advice in This Chapter

Apple's traditional practice is to release a new version of iPhoto (and iMovie, and iDVD...) that's got some bugs and glitches—and then, just when public outcry reaches fever pitch a couple of weeks later, send out a .0.1 updater that cleans up most of the problems.

Spare yourself the headache: Update your copy to 8.0.2 (or whatever the latest version is)! To do that right now, choose iPhoto→Check for Updates.

Importing, Upgrading, and Opening

Getting photos into iPhoto is supposed to be one of the most effortless parts of the process. Remember, Steve Jobs promised that iPhoto would forever banish the "chain of pain" from digital photography. And yet...

Importing, Upgrading, and Opening

"Unable to upgrade this photo library"

There may be locked files somewhere inside your iPhoto library. If something's locked, iPhoto can't very well convert it to the '09 format.

Trouble is, there can be hundreds of thousands of files in an iPhoto library. How are you supposed to find the one file that's somehow gotten locked?

The quickest way is to type out a Unix command. Don't worry, it won't bite.

Open your Applications—Utilities folder, and then double-click Terminal. The strange, graphics-free, all-text command console may look alien and weird, but you'll witness its power in just a moment.

Type this, exactly as it appears here:

```
sudo chflags -R nouchg
```

—and add a space at the end (after "nouchg"). Don't press Return or Enter yet.

Now switch to the Finder. Open your Pictures folder and drag your iPhoto Library icon right *into* the Terminal window. Now the command looks something like this:

```
sudo chflags -R nouchg /Users/Casey/Pictures/iPhoto\ Library/
```

Press Return or Enter to issue the command. Mac OS X asks for your account password, to prove that you know what you're doing. Type it, press Return or Enter, and your problem should be solved.

iPhoto doesn't recognize my camera.

iPhoto generally "sees" any recent camera model, even iPhones and photos saved on an iPod Touch. If you don't see the Import screen (Chapter 1) even though the camera most assuredly is connected, then try these steps in order:

- Make sure the camera is turned on. Check the USB cable at both ends.
- Try plugging the camera into a different USB port.
- Some models don't see the computer until you switch them into a special "PC" mode, using the Mode dial. Check to see if your camera's in that category.
- Try turning on the camera *after* connecting its USB cable to the Mac.
- Turn the camera off, then on again, while it's plugged in.
- If iPhoto absolutely won't notice its digital companion, then use a memory-card reader, as described on page 17.

iPhoto crashes when I try to import.

This problem is most likely to crop up when you're bringing pictures in from your hard drive or another disk. Here are the possibilities:

Importing, Upgrading, and Opening

- The culprit is usually a single corrupted file. Try a test: Import only half the photos in the batch. If nothing bad happens, then split the remaining photos in half again and import *them*. Keep going until you've isolated the offending file.
- Consider the graphics program you're using to save the files. It's conceivable that
 its version of JPEG or TIFF doesn't jibe perfectly with iPhoto's. (This scenario is
 most likely to occur right after you've upgraded either your graphics program or
 iPhoto itself.)

To test this possibility, open a handful of images in a different editing program, save them, and then try the import again. If they work, then you might have a temporary compatibility problem. Check the editing program's Web site for updates and troubleshooting information.

• Some JPEGs that were originally saved in Mac OS 9 won't import into iPhoto. Try opening and resaving these images in a native Mac OS X editor like Photoshop. Speaking of Photoshop, it has an excellent batch-processing tool that can automatically process mountains of images while you go grab some lunch.

Tip: Can't afford hundreds of dollars for full Photoshop? Try the free online version, Photoshop Express, at www.photoshop.com. You can do most basic photo-editing tasks and even store up to 2 gigabytes of pix.

Finally, a reminder, just in case you think iPhoto is acting up: iPhoto imports RAW files—but not from all camera models. For details, see the Note on page 24.

iPhoto crashes when I try to empty the Trash.

Open iPhoto while pressing **\mathbb{H}** and Option; in the dialog box shown in Figure A-2 (page 330), turn on "Rebuild the photos' small thumbnails," and then click Rebuild.

iPhoto won't import images from my video camera.

Most modern digital camcorders can store your still images on a memory card instead of DV tape. If you're having a hard time importing these stills into iPhoto with a direct camera connection, try these tips:

- Take out the tape cassette before connecting the camcorder to your Mac.
- Try copying the files directly from the memory card to your hard drive with a memory-card reader. Once the images are on your hard drive, you should be able to import them into iPhoto.

Exporting

Clearly, "Easy come, easy go" doesn't always apply to photos.

After I upgraded iPhoto to the latest version, my Export button became disabled.

This problem is usually caused by outdated plug-ins. If you have any older plug-ins, such as an outdated version of the Toast Titanium export plug-in, disable them, and then relaunch iPhoto to see whether that solves the problem.

Exporting

Here's how to turn your plug-ins on or off:

Quit iPhoto. In the Finder, highlight the iPhoto application icon. Choose File→Get
Info.

You may have seen the Get Info box for other files in your day, but you probably haven't seen a *Plug-ins* panel (Figure A-1).

Figure A-1:

You may be surprised to discover that a number of iPhoto's "built-in" features are actually plug-ins written by Apple's programmers. Most of them are responsible for familiar printing and exporting options. Any others should be turned off in times of troubleshooting. (If you can't remember which plug-ins you've installed yourself, then reinstall iPhoto.)

2. Click the triangle to expand the Plug-ins panel.

A complete list of the plug-ins you currently have loaded appears with a checkbox next to each item.

3. Turn off the non-Apple plug-ins that you suspect might be causing the problem.

Now open iPhoto and test the Export function. If the technology gods are smiling, the function should work now. All that's left is to figure out which *one* of the plug-ins was causing your headaches.

To find out, quit iPhoto. In the Finder, open its Get Info window again. Reinstate your plug-ins one by one, using the on/off checkboxes depicted in Figure A-1, until you find the offending software.

Once you locate the culprit, highlight its name, and then click Remove. (You may also want to check the Web site of the offending plug-in for an updated version.)

Tip: Here's another, somewhat more interesting way to remove a plug-in. Control-click (or right-click) the iPhoto icon; from the shortcut menu, choose Show Package Contents. In the resulting window, open the Contents—PlugIns folder, where each plug-in is represented by an easily removable icon.

Printing

Printing has its share of frustrations and wasted paper, but checking a few settings can solve some common problems:

I can't print more than one photo per page. It seems like a waste to use a whole sheet of paper for one 4×6 print.

Check the following:

- Have you, in fact, selected a paper size that's larger than the prints you want on it? (See Figure 7-2 back in Chapter 7.)
- Have you entered the photo-layout mode (Figure 7-3), clicked Settings, and then turned on "Multiple photos per page"?

My picture doesn't fit right on 4×6 , 5×7 , or 8×10 inch paper.

Most digital cameras produce photos in a 4:3 width-to-height ratio. Unfortunately, those dimensions don't fit neatly into any of the standard print sizes.

The solution: Crop the photos first, using the appropriate print size in the Constrain pop-up menu (see page 121).

Editing and Sharing

There's not much that can go wrong here, but when it does, it really goes wrong.

iPhoto crashes when I double-click a thumbnail to edit it.

You probably changed a photo file's name in the Finder—in the iPhoto Library package, behind the program's back. iPhoto hates this! Only grief can follow.

Sometimes, too, a corrupted picture file will make iPhoto crash when you try to edit it. To locate the scrambled file in the Finder, Control-click (or right-click) its thumbnail; from the shortcut menu, choose Show Original File. Open the file in another graphics program, use its FileSave As command to replace the corrupted picture file, and then try again in iPhoto.

iPhoto won't let me use an external graphics program when I double-click a thumbnail.

Choose iPhoto—Preferences. Click General. Check the "Edit photo" pop-up menu to make sure that the external program's name is selected. (If not, click "In application," and then choose the program you want to use.)

Also make sure that your external editing program still *exists*. You might have upgraded to a newer version of that program, one whose file name is slightly different from the version you originally specified in iPhoto.

Faces really stinks at identifying the people in my pictures!

As with music and sports, some things get better with practice. To get Faces more skilled at matching up names to the folks in your photos, you need to help it along by *training* it. If Faces hasn't identified someone you *know* is in your library, then open up the photo (or photos) with the poor nameless soul, click the Name button on the toolbar, and then type in the person's name. Manually naming the face, however, does not do much for iPhoto's face-recognition algorithm—it's your *confirming* results in the automatic face-recognition roundup that helps Faces learn.

So click Faces in the Source list, open that person's snapshot on the corkboard, and click the Confirm Name button in the toolbar. Scroll down to the "may also be in the photos below" list (Figure 4-4), and start confirming or rejecting the suggestions (page 94), so Faces gets more practice in *correctly* identifying your associates.

Published pictures I re-edit in iPhoto aren't updating on my free Flickr page.

Sometimes there's a breakdown in communication: between heads of state, management and labor, and even iPhoto and Flickr. Fortunately, that last one is the easiest to solve. In iPhoto, delete the misbehaving photo(s) from your Flickr album. Then make your edits or changes to the pictures (if you haven't already), and then publish the photos to Flickr again—as described on page 194. If you have only one picture in the Flickr album, delete the whole album from the iPhoto Source list, fix the picture in iPhoto, and then republish the photo to Flickr as a brand new album.

I've messed up a photo while editing it, and now it's ruined!

Highlight the file's thumbnail and then choose Photos→Revert to Original. iPhoto restores your photo to its original state, drawing on a backup it has secretly kept.

General Questions

Finally, here's a handful of general—although perfectly terrifying—troubles.

iPhoto's wigging out.

If the program "unexpectedly quits," well, that's life. It happens. This is Mac OS X, though, so you can generally open the program right back up again and pick up where you left off.

If the flakiness is becoming really severe, try logging out (choose $\bigoplus -Log Out$) and logging back in again. And if the problem persists, see the data-purging steps at the bottom of this page.

I don't see my other Mac's shared photos over the network.

Chapter 8 covers network photo sharing in detail. If you're having trouble making it work, here's your checklist:

- Make sure you've turned on "Look for shared photos" in the Sharing pane of iPhoto Preferences.
- Is the Mac that's sharing the photos turned on and awake? Is iPhoto running on it, and does it have photo sharing turned on? Is it on the same network subnet (network branch)?
- Do the photo-sharing Macs both have iPhoto 4 or later installed?

I can't delete a photo!

You may be trying to delete a photo right out of a smart album. That's a no-no.

There's only one workaround: Find the same photo in the iPhoto Library, the Last Import icon, or the Last 12 Months icon—and delete it from there.

I deleted a photo, but it's back again!

You probably deleted it from an album (or book, calendar, card, or slideshow). These are all only *aliases*, or *pointers*, to the actual photo in your library. Just removing a thumbnail from an album doesn't touch the original.

All my pictures are gone!

Somebody probably moved, renamed, or fooled with your iPhoto Library icon. That's a bad, bad idea.

If it's just been moved or renamed, then find it again using your Mac's search feature (Spotlight, for example). Drag it back into your Pictures folder, if you like. In any case, the important step is to open iPhoto while pressing the Option key. When the dialog box shown on page 316 appears, show iPhoto where your library folder is now. (If that solution doesn't work, read on.)

All my pictures are still gone! (or) My thumbnails are all gray rectangles! (or) I'm having some other crisis!

The still-missing-pictures syndrome and the gray-rectangle thumbnails are only two of several oddities that may strike with all the infrequency—and pain—of lightning. Maybe iPhoto is trying to import phantom photos. Maybe it's stuck at the "Loading photos..." screen forever. Maybe the photos just don't look right. There's a long list, in fact, of rare but mystifying glitches that can arise.

What your copy of iPhoto needs is a big thwack upside the head, also known as a major data purge.

General Questions

You may not need to perform all of the following steps. But if you follow them all, at least you'll know you did everything possible to make things right. Follow these steps in order; after each one, check to see if the problem is gone.

- If you haven't already done so, upgrade to the very latest version of iPhoto. For example, the 8.0.1 update was hot on the heels of iPhoto 8.0 (also known as iPhoto '09, of course).
- Rebuild the iPhoto Library; fix its permissions. To do that, quit iPhoto. Then reopen it, pressing the Option and **%** keys as you do so.

The dialog box shown in Figure A-2 appears; it offers six different repair techniques. For best results, turn on all of them. (Or, to save time, try the second checkbox only if the other ones, which are faster, don't solve the problem.)

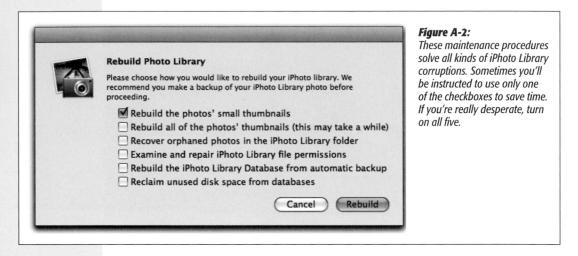

Once you click Rebuild, iPhoto works its way through each album and each photo, inspecting it for damage, repairing it if possible, and finally presenting you with your new, cleaned-up library. This can take a *very* long time, but it usually works.

• Throw away the iPhoto preference file. Here we are in the age of Mac OS X, and we're still throwing away preference files?

Absolutely. A corrupted preference file can still bewilder the program that depends on it.

Open your Home—Library—Preferences folder, where you'll find neatly labeled preference files for all of the programs you use. In this case, trash the file called com.apple.iPhoto.plist.

The next time you run iPhoto, it will build itself a brand-new preference file that, if you're lucky, lacks whatever corruption was causing your problems.

• Import the library into itself. If, after all these steps, some or all of your photos are still missing, try this radical step. Create a new, empty iPhoto Library (page

General Questions

316). Then drag the older, troubled library folder right from the Finder into the empty iPhoto window. The program imports all of the graphics it finds (except the thumbnails, which you don't want anyway).

You lose all your keywords, Event names, comments, albums, folders, books, saved slideshows, and so on. And you might wind up with duplicates (the edited and unedited versions of the pictures). But if any photos were in the old library but somehow unaccounted for, they'll magically reappear.

• Just find the pix yourself. If none of these steps restored your missing photos, all is not lost. Unless you somehow opened your Home—Pictures folder and, while sleepwalking, manually *threw away* your iPhoto Library folder, then your pictures are still there, somewhere, on your hard drive.

Use Spotlight or the Find command to search for them, as shown in Figure A-3.

Figure A-3: Search for images (or file extensions .JPG or .JPEG), with file sizes greater than, say, 50 K (to avoid rounding up all of the little thumbnail representations; it's the actual photos you

want).

The results may include thousands of photos. But in this desperate state, you may be grateful that you can either (a) click one to see where it's hiding, or (b) select all of them, drag them into a new, empty iPhoto Library, and begin the process of sorting out the mess.

iPhoto '09, Menu by Menu

Some people use iPhoto for years without pulling down a single menu. But unless you explore its menu commands, you're likely to miss some of the options and controls that make it a surprisingly powerful little photo manager. Especially since some commands, like Export, appear *only* in menus.

Here's a menu-by-menu look at iPhoto's commands.

iPhoto Menu

This first menu, Mac OS X's Application menu, takes on the name of whatever program happens to be running in the foreground. In iPhoto's case, that would be "iPhoto."

About iPhoto

This command opens the "About" box containing the requisite Apple legalese.

There's really only one good reason to open the About iPhoto window: It's the easiest way to find out exactly which version of iPhoto you have.

Preferences

Opens the Preferences window (Figure B-1), which has six panels to choose from:

General

- Tell iPhoto how many months to show in the Last ____ Months album, as discussed in Chapter 2.
- Have iPhoto display the total photo count, in parentheses, next to each album in the Source list.

iPhoto Menu

- Specify what you want to happen when you double-click a thumbnail: Open it for editing, or magnify it so that it fills the iPhoto window (and shrinks down again with another click).
- Change the setting of iPhoto's Rotate button so that it spins selected photos counterclockwise instead of clockwise.
- Choose how you want iPhoto to open photos when you double-click them. You have three choices: You can open the photo for editing in the main iPhoto window, in the full-screen mode, or in another program (which you choose by clicking the Set button). Details appear in Chapter 5.
- Choose the email program that you want iPhoto to use when emailing pictures as attachments using the Mail Photo feature.
- Choose the photo downloading program that you want to open automatically when you connect a camera. iPhoto, of course, is the factory setting. But you may prefer to use the old Image Capture program. Or you may want *nothing* to happen automatically.
- Specify whether or not iPhoto is allowed to check for ".0.1" upgrades that Apple releases via the Internet. If yes, then you'll see, from time to time, dialog boxes that invite you to download and install these updates (which usually fix bugs).

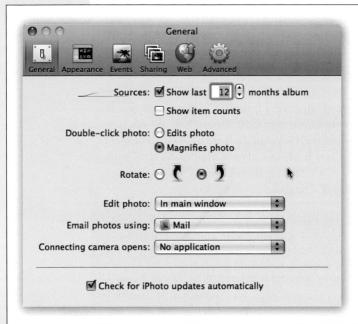

Figure B-1:

You'll probably be visiting iPhoto's Preferences window fairly regularly, so remember the keyboard shortcut that takes you here: 第-comma. You need to open Preferences every time you want to turn Photo Sharing on or off, for example.

Appearance

- Add a drop shadow or a thin black outline frame to your thumbnails in the photoviewing area.
- Change the background of the photo-viewing area from white to black—or any shade of gray.
- Align thumbnails to a grid in the iPhoto window.
- Show scrolling information superimposes a floating, dark gray Scroll Guide label on the screen while you're scrolling to help you figure out where you are in your vast library. (It shows the date, or rating, or name of the photos whizzing by, according to your sort criterion.)
- Use smooth scrolling refers to what happens when you press the Page Up or Page Down keys on your keyboard (or click in an empty spot in the scroll bar). When this option is on, the thumbnails slide up or down on the screen. When it's off (or when you're going too fast for iPhoto to process the animation), the window just jumps suddenly to the next screenful.

Events

The Events organizing structure in iPhoto '09 (Chapter 2) comes with some preferences of its own.

- Double-click event is a more complicated option than it may seem. See page 115 for details.
- Show Event reflections lets you turn the little Event-thumbnail reflections on or off. Turning them off doesn't save any space, although in extreme situations, it could gain a little speed.
- Show scrolling information makes scroll guides appear in the Events window, just as it does in the Photos window (page 73).
- Autosplit into Events governs how iPhoto splits imported photos into separate, time-grouped batches; page 38 tells all. (The "Imported items from Finder" checkbox applies the same feature to pictures you import from your hard drive, rather than from a camera.)

Sharing

Set up iPhoto for sharing your iPhoto Library over a home or small-office network, as described on page 220.

Web

This simple panel lets you control your privacy by giving you the choice to include location information from Places in published photos. You can also tell iPhoto how often to check for updates to published albums and see how much of your iDisk space —if you have one—remains. Page 209 tells all.

Advanced

A better name might be "Miscellaneous." Here we go:

- Copy items to the iPhoto Library. As noted on page 20, iPhoto '09 is willing to track your photos no matter where they are on your hard drive—in their current folder homes—without duplicating them in its own library. Here's the on-off switch.
- Embed ColorSync profile. As you may have discovered through painful experience, computers aren't great with color. Each device you use to create and print digital images "sees" color a little bit differently, which explains why the deep amber captured by your scanner may be rendered as chalky brown on your monitor, yet come out as a fiery orange on your Epson inkjet printer. Since every gadget defines and renders color in its own way, colors are often inconsistent as a print job moves from design to proof to press.

ColorSync attempts to sort out this mess, serving as a translator between all the different pieces of hardware in your workflow. For this to work, each device (scanner, monitor, printer, digital camera, copier, proofer, and so on) has to be calibrated with a unique *ColorSync profile*—a file that tells your Mac exactly how it defines colors. Armed with the knowledge contained in the profiles, the ColorSync software can compensate for the various quirks of the different devices, and even the different kinds of paper they print on.

Using the ColorSync Utility program (in Applications—Utilities), you can specify which ColorSync profile each of your gadgets should use. The next step, though, is to embed a profile right into each photo, making all of the ColorSync tracking automatic.

What this option is saying, though, is this: "If you import a photo that doesn't have a ColorSync profile, I'll give it one. I'll give it the profile called CameraRGB, which is Apple's version of the popular sRGB profile; it maps image colors very closely to Apple monitors."

- Use RAW files when using external editor. This means, "Open RAW photos with Adobe's RAW-file editor, as described on page 145 of this book."
- Save edits as 16-bit TIFFs. Here's another high-end feature. As you know from page 144, iPhoto ordinarily saves RAW files as JPEG graphics once you've edited them. But many photographers object that JPEG is a compressed format that, in theory, can degrade the quality of the original photo. This option tells iPhoto to save such pictures in the TIFF format instead, which consumes far more disk space but doesn't compress the photos.
- Look up Places. If your photos have embedded location coordinates (page 102), choose Automatically from the pop-up menu here to have iPhoto match the numbers to actual place names on the map. Choose the Never option if you'd like to keep locations private.

Empty iPhoto Trash

Purges the contents of the iPhoto Trash, permanently deleting any photos, books, slideshows, and albums in it. There's no turning back once you choose Empty iPhoto Trash: Your photos are gone, and there's no Undo command. Think before you empty.

Shop for iPhoto Products

This isn't so much a command as it is a marketing ploy. It opens your Web browser to a page on Apple's Web site that offers to sell you digital cameras, tripods, printers, and other accessories.

Provide iPhoto Feedback

This command takes you to a Web form on Apple's site where you can register complaints, make suggestions, or gush enthusiastically about iPhoto.

Register iPhoto

This is a link to yet another Apple Web page. Registering iPhoto simply means giving Apple your contact information. There's no penalty for not registering, by the way. Apple just wants to know more about who you are, so it can offer you exciting new waves of junk mail.

Check for Updates

As noted earlier, Apple occasionally patches iPhoto to make it faster or better. If you've turned off *automatic* checking, here you can instruct the program manually to check in with the mother ship via the Internet.

Hide iPhoto, Hide Others, Show All

These aren't iPhoto's commands—they're Mac OS X's.

In any case, they determine which of the various programs running on your Mac are visible onscreen at any given moment. The Hide Others command is probably the most popular of these three. It zaps away the windows of all other programs—including the Finder—so that the iPhoto window is the only one you see.

Tip: If you know this golden Mac OS X trick, you may never need to use the Hide Others command: To switch into iPhoto from another program, hold down the Option and **%** keys when clicking the iPhoto icon in the Dock. Doing so simultaneously brings iPhoto to the front *and* hides all other programs you have running, producing a distraction-free view of iPhoto.

Quit iPhoto

This command closes iPhoto, no questions asked. You're not even asked to save changes, because as you've probably noticed, iPhoto doesn't even *have* a Save command. Like Filemaker Pro, 4D, and other database programs, iPhoto—itself a glorified database—continually saves changes as you add, delete, or edit photos.

File Menu

Most of the commands in the File menu involve creating new storage entities: albums, books, slideshows, and so on. See Chapters 2, 9, and 6, respectively. This is also where you do all your printing.

New Album

Creates a new photo album in the Source list, and prompts you to name it. (You can also create an album by pressing **%**-N or clicking the + button in the main iPhoto window.)

New Album From Selection

Select some photos in the iPhoto window, then choose this command. iPhoto creates a new album, already stocked with the selected pictures.

New Smart Album

Opens a dialog box where you can set up criteria for a smart album, as described on page 61.

New Folder

This humble command is the key to the all-powerful folder. A folder is a Source-list icon that can contain other icons, like albums, book layouts, and slideshows.

Get Info

With a snapshot selected in Faces, choosing Get Info flips the frame around to reveal the person's name and email address for handy Facebook tagging. When invoked on a selected photo, iPhoto spins the picture around to reveal location information (if any), and other details like titles and ratings. *Keyboard shortcut:* **%**-I.

Import to Library

Use this command to add photos to your iPhoto Library from your hard disk, a CD, or some other disk. Choose Add to Library, select the file or folder you want to add, then click the Import button in the Import Photos dialog box. *Keyboard shortcut*: Shift-**%**-I.

Export

Yes, kids, it's the amazing peripatetic Export command—in a different menu every version of iPhoto!

Anyway, it opens the Export Images window, whose panels offer the following ways of copying photos:

• File Export. Makes fresh copies of your photos in the file format and size you specify. You can export photos in their existing file format or convert them to JPEG, TIFF, or PNG format. You also can set a maximum size for the photos, so that iPhoto scales down larger photos on the fly as it exports them.

- Web Page. Publishes selected photos as a series of HTML pages that you can post on a Web site. The finished product includes an index page with clickable thumbnails that open individual pages containing each photo. (See Chapter 8 for step-by-step instructions on using this pane to set image sizes and format the HTML pages.)
- QuickTime. Turns a series of photos into a self-running slideshow, saved as a QuickTime movie that you can post on the Internet, send to friends, or burn to a CD. You can set the size of the movie, pick a background color, and add music (the sound file selected for the current photos' album or slideshow) before exporting. You'll find more about going from iPhoto to QuickTime in Chapter 10.
- Slideshow. A new option in iPhoto '09, Slideshow makes a copy of your lovingly handcrafted photo extravaganza and exports it to a video file perfectly sized for your chosen screen—whether it be an iPhone, TV, or Web page. Chapter 10 explains it all for you.

You can save yourself a trip to the Export menu by using the keyboard shortcut Shift-**%**-E. (By the way, you may find additional tabs in the Export dialog box if you've installed iPhoto plug-in software.)

Close Window

Closes the frontmost window. If only the main iPhoto window is open, then this command quits the program. *Keyboard shortcut:* **%**-W.

Edit Smart Album

Lets you edit the criteria for an existing smart album. Select the album before choosing this command. When you click OK, iPhoto updates the smart album.

Subscribe to Photo Feed

Asks you for the URL (Web address) for someone's Flickr feed or MobileMe Gallery so that you can enjoy their pictures in your copy of iPhoto. See page 209.

Order Prints

Use this command when it's time to order up professionally printed copies of your pictures in a variety of sizes. Chapter 7 is all about making prints.

Print

Opens iPhoto's Print dialog box, where you can print contact sheets, greeting cards, full-page photos, or groups of photos in standard sizes like 4×6 or 5×7 . See Chapter 7 for details.

Browse Backups

This command is exclusively for the benefit of people who use Time Machine, the automated backup program in Mac OS X Leopard.

File Menu

Unbeknownst to most people, iPhoto '09 comes with a very special miniature version of itself that's intended exclusively for using Time Machine to recover lost, damaged, or deleted files.

If you've been using Time Machine (see *Mac OS X Leopard: The Missing Manual*), start by choosing this command (or just click the Time Machine icon on your Dock).

Now something weird and wonderful happens: The entire world of menus, windows, and the Dock drops away, leaving only a stripped-down version of iPhoto in its place. There's no toolbar, no menu bar, no way to resize the window or change the thumbnail sizes. There's very little in the Source list except Photos, Events, and your albums. And there's a Search box, too.

As Figure B-2 illustrates, you can now browse or search the old copies of your backups. Each time you click on the big perspective arrow, Time Machine shows you the same iPhoto window as it was the last time anything changed. The idea is that this way, you can find the photo or album as it existed before it got deleted or damaged. (You can also drag your cursor through the time ruler on the right side of the screen.)

When you find the missing photos or albums, select them (page 48), and then click Restore. You return to your current iPhoto library, where the missing or damaged photos are magically reimported—from the past.

Figure B-2: In Time Machine view, iPhoto is very stripped down.

When you select some photos, and then click Restore, you return to your current iPhoto setup, where the rescued photos are reinstated. (Try to avoid getting your tears of relief into the keyboard.)

Edit Menu

As you would expect, the commands in the Edit menu let you edit various parts of your library, such as keywords, photo titles, and the sort order. The standard Cut, Copy, and Paste commands operate on selected text and photos as normal.

Undo

Where would this world be without Undo? In iPhoto, you even have a *multiple* Undo; using this command (or its keyboard equivalent, **%**-Z), you can reverse your last series of actions in iPhoto, backing out of your bad decisions with no harm done (Figure B-3). How nice to know that if you go too heavy on the contrast, delete an important photo, or crop out your grandmother's ear, there's a quick and easy way out.

If you're editing two photos side by side in the main iPhoto window, note that the Undo command tracks your changes in each photo independently. For example, say you're in Edit mode with the two pictures up big in the window, clicking on each one separately one to select it for fiddling. You crop and rotate the one on the left. For the one on the right you fix some red-eye and adjust the contrast.

As long as the right-side photo is selected, you can undo the contrast and red-eye adjustments—but if you click the picture on the left, you'll find that the Undo command will take back only your original actions—the cropping and rotating.

So while iPhoto can handle multiple levels of Undo, keep in mind that each selected photo maintains its own private stash of Undos.

Redo

Redo (Shift-\(\mathbb{H}\)-Z) lets you undo what you just undid. In other words, it reapplies the action you just reversed using the Undo command.

Cut, Copy, Paste

These commands work exactly the way they do in your word processor when you're editing photo titles, comments, keywords, or any other text fields. In addition, they have a few special functions when they're used in certain parts of iPhoto.

- In a photo album (not the main photo library), you can select photos and use Cut to remove them from the album. (This doesn't delete them from iPhoto, only from that particular album.) To move the photos to a different album, click the album's name, or click one of its photos, and then choose Paste.
- You can assign photos from the main iPhoto library to a specific album using the Copy and Paste commands. Select a file, choose Copy, click the destination photo album, and then choose Paste.
- Cut, Copy, and Paste are all inactive when you're in Edit mode (Chapter 5).

Select All

This command (**%**-A) behaves in three different ways, depending on when you use it in iPhoto:

- In the thumbnails view, it selects all thumbnails visible in the viewing area—either those in the Events view or the Photos view.
- In Edit mode, with a photo opened in the main iPhoto window, the Select All command extends the cropping rectangle to the very edges of the photo.
- When you're editing photo titles, descriptions, keywords, or any other text fields, the Select All command selects all the text in the field you're editing.

Select None

As you would expect, this command is the opposite of Select All. The only practical way to use this command is to employ its handy keyboard shortcut, Shift-**%**-A, to quickly deselect a group of photos without having to click the mouse.

Find

Just puts your blinking insertion point into the Search box at the bottom of the iPhoto window. Cute—real cute.

Font

This submenu offers quick access to text-formatting options like Bold, Italic, and Show Fonts (which opens the standard Mac OS X Font Panel). It also offers Copy Style and Paste Style commands, which let you apply the formatting of one text blob onto another one without having to go through all the same formatting steps.

These commands aren't of much use except when using iPhoto's book/calendar/card-designing feature (Chapter 9). You can't change the font used to display titles, descriptions, or keywords.

Spelling

Use the Spelling and Grammar commands to check for misspelled words and poorly written sentences within iPhoto. It's primarily useful when you're typing in the text paragraphs and photo names for books and calendars that you plan to order, as described in Chapter 9. Even then, you may find this feature a bit cumbersome.

Special Characters

Opens a palette of non-alphabetic symbols for entering into text boxes.

Photos Menu

This menu's commands come in handy when you're working with one or more photos. Most of the time, you need to select the photos, using any of the methods described on page 48, before choosing from this menu.

Show Extended Photo Info

This command (or Option-\(\mathbb{H}\)-I) opens the Extended Photo Info window. The various panels show information about a selected photo, such as its creation date and the camera model used to create it. The Location panel shows the GPS coordinates where it was taken (if there are any). Expand the Exposure panel for details about the specific camera settings that were used to take the picture. (iPhoto gathers all this information by reading EXIF tags—snippets of data invisibly embedded in the photo files created by most of today's digital cameras.)

You can open the Extended Photo Info window even when no photos are selected, but it won't have any info filled in. The data pops into the window as soon as you select a photo.

Tip: Once the Extended Photo Info window is open, you can leave it open. As you click different photos, the information in the window changes instantly to reflect your selection.

Adjust Date and Time

Opens a dialog box where you rewrite history by modifying the date and time stamps on the selected photos.

Batch Change

Opens a dialog box where you can apply a new title, date, or comment to any number of selected photos. See page 65 for full details.

Rotate

You can use the two Rotate commands in the submenu—Counter Clockwise or Clockwise—to rotate selected photos in 90-degree increments, switching them from landscape to portrait orientation as needed.

Photos Menu

However, the Rotate menu command is by far the *least* convenient way to rotate your photos. Here are some alternatives:

- Click the Rotate button below the main iPhoto window.
- Option-click the Rotate button to reverse the direction of the rotation. (You specify the "main" rotation direction in iPhoto—Preferences.)
- Press **%**-R to rotate selected photos counterclockwise, or Shift-**%**-R to rotate them clockwise.
- Control-click (or right-click) a photo or a thumbnail; choose Rotate from the shortcut menu.

My Rating

Lets you apply a rating of one through five stars to selected photos. See page 88 for the full story on this feature.

Flag Photo

Marks the selected photos with a little pennant icon. What it means is up to you: "Edit me later," "Candidate," whatever. Chapter 3 has details.

Hide Photo

Makes the selected photos disappear, so you don't have to stare at them. Great way to cull your library without actually deleting anything. See page 50 for details.

Duplicate

Just as in the Finder, this command creates a duplicate of whichever photo is selected and adds it to the library. And just as in the Finder, the keyboard shortcut is **%**-D. If you select multiple photos, then iPhoto duplicates all of them.

If an album is selected (and no photos are), this command duplicates the album itself. The copy appears at the bottom of the Source list, named Album-1 (or whatever number it's up to).

Move to Trash

Moves selected photos to iPhoto's private Trash, a holding bin for files you plan to permanently delete from your library. Instead of choosing this command, you can just drag thumbnails onto the Trash icon in the Source list; Control-click selected photos and choose Move to Trash from the shortcut menu; or press \(\mathbb{H} \)-Delete. (They're not actually deleted until you choose Empty iPhoto Trash.)

Revert to Original

The Revert to Original command restores edited photos to the condition they were in when you first imported them into iPhoto, reversing all the cropping, rotating, brightening, or anything else you've done (although it leaves titles, comments, and keywords undisturbed). This command is active only if you've edited the selected photo at least once.

If the Revert to Original command is dimmed out, it's probably for one of these reasons:

- · You don't have a photo selected.
- The photo you've selected hasn't been edited, so there's nothing to revert to.
- You edited the photo outside of iPhoto in an "unauthorized" way (by dragging the thumbnail to the Photoshop icon in the Dock, for example). iPhoto never had the chance to make a backup of the original version, which it needs to revert the file.

On the other hand, it's totally OK to edit photos outside of iPhoto—still activating the Revert to Original feature—if you do it by *double-clicking* the photo's thumbnail rather than dragging it, or by Control-clicking (right-clicking) it and choosing "Edit in external editor" from the shortcut menu.

Tip: When you're actually editing a photo, the command wording changes to say Revert to Previous. And when you've selected a RAW photo (page 23), the command says Reprocess RAW. They all mean the same thing.

Restore to Photo Library

The Move to Trash command morphs into this command when you're viewing the contents of iPhoto's Trash and have at least one thumbnail selected. It moves the selected photos out of the Trash and back into your library. The shortcut is the same as the one for Move to Trash—\$\mathfrak{H}\-96\$-Delete.

Events Menu

You can read all about Events—indeed, all about this menu's commands—in Chapter 2. But in short, an Event is a batch of photos that were taken all at about the same time; the premise is that it makes a lot of sense to organize photos by wedding, party, tournament, or whatever.

But Events are also extremely malleable. You can arbitrarily create them, split them, merge them, and so on. For example:

- Create Event. Moves the highlighted photos into a new, untitled Event.
- Create Event from Flagged Photos. Moves all *flagged* photos (page 77) into a new, untitled Event.
- Split Event. Breaks the currently displayed Event full of photos in two, using the first highlighted thumbnail as the split point. The command then changes to Merge With Above, in case you want to rejoin the two.
- Make Key Photo. Uses the highlighted picture as the *key photo*, the thumbnail that represents an entire Event "stack" when displayed in Events view.
- Add Flagged Photos To Selected Event. Moves all flagged photos (page 77) into the currently open Event. Handy way to round up photos from all over your library.

- Open Event in Separate Window. Just what it says. (Works only in Event view.)
- Autosplit Selected Events. Splits the selected Event into smaller ones, based on when those photos were taken. You'd use this command if you *didn't* use the Autosplit option at the moment you imported these pictures. (It's available only in Event view, and it determines which time blocks to use as Event delimiters according to your selection in iPhoto Preferences.)

Share Menu

The Share menu duplicates the functions of the icons on the bottom toolbar—but never changes. (The toolbar, on the other hand, may be different in someone else's copy of iPhoto.)

Email, Set Desktop, MobileMe, Facebook, Flickr...

Choosing one of these commands is exactly the same as clicking the corresponding toolbar button below the main iPhoto window. See Chapter 8 for emailing and online sharing; Chapter 12 for desktop pictures and screen savers; or Chapter 11 for burning slides to a DVD.

View Menu

This menu lets you change the order of your photos in the main viewing area, as well as the kind of information you want displayed along with each picture.

Titles, Ratings, Keywords, Event Titles

Select these commands to display titles, star ratings, keywords, or Event-name info in the main photo-viewing area. Titles, stars, and keywords always appear beneath each thumbnail; Events are denoted by horizontal lines, tiny key-photo icons, and flippy triangles.

You can turn each of these four commands on or off, in any combination, by repeatedly selecting it or by using the corresponding keyboard shortcuts: Shift-\mathbb{H}-T for Titles, Shift-\mathbb{H}-K for Keywords, Shift-\mathbb{H}-R for Ratings, and Shift-\mathbb{H}-F for Event Titles (it's F, because Events used to be called Film Rolls). A checkmark next to a command shows that it's currently turned on.

Hidden Photos

Makes all photos you've hidden reappear, for your convenience. (Choose again to make them vanish again.)

Sort Photos

Determines how iPhoto sorts the photo thumbnails in the viewing area. You have several options:

• By date. Arranges the photos chronologically based on the creation dates of each file.

- By keyword. Sorts your photos alphabetically by the *first* keyword you've applied to each. (Photos with no keywords appear at the top of the list.)
- By title. Uses the titles to sort photos alphabetically.
- By rating. Arranges all of your pictures by how good they are, from best to worst—at least, if you've taken the time to apply star ratings to them (Chapter 3). Unrated photos appear at the bottom.
- Manually. Lets you drag your photos into any order you like. (This choice is dimmed unless you're in an album. In the main library, you must use one of the first two options.)
- Ascending, Descending. Reverses the sorting order, no matter which criterion
 you've specified above. For example, it puts oldest photos at the top rather than
 newest.
- Reset Manual Sort. What if you're in an album, you carefully drag pictures into a custom order—and then you carelessly sort the whole thing alphabetically? This command restores the manual positioning.

Show in Toolbar

See those icons at the bottom of the main iPhoto window? Some of them are permanently installed and nonnegotiable, like Rotate, Edit, and Book.

The others, though, are optional. By choosing their names from the Show in Toolbar submenu, you can make them appear or disappear. (The names bearing checkmarks in the submenu are the ones that currently appear on the toolbar.)

The freedom to eliminate certain icons make a lot of sense. For one thing, some of them may not apply to you. The MobileMe Gallery icon is useful only if you're a MobileMe subscriber, the Send to iDVD button is helpful only if your Mac can burn DVDs, and so on. Furthermore, hiding the less useful icons leaves more room for the ones you do use (and reduces the likelihood that some of the buttons will be hidden behind the >> menu that sprouts whenever the window isn't wide enough).

Anyway, whatever functions you eliminate from the toolbar aren't gone for good. They're still available as commands right in the body of the Share menu.

Full Screen

Opens the Full Screen editing mode described on page 117.

Always Show Toolbar/Autohide Toolbar

In the full-screen editing view, the toolbar containing the various editing tools, ordinarily slips out of sight when you're not using it. It reappears only when your cursor approaches the bottom of the screen.

Choose this command to make the toolbar remain on the screen full-time. (At that point, the command changes to say Autohide Toolbar so you can restore the original behavior.)

Thumbnails

Several of iPhoto's modes—editing and book/card/calendar creation, for example—feature a scrolling stream of thumbnails that lets you jump from one photo to another without leaving the mode. The submenu here offers some useful flexibility, mostly in full-screen view:

- Show. In full-screen view, the thumbnails browser hides itself until your cursor approaches the top of the screen (or side, or wherever you've put it). Choose this command to make the thumbnails browser remain open all the time. (When you're editing in the iPhoto window, this command just says Hide or Show.)
- Position on Top/Left/Right. Governs where the thumbnails browser appears in full-screen view. Frankly, the left or right side may make more sense, since most monitors are wider than they are tall.
- 1 Row/2 Rows/3 Rows/4 Rows. In full-screen view, you can have easier access to more photos by stacking their thumbnails up to four deep in the thumbnails browser.

Window Menu

The Window menu is filled with the standard Mac OS X window-manipulating commands.

Minimize

Collapses the frontmost iPhoto window into the Dock, in standard Mac OS X fashion. It's just as though you pressed **%**-M or clicked the yellow Minimize button in the upper-left corner of any window.

Zoom

Zooms any iPhoto window to fill your entire screen (although it's nice enough to avoid covering up your Dock). Choosing this command is the same as clicking the green Zoom button in the upper-left corner of any iPhoto window.

If you choose the Zoom Window command (or click the Zoom button) again, the window shrinks back to its original proportions.

Show Keywords

Opens the Keywords window described on page 84.

Manage My Places

Opens the window where you can edit your My Places list when precisely geotagging your photos. See page 104.

Bring All to Front

Every now and then, the windows of two different Mac OS X programs get shuffled together, so that one iPhoto window is sandwiched between, say, two Safari windows.

This command brings all your iPhoto windows to the front so they're not being blocked by any other program's windows. (Clicking iPhoto's icon on the Dock does the same thing.)

[Window Names]

At the bottom of the Window menu, you'll see the names of all open windows. The main iPhoto window is, of course, called "iPhoto."

Help Menu

You know all too well that iPhoto comes with no user manual; that's why you're reading this book! What official Apple documentation you do get appears in this menu. (Hint: It ain't much.)

iPhoto Help

The assistance available through iPhoto Help is pretty limited, but at least you've got a searchable reference at your disposal if you forget how to do something (or lose this book).

- iPhoto Help. This command opens Apple's Help Viewer program—eventually.
- Welcome to iPhoto. Miss that big, imposing Welcome screen (Figure 1-1, top) that jumped up the first time you opened iPhoto '09? You can get it back with this command. It plays the Getting Started video.
- Video Tutorials. Takes you to Apple's Web site, where you can watch some useful video demos of various features.
- **Keyboard Shortcuts.** This is just another link into the iPhoto Help system, but a particularly valuable one. It takes you to a table showing more than 50 keyboard shortcuts in iPhoto. This is one help page that's worth printing out.
- Service and Support. Fires up your Web browser and opens Apple's main iPhoto support page. You may be asked to enter your Apple ID and password. (This is usually your email address plus the password you created when you registered iPhoto or another Apple product.)

Where to Go From Here

Your Mac, your trusty digital camera, and this book are all you need to *begin* enjoying the art and science of modern photography. But as your skills increase and your interests broaden, you may want to explore new techniques, add equipment, and learn from people who've become just as obsessed as you. Here's a tasty menu of online resources to help you along the way.

iPhoto and the Web

- Apple's iPhoto support page features the latest product information, QuickTime tutorials, FAQ (frequently asked questions) lists, camera and printer compatibility charts, and links to discussion forums where other iPhoto users share knowledge and lend helping hands. There's even a feedback form that goes directly to Apple. In fact, each piece of feedback is read personally by top-level Apple executives. (Just a little joke there.) www.apple.com/iphoto
- VersionTracker is a massive database that tracks, and provides links to, all of the latest software for Mac OS X, including the cool iPhoto add-ons described in this book. www.versiontracker.com
- O'Reilly's Mac DevCenter features the latest Mac software techniques for power users and programmers. www.macdevcenter.com

Digital Photo Equipment Online

• Imaging-Resource offers equipment reviews, price comparisons, and forums, all dedicated to putting the right digital camera in your hands. www.imaging-resource. com

Digital Photo Equipment Online

- Digital Photography Review is similar: It offers news, reviews, buying guides, photo galleries, and forums. It's a must-visit site for the digicam nut. www.dpreview.com
- Digital Camera Resource is just what it says: a comprehensive resource page comparing the latest in digital cameras. www.dcresource.com
- Photo.net offers industry news, galleries, shopping, travel, critique, and community sharing. www.photo.net
- Photo District News covers trends on the photography industry, news, and camera reviews, plus RSS feeds to keep you updated on the go. www.pdnonline.com

Show Your Pictures

Nothing beats Flickr.com, Facebook.com, and MobileMe for easily posting your pictures online, straight from iPhoto (Chapter 8). But there are alternatives:

- Photobucket offers its members Web space for 10,000 photos—free. The photosharing site groups submitted photos into categories like "Funny Signs" and "Black & White" for easy browsing on its home page and features one-click posting to sites like Facebook, Blogger, TypePad, and MySpace. www.photobucket.com
- Fotki.com is similar—it, too, is a thriving online community of photo fans who share their work online—but the free account is unlimited. Chime in with your shots, or just check out what everyone else is shooting. www.fotki.com

Online Instruction

 ShortCourses.com offers short courses in digital photography techniques and how to use current equipment. www.shortcourses.com

Online Printing

- **Shutterfly** is an alternative to iPhoto's built-in photo-ordering system. It's Mac OS X-friendly and highly reviewed (at least by *Macworld*). *www.shutterfly.com*
- American Greetings PhotoWorks is another Mac OS X-friendly photo printing site that's also received high marks for quality. www.photoworks.com

O'Reilly Guides

David Pogue's Digital Photography: The Missing Manual offers expert advice from the moment you start shopping for a digital camera to producing your own stunning shots—with plenty of nuts-and-bolts instruction on lighting, composition, and choosing the best camera settings along the way.

Digital Photography Companion by Derrick Story is a handy, on-the-go digital-photo reference that fits nicely in your camera bag.

Take Your Best Shot by Tim Grey dives into the digital darkroom, covering the fundamentals of camera hardware as well as more advanced topics like color management and optimizing images.

Index

Index

Numbers	Aperture, 62, 319, 320
16-bit TIFF files, 147, 336	Appearance, 72, 335 Add or remove an outline or a shadow, 72
<u>A</u>	Adjust the alignment, 73 Change the background color, 73
AAC file format, 279	Show scrolling information, 73
About iPhoto, 333	Use smooth scrolling, 73
Action list (Automator), 305	AppleScript tricks, 304
Add Flagged Photos To Selected Event, 345	archiving photos to disc, 315
Add New Place, 104–106	aspect ratio, 177
Adjust Date and Time, 343	ATP PhotoFinder, 103
Adjust palette, 183	Autoflow button, 231
Adjust panel, 131–132	Autohide Toolbar, 347
Adobe Photoshop Lightroom, 319, 320	Auto Levels command, 142
Advanced (Preferences), 336	automating iPhoto, 306–308
AlbumData.xml, 30	Automator, 304–307
albums, 37, 55–60	Action list, 305
adding photos, 57	automating iPhoto, 306-308
advantages, 55	Library list, 304
creating	scanner/cellphone auto-import workflow, 306
by dragging, 56	Workflow pane, 305
by selecting, 57	Autosplit Selected Events, 45, 346
empty album, 56	
deleting, 60	B
duplicating, 60	backups, 313-314
duplicating photos, 59	backing up Library, 29
merging, 60	CDs or DVDs, 313
moving photos between, 58	deleting originals, 315
putting photos in order, 59	without CD burner, 313–314
removing photos, 58	Batch Change, 65, 66, 343
smart albums, 61–63	BetterHTMLExport, 219, 303
versus keywords, 84	downloading, 220
viewing, 57	blurry-photo effect, 50
Always Show Toolbar, 347	BMP files, 25
American Greetings PhotoWorks, 352	book-creation process
America Online, 190	Book Type pop-up menu, 227
Antique effect, 130	choosing page layout, 233–236

book-creation process continued	choosing cover color, 251
Blank, 236	inspecting charges, 252
Cover, 234	quantity, 252
Introduction, 234	themes, 227–231
Map, 234	Contemporary, 230
One, Two, Three, Four, 235	Crayon, 230
Title, Text, About, Contact, 235	Family Album, 230
cover photo, 235	Folio, 230
designing pages, 231–243	Formal, 230
4:3 aspect ratio, 242	Line Border, 228
backgrounds, 240–241	Picture Book, 228
choosing page layout, 233–236	Simple Border, 228
choosing photos, 226	Snapshots, 229
hiding page numbers, 243	Textured Border, 228
opening page, 232–233	Travel, 228
page limits, 243	Watercolor, 230
editing titles and captions, 243-248	yellow triangle exclamation point, 249
About, 245	Boost Color effect, 130
book title, 244	Bring All to Front, 348
Captions, 245	Browse Backups, 339
Chapter, 244	bundles, 29
Contact, 245	Burn command, 29
dust jacket, 244	burning CDs or DVDs, 310-313
editing text, 245	deleting originals, 315
formatting text, 245	when not to burn, 312
Introduction, 244	Burns, Ken, 166
listening to book, 248	B & W (Black and White) effect, 130
spelling, 247	
5pc11115, 2-17	
	C
Text Page, 245 Keepsakes button, 226	
Text Page, 245	C calendars, 80–83 date, 82
Text Page, 245 Keepsakes button, 226 laying out book, 236–240	calendars, 80–83 date, 82
Text Page, 245 Keepsakes button, 226 laying out book, 236–240 adding photos, 236	calendars, 80–83
Text Page, 245 Keepsakes button, 226 laying out book, 236–240 adding photos, 236 adding photos to photo browser, 237	calendars, 80–83 date, 82 deselecting photos, 83 month, 81
Text Page, 245 Keepsakes button, 226 laying out book, 236–240 adding photos, 236 adding photos to photo browser, 237 editing photos, 239	calendars, 80–83 date, 82 deselecting photos, 83
Text Page, 245 Keepsakes button, 226 laying out book, 236–240 adding photos, 236 adding photos to photo browser, 237 editing photos, 239 enlarging or cropping photos, 238	calendars, 80–83 date, 82 deselecting photos, 83 month, 81 skipping to next, 83 multiple adjacent time units, 82
Text Page, 245 Keepsakes button, 226 laying out book, 236–240 adding photos, 236 adding photos to photo browser, 237 editing photos, 239	calendars, 80–83 date, 82 deselecting photos, 83 month, 81 skipping to next, 83
Text Page, 245 Keepsakes button, 226 laying out book, 236–240 adding photos, 236 adding photos to photo browser, 237 editing photos, 239 enlarging or cropping photos, 238 filling empty placeholder, 238	calendars, 80–83 date, 82 deselecting photos, 83 month, 81 skipping to next, 83 multiple adjacent time units, 82 multiple time units that aren't adjacent, 82
Text Page, 245 Keepsakes button, 226 laying out book, 236–240 adding photos, 236 adding photos to photo browser, 237 editing photos, 239 enlarging or cropping photos, 238 filling empty placeholder, 238 layout strategies, 240	calendars, 80–83 date, 82 deselecting photos, 83 month, 81 skipping to next, 83 multiple adjacent time units, 82 multiple time units that aren't adjacent, 82 week, 82
Text Page, 245 Keepsakes button, 226 laying out book, 236–240 adding photos, 236 adding photos to photo browser, 237 editing photos, 239 enlarging or cropping photos, 238 filling empty placeholder, 238 layout strategies, 240 manipulating pages, 240	calendars, 80–83 date, 82 deselecting photos, 83 month, 81 skipping to next, 83 multiple adjacent time units, 82 multiple time units that aren't adjacent, 82 week, 82 Year view, 82
Text Page, 245 Keepsakes button, 226 laying out book, 236–240 adding photos, 236 adding photos to photo browser, 237 editing photos, 239 enlarging or cropping photos, 238 filling empty placeholder, 238 layout strategies, 240 manipulating pages, 240 moving photo to different page, 236	calendars, 80–83 date, 82 deselecting photos, 83 month, 81 skipping to next, 83 multiple adjacent time units, 82 multiple time units that aren't adjacent, 82 week, 82 Year view, 82 calendars, creating, 253–258 choosing photos, 253
Text Page, 245 Keepsakes button, 226 laying out book, 236–240 adding photos, 236 adding photos to photo browser, 237 editing photos, 239 enlarging or cropping photos, 238 filling empty placeholder, 238 layout strategies, 240 manipulating pages, 240 moving photo to different page, 236 overlapping photos, 239	calendars, 80–83 date, 82 deselecting photos, 83 month, 81 skipping to next, 83 multiple adjacent time units, 82 multiple time units that aren't adjacent, 82 week, 82 Year view, 82 calendars, creating, 253–258
Text Page, 245 Keepsakes button, 226 laying out book, 236–240 adding photos, 236 adding photos to photo browser, 237 editing photos, 239 enlarging or cropping photos, 238 filling empty placeholder, 238 layout strategies, 240 manipulating pages, 240 moving photo to different page, 236 overlapping photos, 239 removing photos, 236	calendars, 80–83 date, 82 deselecting photos, 83 month, 81 skipping to next, 83 multiple adjacent time units, 82 multiple time units that aren't adjacent, 82 week, 82 Year view, 82 calendars, creating, 253–258 choosing photos, 253 designing pages, 255–257
Text Page, 245 Keepsakes button, 226 laying out book, 236–240 adding photos, 236 adding photos to photo browser, 237 editing photos, 239 enlarging or cropping photos, 238 filling empty placeholder, 238 layout strategies, 240 manipulating pages, 240 moving photo to different page, 236 overlapping photos, 239 removing photos, 236 swapping in photo, 237	calendars, 80–83 date, 82 deselecting photos, 83 month, 81 skipping to next, 83 multiple adjacent time units, 82 multiple time units that aren't adjacent, 82 week, 82 Year view, 82 calendars, creating, 253–258 choosing photos, 253 designing pages, 255–257 cover, 255 individual date squares, 256
Text Page, 245 Keepsakes button, 226 laying out book, 236–240 adding photos, 236 adding photos to photo browser, 237 editing photos, 239 enlarging or cropping photos, 238 filling empty placeholder, 238 layout strategies, 240 manipulating pages, 240 moving photo to different page, 236 overlapping photos, 239 removing photos, 236 swapping in photo, 237 swapping photos, 236 Options+Prices button, 231 placing photos	calendars, 80–83 date, 82 deselecting photos, 83 month, 81 skipping to next, 83 multiple adjacent time units, 82 multiple time units that aren't adjacent, 82 week, 82 Year view, 82 calendars, creating, 253–258 choosing photos, 253 designing pages, 255–257 cover, 255 individual date squares, 256 upper page, 255
Text Page, 245 Keepsakes button, 226 laying out book, 236–240 adding photos, 236 adding photos to photo browser, 237 editing photos, 239 enlarging or cropping photos, 238 filling empty placeholder, 238 layout strategies, 240 manipulating pages, 240 moving photo to different page, 236 overlapping photos, 239 removing photos, 236 swapping in photo, 237 swapping photos, 236	calendars, 80–83 date, 82 deselecting photos, 83 month, 81 skipping to next, 83 multiple adjacent time units, 82 multiple time units that aren't adjacent, 82 week, 82 Year view, 82 calendars, creating, 253–258 choosing photos, 253 designing pages, 255–257 cover, 255 individual date squares, 256
Text Page, 245 Keepsakes button, 226 laying out book, 236–240 adding photos, 236 adding photos to photo browser, 237 editing photos, 239 enlarging or cropping photos, 238 filling empty placeholder, 238 layout strategies, 240 manipulating pages, 240 moving photo to different page, 236 overlapping photos, 239 removing photos, 236 swapping in photo, 237 swapping photos, 236 Options+Prices button, 231 placing photos	calendars, 80–83 date, 82 deselecting photos, 83 month, 81 skipping to next, 83 multiple adjacent time units, 82 multiple time units that aren't adjacent, 82 week, 82 Year view, 82 calendars, creating, 253–258 choosing photos, 253 designing pages, 255–257 cover, 255 individual date squares, 256 upper page, 255 editing text, 258 iCal, 255
Text Page, 245 Keepsakes button, 226 laying out book, 236–240 adding photos, 236 adding photos to photo browser, 237 editing photos, 239 enlarging or cropping photos, 238 filling empty placeholder, 238 layout strategies, 240 manipulating pages, 240 moving photo to different page, 236 overlapping photos, 239 removing photos, 236 swapping in photo, 237 swapping in photo, 237 swapping photos, 236 Options+Prices button, 231 placing photos Autoflow button, 231	calendars, 80–83 date, 82 deselecting photos, 83 month, 81 skipping to next, 83 multiple adjacent time units, 82 multiple time units that aren't adjacent, 82 week, 82 Year view, 82 calendars, creating, 253–258 choosing photos, 253 designing pages, 255–257 cover, 255 individual date squares, 256 upper page, 255 editing text, 258
Text Page, 245 Keepsakes button, 226 laying out book, 236–240 adding photos, 236 adding photos to photo browser, 237 editing photos, 239 enlarging or cropping photos, 238 filling empty placeholder, 238 layout strategies, 240 manipulating pages, 240 moving photo to different page, 236 overlapping photos, 239 removing photos, 236 swapping in photo, 237 swapping in photo, 237 swapping photos, 236 Options+Prices button, 231 placing photos Autoflow button, 231 manually, 232	calendars, 80–83 date, 82 deselecting photos, 83 month, 81 skipping to next, 83 multiple adjacent time units, 82 multiple time units that aren't adjacent, 82 week, 82 Year view, 82 calendars, creating, 253–258 choosing photos, 253 designing pages, 255–257 cover, 255 individual date squares, 256 upper page, 255 editing text, 258 iCal, 255 Keepsakes button, 253
Text Page, 245 Keepsakes button, 226 laying out book, 236–240 adding photos, 236 adding photos to photo browser, 237 editing photos, 239 enlarging or cropping photos, 238 filling empty placeholder, 238 layout strategies, 240 manipulating pages, 240 moving photo to different page, 236 overlapping photos, 239 removing photos, 236 swapping in photo, 237 swapping in photo, 237 swapping photos, 236 Options+Prices button, 231 placing photos Autoflow button, 231 manually, 232 previewing, 248–250	calendars, 80–83 date, 82 deselecting photos, 83 month, 81 skipping to next, 83 multiple adjacent time units, 82 multiple time units that aren't adjacent, 82 week, 82 Year view, 82 calendars, creating, 253–258 choosing photos, 253 designing pages, 255–257 cover, 255 individual date squares, 256 upper page, 255 editing text, 258 iCal, 255 Keepsakes button, 253 ordering, 258
Text Page, 245 Keepsakes button, 226 laying out book, 236–240 adding photos, 236 adding photos to photo browser, 237 editing photos, 239 enlarging or cropping photos, 238 filling empty placeholder, 238 layout strategies, 240 manipulating pages, 240 moving photo to different page, 236 overlapping photos, 239 removing photos, 236 swapping in photo, 237 swapping in photo, 237 swapping photos, 236 Options+Prices button, 231 placing photos Autoflow button, 231 manually, 232 previewing, 248–250 PDF document, 250	calendars, 80–83 date, 82 deselecting photos, 83 month, 81 skipping to next, 83 multiple adjacent time units, 82 multiple time units that aren't adjacent, 82 week, 82 Year view, 82 calendars, creating, 253–258 choosing photos, 253 designing pages, 255–257 cover, 255 individual date squares, 256 upper page, 255 editing text, 258 iCal, 255 Keepsakes button, 253 ordering, 258 themes, 254 Camera Model, 62
Text Page, 245 Keepsakes button, 226 laying out book, 236–240 adding photos, 236 adding photos to photo browser, 237 editing photos, 239 enlarging or cropping photos, 238 filling empty placeholder, 238 layout strategies, 240 manipulating pages, 240 moving photo to different page, 236 overlapping photos, 239 removing photos, 236 swapping in photo, 237 swapping in photo, 237 swapping photos, 236 Options+Prices button, 231 placing photos Autoflow button, 231 manually, 232 previewing, 248–250 PDF document, 250 printing, 248	calendars, 80–83 date, 82 deselecting photos, 83 month, 81 skipping to next, 83 multiple adjacent time units, 82 multiple time units that aren't adjacent, 82 week, 82 Year view, 82 calendars, creating, 253–258 choosing photos, 253 designing pages, 255–257 cover, 255 individual date squares, 256 upper page, 255 editing text, 258 iCal, 255 Keepsakes button, 253 ordering, 258 themes, 254
Text Page, 245 Keepsakes button, 226 laying out book, 236–240 adding photos, 236 adding photos to photo browser, 237 editing photos, 239 enlarging or cropping photos, 238 filling empty placeholder, 238 layout strategies, 240 manipulating pages, 240 moving photo to different page, 236 overlapping photos, 239 removing photos, 236 swapping in photo, 237 swapping in photo, 237 swapping photos, 236 Options+Prices button, 231 placing photos Autoflow button, 231 manually, 232 previewing, 248–250 PDF document, 250 printing, 248 slideshow, 249	calendars, 80–83 date, 82 deselecting photos, 83 month, 81 skipping to next, 83 multiple adjacent time units, 82 multiple time units that aren't adjacent, 82 week, 82 Year view, 82 calendars, creating, 253–258 choosing photos, 253 designing pages, 255–257 cover, 255 individual date squares, 256 upper page, 255 editing text, 258 iCal, 255 Keepsakes button, 253 ordering, 258 themes, 254 Camera Model, 62 camera not importing images, 325
Text Page, 245 Keepsakes button, 226 laying out book, 236–240 adding photos, 236 adding photos to photo browser, 237 editing photos, 239 enlarging or cropping photos, 238 filling empty placeholder, 238 layout strategies, 240 manipulating pages, 240 moving photo to different page, 236 overlapping photos, 239 removing photos, 236 swapping in photo, 237 swapping in photo, 237 swapping photos, 236 Options+Prices button, 231 placing photos Autoflow button, 231 manually, 232 previewing, 248–250 PDF document, 250 printing, 248 slideshow, 249 publishing options, 226–231	calendars, 80–83 date, 82 deselecting photos, 83 month, 81 skipping to next, 83 multiple adjacent time units, 82 multiple time units that aren't adjacent, 82 week, 82 Year view, 82 calendars, creating, 253–258 choosing photos, 253 designing pages, 255–257 cover, 255 individual date squares, 256 upper page, 255 editing text, 258 iCal, 255 Keepsakes button, 253 ordering, 258 themes, 254 Camera Model, 62 camera not importing images, 325 camera not recognized, 324

captions (slideshows), 160	transferred, 16
CDs and DVDs, burning, 310–313	unable to delete, 329
backups, 313	De-noise slider, 139
when not to burn, 312	Description (smart albums), 62
channels, 133	desktop wallpaper, 297–299
Check for Updates, 323, 337	Center, 298
Claris Emailer, 192	Fill screen, 298
Clockwise, 120	Stretch to fill screen, 298
Close Window, 339	Tile, 299
color balance, 139–142	digital asset management, 319
automatic color correction, 141-147	Digital Camera Resource, 352
manual color adjustment, 140-141	Digital Photography Companion, 352
Temperature slider, 140	Digital Photography Review, 352
Tint slider, 140	digital photo management, 9
ColorSync Utility program, 336	digital shoebox, 33–76
comments, changing, 65	Appearance panel, 72
Compare button, 117	Add or remove an outline or a shadow, 72
Contrast slider, 135–136	Adjust the alignment, 73
converting photos (see exporting and	Change the background color, 73
converting photos)	Show scrolling information, 73
Copy, 342	Use smooth scrolling, 73
Copy button, 142	customizing, 72–76
copying items to iPhoto Library, 336	showing/hiding keywords, titles, and event
Counter Clockwise, 120	info, 74
crashing	Dir.data, 30
double-click thumbnail, 327	disk image files, 315
emptying trash, 325	document management program, 22
importing, 324	dpi (dots per inch), 176
Create Event, 345	dragging files into iPhoto, 21
Create Event, 345 Create Event from Flagged Photos, 345	dragging files into iPhoto, 21 Duplicate, 344
Create Event, 345 Create Event from Flagged Photos, 345 creation dates, 29	dragging files into iPhoto, 21
Create Event, 345 Create Event from Flagged Photos, 345 creation dates, 29 cropping photos, 121–124	dragging files into iPhoto, 21 Duplicate, 344
Create Event, 345 Create Event from Flagged Photos, 345 creation dates, 29 cropping photos, 121–124 adjusting, 124	dragging files into iPhoto, 21 Duplicate, 344 duplicating imported photos, 20 E
Create Event, 345 Create Event from Flagged Photos, 345 creation dates, 29 cropping photos, 121–124 adjusting, 124 Constrain pop-up menu, 121–124	dragging files into iPhoto, 21 Duplicate, 344 duplicating imported photos, 20 E Edge Blur effect, 131
Create Event, 345 Create Event from Flagged Photos, 345 creation dates, 29 cropping photos, 121–124 adjusting, 124 Constrain pop-up menu, 121–124 isolated photo, 124	dragging files into iPhoto, 21 Duplicate, 344 duplicating imported photos, 20 E Edge Blur effect, 131 editing photos, 10, 28, 113–116
Create Event, 345 Create Event from Flagged Photos, 345 creation dates, 29 cropping photos, 121–124 adjusting, 124 Constrain pop-up menu, 121–124 isolated photo, 124 ordering prints online, 185	dragging files into iPhoto, 21 Duplicate, 344 duplicating imported photos, 20 E Edge Blur effect, 131 editing photos, 10, 28, 113–116 Adjust panel, 131–132
Create Event, 345 Create Event from Flagged Photos, 345 creation dates, 29 cropping photos, 121–124 adjusting, 124 Constrain pop-up menu, 121–124 isolated photo, 124 ordering prints online, 185 problems, 123	dragging files into iPhoto, 21 Duplicate, 344 duplicating imported photos, 20 E Edge Blur effect, 131 editing photos, 10, 28, 113–116 Adjust panel, 131–132 backing out, 119
Create Event, 345 Create Event from Flagged Photos, 345 creation dates, 29 cropping photos, 121–124 adjusting, 124 Constrain pop-up menu, 121–124 isolated photo, 124 ordering prints online, 185	dragging files into iPhoto, 21 Duplicate, 344 duplicating imported photos, 20 E Edge Blur effect, 131 editing photos, 10, 28, 113–116 Adjust panel, 131–132 backing out, 119 color balance, 139–142
Create Event, 345 Create Event from Flagged Photos, 345 creation dates, 29 cropping photos, 121–124 adjusting, 124 Constrain pop-up menu, 121–124 isolated photo, 124 ordering prints online, 185 problems, 123	dragging files into iPhoto, 21 Duplicate, 344 duplicating imported photos, 20 E Edge Blur effect, 131 editing photos, 10, 28, 113–116 Adjust panel, 131–132 backing out, 119 color balance, 139–142 automatic color correction, 141–147
Create Event, 345 Create Event from Flagged Photos, 345 creation dates, 29 cropping photos, 121–124 adjusting, 124 Constrain pop-up menu, 121–124 isolated photo, 124 ordering prints online, 185 problems, 123 Cut, 342 D	dragging files into iPhoto, 21 Duplicate, 344 duplicating imported photos, 20 E Edge Blur effect, 131 editing photos, 10, 28, 113–116 Adjust panel, 131–132 backing out, 119 color balance, 139–142 automatic color correction, 141–147 manual color adjustment, 140–141
Create Event, 345 Create Event from Flagged Photos, 345 creation dates, 29 cropping photos, 121–124 adjusting, 124 Constrain pop-up menu, 121–124 isolated photo, 124 ordering prints online, 185 problems, 123 Cut, 342 D damaging photo collections, 31	dragging files into iPhoto, 21 Duplicate, 344 duplicating imported photos, 20 E Edge Blur effect, 131 editing photos, 10, 28, 113–116 Adjust panel, 131–132 backing out, 119 color balance, 139–142 automatic color correction, 141–147 manual color adjustment, 140–141 comparing "before" and "after" versions of
Create Event, 345 Create Event from Flagged Photos, 345 creation dates, 29 cropping photos, 121–124 adjusting, 124 Constrain pop-up menu, 121–124 isolated photo, 124 ordering prints online, 185 problems, 123 Cut, 342 D damaging photo collections, 31 Data folder, 31	dragging files into iPhoto, 21 Duplicate, 344 duplicating imported photos, 20 E Edge Blur effect, 131 editing photos, 10, 28, 113–116 Adjust panel, 131–132 backing out, 119 color balance, 139–142 automatic color correction, 141–147 manual color adjustment, 140–141 comparing "before" and "after" versions of photo, 119
Create Event, 345 Create Event from Flagged Photos, 345 creation dates, 29 cropping photos, 121–124 adjusting, 124 Constrain pop-up menu, 121–124 isolated photo, 124 ordering prints online, 185 problems, 123 Cut, 342 D damaging photo collections, 31 Data folder, 31 dates	dragging files into iPhoto, 21 Duplicate, 344 duplicating imported photos, 20 E Edge Blur effect, 131 editing photos, 10, 28, 113–116 Adjust panel, 131–132 backing out, 119 color balance, 139–142 automatic color correction, 141–147 manual color adjustment, 140–141 comparing "before" and "after" versions of photo, 119 Contrast slider, 135–136
Create Event, 345 Create Event from Flagged Photos, 345 creation dates, 29 cropping photos, 121–124 adjusting, 124 Constrain pop-up menu, 121–124 isolated photo, 124 ordering prints online, 185 problems, 123 Cut, 342 D damaging photo collections, 31 Data folder, 31 dates changing, 65, 67	dragging files into iPhoto, 21 Duplicate, 344 duplicating imported photos, 20 E Edge Blur effect, 131 editing photos, 10, 28, 113–116 Adjust panel, 131–132 backing out, 119 color balance, 139–142 automatic color correction, 141–147 manual color adjustment, 140–141 comparing "before" and "after" versions of photo, 119 Contrast slider, 135–136 copying and pasting, 142
Create Event, 345 Create Event from Flagged Photos, 345 creation dates, 29 cropping photos, 121–124 adjusting, 124 Constrain pop-up menu, 121–124 isolated photo, 124 ordering prints online, 185 problems, 123 Cut, 342 D damaging photo collections, 31 Data folder, 31 dates changing, 65, 67 sorting by, 42	dragging files into iPhoto, 21 Duplicate, 344 duplicating imported photos, 20 E Edge Blur effect, 131 editing photos, 10, 28, 113–116 Adjust panel, 131–132 backing out, 119 color balance, 139–142 automatic color correction, 141–147 manual color adjustment, 140–141 comparing "before" and "after" versions of photo, 119 Contrast slider, 135–136 copying and pasting, 142 cropping, 121–124
Create Event, 345 Create Event from Flagged Photos, 345 creation dates, 29 cropping photos, 121–124 adjusting, 124 Constrain pop-up menu, 121–124 isolated photo, 124 ordering prints online, 185 problems, 123 Cut, 342 D damaging photo collections, 31 Data folder, 31 dates changing, 65, 67 sorting by, 42 (see also calendars)	dragging files into iPhoto, 21 Duplicate, 344 duplicating imported photos, 20 E Edge Blur effect, 131 editing photos, 10, 28, 113–116 Adjust panel, 131–132 backing out, 119 color balance, 139–142 automatic color correction, 141–147 manual color adjustment, 140–141 comparing "before" and "after" versions of photo, 119 Contrast slider, 135–136 copying and pasting, 142 cropping, 121–124 adjusting, 124
Create Event, 345 Create Event from Flagged Photos, 345 creation dates, 29 cropping photos, 121–124 adjusting, 124 Constrain pop-up menu, 121–124 isolated photo, 124 ordering prints online, 185 problems, 123 Cut, 342 D damaging photo collections, 31 Data folder, 31 dates changing, 65, 67 sorting by, 42 (see also calendars) Date (smart albums), 62	dragging files into iPhoto, 21 Duplicate, 344 duplicating imported photos, 20 E Edge Blur effect, 131 editing photos, 10, 28, 113–116 Adjust panel, 131–132 backing out, 119 color balance, 139–142 automatic color correction, 141–147 manual color adjustment, 140–141 comparing "before" and "after" versions of photo, 119 Contrast slider, 135–136 copying and pasting, 142 cropping, 121–124 adjusting, 124 Constrain pop-up menu, 121–124
Create Event, 345 Create Event from Flagged Photos, 345 creation dates, 29 cropping photos, 121–124 adjusting, 124 Constrain pop-up menu, 121–124 isolated photo, 124 ordering prints online, 185 problems, 123 Cut, 342 D damaging photo collections, 31 Data folder, 31 dates changing, 65, 67 sorting by, 42 (see also calendars) Date (smart albums), 62 David Pogue's Digital Photography:	dragging files into iPhoto, 21 Duplicate, 344 duplicating imported photos, 20 E Edge Blur effect, 131 editing photos, 10, 28, 113–116 Adjust panel, 131–132 backing out, 119 color balance, 139–142 automatic color correction, 141–147 manual color adjustment, 140–141 comparing "before" and "after" versions of photo, 119 Contrast slider, 135–136 copying and pasting, 142 cropping, 121–124 adjusting, 124 Constrain pop-up menu, 121–124 isolated photo, 124
Create Event, 345 Create Event from Flagged Photos, 345 creation dates, 29 cropping photos, 121–124 adjusting, 124 Constrain pop-up menu, 121–124 isolated photo, 124 ordering prints online, 185 problems, 123 Cut, 342 D damaging photo collections, 31 Data folder, 31 dates changing, 65, 67 sorting by, 42 (see also calendars) Date (smart albums), 62 David Pogue's Digital Photography: The Missing Manual, 352	dragging files into iPhoto, 21 Duplicate, 344 duplicating imported photos, 20 E Edge Blur effect, 131 editing photos, 10, 28, 113–116 Adjust panel, 131–132 backing out, 119 color balance, 139–142 automatic color correction, 141–147 manual color adjustment, 140–141 comparing "before" and "after" versions of photo, 119 Contrast slider, 135–136 copying and pasting, 142 cropping, 121–124 adjusting, 124 Constrain pop-up menu, 121–124 isolated photo, 124 problems, 123
Create Event, 345 Create Event from Flagged Photos, 345 creation dates, 29 cropping photos, 121–124 adjusting, 124 Constrain pop-up menu, 121–124 isolated photo, 124 ordering prints online, 185 problems, 123 Cut, 342 D damaging photo collections, 31 Data folder, 31 dates changing, 65, 67 sorting by, 42 (see also calendars) Date (smart albums), 62 David Pogue's Digital Photography: The Missing Manual, 352 Definition slider, 138	dragging files into iPhoto, 21 Duplicate, 344 duplicating imported photos, 20 E Edge Blur effect, 131 editing photos, 10, 28, 113–116 Adjust panel, 131–132 backing out, 119 color balance, 139–142 automatic color correction, 141–147 manual color adjustment, 140–141 comparing "before" and "after" versions of photo, 119 Contrast slider, 135–136 copying and pasting, 142 cropping, 121–124 adjusting, 124 Constrain pop-up menu, 121–124 isolated photo, 124 problems, 123 Definition slider, 138
Create Event, 345 Create Event from Flagged Photos, 345 creation dates, 29 cropping photos, 121–124 adjusting, 124 Constrain pop-up menu, 121–124 isolated photo, 124 ordering prints online, 185 problems, 123 Cut, 342 D damaging photo collections, 31 Data folder, 31 dates changing, 65, 67 sorting by, 42 (see also calendars) Date (smart albums), 62 David Pogue's Digital Photography: The Missing Manual, 352 Definition slider, 138 Delete Originals, 16	dragging files into iPhoto, 21 Duplicate, 344 duplicating imported photos, 20 E Edge Blur effect, 131 editing photos, 10, 28, 113–116 Adjust panel, 131–132 backing out, 119 color balance, 139–142 automatic color correction, 141–147 manual color adjustment, 140–141 comparing "before" and "after" versions of photo, 119 Contrast slider, 135–136 copying and pasting, 142 cropping, 121–124 adjusting, 124 Constrain pop-up menu, 121–124 isolated photo, 124 problems, 123 Definition slider, 138 De-noise slider, 139
Create Event, 345 Create Event from Flagged Photos, 345 creation dates, 29 cropping photos, 121–124 adjusting, 124 Constrain pop-up menu, 121–124 isolated photo, 124 ordering prints online, 185 problems, 123 Cut, 342 D damaging photo collections, 31 Data folder, 31 dates changing, 65, 67 sorting by, 42 (see also calendars) Date (smart albums), 62 David Pogue's Digital Photography: The Missing Manual, 352 Definition slider, 138 Delete Originals, 16 deleting photos, 28, 70–72	dragging files into iPhoto, 21 Duplicate, 344 duplicating imported photos, 20 E Edge Blur effect, 131 editing photos, 10, 28, 113–116 Adjust panel, 131–132 backing out, 119 color balance, 139–142 automatic color correction, 141–147 manual color adjustment, 140–141 comparing "before" and "after" versions of photo, 119 Contrast slider, 135–136 copying and pasting, 142 cropping, 121–124 adjusting, 124 Constrain pop-up menu, 121–124 isolated photo, 124 problems, 123 Definition slider, 138 De-noise slider, 139 double-clicking, 115
Create Event, 345 Create Event from Flagged Photos, 345 creation dates, 29 cropping photos, 121–124 adjusting, 124 Constrain pop-up menu, 121–124 isolated photo, 124 ordering prints online, 185 problems, 123 Cut, 342 D damaging photo collections, 31 Data folder, 31 dates changing, 65, 67 sorting by, 42 (see also calendars) Date (smart albums), 62 David Pogue's Digital Photography: The Missing Manual, 352 Definition slider, 138 Delete Originals, 16	dragging files into iPhoto, 21 Duplicate, 344 duplicating imported photos, 20 E Edge Blur effect, 131 editing photos, 10, 28, 113–116 Adjust panel, 131–132 backing out, 119 color balance, 139–142 automatic color correction, 141–147 manual color adjustment, 140–141 comparing "before" and "after" versions of photo, 119 Contrast slider, 135–136 copying and pasting, 142 cropping, 121–124 adjusting, 124 Constrain pop-up menu, 121–124 isolated photo, 124 problems, 123 Definition slider, 138 De-noise slider, 139

editing photos

editing photos continued	editing toolbar, 116
Boost Color, 130	editing tools, 3
B & W (Black and White), 130	Edit menu, 341–343
Edge Blur, 131	Copy, 342
Fade Color, 130	Cut, 342
Matte, 130	Find, 342
Original, 130	Font, 342
Sepia, 130	Paste, 342
Vignette, 130	Redo, 341
Enhance button, 125–127	Select All, 342
applying multiple times, 126	Select None, 342
Exposure slider, 134–135	Special Characters, 343
JPEG files, 134	Spelling, 343
RAW files, 134	Undo, 341
external editors, 143	Edit Smart Album, 339
fluorescent lighting, 140	Effects palette, 129–131
full-screen mode, 114, 117-118	Antique, 130
Compare button, 117	Boost Color, 130
deleting photos, 118	B & W (Black and White), 130
exiting, 118	Edge Blur, 131
multiple photos, 118	Fade Color, 130
toolbar and the thumbnails browser, 117	Matte, 130
zooming, 118	Original, 130
Highlights slider, 137–138	Sepia, 130
histogram, 132–134	Vignette, 130
adjusting levels, 133	Email command, 346
channels, 133	email, importing photos into iPhoto from, 22
in another program, 114	emailing photos, 189–192
in iPhoto window, 114	choosing email program, 191
opening different editing windows on the fly,	choosing size, 191
115	file size, 189
Preferences, 114	including Titles, Descriptions, and Location
RAW files, 144–147	Information, 192
Camera Raw's Save As command, 146	iPhoto Mailer Patcher, 192
external editors, 145	large file size, 190
red-eye, 127–128	selecting photos, 191
Retouch brush, 128–129	Embed ColorSync profile, 336
Revert to Original command, 143	Empty iPhoto Trash, 337
rotating, 120	Empty Trash, 72
Saturation slider, 136	Enhance button, 125–127
scrolling tricks, 119	applying multiple times, 126
Shadows slider, 137–138	event info, showing/hiding, 74
Sharpness slider, 138	Event name, 15
smaller files, larger size, 146	Events, 34, 37–41, 335
Straighten slider, 125	Autosplit Selected Events, 45
Temperature slider, 140	changing key photo, 39
thumbnails browser, 116	collapsing, 44
thumbnails view, 115	creating manually, 45
TIFF files, 147	defining, 38
Tint slider, 140	deleting, 40
toolbar, 116	displaying names, 44
unsharpening, 138	flagged photos, 79
white balance, 140	merging, 40
zooming in full-screen mode, 118	merging in Photos view, 47
zooming within editing views, 118	

moving photos between events, 46	Extended Photo Info panel, 69-70
opening	Camera, 70
photo directly, 40	Exposure, 70
Photos view, 40	File, 70
rearranging thumbnails, 39	Images, 70
renaming, 40	Location, 70
renaming and dating, 47	Extensis Portfolio, 319
scanning through pile, 39	external editors, 143
sorting, 39	Eye-Fi Explore Card, 103
splitting, 45	
Event (smart albums), 62	F
Events menu, 345–346	Facebook, 3, 37, 198–201, 346
Add Flagged Photos To Selected Event, 345	adding photos to Facebook albums, 201
Autosplit Selected Events, 346	automatic photo-tagging, 200
Create Event, 345	deleting photos, 201
Create Event from Flagged Photos, 345	uploading photos, 199
Make Key Photo, 345	Faces, 2, 35, 89–101
Open Event in Separate Window, 346	adding more details, 98
Split Event, 345	adding more pictures to a name, 92–96
Event Titles, 346	deleting, 97
EXIF tags, 69	key photo, changing, 100
Export, 338	Name button, 95
File Export, 338	not identifying people, 328
QuickTime, 339	organizing albums, 99–101
Slideshow, 339	payoff, 96
Web Page, 339	rearranging order, 100
Export dialog box (QuickTime tab), 268	smart albums, 62, 99
exporting and converting photos, 299-303	
exporting by dialog box (see Export Photos	tagging automatically, 91
dialog box)	
exporting by dragging, 300	manually, 91–92 Face (smart albums), 62
exporting iPhoto Web pages, 214–220	Fade Color effect, 130
BetterHTMLExport, 219	File Export, 338
enhancing HTML code, 218	file formats, 23–26
examining results, 217–218	BMP, 25
preparing, 214–217	FlashPix, 25
Include location, 217	GIF, 25
Page attributes, 215	JPEG, 25
selecting size, 216	MacPaint, 25
Show comment, 217	movies, 24
Show metadata, 217	PDF, 26
Show title, 216	Photoshop files, 25
exporting, troubleshooting, 325–331	PICT, 25
Export Photos dialog box, 301–303	PNG, 25
file format, 301–304	
JPEG, 301	RAW, 23 SGI, 26
Original, 301	
PNG, 302	Targa, 26 TIFF, 25
TIFF, 302	
size options, 302	file management, 309–320
titles and keywords, 302	about iPhoto discs, 309
Exposure slider, 134–135	backups (see backups)
JPEG files, 134	burning CDs or DVDs, 310–313
RAW files, 134	when not to burn, 312
	managing photo libraries (see libraries)

File menu, 338–340	When You Don't Feel Like Sharing, 102
Browse Backups, 339	Where Did All the Photos Go?, 211
Close Window, 339	Your Own Personal Sorting Order, 36
Edit Smart Album, 339	Full Screen command, 347
Export, 338	full-screen mode
File Export, 338	editing photos, 117–118
QuickTime, 339	Compare button, 117
Slideshow, 339	deleting photos, 118
Web Page, 339	exiting, 118
Get Info, 338	multiple photos, 118
Import to Library, 338	opening photos, 53
New Album, 338	
New Album From Selection, 338	G
New Folder, 338	Gem in the Rough
New Smart Album, 338	Memory Card's Back Door, 17
Order Prints, 339	Pop-Up You Might Miss, 260
Print, 339	Portraits & Prints, 182
Subscribe to Photo Feed, 339	Scanner/Cellphone Auto-Import Workflow,
Filename (smart albums), 62	306
Find, 342	geotagging photos, 101–112
flagging photos, 28, 77–79	adding additional information to photo or
hide all at once, 79	event, 106–108
	ATP PhotoFinder, 103
how to flag, 78	
how to unflag, 78	automatically, 102–104
move all at once, 79	Eye-Fi Explore Card, 103
put into Event, 79	hiding location, 102
see all at once, 78	manually, 104–106
smart albums, 79	Get Info command, 338
Flag Photo, 344	GIF, 25
FlashPix files, 25	Google Search tab, 104
Flash (smart albums), 62	greeting cards, 259–262
Flickr, 3, 37, 194–198, 346	Background pop-up menu, 261
adding photos to Flickr sets, 197–198	Design pop-up menu, 260
deleting photos, 198	Grey, Tim, 352
keywords, 195	Н
not updating, 328	п
Places on Flickr maps, 196–197	Help menu, 349
subscribing to Flickr feeds, 210	Hidden Photos, 51, 346
fluorescent lighting, 140	Hide iPhoto command, 337
Focal Length, 62	Hide Others command, 337
folders, 63–64	Hide Photo command, 344
Font submenu, 342	hiding photos, 28, 50–52
Fotki.com, 352	seeing hidden photos, 51
Frequently Asked Question	unhiding, 52
Battle of the Sliders, 136	Highlights slider, 137–138
Blurry-Photo Effect, 50	histogram, 132–134
Doubling the Cover Photo, 235	adjusting levels, 133
In iPhoto, Less is More, 146	channels, 133
Ken Burns Effect, 166	Hot Corners button, 297
Moving the iPhoto Library, 30	
Photocasting, R.I.P., 208	
Slideshow Smackdown: iPhoto vs. iMovie, 170	
Using iPhoto with PowerMail, QuickMail Pro,	
MailSmith, 192	
Manonini, 192	

I	Hide iPhoto, Hide Others, Show All, 337
iCal, 255	Preferences, 333
iDVD slideshows, 173, 283–292	Advanced, 336
customizing, 286–291	Appearance, 335
e	Events, 335
Add image files to DVD-ROM, 290	General, 333
adding more slideshows, 290	Sharing, 335
adding, removing, and reordering pictures,	Web, 335
287	Provide iPhoto Feedback, 337
background graphics, 287	Quit iPhoto, 337
Display navigation arrows, 289	Register iPhoto, 337
Fit to Audio option, 288	Shop for iPhoto Products, 337
Loop slideshow, 289	iPhoto support page, 351
Show titles and comments, 290	iPhoto, the application, 9–12
Slide Duration, 288	editing, 10
Slideshow volume, 289	getting iPhoto, 10–12
Themes button, 287	importing, 9
Transition, 289	organizing, 9
previewing, 290	requirements, 10
self-playing, 291–292	running for first time, 12
starting in iDVD, 285–290	sharing, 10
starting in iPhoto, 284–285	
Imaging-Resource, 351	upgrading from earlier version, 11
"I'm Feeling Lucky" button in Picasa, 142	iPhoto versus iMovie, 170 ISO, 62
iMovie versus iPhoto, 170	
Import All, 15	iView MediaPro, 319
importing, 9, 13–26	iWeb, 211–213
deleting transferred photos, 16	editing or deleting, 213
dragging files into iPhoto, 21	end result, 213
duplicating imported photos, 20	transferring photos to MobileMe Web site, 211
existing graphics files, 19	I
file formats (see file formats)	J
from email, 22	Jacquier, Simon, 192
from old cameras, 18	JPEG files, 25
internal or external, 20	exporting, 301
post-import inspection, 26–28	Exposure slider, 134
troubleshooting crashes, 324	K
USB camera, 13–17	
USB memory card reader, 17-18	Keep Originals command, 16
Import Selected, 15	Keepsakes button, 226, 253
Import to Library, 21, 338	keyboard shortcuts, 6, 349
Information panel, 64–69	key photo
Date field, 67	changing, 100
Description field, 67	Events, 39
captions, 69	keywords, 83–88, 346
renaming photos, 65	assigning/unassigning, 85
iPhoto.db, 30	editing, 83–85
iPhoto Help, 349	important points, 87
iPhoto Library Manager, 318	keyboard shortcuts, 86
	showing/hiding, 74
iPhoto Mailer Patcher, 192	smart albums, 62
iPhoto menu, 333–337	sorting by, 42
About iPhoto, 333	using, 86–88
Check for Updates, 337	versus albums, 84
Empty iPhoto Trash, 337	viewing assignments, 86

L	Allow: Downloading of photos or entire
levels, adjusting, 133	album, 204
libraries, 314–318	allowing people to download copies of photos,
archiving photos to disc, 315	205
creating new, 316	Allow uploading of photos via Web browser,
disk image files, 315	204
iPhoto Library Manager, 318	Carousel, 207
merging, 318	configuring gallery, 204
multiple, 315–318	Download button, 207
sharing across accounts, 222-224	getting a MobileMe account, 203
sharing across network, 222-224	Grid, 206
swapping (Apple's method), 316	Hide album on my Gallery page, 204
swapping (automatic method), 317	Mosaic, 207
Library, 28-31, 33	Send to Album button, 208
AlbumData.xml, 30	Show email address for uploading photos, 204
copying items to, 336	Show: Photo titles, 204
damaging photo collections, 31	Slideshow, 207
Data folder, 31	slideshows on Web, 280
Dir.data, 30	Subscribe button, 207
iPhoto.db, 30	subscribing to published albums, 209
Library6.iPhoto, 30	Tell a Friend button, 206, 208
Library.data, 30	transferring photos using iWeb, 211
Modified folder, 31	turning off albums, 208
moving, 30	Upload button, 207
numbered files and folders, 29	using, 206–208
Originals folder, 31	Modified folder, 31
rebuilding, 330	Move to Trash, 344
Library6.iPhoto, 30	movies, 24, 263–282
Library.data, 30	managing movies imported from camera, 275
Library list (Automator), 304	QuickTime
location where photos stored, 28-31	background crophics 270
low resolution, 176	background graphics, 270
M	exporting, 267–271
M	proportion considerations, 267 seconds per photo, 269
MacPaint files, 25	size considerations, 268
.Mac Web Gallery photo feed, 208	QuickTime Pro (see QuickTime Pro)
magnified pictures, walking through, 27	slideshows
Mail, 190	before exporting, 263–264
MailSmith, 192	burning CD or DVD, 276–278
Make Key Photo, 345	exporting instant slideshows, 265–266
Manage My Places, 348	exporting saved slideshows, 266–267
maps, 3	on Web, 278–281
Matte effect, 130	specifying which photos are exported, 264
memory card reader, 17–18	MyPublisher.com, 257
Microsoft Entourage, 190	My Rating, 88, 344
Microsoft Expression Media, 319	smart albums, 62
miniature page-layout program, 181	
Minimize command, 348	N
missing pictures, 329–332	Name button, 95
MobileMe, 346	New Album, 338
MobileMe feed, 208	New Album From Selection, 338
MobileMe Gallery, 37, 201–210	new features, 2–4
Album Viewable by, 203	Faces (see Faces)
Allow: adding of photos by email, 204	ruces (see ruces)

maps (see maps)	hiding, 346
online sharing (see online sharing)	hiding (see hiding photos)
Places (see Places)	jump to top of photo collection, 48
Slideshow Export (see Slideshow Export)	magnified pictures, walking through, 27
slideshow themes (see slideshow themes)	marking (see flagging photos)
supercharged editing tools (see editing tools)	merging events, 47
New Folder, 338	messing up, 328
New Smart Album, 61, 338	missing, 329–332
noise, 139	moving photos between events, 46
	opening, 52–55
0	full-screen mode, 53
online sharing, 3	in another program, 55
Open Event in Separate Window, 346	in window, 52
ordering prints online, 184–188	organizing automatically, 89
cropping photos, 185	renaming, 43
minimum resolution, 187	Information panel, 65
Order Prints, 339	renaming and dating events, 47
O'Reilly's Mac DevCenter, 351	scrolling through pane, 47
organizing, 9	searching by text, 79
Original effect, 130	selecting (see selecting photos)
Originals folder, 31	Size Control slider, 42
originals lolder, 51	sorting, 346
P	Sort Photos submenu, 42
packages, 29	splitting events, 45
page-layout mode	Photoshop, 143
Adjust, 183	Photoshop Elements, 143
Background, 183	Photoshop files, 25
Borders, 183	Photo (smart albums), 62
Layout, 183	Photos menu, 343–345
Print Settings, 183	Adjust Date and Time, 343
Settings, 184	Batch Change, 343
Themes, 183	Duplicate, 344
page-layout program, miniature, 181	Flag Photo, 344
Paste, 342	Hide Photo, 344
Paste button, 142	Move to Trash, 344
PDF files, 26	My Rating, 344
Photobucket, 352	Restore to Photo Library, 345
photocasting, 208	Revert to Original, 344
Photo District News, 352	Rotate, 343
Photo.net, 352	Show Extended Photo Info, 343
photos, 34, 41–48	PICT files, 25
Albums (see Albums)	Places, 2, 35, 101–111
Autosplit Selected Events, 45	adding additional information to photo or
Batch Change, 66	event, 106–108
blurry-photo effect, 50	adding description, 106
calendar (see calendar)	ATP PhotoFinder, 103
changing comments, 65	Browser view, 109
collapsing events, 44	changing look of map, 107
creating events manually, 45	Edit My Places, 104–106
dates, changing, 65, 67 deleting, 70–72	enlarging map, 107
deleting, 70–72 deleting transferred, 16	Eye-Fi Explore Card, 103
displaying event name, 44	geotagging photos
flagging (see flagging photos)	automatically, 102–104

Places continued	Simple Mat, 180
Google Search tab, 104	Standard, 180
hiding location, 102	Provide iPhoto Feedback, 337
moving to next picture, 107	publishing photos on the Web, 193-194
on Flickr maps, 196–197	exporting iPhoto Web pages (see exporting
rating photo, 106	iPhoto Web pages)
renaming photo, 106	Facebook (see Facebook)
smart albums, 110-112	Flickr (see Flickr)
World view, 108	iPhoto to iWeb (see iWeb)
zooming map, 107	MobileMe Gallery (see MobileMe Gallery)
Place (smart albums), 62	Web-publishing routes, 193
plug-ins and add-ons, 303	
PNG files, 25	Q
exporting, 302	Qualcomm's Eudora, 190
Pogue, David, 352	QuickMail Pro, 192
Portraits & Prints, 182, 303	QuickTime, 339
postcards, 259–262	QuickTime Export, 263
Background pop-up menu, 261	seconds per photo, 269
Design pop-up menu, 260	QuickTime movies
post-import inspection, 26–28	background colors, 269
PowerMail, 192	background graphics, 270
Power Users' Clinic	
	exporting, 267–271
Coping with Fluorescent Lighting, 140	proportion considerations, 267
Musical Liposuction, 269	seconds per photo, 269
Preferences, 333	shrinking size of music track, 269
Advanced, 336	size considerations, 268
Appearance, 335	QuickTime Pro, 271–275
Events, 335	adjusting video and audio, 271, 274
General, 333	editing digital-camera movies, 275, 276
Sharing, 335	Save As, 276
Web, 335	Select, Copy, Add, 276
Print command, 339	Trim, 276
printing, 175–188	editing movies, 271
from iPhoto, 179–184	exporting edited movies, 274
adjusting layout, 181–184	no nagware, 271
choosing a printing style (theme), 180	playing movies in full-screen mode, 271, 272
choosing photos to print, 179	Save as a reference movie, 275
choosing print and paper sizes, 181	Save as a self-contained movie, 275
making your own prints, 175–184	selecting footage, 273
aspect ratio, 177	Quit iPhoto, 337
calculating resolution, 176	R
dpi (dots per inch), 176	
low-resolution, 176	ratings, 28, 88, 346
paper, 179	sorting by, 43
printer settings, 178	RAW files, 23, 336
resolution, 176	16-bit TIFF files, 147
ordering prints online, 184-188	Camera Raw's Save As command, 146
cropping photos, 185	editing, 144–147
minimum resolution, 187	external editors, 145
troubleshooting, 327	Exposure slider, 134
print options	rebuilding Library, 330
Contact Sheet, 180	Recent heading (Source list), 35
Double Mat, 180	Flagged, 36
Simple Border, 180	Last 12 Months, 36
cample border, 100	2001 12 110111110, 00

Last Import, 36	not seeing shared photos, 329
Most recent Event, 36	online (see online sharing)
red-eye, 127–128	Sharpness slider, 138
Redo, 341	Shop for iPhoto Products, 337
Register iPhoto, 337	ShortCourses.com, 352
renaming photo in Finder, 19	Shortcut menu, 6
requirements, 10	Show All command, 337
resolution, 176	Show Extended Photo Info, 69, 172, 343
calculating, 176	Show in Toolbar, 347
minimum resolution when ordering prints	Show Keywords, 83, 348
online, 187	Show Photos button, 41
Restore to Photo Library, 345	Shutterfly, 352
Retouch brush, 128–129	Shutter Speed, 62
Revert to Original, 31, 143, 328, 344	Slideshow button, 153
Rotate, 343	Slideshow command, 339
running for first time, 12	Slideshow dialog box, Music tab, 156
S	Slideshow Export, 3, 263
	slideshows, 151–174
Saturation slider, 136	before exporting, 263–264
screen savers	burning CD or DVD, 276–278
basics, 297	different slideshow settings for different
building custom, 295–297	albums, 158
Hot Corners button, 297	iDVD (see iDVD slideshows)
scrolling tricks, 119	instant, 151, 154–158
searching photos by text, 79 Select All, 342	closing full-screen view, 155
selecting photos, 48–50	Display (export option), 266
all, 48	exporting, 265–266
almost all the photos in a window, 49	Large (export option), 266
by dragging, 48	Medium (export option), 265 Mobile (export option), 265
consecutive, 49	Music chooser, 154
deselect a photo, 49	pausing, 154
pick and choose, 49	picking photos, 161–162
Select None, 342	selecting theme, 154
Sepia effect, 130	Settings panel, 155
Service and Support, 349	slide browser, 155
Set Desktop, 346	music, 156–158
SGI files, 26	Custom Playlist for Slideshow, 157
Shadows slider, 137–138	GarageBand, 157
Share menu, 346	iTunes, 157
Email, 346	listen to a song before committing, 157
Facebook, 346	playlist, 156
Flickr, 346	searching, 157
MobileMe, 346	sorting by Artist, Name, or Time, 157
Set Desktop, 346	Theme Music folder, 156
Shares heading (Source list), 36	use an entire playlist as soundtrack, 157
sharing, 10, 335	use an individual song, 157
across accounts, 222-224	on the Web, 278–281
moving library, 222	high-bandwidth movies, 280
sharing library, 222	low-bandwidth movies, 278-280
across network, 220-222	MobileMe Gallery, 280
dragging photos to your albums, 221	photo order, 162
Look for shared photos, 221	picture size, 171
Require password, 221	Repeat slideshow, 161
Share entire library, 221	

365

slideshows continued	Faces, 62, 99
saved, 152, 162-171	Filename, 62
All Slides tab, 166	flagging photos, 79
color options, 167	Flash, 62
creating and fine-tuning, 162-164	Focal Length, 62
cropping, 168	ISO, 62
exporting, 266–267	Keyword, 62
global settings, 165–167	My Rating, 62
individual-slide options, 167–171	Name, 62
Ken Burns checkbox, 168–171	Photo, 62
Music Settings dialog box, 165	Place, 62
Slideshow Settings dialog box, 166	Places, 110–112
slide timing, 167	Shutter Speed, 62
Themes dialog box, 165	Title, 62
transitions, 167	
transition speed and direction, 167	softening photos, 138
zooming, 168	sorting, custom, 36
	Sort Photos, 346
Scale photos to fill screen, 161	Sort Photos submenu, 42
settings, 158–162	By date, 42
Show Extended Photo Info, 172	By keyword, 42
Shuffle slide order, 161	By rating, 43
slide timing, 158–159	By title, 42
specifying which photos are exported, 264	Manually, 43
themes, 3, 152–154	Source list, 33–37
Classic, 153	adjusting width, 48
Ken Burns, 153	Albums (see Albums)
Scrapbook, 153	Events (see Events)
selecting, 154	Facebook, 37
Shatter, 153	Faces, 35
Sliding Panels, 153	Flickr, 37
Snapshots, 153	Library, 33
tips, 171–173	MobileMe Gallery, 37
- titles, 161	Photos (see Photos)
transition effects, 159-160	Places, 35
Cube, 159	Recent, 35
Direction, 160	Flagged, 36
Dissolve, 159	Last 12 Months, 36
Droplet, 159	Last Import, 36
Fade Through Black, 159	Most recent Event, 36
Flip, 159	Shares, 36
Mosaic Flip Large, Mosaic Flip Small, 159	
Move In, 159	Subscriptions, 37
None, 159	Special Characters, 343
Page Flip, 159	special-effect filters, 142
Push, Reveal, Wipe, 159	Spelling, 343
Speed, 160	Split Event, 345
Twirl, 159	Story, Derrick, 352
	Straighten slider, 125
smart albums, 61–63	Subscribe to Photo Feed, 339
Aperture, 62	subscriptions, 37
Camera Model, 62	Flickr feeds, 210
creating, 61	MobileMe Gallery albums, 209
Date, 62	support page, 351
Description, 62	
Event, 62	

T
Take Your Best Shot, 352
Targa files, 26
Temperature slider, 140
Themes dialog box, 181
thumbnails
crashing, 327
external program, 328
gray rectangles, 329-332
thumbnails browser, 116
Thumbnails submenu, 348
TIFF files, 25, 147
16-bit, 336
exporting, 302
Time Machine, 339
Tint slider, 140
titles, 346
showing/hiding, 74
sorting by, 42
Title (smart albums), 62
toolbar, hiding/showing, 347
transition effects, captions, 160
Trash, 70–72, 344
permanently deleting, 72
travel maps (see maps)
troubleshooting, 323–332
camera not importing images, 325
camera not recognized, 324
Check for Updates, 323
crashing
double-click thumbnail, 327
emptying trash, 325
importing, 324
deleting photos
deleted photo reappearing, 329
unable to delete, 329
exporting, 325–327
Faces not identifying people, 328
Flickr not updating, 328
iPhoto wigging out, 328
messing up photos, 328
missing pictures, 329–332
not seeing shared photos, 329
printing, 327
thumbnails in external program, 328
upgrading, 324
U
Undo, 341
Unflag Photos, 78
unsharpening, 138

upgrading from earlier version, 11 troubleshooting, 324

	1
	Defining an Event, 38
(Getting a MobileMe Account, 203
	Heartbreak of the Yellow Exclamation Point,
	249
]	How Low Is Too Low?, 187
	Screen Saver Basics, 297
	Smart Albums and Happy Faces, 99
	When Cropping Problems Crop Up, 123
	camera, 13–17
USB	memory card reader, 17–18
V	
Vers	sionTracker, 351
	eo Tutorials, 349
Viev	w menu, 346–348
1	Always Show Toolbar, 347
	Autohide Toolbar, 347
]	Event Titles, 346
	Full Screen, 347
	Hidden Photos, 346
	Keywords, 346
	Ratings, 346
	Show in Toolbar, 347
	Sort Photos, 346
	Thumbnails, 348
	litles, 346
	nette effect, 130
W	
wall	paper, 297–299
	Center, 298
I	Fill screen, 298
9	Stretch to fill screen, 298
	Гile, 299
Web	Page command, 339
	panel, 335
Wel	come to iPhoto command, 349
	te balance, 140
	dow menu, 348-349
	Bring All to Front, 348
	Manage My Places, 348
	Minimize, 348
	Show Keywords, 348
	Vindow Names, 349
	Zoom, 348
	karound Workshop
	Secrets of the Apple Book-Publishing Empire
	257
Wor	kflow pane (Automator), 305

Up to Speed

yellow triangle exclamation point

Y yellow triangle exclamation point, 249

Zoom command, 348 zooming in full-screen mode, 118 zooming within editing views, 118

Colophon

This book was written on several computers, including a black MacBook laptop that remained attached to David Pogue like an appendage and J.D. Biersdorfer's trusty silver MacBook Pro. It was originally typed in Microsoft Word, with substantial assistance from the typing-shortcut program TypeIt4Me (www.typeit4me.com) and the macro program QuicKeys (www.quickeys.com). Later revisions were written directly in Adobe InDesign CS3.

The book's screen illustrations were captured with Ambrosia Software's Snapz Pro X (*www.ambrosiasw.com*), edited in Adobe Photoshop CS3 (*www.adobe.com*), and overlaid with labels, lines, and circles in Macromedia Freehand Mac OS X.

The book was designed and laid out in Adobe InDesign CS3 on a Mac Pro G5 Intel. The fonts include Formata (as the sans-serif family) and Minion (as the serif body face). To provide the symbols (♠, ಱ, ♠, and so on), Phil Simpson designed two custom fonts using Macromedia Fontographer.

The book was then exported as Adobe Acrobat PDF files for final transmission to the printing plant in Canada.

Try the online edition free for 45 days

Get the information you need, when you need it, with Safari Books Online. Safari Books Online contains the complete version of the print book in your hands, as well as all of the other Missing Manuals.

Safari is designed for people who are in a hurry for information, so you can learn just what you need and put it to work right away. And with new content added as soon as it's published, you can be sure the information in Safari is the most current and relevant to the job at hand.

To try out Safari and the online edition of the above title FREE for 45 days, go to www.oreilly.com/go/safarienabled and enter the coupon code CYCTPVH.

To see the complete Safari Library visit: safari.oreilly.com